EDITED AND INTRODUCED BY JANE ALISON

ADVISORS AND CONTRIBUTORS: ELIZABETH EDWARDS
PAULA RICHARDSON FLEMING (PRINCIPAL ADVISOR
ON 19TH CENTURY PHOTOGRAPHS)
MICK GIDLEY · THERESA HARLAN (CO-SELECTOR
OF 20TH CENTURY NATIVE AMERICAN PHOTOGRAPHIC ARTISTS)
GEORGE HORSE CAPTURE · JOLENE RICKARD · COLIN TAYLOR
HULLEAH TSINHNAHJINNIE (CO-SELECTOR OF 20TH CENTURY
NATIVE AMERICAN PHOTOGRAPHIC ARTISTS)

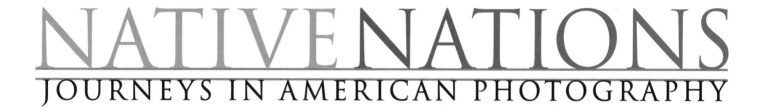

NATIVE NATIONS

JOURNEYS IN AMERICAN PHOTOGRAPHY

BARBICAN ART GALLERY

PLATE 2-6

LARRY MCNEIL
(TLINGIT/NISHGAA)

*From left to right: 1992, 1491,
1492, Elders, Circle of Rebirth*

All platinum palladium prints.
Courtesy of the artist

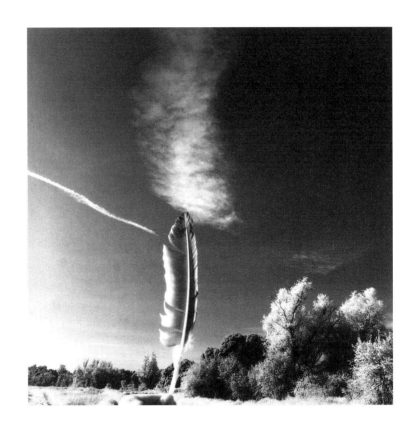

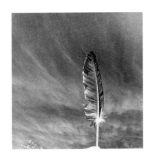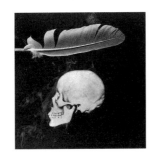

THE FEATHER SERIES, 1992

The first image, 1491, symbolizes the future that never was – what would have happened had we evolved without outside interference. 1492 represents the legacy of death. Entire nations were relegated to barren, desolate regions deprived of their livelihoods. Our people are still dying as a consequence of their ancestors' contact with the first foreign people. Circle of Rebirth *is in homage to fellow Native Americans who struggle, often against incredible odds, to maintain their identity, to continue the circle of life. 1992 represents the future denied us in 1491 – a reminder that native people still have a future that we can make our own.* Elders *is an homage to the people who have carried the gift of tradition over the years. Our elders recognised that surviving is not enough. With love and humour, they have taught us that each individual has a responsibility to make this world a better place.* LARRY McNEIL

CONTENTS

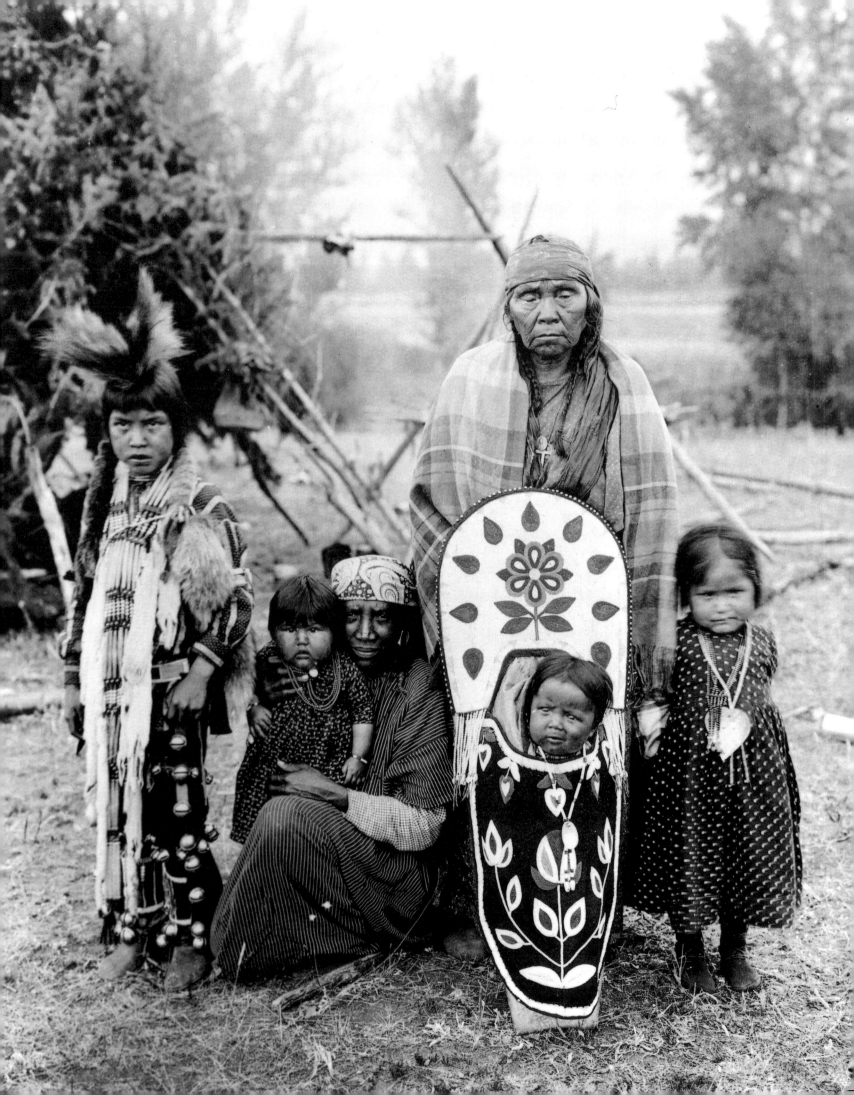

FOREWORD

NATIVE NATIONS – JOURNEYS IN AMERICAN PHOTOGRAPHY is a unique and challenging exhibition which explores the nature of photography and the photographic endeavour, but within the particular context of the representation of Native North Americans in the 19th century and the reclaiming of that medium by Native subjects in the 20th century.

To have integrity and strength, the exhibition required the backing and input of Native contributors. That contribution has been by way of advice, interpretative 'journeys,' and from artists, their agreement for their own work to be shown as part of the 20th century display of Native photographic art. We are especially indebted to Theresa Harlan, George Horse Capture, Jolene Rickard and Hulleah Tsinhnahjinnie for their insights and to Hulleah and Theresa for selecting the other 20th century Native photographic artists to be included. We are delighted to be able to introduce the works of Dugan Aguilar, Jennie Ross Cobb, Larry McNeil, Lee Marmon, Shelley Niro, Horace Poolaw, Jolene Rickard and Pamela Shields, Richard Throssel, Hulleah Tsinhnahjinnie, to a British audience.

The exhibition has come about through the creative thinking and hard work of our own staff in collaboration with a number of advisors in this country and from the United States who have given us invaluable help and contributed enormously to this book which accompanies the exhibition. Paula Richardson Fleming of the National Anthropological Archives, Smithsonian Institution was encouraging from the outset and her willingness to smooth the way for the substantial loan of vintage images meant that we could plan for an exhibition that would include a comprehensive exploration and contextualisation of the photographic taking of Native subjects in the 19th century. The exhibition has greatly benefited from her breadth of knowledge and her tremendous support. In this country, Mick Gidley, Elizabeth Edwards and Colin Taylor, advisors to the exhibition, have been generous with their time and knowledge and have been a great source of encouragement. We are also grateful to Irene Gilchrist and John Cuthbert of Guildhall Library who have both been enthusiastic from the start about the prospect of a selection of The Corporation of London's Curtis collection being shown at the Barbican Art Gallery.

Alongside the Smithsonian Institution and the Guildhall Library, The Pitt Rivers Museum, Oxford and the British Museum are major lenders to the exhibition. We would like to express my thanks to their directors, curators and trustees for supporting the exhibition so marvellously. We have also been fortunate enough to secure the loan of other significant vintage material from the Wellcome Institute Library, the John Judkyn Memorial, Bath, the Royal Anthropological Institute and the Royal Engineers Library, Chatham and the Union Pacific Museum, Omaha.

Each of the loans has enriched the display and each contributor helped to make this exhibition a success, bringing new insights to our understanding of photography and Native American history and experience.

John Hoole, Curator, Barbican Art Gallery
Jane Alison, Exhibition Organiser, Barbican Art Gallery

PLATE 7

UNIDENTIFIED
PHOTOGRAPHER

'La la See's wife, mother and children' 1907

Albumen print. Sir Benjamin Stone Collection, Birmingham Central Library

PLATE 8

WILLIAM HENRY
JACKSON?

*Us-caw-da-war-Uxty [Medicine
Antelope] and child (Pawnee),
Omaha, Nebraska, 1865*

From Dr F V Hayden's album
'Photographic Portraits of the
Indians of the United States
of North America'
(A selection of photographs
from a catalogue by William
Henry Jackson)
The Royal Anthropological
Institute, London

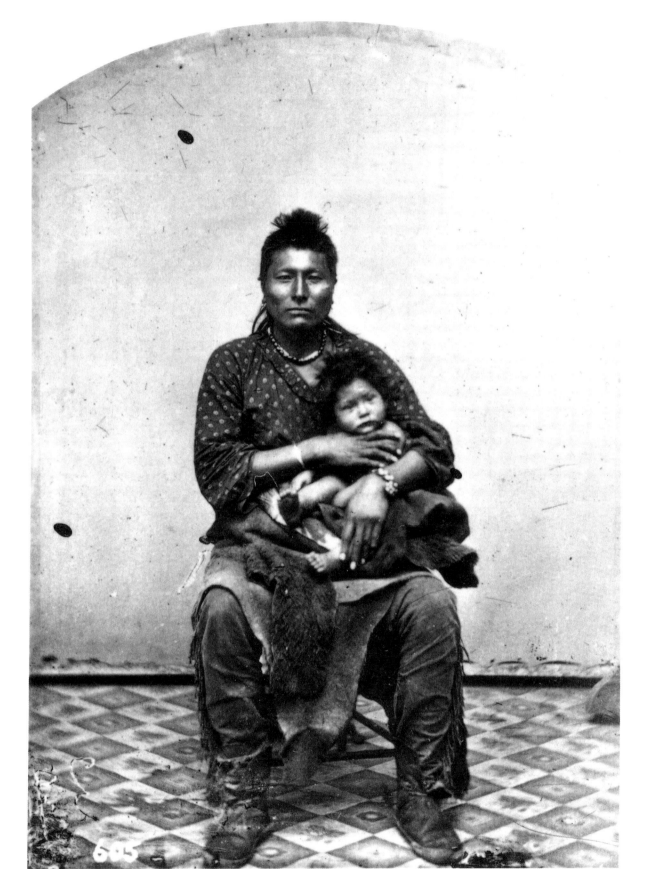

INTRODUCTION

JANE ALISON

Photography implies that we know about the world if we accept it as the camera records it.
But this is the opposite of understanding, which starts from not accepting the world as it looks.[1]
SUSAN SONTAG

The creating of an exhibition is a process of learning, a finding of parts of oneself. It is a journey which is inevitably directed by one's own beliefs, desires, qualities, failings – some of them not yet known. The exhibition, a reflection, and indeed one's comment on it, of where one is situated in the world and in one's own life at this moment.

Native Nations is a presentation in two parts, complementing and contrasting each other – two inseparable parts of the same story; photographs of Native subjects, photographs by Native subjects.

This book opens with a series of iconic images and words by the Native artist Larry McNeil (Tlingit/Nishgaa). The Feather Series (pl.2-6) reflects upon over 500 years of Native history: '1491 symbolises the future that never was – what would have happened had we evolved without interference. 1492 represents the legacy of death.' Those that arrived in 1492 were from Europe and so we should remember that we cannot distance ourselves from the injustices of this particular history.

We pick up the story in the mid-19th century when photography emerged as a tool, some might say a weapon, in the hands of the colonisers.[2] It developed alongside, and as part of, the final thrust of colonial expansion, the formation – in words and pictures – of the mythic West, the 'bloodthirsty Indian', the 'noble savage' and the 'exotic' other. The different contexts in which such a view came to predominate are developed in the plate sections of the book; 'Invaded spaces', 'Theatre of diplomacy', 'The American dream', 'Desirable objects' and 'Curious Curtis'.[3]

However, by the end of the century, Native Americans – those that observed as well as being observed – began to use photography to record their own lives, to make sense of their experiences. Hulleah Tsinhnahjinnie (Seminole/Muskogee/Diné) writes in this

book of the 'beautiful day' in which she decided to 'take responsibility to reinterpret images of Native people.' It is principally through the insights and reworkings of contemporary Native photographic artists that we can be begin to shape new understandings of the great weight of 19th century archive photographs held in American and UK museums.

Overlaid upon the historical and thematic contextualisation of images into groups, are what I began to think of as 'photo-journeys' by Native Americans, and in this book by non-Natives as well, each of which would suggest new ways of feeling and thinking about these images.

While every view-point helps us to understand how to 'read' these images – whether it stems from the outside looking in or the inside looking out – the most revealing responses to photographs of Native Americans have to be from those that *know*. That *knowing* is a profound richness which is unique to Indigenous peoples themselves, shaped by memory and stories, shared experience and cultural affection, and it also has the quality and purpose of a reclaiming and a celebration of survival and self-belief.

George Horse Capture (A'ani) sets the scene with his essay, a broad sweep of Native history. He chooses to focus on the place of children in Native society and their importance in terms of the continuance of the five hundred separate Native Nations that have survived the gross abuse of their human rights in the face of a European settler arrogance that carried these out in the belief of their own superiority. Horse Capture selected the images, his own favourites, to illustrate the text. The jewels of Hulleah Tsinhnahjinnie's journey are her own dreams, reflections and insights – strung beautifully between images that are part woven in her imagination – images of 'lustrous warm dark skin, lightening sharp witty eyes, with smiles that could carry one for days.' Jolene Rickard presents a broad ranging analysis of non-Native photographs as markers in the process of white colonisation of Native land. She contrasts these powerful images with the work of early Native photographers and suggests ways in which we may begin to read these in order to access Native experience and values. Theresa Harlan (Laguna/Santo Domingo/Jemez Pueblo) explores the creative approaches of Native photographers who documented their own communities, intimately and lovingly, in the early and mid-20th century and those of contemporary Native practitioners, many of whom are using new technologies and strategies of intervention and manipulation to reposition themselves affirmatively.

Four invited non-Native contributors; Mick Gidley, Paula Richardson Fleming, Elizabeth Edwards and Colin Taylor have addressed issues that the 19th century non-Native photographs raise for them. Mick Gidley takes a personal journey, informed by memory and the development of his own photographic awareness. He explores how the construction of images, their composition and framing 'more readily reflect the assumptions of the culture(s) of their makers than those of their subjects.' Paula Fleming tells of Little Crow and the Sioux Revolt of 1862. Some of the individuals

involved and Little Crow himself were photographed whilst in captivity and these images were made into stereographs, the new fashion in home entertainment and news coverage in the 1860s and 1870s. Fleming reminds us of the need to return to what or who the photograph depicts – an aperture onto a Native American history of which there is much ignorance among non-Native people. For her, photographs are a way of bringing that history into sight. Colin Taylor, a recognised authority on Native American Plains history and ethnography, revisits Buffalo Bill's Wild West show and examines the British love affair with the American Indian. Benedetta Cestelli Guidi has written about the photographically illustrated book at the turn of the century and has documented those books included in the exhibition.

THE CHALLENGE OF SEEING

Through what is said and the tenor of how it is said, each Native author apprehends the most immediate, superficial and questionable reaction to the photographs before us; Hulleah Tsinhnahjinnie tells of these as the 'two greatest assaults on Native existence' still perpetuated – 'its over romanticisation and its simplification.' It is the very seductiveness of the images and the richness of Native American culture which tend to obscure what is profound, what is diverse and perhaps also what is painful in the images. It also has grave implications in the long term. The Native writer, Gerald Vizenor, sums it up when he writes of how the occidental fascination with the 'Indian' has resulted in the absence of the 'Native.'[4] In other words, we see the photographs, we see the films – they live on in our imaginations, feed our fantasies, but their continued presence denies the visibility of the Native, blinds us to the injustices of history and contemporary political and social reality go unmarked. It is time for Native voices to be heard and Native visions to be seen.

With awareness comes the realisation that in making an exhibition and a book which focuses significantly on the photographs of Native subjects by non-Native photographers it is possible to reinforce the very things we seek to challenge. It is a point Jolene Rickard makes in the opening paragraphs of her essay; that it is a delicate task. Native commentators like Jimmie Durham and Vizenor have poured scorn on the white, Western 'parasites' who devour aspects of indigenous North American cultures, proclaiming it their own. ie. the tipi experience in rural Devon.[5]

Susan Sontag's series of essays, *On Photography*, is much quoted, especially in this context. She incisively points to the invasive nature of photography and also the way in which it can come to replace reality itself – the world existing to photograph or be photographed.[6] Vizenor, hard on her heels, writes:

'Photographers abused the native sense of privacy to capture an image and then either sold or distributed the pictures to various agencies. How should we now respond to the photographs that have violated the privacy of the natives? Cover the eyes? Whose eyes should be covered?'[7]

His meaning is not lost on us. The tale of the taking of Native subjects in photography is undoubtedly one of possession and dispossession – the invasion of privacy and of space, the literal 'taking' of the photograph – without any permission to do so, the 'exposure' of the subject to the camera, the profit and entertainment from the sale of 'exotica' and 'primitivism'; in short, the colonisation of a people through images.[8]

The taking of photographs by non-Natives of Native subjects, only continued what had been there from the first step of a white European on North American soil; the desire to 'capture' the 'other', the 'exotic specimen' for the delectation of oneself and others. Photography merely made that process less open to claims of exaggeration or falsification. Here was evidence for all to see. Evidence of what? Evidence that suited the public for which it was intended: a noble and exotic specimen perhaps, but an uncivilised savage nonetheless. Evidence of an Indigenous people tamed. The idea of a 'vanishing race' – brought to a pinnacle of pictorial refinement by the photographers Edward S. Curtis and Joseph Kossuth Dixon – gained currency toward the end of the century. It was a view promulgated by anthropologists, pseudo-anthropologists, politicians and journalists alike. Everybody wanted a piece of the action before it was lost. Having been effectively neutralised, herded onto reservations, deprived of their livelihoods and forcibly assimilated, it was possible for white people to now be nostalgic about a Native past. Aboriginal peoples became collectable as images – objectified as *cartes-de-visite*, stereographs and postcards.

I would advise visitors to these pages to take up Vizenor's suggestion that perhaps we should cover our eyes as a challenge to not just look, but to really see, to go beyond shallow appearances to search for something real, something true. Even if you don't find it. The truth may be more about what is not visible in the photograph – what is omitted; or, it may be that the photograph provides evidence of the intentions of the person or culture that directed the picture-taking. Perhaps the truth lies in the space to be explored between the subject, the photographer and ourselves. How do we truly feel in gazing at these images of peoples no longer alive, people with such a different life experience to our own? The question of how we respond to *difference* clearly has to be a critical one – as significant and important now as it has always been.

All these considerations are relevant and yet I am inclined to think, also like Vizenor, that the photograph still holds some kind of truth about the subject, or about the encounter between the photographer and the subject – and I suppose that my 'journey', in part, has been a search for what that truth might be.

NATURAL FEELING

Vizenor fixes on two critical reference points in the photographs of Native subjects by non-Native photographers, and at the same time writes off any notion of ethnographic validity:

'The eyes and hands of wounded fugitives in photographs are the sources of stories,

PLATE 9

LEE MARMON
(LAGUNA PUEBLO)

*White Man's Moccasins,
(Jeff Sousea) 1954*

Silver gelatin print.
Courtesy of the artist

the traces of native survivance; all the rest is ascribed evidence, surveillance, and interimage simulations of dominance. The eyes and the hands have never been procured in colonial poses, never contrived as cultural evidence to serve the fever of institutional power.'[9]

I am taken by his argument – the simplicity and the strength of it. From now on I look at the photographs in a different way. I wonder about the hands; certainly agents of creative expression. I reflect upon the cropping of an image that takes away the hands – something of the power of the subject is inevitably lost.

It is Vizenor who reminds me that the reflection of the photographer is held in the subject's eye – a reminder of that invisible third party; the subject, myself looking – and the photographer, missing no longer.[10] It is with this insight that I can begin to think of the subject as an observer of the photographer – a subject actively reacting, thinking, feeling – just as I am in looking. An active participant in history; capable of experiencing pain and indignity, but also of walking away and laughing, sitting down to eat, cradling a child, continuing to respect Native values, Native ways – having a life in the face of adversity.

In selecting an exhibition like this, it is necessary to sift through many images and like Lucy Lippard who went through the same process for the book *Partial Recall*[11] the expected pose, the romanticised view begins to tire and you long for some other something in an image that has more movement about it, a spark of reality, humour, something unexpected, something non-constructed, something – yes, natural. This is where Native images by and of Native peoples shine out. Lee Marmon's *White Man's Moccasins,* 1954 (pl.9) is a classic case in point. There are not many that stand out in the same way among non-Native images. However, there are some that surprise: an image by Aby Warburg comes immediately to mind, it is pretty much unique among images taken by non-Native people weilding a camera. It is a picture of a Diné [Navajo] man and teenage boy in Hopi territory (pl.72). The camera angle is low to the ground and the shot focuses on the Diné man who smiles very broadly, while the boy turns around to look at the photographer, a great pair of legs fills the foreground. Perhaps it was the photographer himself who made them laugh, or perhaps they were laughing at him. The 'snapshot'quality of Warburg's approach seems to have resulted in the taking of many candid images.

George Horse Capture has selected some wonderful images of women and children or families with children to illustrate his essay. In one case, he has chosen an image of Geronimo on horseback, with warriors at his side (pl.17). The suprise comes when our point of focus shifts away from Geronimo to the man on his right, who holds a child in his arms. Such images are extremely rare in the 19th century, not exactly the predicatable warrior-villain pose; while Geronimo crops up all the time, always ready to pose for the camera.[12]

For this reason the studio portrait of *Us-caw-da-war-Uxty [Medicine Antelope] and child*

PLATE 10

FRED E MILLER

Lizzie Shane Yellowtail (1864-1968) and Mary Shane Takes the Gun (1873-1963) with baby Irene Takes the Gun, between 1898-1910 (Crow)

Modern printing-out paper print from an original negative in the Fred E Miller collection:
Nancy F O'Connor

(pl.8) was a wonderful find in the Royal Anthropological Institute's Hayden Album 'Photographic Portraits of the Indians of the United States of North America'. The man looks totally at ease with himself – happy even, and again, the child is wrapped lovingly in his arms. The weight of the man is firmly placed on seat and floor – however, the child has that look of being slightly out of sorts, not quite supported correctly. The hands of the man and the legs of the child make a wonderful ragbag composition of parts. No compromises have been made to the photographer.

SHADES OF INTIMACY

In reviewing a broad selection of documentary and portrait image-making, from the early delegation and survey photographs of the 1850s and 1860s to the wonderfully sensitive and affirmative portraits taken by Horace Poolaw and Lee Marmon of people from their own communities, taken in the 1920s onwards, it is possible to discern in the photograph the degree to which intimacy and friendship exists between subject and photographer. It would be surprising were it otherwise, but the contrast between Native and non-Native images is nonetheless striking and moving. It points to another way of gauging the veracity and worth of the image.

A non-Native photographer who stands out beyond all others in this respect is Fred Miller (pl.10,11,80,81,82,83).

A professional photographer, Miller lived and worked among the Crow people from 1898 to 1910, and this was where he met his future wife, a part-Shawnee woman called Emma Smith. On their wedding day, Perits-Shinakpas [Medicine Crow] (pl.62,63) and the tribal council, agreed that they would be adopted into the Crow Nation should they desire to do so. Miller was apparently 'obsessed' with upholding the rights of the Crow people and it is clear from his images that he was accepted into their community with some affection.[13]

Two images by Miller attracted my attention more powerfully than the others. The first carries the name of the subjects captured by the lens of the camera, *Lizzie Shane Yellowtail (1864-1968) and Mary Shane Takes The Gun (1873-1963) with baby Irene takes the Gun* (pl.10). How refreshing it is to know each of their names, and to know that both women lived into the 1960s. Lizzie and Mary (sisters?) are posed against a plain canvas backcloth. First and foremost I am struck by the incredible presence of the two women. They appear quite willing to pose for the camera, and have obviously lifted the child to be included in the image. Again, as with the *Us-caw-da-war-Uxty [Medicine Antelope] and child* the unsteadiness of Irene adds a note of movement and uncertainty, her arms and hands moving to create a slight blur on the image. Life in movement. Apparently *Yellow Ears with her sick baby* (pl.11) was one of Miller's own favourites. Here we are treated to a view of inside the tipi – comforting, containing, decorative – where Yellow Ears sews while keeping an eye on her child who rests beside her. Again the baby has slightly moved, while Yellow Ears remains engrossed in her sewing – untroubled by the

PLATE 11

FRED E MILLER

Yellow Ears with her sick baby,
between 1898-1910 (Crow)

Modern printing-out paper
print from an original
negative in the Fred E Miller
collection:
Nancy F O'Connor

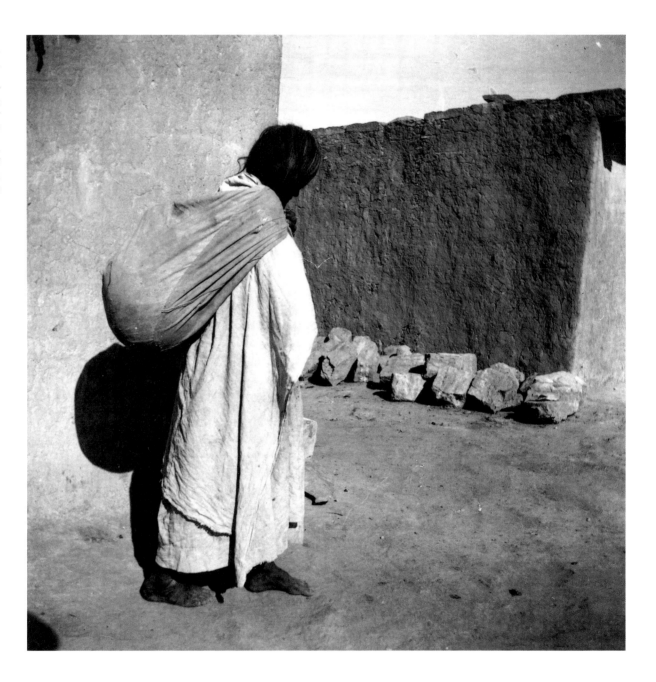

photographer in her midst.

I have space to mention only one last image. I choose another non-Native photographer who took special images: Kate Cory, a fine artist who lived in the Hopi pueblos of Oraibi and Walpi from 1905 to 1912. Kory's photographs (pl.12,67,68) are not intimate but they suggest that she was part of the community and so able to go about the business of taking pictures without exciting too much interest. An image of a Hopi woman walking away from us, returning home with a sack containing water, is one of her finest; the image is a study in textures, worn and sun-parched. It also stands as a comment on the hard – unromantic – life these people led.

Of all the images and choices and journeys to make, each person will have their own – images which speak to them personally. Hulleah Tsinhnahjinnie writes about how in the images of the Yebichai by Curtis and the Ghost Dance by Mooney the photographers saw a 'vanishing race' but she saw perseverance. Such an observation is confirmation that photographs can be powerful points of reference from which we take what we need to know and what we can believe in.

NOTES

1 Sontag, Susan, *On Photography*, Penguin 1979, p.23

2 The camera as predatory, a theme taken up by Sontag and much elaborated by other authors in this context

3 I am grateful to Hulleah Tsinhnahjinnie and Theresa Harlan for suggesting some of these title headings; 'Theatre of Diplomacy', 'The American Dream' and 'Curious Curtis'.

4 Vizenor, Gerald, *Fugitive Poses: Native American Indian Scenes of Absence and Presence*, University of Nebraska Press, 1989

5 Durham, Jimmie, 'Savage Attacks on White Women as Usual' 1990 in *A Certain Lack of Coherence*, Kala Press, 1993

6 Sontag, Susan, *On Photography*, Penguin 1979, p.??

7 Vizenor, Gerald, *Fugitive Poses: Native American Indian Scenes of Absence and Presence*, University of Nebraska Press, 1989

8 An argument discussed at length by Sontag, and also here addressed by Mick Gidley in his essay.

9 Vizenor, Gerald, *Fugitive Poses: Native American Indian Scenes of Absence and Presence*, University of Nebraska Press, 1989 p.158

10 Vizenor, Gerald, *Fugitive Poses: Native American Indian Scenes of Absence and Presence*, University of Nebraska Press, 1989, p.158

11 Lippard, Lucy, *Partial Recall*, The New Press, 1992. This book broke new ground and the quality of the interpretative writing by Lippard and the other Native contributors I found persuasive, enlightening and influential

12 Durham, Jimmie, poses an interesting argument in 'Geronimo!' in *Partial Recall* which is that Geronimo continued to resist through his stance in photographs.
 'On his own, he reinvented the concept of photographs of American Indians. At least he did so as far as he could, concerning pictures of himself, which are so ubiquitous that he must have sought 'photo-opportunities' as eagerly as the photographers.' p.56

13 An account of Fred Miller's life and work is given in *Fred E Miller: photographer of the Crows*, University of Montana. Carnan VidFilm, Inc., 1985

JOURNEYS

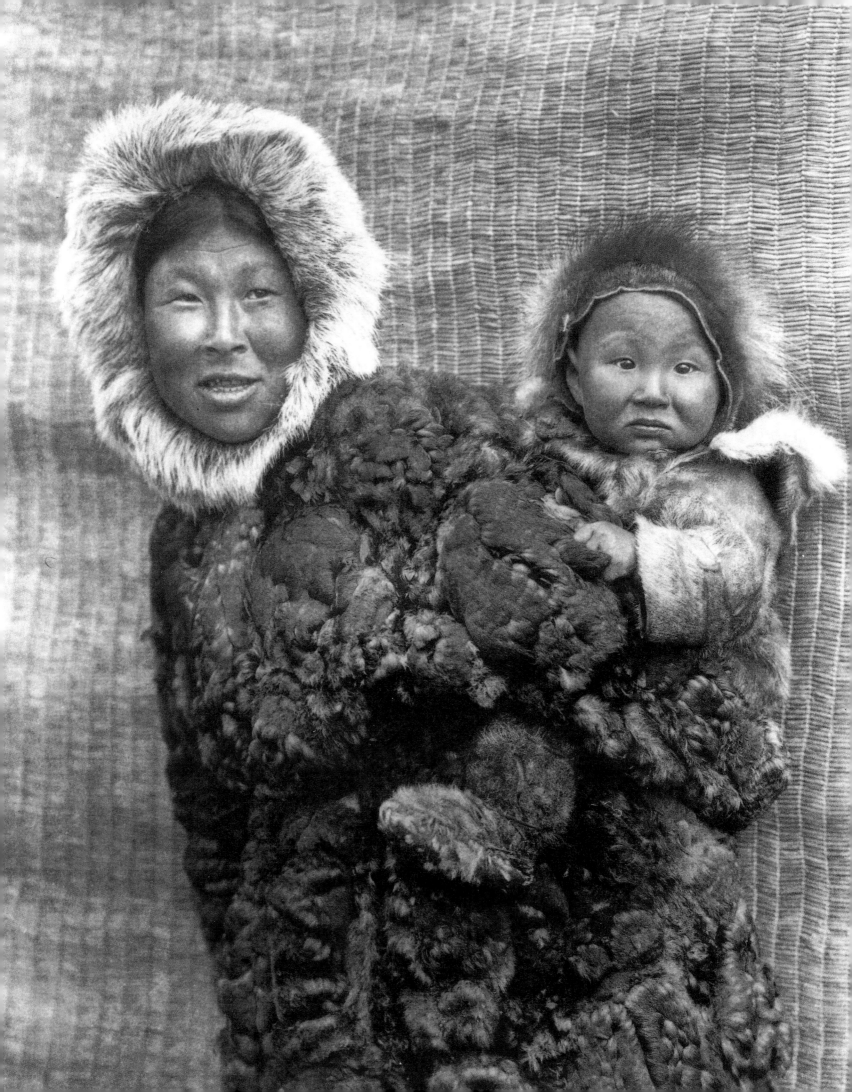

THEY'RE TAKING OUR CHILDREN

GEORGE HORSE CAPTURE

ARRIVAL

Upon arriving on this hemisphere many thousands of years ago, the first people established settlements where life was hospitable and they lived their lives. After many tens of thousands of years most everywhere was inhabited and the people lived from the bounty of the earth, achieving a balance with nature and the One Above.

ENVIRONMENTS

Lifestyles varied greatly among the groups. The people who settled in the Southwest adjusted their ways to fit within that environment. Having limited foliage they fashioned their structures from the soil of the earth and farmed vegetables for food. The people of the Northwest lived among the tall trees which provided the material for their houses, utensils, boats and other things. The sea provided the food.

PLAINS

The Plains area extends from mid-Saskatchewan in Canada to the north, down to mid Texas. The Mississippi River marks its boundary to the east and it reaches westward to the deserts. The many tribes who inhabited this vast region depended on the buffalo for their sustenance and everything in their world reflected this association. They became a migratory people following the buffalo herds and developed into mighty warriors and hunters.

TRIBAL SIMILARITIES

In spite of the differences shaped by their environments the various tribes shared many similarities that are universal among peoples. Most civilisations organise a form of government, moral standards, a religious belief system and other such necessities. Foremost, if a society is going to exist they must also place a high value on their children, for through children there is a future and a degree of immortality: survival.

PLATE 13

EDWARD S CURTIS

'A Nunivak woman and child'
1928 (Inuit)

A photogravure from the folio accompanying Vol. XX *The North American Indian*, published 1930. Guildhall Library, Corporation of London

PLATE 14

WILLIAM HENRY
JACKSON

A Bannock family of the Sheep-eater band in camp at the head of Medicine Lodge Creek, Idaho. Taken while Jackson was a member of the Department of the Interior funded Geological and Geographical Survey of the Territories, under the direction of Dr Ferdinand Vandiveer Hayden (Hayden Survey 1879-79), 11 June 1871

Albumen print. National Anthropological Archives, Smithsonian Institution

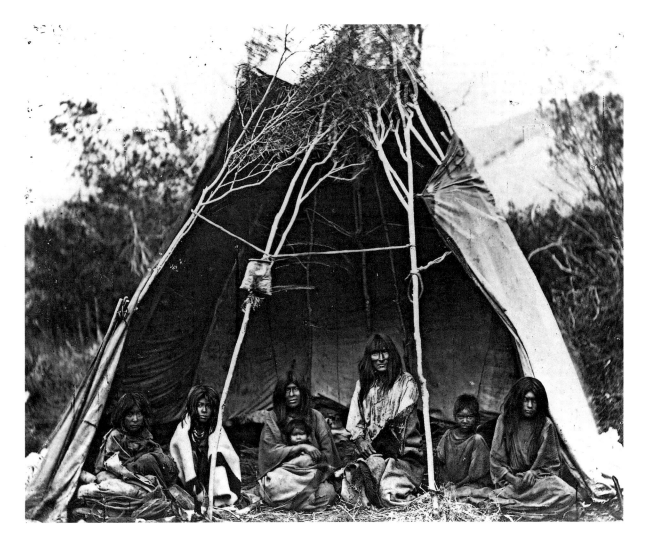

RELATIONSHIPS

From the moment of birth to adulthood, the babies were treated very specially, some would even say spoiled. When the time of birth came the mother would often face the ordeal by herself. In the buffalo days, the recovery time was short and the mother was active within a short period of time. In those days the people lived from the land because there were no stores from which to purchase medicines or baby supplies, and after centuries of improvisation the people could provide for themselves.

A typical day for a baby often went something like this: after sleeping the night on soft furs, the baby was fed and able to play in the tipi under the watchful eye of parents or relatives. Before too long it was time for the mother to perform the day's duties so the baby would be prepared: after a bath, the baby was placed on a soft hide that was covered with an absorbent plant material such as burst cattail down or moss. The arms were placed next to the baby's sides and they were snugly wrapped or swaddled by the hide with only the head protruding. Then they were laced into a baby carrier. The design of baby carriers varies among the Plains tribes but most of them are fashioned with a soft centre where the baby is placed and reinforced on the outside with a rigid frame that protects the child. Objects are often tied in front of the baby for its enjoyment.

When the mother leaves the tipi she takes the baby and places him near her workplace and throughout the day he is within sight. At the end of the day they return to the tipi where the baby is removed from his covering, the cattail or moss diaper discarded and he is bathed. After being fed the baby is once again free to crawl around; clean and naked to enjoy himself.

ADOLESCENCE

As the children grew older they experienced many things. When they misbehaved they were never physically spanked. Indian people wanted their children to be active and energetic in order to best cope with the world. If a child demonstrated these traits they did not want to spank them: that would cause pain and perhaps break their spirit.

Teaching a child was accomplished in a number of ways. There were few classroom situations, where the teachers outlined a situation, then proceeded step-by-step to solve it. An Indian child was free to learn whenever the opportunity arose. They learned by watching. When an experienced horseman rode his favourite horse, the children watched. Through observation they learned how best to mount, lean into a turn and even stop. When they felt they were ready they would tell their parents or a relative and then ride a horse. This method of learning accomplishes the purpose without the pressure of achievement or competition.

The relationship between the Indian people and their children was very close. It started with the 'parents'. In the Indian world, family relationships are like the parallel layers of the earth: they extend horizontally across the culture. For example, in addition

to having a biological mother and father, every brother to the mother and father was also a father to the child and every sister to the parents was another mother. So, if the mother had three sisters, the child would have four mothers. There were no such things as aunts and uncles only additional mothers and fathers. The children of the additional 'parents' were one's brothers and sisters. There were no such things as cousins. These relationships repeated themselves over the generations and kept the relatives close to each other and to the children.

This system also utilised cross-duties. An 'uncle' would assume the privilege of teaching the boy how to make a bow and arrows and even how to hunt, and a girl child could be taught how to prepare hides by her 'aunt'. Often children were raised by their grandparents, who taught them of the old ways.

NAMES

Names have a special place in the Indian world and they have power. When a baby was first born a relative might be called in to name him or the mother might see a streak in the heavens and call the new one Falling Star. Or the child might just be called The Boy or The Girl until a proper name became available. Names often came in dreams or they might be named after prominent relatives. At some juncture, such as becoming a teenager, a new name was given. In the old days names for girls were not as romantic as we hear today. Real Indian names have a source, they are not just whimsy: Kills In the Water, Eagle Plume Woman, Singing Rock, Meadow Lark Woman and Coming Daylight are female names in our family and Spotted Otter, Horse Capture, Sings In the Middle and Warrior are some family male names.

If a child was sickly their name could be changed, to help change their health. When older, a person could give their name away.

The actual naming is more than a casual gesture, even today it is a time for celebration. The child to be named should be dressed in their finest Indian clothing and stand before the respected elder who performs the ceremony. While saying a special prayer the elder holds the shoulders of the child from behind and pushes them toward the east, calling out their new Indian name. Drawing them backward toward the centre the child is then faced south and the same procedure takes place, as it does until all four directions are recognised. The elder is announcing this new name to all four directions of the universe. Finally, the child is greeted by their new name by the friends and relatives who have gathered. Now they are a part of the customs that have kept the tribe together for thousands of years.

ORAL TRADITION

Children learned in several ways, but the principal way was the oral tradition. The elders who were filled with a lifetime of knowledge shared this with the children. These lessons did not take place in a crowded classroom but often around a flickering

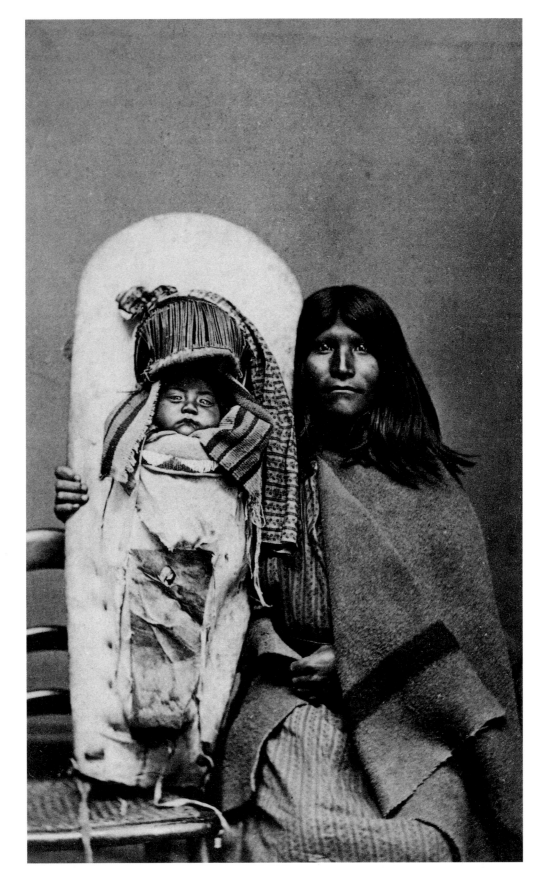

PLATE 15

UNIDENTIFIED
PHOTOGRAPHER

Ute woman and baby, undated

Albumen *carte-de-visite*.
William Blackmore
Collection. The Trustees of
the British Museum

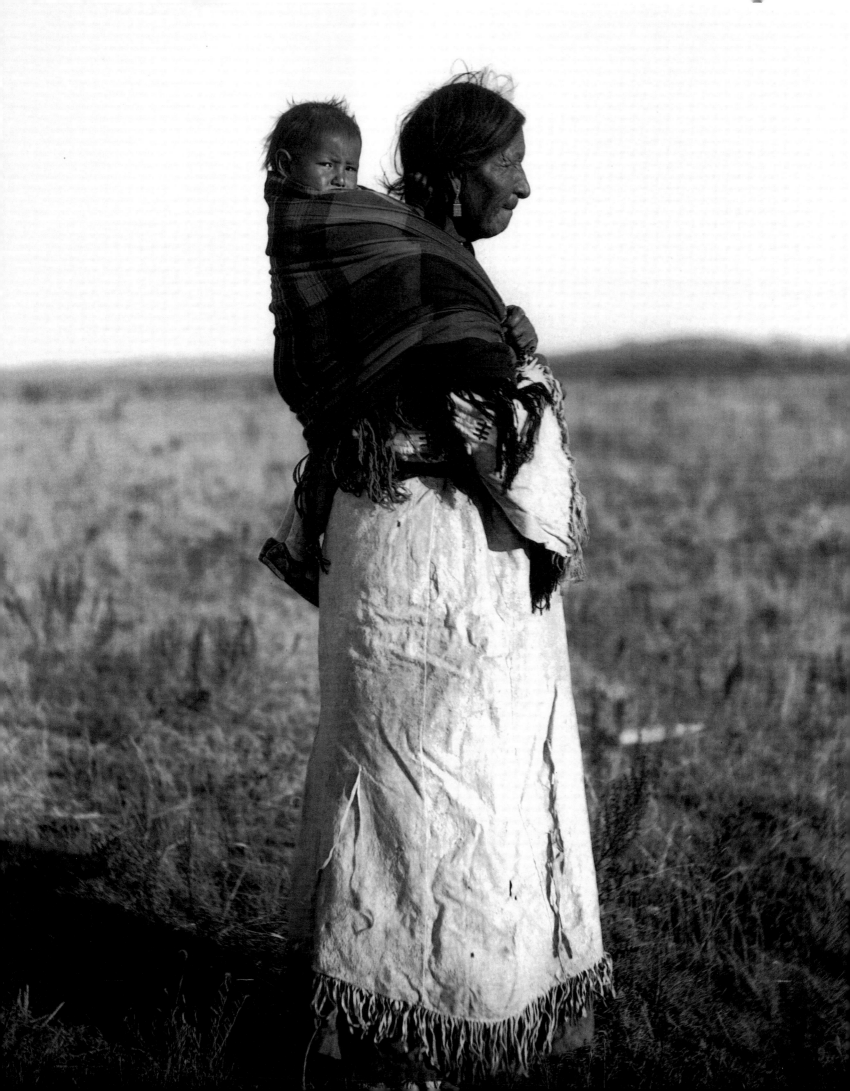

campfire. With the canopy of stars high above, the children were taught the tribe's beginning: when after forty days and nights of rain the water covered the earth, the first man floated on the back of a giant turtle. They could learn why dog is man's best friend, why the chipmunk has spots and why the bear must live alone. It was here that they found out what causes thunder, the names of the stars in the Big Dipper and about the One Above. In this way the children became keepers of the knowledge, assuring the future of the tribe.

PLATE 16

JOHN ALVIN ANDERSON

A Sicangu (Brulé) Lakota woman and child, after 1880

Modern print from a negative in the collection of the Nebraska State Historical Society

TEENAGE YEARS

In the teenage years on the Plains, the boys would join the first of the age-graded societies, such as the Mosquitoes, where that age group would come together and pray, hold ceremonies, hunt and practice to be warriors together. When they became older they could enter the next society – perhaps the Nighthawks and learn more about each other and the ways of a hunter and warrior, two essential skills to ensure the continuity of the tribes.

The girls' world was filled with activity as well, but centred more around the home. It was up to her to keep everything together. Her relatives taught her how to gather and prepare food, how to tan hides and to fashion clothing. Most of the attractively decorated moccasins, shirts, dresses, leggings and other traditional artwork were created by the women.

SPIRITUALITY

In order for a civilisation to be successful the components within it must be compatible, there must be a universal force recognised by everyone that holds them together and this power must be an all encompassing spiritual entity. Some groups call this divinity God and the Christian churches present his actual images and rules to live by to the believers. In the American Indian world it is different.

We believe in a Supreme Being, but he does not have a human form. He is sometimes called the Great Spirit, the One Above or simply Grandfather. He has no image but is an all powerful force – an essence. He is in the sweet spring rain that falls upon our faces or the bright flowers that colour the meadows. He teaches us that all things have power and deserve respect because, like us, they have been here since the beginning and we must travel the road of life together. Birds, trees and even rocks have this essence and deserve a place on Mother Earth. And we must all take care of this Mother as she produced all of us and everything we have comes from her. If we are to survive thiry thousand more years we must protect her for our future children.

It is known that under special circumstances the One Above communicates directly with Indian people. His helpers are often animals or special human beings and they appear in dreams or visions. In this way the Indian people received the buffalo, horse, corn, tobacco and other special gifts.

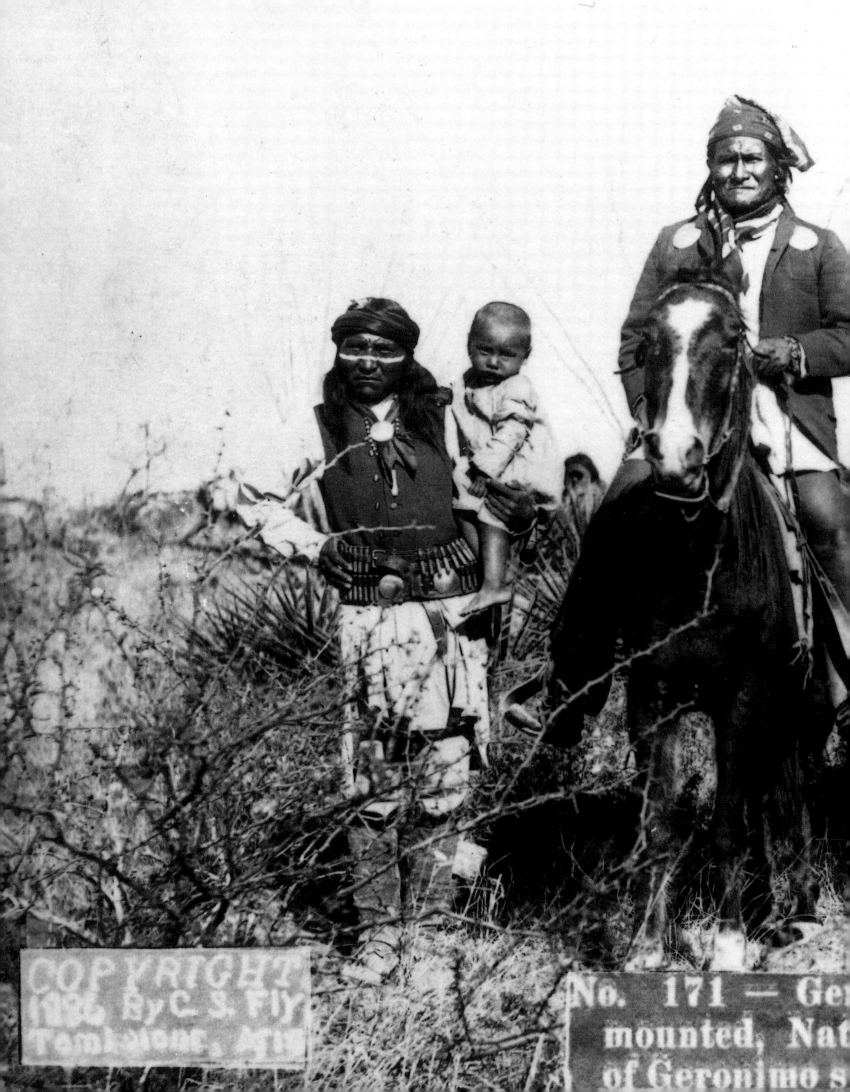

No. 171 — Ge
mounted, Nat
of Geronimo

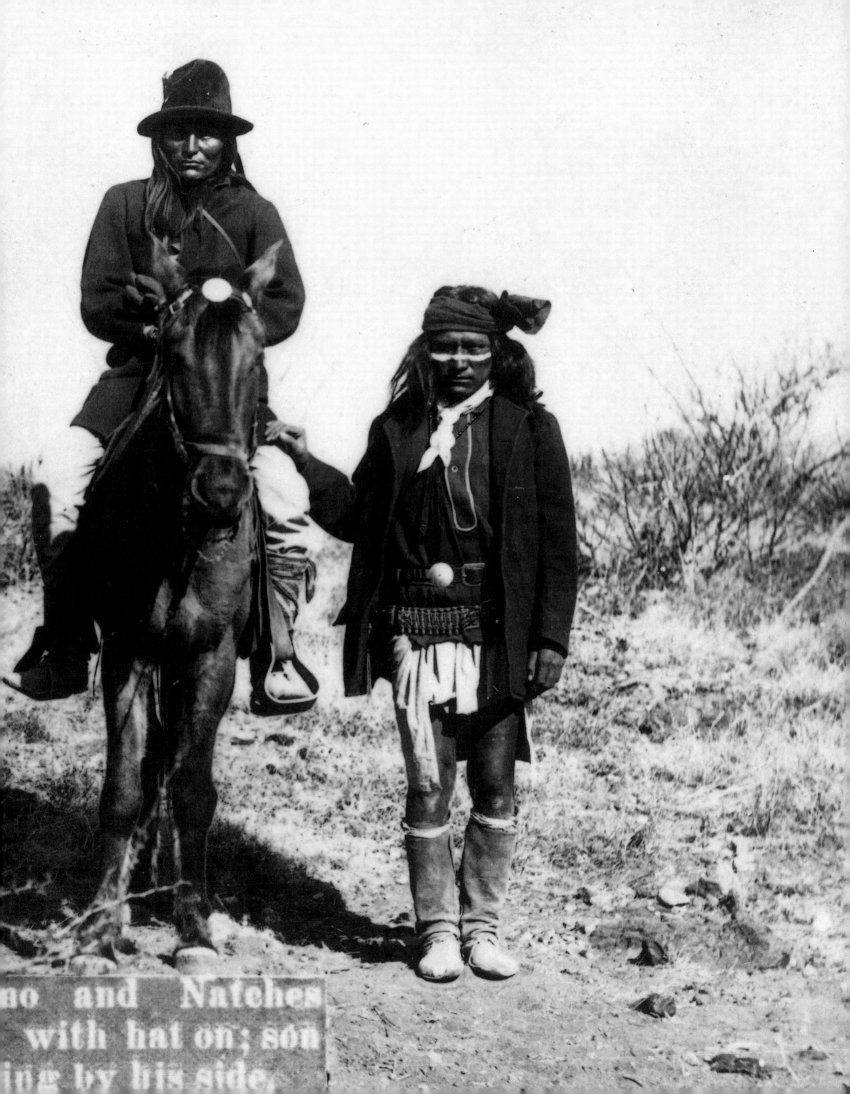

no and Natches
with hat on; son
ng by his side.

Formal ceremonies, such as a pipe ceremony or a Sun dance unite the tribe as they all pray together. Living for thousands of years within this religious structure makes the people holy and provides strength, knowledge and confidence.

It was a good life. The air and water were clear and sweet and the people learned to live in a balance with nature and the One Above. And they lived this way together for thousands of years.

INVADERS ARRIVE

The harmony was disrupted in 1492, when a foreign power landed on our shores. The foreigners sailed from a land that placed the highest value on wealth; everything else was secondary. Once on these shores they subdued the local Native people and began to seek riches. They quickly realised that the Native people were obstacles to their advancement to fulfil their manifest destiny and the people had to be removed one way or another. Those that were not killed by the new foreigners and the new diseases for which they had no immunity, were removed westward so the newcomers could take the Native land. Some reasoned they should be moved far away for their own good.

TREATIES

Treaties were first negotiated between the tribes and England, then the USA, promising 'the utmost good faith' and peace while they defined the Indian land holdings. But as soon as the Treaties were made the foreigners broke them and the tribes were removed westward. The missionaries campaigned to remove the Native traditions from the People replacing them with Christianity. The Indian people were under siege. In 1492 their population in the contiguous USA has been estimated at over five million; by early 1900 it had fallen to a low of 250,000. They were called the vanishing race.

The newcomers soon realised that it was too expensive to kill all of the Indian people so they reverted to removing them. This removal came in two broad categories: first, removal from their ancient land to make room for the settlers; second, removal from their culture and practised religion, so they could become Christians and assimilate into the larger culture.

PHYSICAL REMOVAL

In 1830, President Jackson signed the official Indian Removal Act. The Aniyunwiya [Cherokee] Indian Tribe and their leader John Ross fought the Act within the American legal system and finally won it before the Supreme Court. Bowing to the political situation, Jackson ignored the decision and ordered the army to remove the tribe, along with the Seminoles, Chickasaws, Creeks and Choctaws. Before the Aniyunwiya removal was complete in 1838-9 approximately four thousand died in confinement or on the eight-hundred-mile trek to Oklahoma on the infamous Trail of Tears.

PLATES 18 AND 19

UNIDENTIFIED
PHOTOGRAPHER

Carrie Anderson, Annie Dawson and Sarah Walker on their arrival (left) at the Hampton Normal and Agricultural Institute (1878), and fourteen months after their arrival in 1880 (right)

Modern print from a negative in the collection of the National Anthropological Archives, Smithsonian Institute

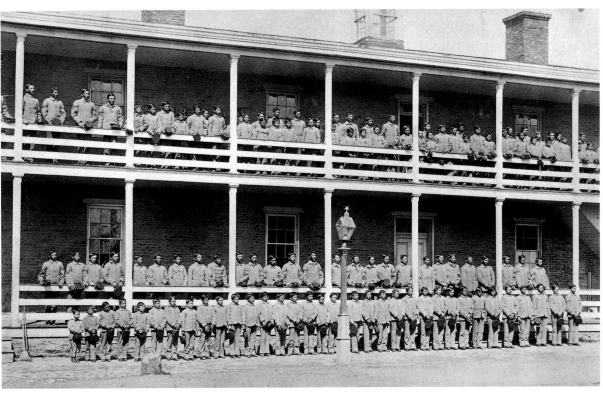

PLATE 20

JOHN NICHOLAS
CHOATE

Native boys, from sixteen different tribes, at the Carlisle Training School, 20 April 1880

Albumen print. National Anthropological Archives, Smithsonian Institute

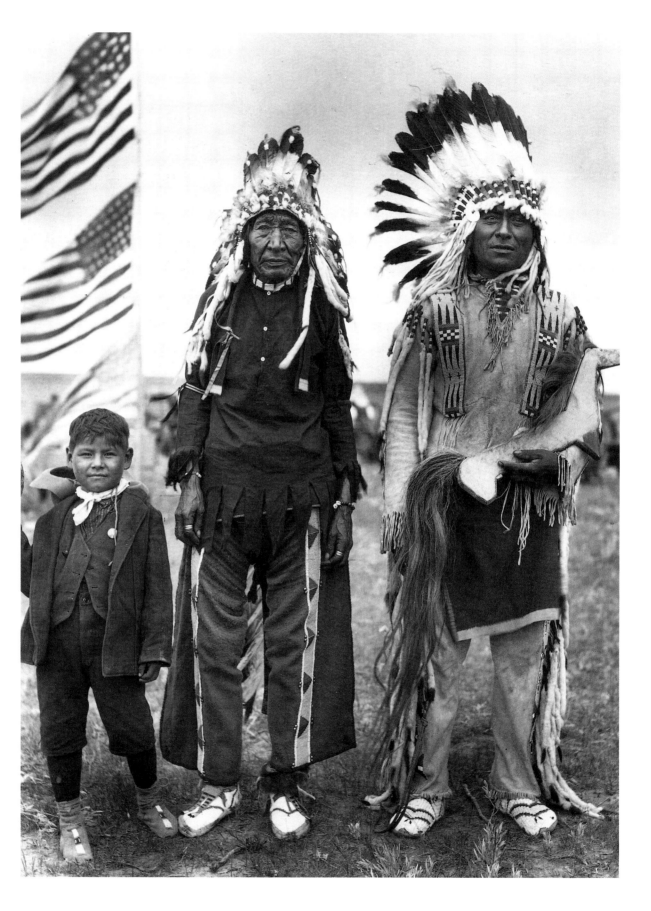

PLATE 21

SUMNER MATTESON

Three generations of males, July 4 celebrations, Fort Belknap Reservation, Montana, home to the Assiniboine Nakota and the A'ani [Gros Ventre], 1905-06

Modern print from a negative in the collection of the Milwaukee Public Museum

PATRIOT WARS

Like all good patriots, the Indian people rose up in arms resisting the invasion of their lands and the destruction of their families and way of life by the invaders. Battles raged from New England and Florida to the lava beds of northern California and the deserts of New Mexico. There were some victories, such as the Little Big Horn in Montana, in 1876, when the Sioux and Tististas [Cheyenne] wiped out General George Custer, but not enough. For many it ended on a bitter frozen day at Wounded Knee, South Dakota, when on 29 December 1890 the US Army massacred four hundred men, women and children of Chief Big Foot's band while they were protected under the white flag of truce (pl.25). The US Congress awarded eighteen Congressional Medals of Honour to the soldiers for what they did that day.

Other tribes soon followed. For example by 1907, the Tististas [Cheyenne], Ponca, Pawnee, Hinano'ei [Arapaho], Oto, Kansa, Wichita, Osage, Missouri, Iowa, Sac and Fox, Kickapoo, Miami, Missouri, Illinois, Peoria, Wyandot, Delaware, Shawnee, Potawatomi, Ottawa, Iroquois and many other tribes from as far away as New York and Florida found themselves removed to Oklahoma. Other tribes were removed to other places.

BOARDING SCHOOLS

A more insidious 'removal' movement, underway since the arrival of the Europeans, began to surge in the 1800s. Realising that the adult Indian people were usually set in their ways, the forces of 'Christianity and civilisation' began to take the Indian children from their parents and cultural environments. One of the earliest formal attempts in this direction was made in the Virginia colony by a directive of King James I. Later, in Virginia, children were specifically taken as hostages by the colonists and educated in the local colonial school for the purpose of forcing peace and friendship with the various frontier tribes. However, such practices were usually cooperative efforts between the government and the churches.

In the early 18th century boarding schools were brought into use. By this method the children could be totally removed from their families and heritage for extended periods of time, often for years.

The way the system worked was that an agreement between the boarding schools and the government was made and the school representatives came to the reservations and forced or coerced the tribes to let them take their children. Soon after arriving at the boarding schools the children were isolated from the forces that kept them together as Indian people for thousands of years. After their long hair was shorn, they were forced to don uniforms. Traditional foods were unavailable, they were forbidden to practice their spiritual ways and were harshly punished if they spoke their Native language. Horror stories of such experiences are still told on the reservation. The damage done to these children and their descendants can never be repaired.

The reasons for such a policy are many. At that time, sincere people believed the

Indian people could not survive in the current world. They believed the Indian people had to be removed out of harm's way, and taught the skills of the white man, such as farming. The two races met and could have lived together in peace but one side dominated over the other and paid little attention to the long-term damage they were inflicting on fellow human beings.

DAMAGE OF REMOVAL

A child removed from their family suffered serious psychological damage. When a child was alone and far from home, they were frightened and lonesome, even disoriented. With their unfamiliar short hair, forbidden to speak their language, dressed in strange foreign clothing, they had no family support, the familiar was replaced with chaos, fear and hate. The warmth and support of the family was superseded by the strict discipline of an institution. No nurturing – only obedience. Such a system was not only destructive when it was applied, but years later when the child grew into an adult they had no role models for parenting their own children and the damage continued generation after generation.

Boarding schools existed across the country, even on Indian reservations. The most famous was the Indian Industrial School at Carlisle, Pennsylvania (pl.20) and operated between 1879 and 1918. More than eight thousand Indian students from nearly every tribe in the country were at this school during this period: Indian graves are still there. Some of the children were only four years old. The famous Sac and Fox athlete Jim Thorpe is the most well known. Many famous chiefs had children at Carlisle and visited the school. The dignitaries included Chief Red Cloud, Spotted Tail, American Horse, and Luther Standing Bear of the Sioux, Geronimo of the N'de [Apache], Quanah Parker of the Comanches and many more. Government funding was eventually cut for many of the boarding schools so they began to close although some are still open to this day.

The American Indian people had been under siege from many quarters since the invasion and their population suffered like never before. Coincidentally, the professions of anthropologists, and other facets of the American scene were developing at the same time tragedy threatened to exterminate the tribes. For the most part, the anthropologists of this period practised their professions from museums and decided that although they could not save the Indian people they could preserve elements of their culture. Wave after wave of anthropologists descended upon Indian country recording stories, collecting ethnographic materials, establishing theories, writing books and becoming famous in the process. It was said that if you looked behind an Indian person you would often see an anthropologist. They still study us and the bones of our ancestors today.

In the first decade after 1900 the pressure began to ease. The Indian people were not seen as a threat anymore. Their numbers had been drastically lowered, they held title to only two per cent of what had been their land, their culture was nearly destroyed, they

were ashamed of being Indians, and their children were being 'civilised' in distant schools. Their sacred hoop was broken.

In survival there is victory and sensing this victory the Indian people somehow hung on, even in their poverty. The days of the buffalo Indian had come to an end: it now became the days of the children. The students came home and over time combined their newly learned skills and knowledge with the cultural traditions of the others who were fortunate enough to have stayed home. That combination is one that is successful even to this day.

History shows that in spite of the hundreds of years dedicated to de-Indianising the Indian people the policy was a dismal failure. When the initial American Indian keepers of the knowledge passed to the other world, their children, now adults, took the tribal knowledge they had learned and began to practice ceremonies in the new 20th century even when forbidden by federal law. When they became elders, they passed it on to their children, thus continuing the ancient circle of life.

Our history is continuing into the next millennium and beyond, and American Indians are still under siege from those who want to abrogate the treaties and remove our sovereign status. The farmers, ranchers and mining companies want our remaining water rights, acres of land and minerals. Every day the tribes do battle with these entities and the politicians who depend upon them for re-election.

Today Indian people can be found in most professions as they pursue their chosen way. Now at least they have a choice. In the past few decades, with our population increased to two million, the Indians' world has experienced a cultural renaissance. Indian students are enrolling in colleges like never before and vision questers fill our sacred buttes. The children are home and the hoop is healing.

PLATE 22

JAMES MOONEY

Ayyuini [Swimmer] also called Ayasta [Spoiler], an Aniyunwiya [Cherokee] 'medicine man.' Taken at Qualla Reservation, North Carolina, 1888

Albumen print. National Anthropological Archives, Smithsonian Institution

WHEN IS A PHOTOGRAPH WORTH A THOUSAND WORDS?

HULLEAH TSINHNAHJINNIE

STORIES ARE ALWAYS TOLD FROM ALL CORNERS OF THE WORLD: stories of creation, stories of the ethereal, stories of survival; grandmothers, grandfathers telling stories that were told to them by their grandmothers and grandfathers; aunties relating stories about brothers and sisters. We are all familiar with the warmth of stories cradling, surrounding, supporting new generations…

I remember several of the stories related to me by my mother, as she spoke I would visualise the scenes in my young mind, just like a television, just like a photograph.

Our family photographs from the past are very few, my mother's family (Seminole and Muskogee) had a collection of family photographs that perished in a house fire during the 1940s. I would occasionally overhear my mother and Aunt Marie lamenting over the loss. Although I know them from the beautifully woven stories, I have never viewed their likeness in a photograph. My mother's father passed on before I was born. I have never seen an image of my grandfather. But in my mind, my imagined photographs, the men are strong and handsome, the women strong and breathtaking, lustrous warm dark skin, lightening sharp witty eyes, with smiles that could carry one for days. A photographic album full of beautiful brown people, a photographic album of visual affirmation.

My father's family (Dine'), never had very many photographs, there was no furious fire to melt the negatives, there was a philosophy which was very protective. To outsiders I suppose the attitude would be interpreted as superstitious or even shy. Whatever the outsider preferred to believe, whatever sophisticated evaluation arrived at, the outsider would leave the reservation satisfied that stereotypes had been affirmed. They never interpreted the 'backwards attitude' of the subject or shyness as a statement about their presence. The superstition or shyness was not explained nor elaborated upon to strangers, because the 'photographer' would not have understood the nuances of privacy that the Dine' perceived.

My Seminole, Muskogee and Dine' relatives may have not shared the same views

about photography, but as American history would have it, they did endure the same government policies created to destroy the very fabric of Native culture. All three Nations experienced forced removal from ancestral homelands.

My Seminole and Muskogee relatives were forced to walk from Florida to Oklahoma, a forced march which began in the late 1830s and is known as the 'Trail of Tears'. My Dine' relatives also have a name for their forced removal 'The Long Walk' (1867). The forced marches were in violation of every basic human right imaginable.

The focus of my relatives was the reality of survival, keeping one's family alive. Time to contemplate Western philosophy or the invention of photography was, shall we say, limited. Because of the preoccupation with survival, Native people became the subject rather than the observer. The subject of judgemental images as viewed by the foreigner – images worth a thousand words. As long as they were in English.

At first when I began reading ethnographic images I would become extremely depressed and then recognition dawned. I was viewing the images as an observer, not as the observed. My analytical eye matured, I became suspicious of the awkward, self-appointed 'expert' narrative. From delegation photographers, expedition photographers and ethnographic researchers, I was very cognisant of methodologies that were of the 'objective' foreign eye. But even so flawed, these 19th century images were very significant in filling the void pages of my family album.

That was a beautiful day when the scales fell from my eyes and I first encountered photographic sovereignty. A beautiful day when I decided that I would take responsibility to reinterpret images of Native peoples. My mind was ready, primed with stories of resistance and resilience, stories of survival. My views of these images are aboriginally based, an indigenous perspective, not a scientific Godly order, but philosophically Native.

The understanding of indigenous continuance must be the understanding of indigenous religion. From healers to the message receivers, enduring the past and continuous assault by Christianity, Native religion and philosophy hid to survive and resurfaced at appropriate moments.

As I look into the eyes of Ayyuini [Swimmer] (pl.22), I recall a conversation I had on a hot humid Oklahoma August afternoon, I was photographing Wilma Mankiller, activist and former principal chief of the Oklahoma Aniyunwiya [Cherokees]. We were outside under the gracious shade of mature Black Jack trees, shades of green cooling the sweat on my face. I raised my head pausing from the view-finder to ask Wilma who Swimmer was. With locusts singing in the background to the rhythm of the heat, Wilma tilted her head to one side and looked at me thoughtfully, 'He was the source of some of the strongest Cherokee medicine. He was extremely powerful... How do you know of Swimmer?' Adjusting my lens I replied, 'I saw his photograph in a book of 19th century images of Native people, the caption read, Ayyuini [Swimmer], Cherokee, no other information just a sliver of a caption.' Wilma told me about Ayyuini, his understudies

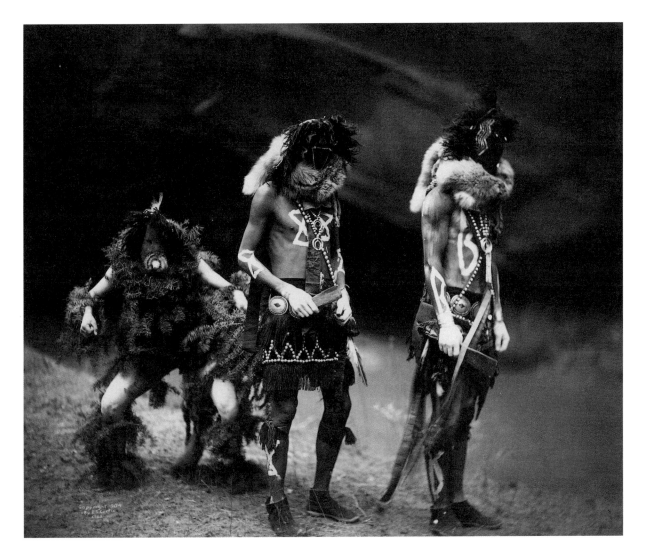

PLATE 23

EDWARD S CURTIS

'Navaho War Gods', (Diné)
1904

Matt brown toned silver
platinum print. The
Wellcome Institute Library,
London

and how no one since has equalled his presence and power. The arrival of information was appropriate, not only in location, but of oral tradition reaffirming the feeling that I had had when I looked into Ayyuini's eyes.

When I gaze upon the image of the Hinano'ei [Arapaho] Followers of the Ghost dance Religion (pl.24) and the image of the Yebichai (pl.23), I am filled with emotion. Though Mooney and Curtis thought they were imaging a vanishing race, I see the contrary, I see perseverance.

I immediately recognised the power of survival and my heart filled with emotion. There was a synthesising of my existence, the very reason of why this indigenous woman, typing on a laptop computer at the end of the 20th century existed. The persistence of that same religion lives within me ensuring Native survival, and thus refusing to surrender the soul. Native land may have to be taken by force or by invented written declarations, natural resources sucked up by an infantile America. No matter how many words written on a piece of paper declaring ownership of land, no matter the towns and metropolitans possessing foreign names, America will always be Native land.

Native people, photographed dramatically in appropriate savage attire, vanishing before one's eyes. Native people photographed in suits of assimilation tailored to the correct perspective of a progressive new world. Such schizophrenia that lamented the disappearing of the 'Indian' and celebrated images of 'Indians' accepting progress. That which could not be scrubbed with soap and water, dressed properly, beaten, or destined for extinction was and is the persistence of the indigenous soul, the persistence to exist, the strength of endurance to be faithful to Native intelligence, Native religion. As I look at these photographs of religion, I think of the ceremonies that take place today, on the reservation, in the cities. I think of those chosen to carry responsibility and those who step forward to take responsibility: the singers who carry the songs, those who know the relationship of plants to people, Native-rights lawyers, activists, philosophers, writers, artists, single mothers, aunts, grandparents, individuals who have accepted the responsibility of continuance. There is no doubt in my mind that the people imaged in these photographs are aware of the integral link they have to today's existence of Native religion. I am also reminded that times have not changed much, the assault continues, in ways that aren't as recognisable as in the past, but tactics that are just as deadly. The over romanticising and simplification of Native existence were two of the greatest assaults on Native existence and continue to be.

I am quite aware this is not a new story, it is a story that has been studied and repeated. Unknown to many, the methodology of the US planned genocide of Native people was studied and emulated.

This story began in a June evening late in 1990 in upstate New York, Haudensonee land, I was in residency at The Center for Conceptual Photography, Buffalo, New York, when Jolene Rickard invited me to visit her reservation. I was given the grand tour, in the evening I rested at her parents' house while Jolene was out on errands. Jolene's

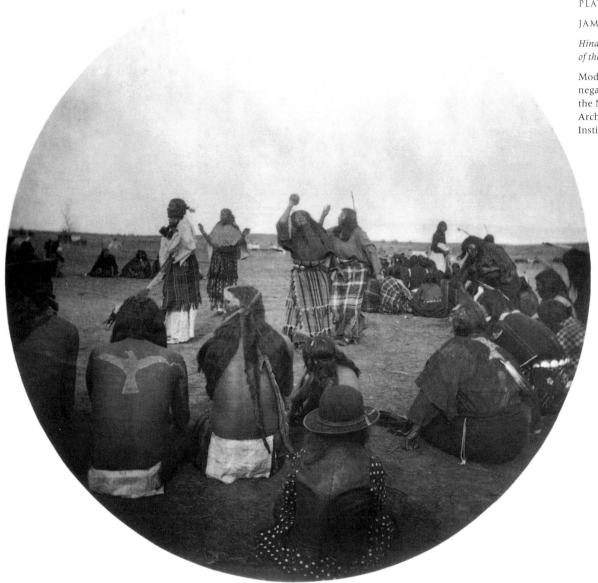

PLATE 25

GEORGE TRAGER

Big Foot [Minneconjou Lakota] lying dead in the snow at Wounded Knee, South Dakota, January 1891

Modern print from a negative in the collection of the National Anthropological Archives, Smithsonian Institution

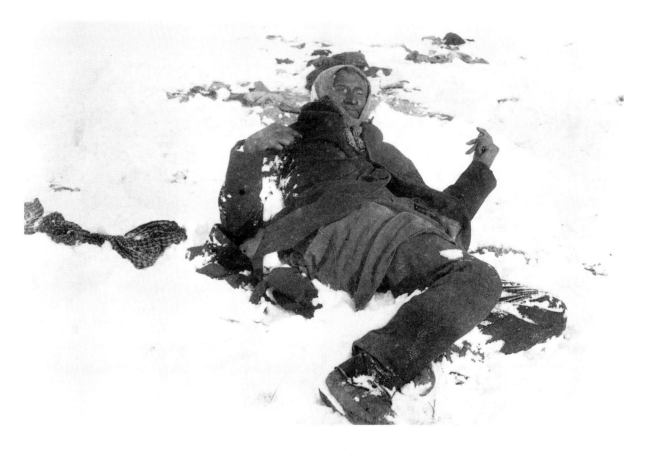

father and I were sitting in webbed lawn chairs sipping ice tea, the scent of citronella candles wafting in the air. Mr Rickard was sharing Tuscarora history. He asked if I knew of 'Old Man Clinton', I replied 'No'. The crickets seemed to soften their voices as Mr Rickard began telling me about Clinton Rickard, the stories were incredible, one was particularly haunting.

In the early 1930s, a German investigation team arrived at the Tuscarora Nation and sought out Clinton Rickard, they wanted information about the genocidal practices of the USA, past and present. Clinton Rickard was an authority on Native American history and law. The investigation team asked questions and took notes, they returned a second day full of questions and notebooks. As I listened to this story my soul shivered, Jolene's father was giving me a gift, a story. The Tuscarora Nation was not the only Nation visited by investigation teams. I related this story to a friend involved with the Jewish museum in San Francisco, she then told the people at the museum, they were sceptical, and then another said that they had heard of such a visitation on the Shoshone reservation. This story has yet to evolve as 'hard evidence' to the doubters, for me this story need not be in print form for it to be true, the oral transference of information that summer evening in Haundensonee Territory will always be more real than words in a book.

When oral history coincides with photographic evidence the impact can be disturbing. The photographic evidence of US genocidal practices is not extensive (if there is no evidence of genocide then there was no genocide). But the few photographs available are poignant. The images of the massacre at Wounded Knee, the bodies of Sioux people stacked on a wagon for a mass burial and the photograph of Big Foot, frozen in death (pl.25).

I had a vivid dream of this photograph. In my dream I was an observer floating, I saw Big Foot as he is in the photograph, and my heart ached. I was about to mourn uncontrollably when in the scene walked a small child of about six-years old. She walked about the carnage, looking into the faces of those lying dead in the snow. She was searching for someone. Small moccasin footprints imprinted the snow as she walked over to Big Foot, looking into his face. She shakes his shoulders, takes his frozen hand into her small warm hand and helps him to his feet, he then brushes the snow off of his clothes. She waits patiently with her hand extended, he then takes her hand and they walk out of the photograph. This is the dream I recall when I look upon this image of supposed hopelessness.

The complexity of the subject being photographed never seems to be included in the thousand words. It seems the thousand words get reduced to a generic title, void of the subject's voice, especially in the case of the indigenous subject. What better photograph to illustrate this than the photograph taken in 1879 by John K. Hillers (pl.26). It's an innocent enough photograph. A documentation of the Zuni mission school run by Taylor Ealy (standing right). Miss Jennie Hammaker (standing left) was their teacher,

Overleaf:

PLATE 26

JOHN K HILLERS

Children in front of their school at Zuni Pueblo with their teacher, Jennie Hammaker and the man who ran the school, Taylor Ealy, 1879

Modern print from an negative in the collection of the National Anthropological Archives, Smithsonian Institution

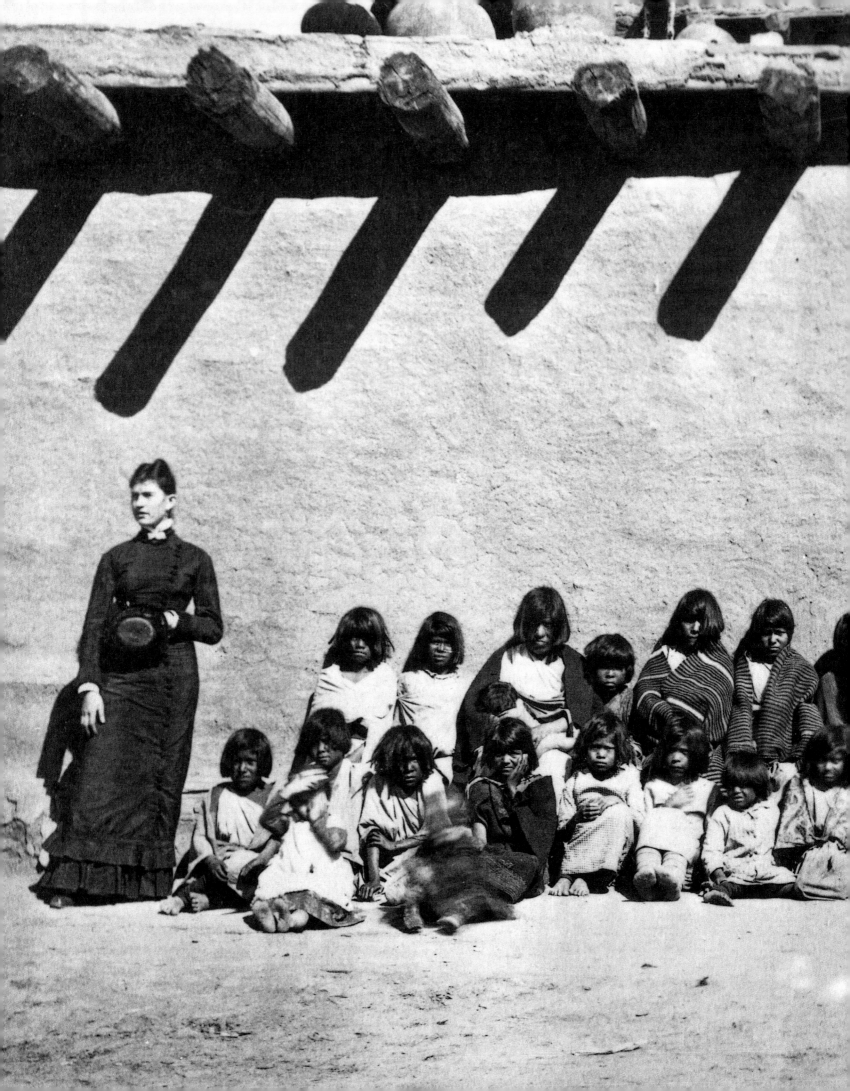

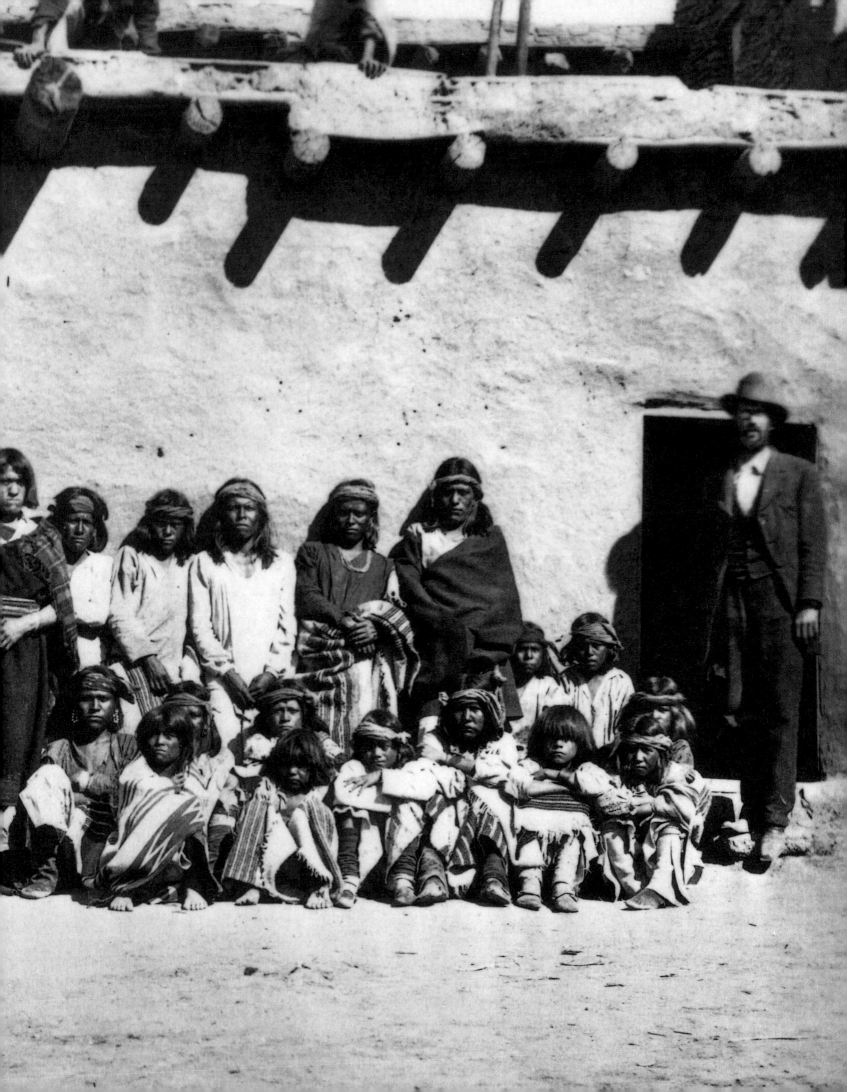

twenty-seven students, one baby, five Zuni men, one Zuni woman and two unfocused observers on the roof, no one is named except for the white people, nothing new. A very dry photograph.

Except for the Zuni woman standing behind the children, standing behind the children in a very maternal protective way. This woman is We'wha, a respected member of the community, involved in the ceremonies, an excellent artist and cultural ambassador for her people. We'wha travelled to Washington in 1886 to meet national leaders and the president. We'wha influenced whites and Native people alike, an incredible life. This beautiful woman was a man.

We'wha was born into this world a male, lived her life as a woman and then departed this world as a man (1896). This photograph is a perfect example of those complexities that cannot be reduced to a three-sentence caption.

In today's politically correct language We'wha would be referred to as gay, but even that is not correct, 'gay' is a foreign, alienating word. The anthropologist would label We'wha berdache whereas contemporary Native gay and lesbians prefer the self-described title of two-spirited society.

The history of the two-spirited society is very limited due to assimilation, Christianity and the need to survive. As written by Will Roscoe in The Zuni Man Woman: 'The abandonment of the dress accrued throughout Native North America. Persons learned of an Isleta berdache in the 1930s who had adopted men's clothes and another at San Felipe who wore men's clothing at his job in Albuquerque and women's clothing while in his pueblo. Among the Dine´ [Navajo], most berdaches stopped cross-dressing in the early 20th century, and several observers have cited the impact of white ridicule... In some cases, cross-dressing and gender mixing were actively suppressed by Indian agents in (or their suppression was contemplated, as in the case of Pueblo agents in the 1890s)... Of course berdaches were not alone in abandoning traditional clothing. Indians who wore Native clothing in the white world – male or female or berdache - were often ridiculed. Eventually, all Indians made compromises in how they dressed, at least in the white setting.'

Similar to the survival tactics of indigenous religion, the two-spirited society survived by becoming invisible. Being invisible by no means connotes defeat. Being invisible signifies the condition of the current political atmosphere. The two-spirited society faced a dilemma much like that of Native religion: conform to the specifics of assimilation or go underground.

Similar to missionaries knocking on the doors of Native homes, presenting the proper road to heaven, so approaches the gay and lesbian community spouting polemic political agendas defining a proper existence, a missionary approach that does not include indigenous philosophy, much less historical or cultural perspective. One must even be aware of the complexities of the self-described title 'two-spirited society' a definition, a contemporary definition in English, when there exist proper titles in

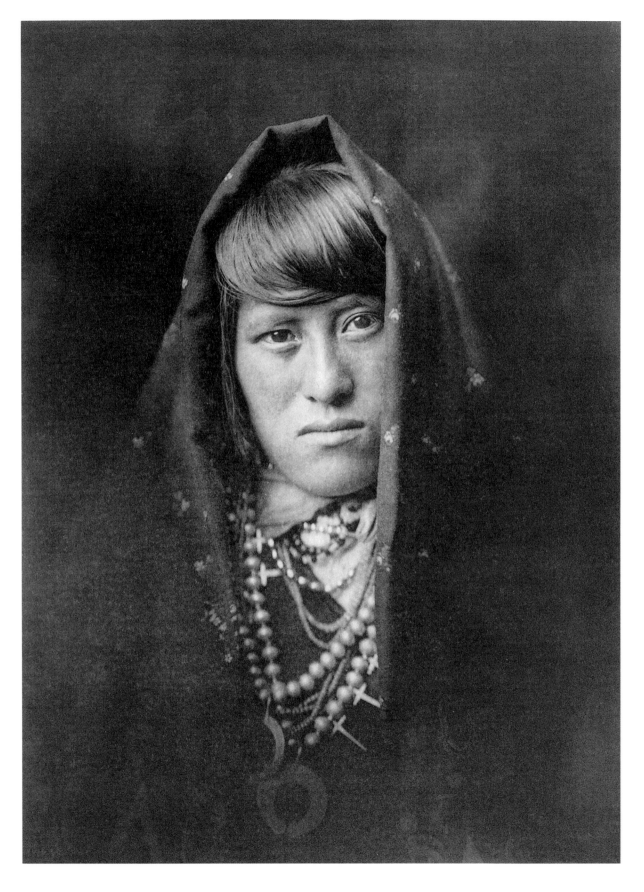

PLATE 27

EDWARD S CURTIS

'An Acoma Woman', 1904

Photogravure from the folio accompanying Vol. XVI *The North American Indian*, published 1926. Guildhall Library, Corporation of London

PLATE 28

JENNIE ROSS COBB.
ANIYUNWIYA
[CHEROKEE]

*'When the train came to
Tahleguoh' 1902. Ozark and
Cherokee Central Railroad,
Fayetteville to Okmulgee.'*

Modern print from a
negative in the collection of
the Archives and
Manuscripts Division of the
Oklahoma Historical Society

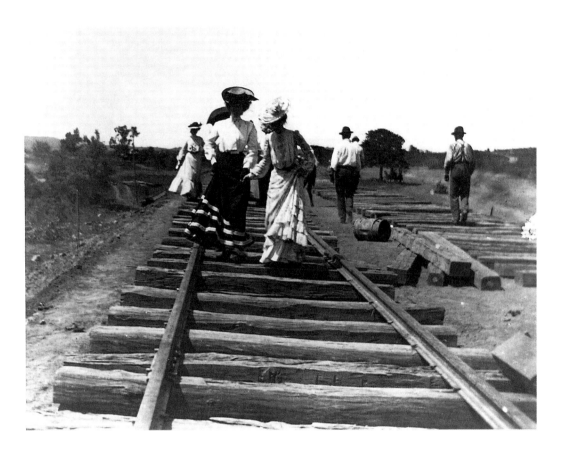

PLATE 29

JENNIE ROSS COBB.
ANIYUNWIYA.
[CHEROKEE]

*'Students strolling along a
boardwalk that led from the
Cherokee Seminary for women
into Tahleguoh, I.T.'
c. 1900-1901*

Modern print from a
negative in the collection of
the Archives and
Manuscripts Division of the
Oklahoma Historical Society

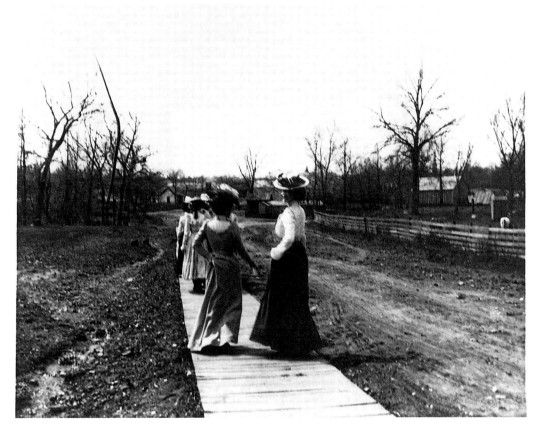

several aboriginal languages. Surviving titles which were not alienating nor judgemental, words describing one's position in community, words before contact with Christians or anthropologists. In the Zuni language We'wha was Ihamana.

When is a photograph worth a thousand words? When photographs were occupied with 'a thousand words' of text often the 'official' language would fall short and many times completely miss the point.

Aboriginal beauty: Curtis photographed a beautiful Acoma Pueblo woman (pl.27) staring into the lens, it is an intense moment, not exactly an endearing stare. Curtis was the voyeur photographer aware of the physical. What of her mind? Her thoughts of yesterday, today and tomorrow? I can relate to the energy which she emits. It reminds me of the summers when my father, a painter, would travel to Monument Valley or Canyon de Chelly to paint the landscape and sell the paintings to the tourists who were watching him paint. My brother, sister and I would play nearby, climbing the red rocks, playing in the sand. The tourists would call us over and take our picture, sometimes giving us a quarter, the look I perfected was the look that the Acoma woman is giving Curtis, 'take your photograph and...' I like this image – perhaps I am projecting, but isn't this what it's all about ?

The 19th century photographer I believe truly imaged Native women with love, and a humanising eye is Jennie Ross Cobb (Aniyunwiya). Photographs of Native women at the Aniyunwiya [Cherokee] women's seminary (pl.29), images of Native women living in the contemporary, relaxed poses, smiling to a friend. Photographs by a Native woman photographing Native women at the end of the 19th century, images Curtis, Vroman, Hillers and the many others could not even begin to emulate, when the eye of the beholder possesses love for the beheld.

Images of the early non-Native photographers documenting Native people will always be interesting but of more interest to me is the aboriginal perspective, the aboriginal photographer. The 'discovery' of early Native photographers is exciting, there are more – I can sense them. They also know when to surface.

Several aspects of Native beauty are resurfacing, the photograph of Johnny Kit Elswa (Haida Gwaii), by Ensign E. P. Niblack, 1886, with the Bear clan inscribed upon his chest and the dog fish permanently on his arms (pl.30). Aboriginal tattoo – the brazen illustration of identity. Tattoos went under the skin to survive, encoded beneath the skin, programmed to resurface when the time is right this is also how I perceive the art of aboriginal tattoo, latent images.

I have been considering tattoos for years. The Muskogee, my mother's people adorned themselves with tattoos to signify status of power both spiritually and socially. From Atearoa to Florida there was a submergence of moko, tattoo. Today there is a healthy resurfacing.

I am in the process of researching and receiving information. Research as in the Western academic sense, scrutinising, investigating, collating assembled notes from

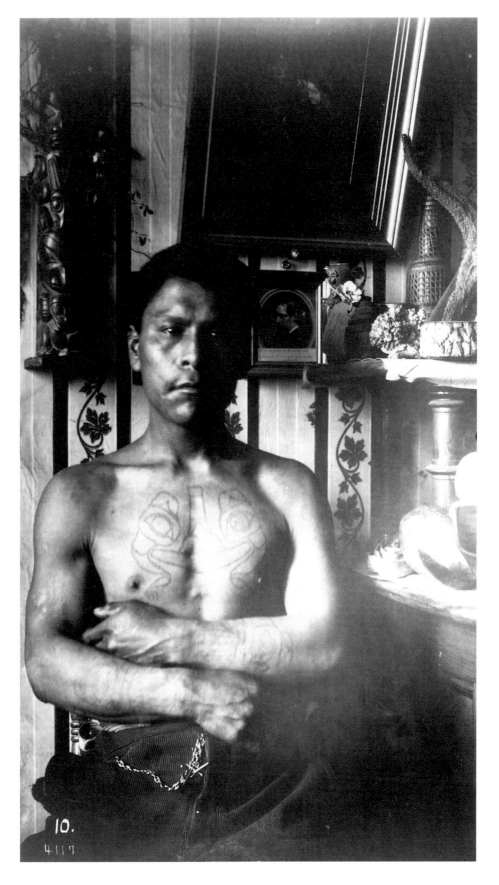

PLATE 30

E P NIBLACK

Johnny Kit Elswa, a Haida Gwaii from Skidegate Village, Queen Charlotte Islands, British Columbia (see pl.45). Taken at the home in Washington Territory of the ethnologist Judge G Swan, 4 December 1886

Albumen print. National Anthropological Archives, Smithsonian Institution

museums, ethnological reports, etching, observances from those who were sincerely curious and yet simultaneously whose preconceived assumptions prepare the climate for the submergence of tattoo.

Receiving information via the aboriginal internal world, information by dreams, ethereal coincidences and the very important oral tradition of the aboriginal people around the world. The re-emergence of aboriginal traditions, the wave of rebirth, people surviving, harvest dances being danced and songs returning in dreams... information resurfacing.

When I begin to tell my stories to my many nieces and nephews, I will first create in their young minds, photographic albums... where the men are strong and handsome the women strong and breathtaking, lustrous warm dark skin, lightening sharp witty eyes, with smiles that could carry one for days. A photographic album full of beautiful brown people, a photographic album of visual affirmation.

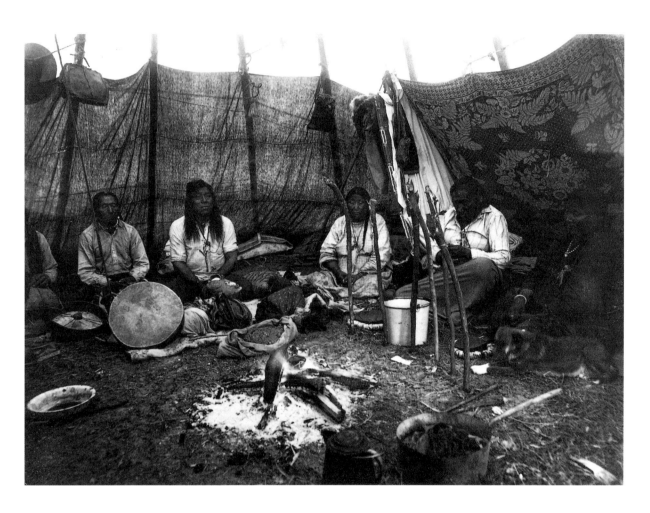

THE OCCUPATION OF INDIGENOUS SPACE AS 'PHOTOGRAPH'

JOLENE RICKARD

The historic photographs in this exhibition are markers that punctuate the loss of Native land from Native stewardship. The photograph became a basis for understanding the delicate web of ideas that were squandered in this process. Although there are numerous ideas one can develop concerning 'land', I am limiting myself to two discussions that take into consideration the formal properties of the photograph. What is the US government's relationship to Native Nations concerning land rights and how do Native people philosophically construct their relationship to land.

The use of photography and the colonisation of Indigenous North America form an historic intersection that is focused on a specific period in the contact narrative. After repeated viewing the images struck me as fragments in a once seamless whole. The absence, or what is not shown is of equal interest. What can we take from these pieces? I approached these images understanding that they document a very specific history but have a wider impact. They represent what is Native America to most viewers. It is a delicate matter to present such a seductive body of images and not to reinforce the already very established stereotypes of Native Americans.[1]

That is why it is important to understand the historic context of these images. They do not represent all of Indigenous America. Nor can that history be unravelled through the photograph alone. The initial impact of contact was documented by European artists' hands through drawings, paintings and prints. There are many other factors which contribute to the emblematic nature of these images. Most significant is the role the actual photograph had to play. It was a new phenomenon in the mid-1800s that was thought to capture the 'truth'. The constructed space of the photograph had yet to be understood. Photography became prominent at precisely the same moment that the American government was staging the take-over of the great Plains. The combination of these layered events created a powerful imaginary image in the mind of most Americans about the Indian. Similar to the role of the lithograph in earlier centuries, the European and American imagination was satisfied through these photographs by the osculating

construction of the Indian as one who is 'savage' to one who is 'vanished'. The American desire to occupy all of the land 'from sea to shining sea' was the overall goal in the manipulation of representation of Indian people.

The photograph is the 19th century version of the ongoing documentation of competing world-views in America. One has to take into account that the purpose of many of these images is to witness an 'unoccupied' land. The erasure of the Indian was juxtaposed against a backdrop of advancing western 'civilisation'.[2]

The images in the 19th century portion of this exhibition with a few exceptions represent the Plains, Southwest and Northwest Native Nations of the Americas. Even using the geographic terminology of the 'Plains' or the 'Southwest' continues to adopt unreflectively a western perspective. It is more revealing to refer to these communities as nations; the Hopi, Lakota and so forth. Acknowledgement that individual tribal groups have both cultural and political autonomy restructures colonial boundaries.

The history of the eastern Native Nations is more difficult to recover from this photographic grouping. The absence of a strong body of eastern images conceals the foundation treaty relationships between the United States and Native Nations that are repeatedly violated. According to legal historian Howard R. Berman, from 1600 to 1776, Europeans negotiated with Indian Nations under the same terms accorded to sovereign European nations. At the time of the American Revolution the United States inherited this well-established tradition and negotiated with Native Nations as sovereign.[3]

Obviously, this precedent broke down and by the time of these early images the race was on to occupy and own Indian land. The 19th century represents perhaps the greatest loss of Native rights in US and Native relations. According to Ward Chruchill in *The State of Native America*, 1992, 'together with an assortment of unilateral executive and congressional actions, these wars and negotiated arrangements resulted by the early 20th century in Native America being constricted to about 2.5 per cent of its original two billion acre land base within the forty-eight contiguous states of the union.'[4]

The notion of a 'modern' Nation/State imposing its will over ancient societies is at the base of this discussion. Clearly, the photograph was a tool of the apparatus of the 'State'. Photography of Native subjects in the 19th century was intricately tied to the desire of the US government to undermine Native authority and autonomy. Lakota scholar, Vine Deloria, Jr. has examined the 19th century as it applies to the Constitution of the United States. He points out that, 'at the time that the Constitution was adopted, it was accepted law that European nations discovering new and uninhabited lands in the Western Hemisphere could lay claim to the legal title to these lands in defiance of whatever title was asserted by the original inhabitants of the New World'.[5] This accounts for the assault against the inherent Native right to eminent domain.

The conflict in understanding Native land rights is complicated by the fact that the United States acknowledged the sovereignty of the Iroquois or Haudenosaunee people in 1794 with the Treaty of Canandaguia. This acknowledgement has formed the legal

basis upon which contemporary Native Nations are asserting their right to autonomy. Due to 'soft' interpretation of Native rights in the US legal system, the negotiation of sovereignty has become a series of tense actions on the part of Native people. Lakota scholar, Vine Deloria, Jr. expresses the contemporary interpretation of this relationship as being a 'Nation within a Nation'.[6] Native Nations have a 'trust' relationship with the executive branch of the Federal government which he characterises as 'quasi-sovereign'. Quasi-sovereign because Native Nations are restricted from operating financially autonomously from the US government. The most recent example is that Native Nations that want to operate gaming within their territories must negotiate a 'compact' with the state and federal governments.[7] Financial independence for Native Nations has become a legal cat-and-mouse game between the Federal, State and Native governments. The US legal system has the advantage in the 'interpretation' of past rulings.

Expectedly, legal historian Curtis G. Berkley points out that, 'the federal government's assertion of unrestricted authority over Indian nations, particularly their land and governments, rests on a flimsy legal foundation'.[8]

It is accepted by most Native people that there will be little justice by the US legal system. Today, within Native Nations, some think of themselves not as citizens of the United States, but rather as a member of their 'tribal' Nation. How this gets interpreted within the US legal system is of course a grey area. The US government asserts a 'trust' relationship with Native people and monitors blood quantum and tribal 'enrolment'. These two factors have financial implications and are taken very seriously. If you have less than one quarter Indian blood you are not available for federally granted education programmes. If you are not given an 'enrolment' number at birth you are not technically recognised as a Native person by the US government. Some Native Nations do not adhere to these measurements and have their own criteria. These demarcations have formed bitter battle lines in our communities today.

The photograph had a key role to play. The circulation of Native images as stereographs and postcards satisfied 19th century angst over the loss of the natural world in the face of progress. The symbol of progress in America in the 19th century was the train. Indian control of the great Plains impeded the necessary expansion of the railroad. The photographers that photographed Indian communities in the 19th century knew that the Indian stood in the way of the goals of the government. The alternative vision of Native people is only hinted at in these photographs.

Some photographers saw their work as a form of salvage, documenting the vanishing race.[9] The photographers of the 19th century for the most part visualised the occupation of Native homelands. It is understood that the overt goal of the survey campaigns was to access the conditions of Native lands for US government insurgence. Many of these photographs are colonial markers that inscribed the land as vacant and ready for American occupation.

The formal properties of the photograph have the power to influence how history is remembered. I am interested less in the obvious construction of the Indian as savage and more in the unobtrusive subject. The survey expedition images are coded in a propaganda that reinforces the uncivilised to civilising process with before-and-after comparisons. The most obvious examples are the boarding school internment photographs. The children were lined up upon entry and photographed as a document of the 'primitive' (pl.32a). After their hair was cut and uniforms were placed on them another shot was taken to demonstrate the 'civilising' process (pl.32b). These images represented progress to the American public. They signified the end of 'Indian' wars and evoked security. They are not overtly photographs of the 'land' but are documents of the systematic removal of Indians from their homelands. The sense of institutional confinement is not only represented in the obvious physical changes of the children but also in the framing of the image. The rigid bodies of the Indian children occupy about ninety per cent of the visual frame with scant detail about their 'environment'. Captain R. H. Pratt, director of the notorious boarding school, Carlisle Indian School of Pennsylvania, believed that formal education could help 'vanquished Indian warriors'.[10]

The delegation images of Native leaders (pl.50-65) attempting to appeal to the federal government operate in a parallel fashion with a slight twist. The 'othering' of Native leaders is underscored in the delegation portraits. Native leaders self-consciously evoked the assistance of their heritage as a strategy for empowerment. Many leaders that were photographed in full traditional regalia had travelled to Washington, DC in clothing consistent with norms of that period. The leaders distinguished themselves by consciously adopting the dress of their ancestors. Unfortunately, the American public interpreted this use of traditions as merely a form of 'exotica'. The real message of an alternative world-view was lost on a people Anglo-centrically focused. The static portraits of individual Native leaders and delegations are documents of their understanding of themselves as sovereign Nations.

The boarding school and delegation images are a refinement on concurrent, more subtle images of impending occupation. This was accomplished by numerous ethnographic surveillances of 'naked' or partially naked bodies on the land. The photographs from the J. W. Powell and A.H. Thompson US Topographical and Geological Survey of the Colorado River of the West in 1871-79 are consistent with this observation (pl.33).

This photography was congruous with a set of anticipated tropes representing the colonised other in the 19th century. In particular, an image of a bare-breasted woman carrying a basket while posing with another basket illustrated the outsider's bias. The desire to 'measure' the body occurs repeatedly along with body activities like breast-feeding, basket-making, hide-scraping and other 'cultural' activities. Her gaze is averted but the exposure of skin confirmed Native 'primitiveness' to the Western mind. Instead, a completely different set of cultural values concerning sexuality is witnessed here. The

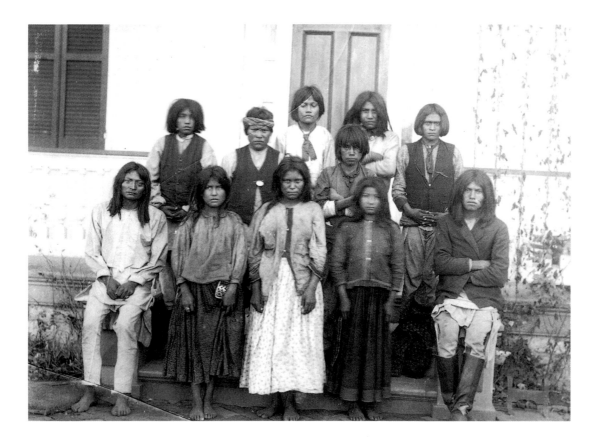

PLATE 32A

JOHN NICHOLAS
CHOATE

*Chiricahua Apaches as they
arrived at the Carlisle School
from Fort Marion, Florida, 4
November 1886*

Albumen print. National
Anthropological Archives,
Smithsonian Institution

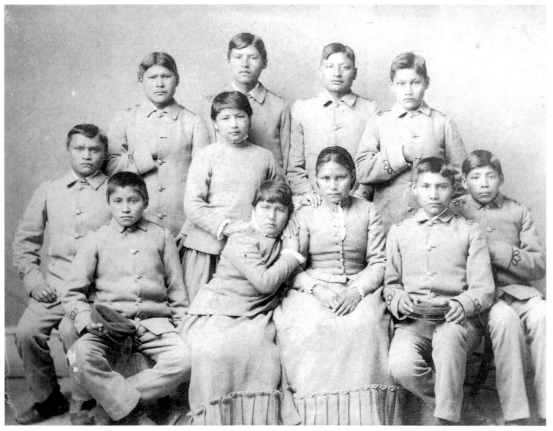

PLATE 32B

JOHN NICHOLAS
CHOATE

*The same group of Chiricahua
Apaches two months after
arriving at the Carlisle School*

Albumen print. National
Anthropological Archives,
Smithsonian Institution

PLATE 33

JOHN K HILLERS

Wu-na´v-ai 'Gathering Seeds'
No.53 from the series 'Indians
of the Colorado Valley.' Taken
on the Department of the
Interior funded Geological
survey of the Rocky Mountain
Region, led by John Wesley
Powell (The Powell Survey
1871-79)

Albumen stereograph.
National Anthropological
Archives, Smithsonian
Institution

body occupied less than a third of the image area and was consistently framed or integrated into the landscape. The posed nature of many of these photographs does not help to reveal the significant inter-relationship between the woman and the basket. The conical shape of the breast is magnified in the placement of the larger basket on the ground. This confuses the actual relationship of her culture to the basket.

The notion of progress or technological advancement remains a tenet of Western thought. Therefore, the desire to locate the state of technological development of a people was often an unacknowledged goal of many photographers. An indirect yet equally effective way to establish the technological acumen of Native people was to document their production or 'level of technology'. The basket is handmade from the materials of the earth relegating it to a 'low' in contrast to 'high' mechanistic form of technology. Ironically, the basket is a significant innovation and invention of human ingenuity. The basket actually had multiple roles. The placement of the strap on the larger basket meant it was used to carry things. The strap would have been placed on the forehead and the counter weight of the basket and its contents would have kept the basket in place. So the basket actually had a very different relationship to the body than that which is suggested.

Native people over millennia had developed an intimate knowledge of their relationship to their environment. Across the Americas a philosophical approach to shelter this knowledge was to develop a world-view where everything was understood as being 'alive'. Every living thing, including rocks, the soil, plants, trees, animals and insects were recognised as having what some refer to as a 'spirit'. Another way to understand the wisdom of this perspective without categorising Native people as 'animists' is to consider the result of creating a sustainable community. The basket in this case is just a hint at the complex web of ideas in play in this culture. The basket is the end result of thousands of years of 'field' research. The basket is evidence of the generational passage of knowledge. It is confirmation of a community of people living cooperatively. A people who actually knew which fibres could hold water, had strength and could sustain the weather. This intimate knowledge of every blade of grass in their world is magnified by knowing which plant had medicinal properties. The way Native people remembered this breadth of knowledge was to 'characterise' it by its effect on the human body. In a sense, an energy measurement was accessed on everything in their environment and named accordingly.

Another aspect of this genre of photograph is the implied framing of the individual. Native communities were successful because of the cooperative nature of their social organisation. The creation of the individual as implied through the portrait is another subtle yet subversive act. Most Native people constructed their identities through their association with their clan families or a similar 'society'. In comparison, photographic 'groupings' mostly result from ceremony, which as something 'exotic' becomes the subject of fetishist observation.

Therefore, this benign photograph of a woman standing bare breasted in a tangle of vines with two baskets is a powerful surveillance of impending occupation. This overt association of the basket and breast equate Native people to being part of the natural world or the past, not the modern, technological world of the future. The Indian was conflated into the landscape just like grass is woven into a basket. The Indian was constructed as part of the 'natural' landscape but not as owner. The 'naked' breast was a taboo for Western society. The breast in this case operates simultaneously as part of the ongoing construction of primitiveness and availability. The availability is less about access to the woman's body, than it is about what the Native woman's body has consistently represented in the Americas, land. Therefore, what is really being suggested is access to the land.

In this and other photographs, the framing of an individual disguised the sense of community, interpreted after contact as Nation. The implied erasure of 'Nation' was read by the American public as vacant or scarcely occupied land. It was read by the military as a people easily defeated. The American public did not comprehend that they were interfering with millennial knowledge that could have proven very useful in relationship to the technological paradigm privileged by the West. The only concern was unbridled consumption of Native land.

Therefore, the colonisation of Native people in the 19th century, I would argue, was significantly influenced by the photographic record. It is easier to defeat one person rather than an entire Nation. It was believed that the Native people of the Americas had no significant knowledge that was worth 'capturing'. The resulting action of removing Native people from their land was played out in interment camps identified as 'forts', 'boarding schools' and finally 'reservations'. The West's ignorance about the interwoven knowledge between Native people and their homelands is a debt paid every day by humanity. The desecration of thousands of millennial eco-human systems is occurring in a blink of 508 years in the Americas. The witness in the 19th century was the photograph, today it is the video in places like the Brazilian jungle.

The early 20th century component of the exhibit represents a sprinkling of image-making that took place in Native communities but by no means is this a complete view. The work of Crow photographer Richard Throssel (1882-1933) provides a slightly different take on the Crow relationship to land. In his photographic work, Throssel was able to take advantage of the fact that, as an adopted Crow, he could bring into play his sustained observation of Crow life. The intent of the photographer does influence how the audience reads the image. *The Three Scouts* 1908 (pl.34) is of three of the six scouts who were with Custer at the Battle of Little Big Horn.[11] As Mardell Hogan Plainfeather reiterates in Throssel's biography 'the battle had not been a positive experience in their lives'.[12] Because of the attention the scouts received due to the prominence of the battle their personal relationships were compromised by petty jealousy.

PLATE 34

RICHARD THROSSEL
(CROW)

*'The Three Scouts' (Whiteman
Runs Him, Hairy Mocassin,
Goes Ahead) 1908*

Modern print. Richard
Throssel Collection
American Heritage Center
University of Wyoming

The image has an aura of foreboding. The terse picture of the men and horses with guns pointing to the sky evokes a menacing yet powerful presence. The chalk-white tombstones are made even more dramatic by the dark prairie landscape. The date on this image is 1908, just ninety years ago. Armed Indians on the Plains in the 20th century is a reminder at how recent all of this was for Native people. This image is about defending the land. At the same time it is about defending the burial place of their ancestors. It also suggests the inability of Native people to band together against a common enemy.

The bright sky behind the scouts, their frozen stance among the burial ground and their gaze into infinity imply continuity. At first glance, a radical political image, and yet further reflection unearths the connection between the sense of place, the resting place of the ancestors and the unknown future. The historic information about this photograph reveals it to be more than a symbol of the connection between Native past and future. It is also a very real document of the intertwined relationship with the 'West'. An illuminated sky presses down against a dark land marked by death and guns pointed upward. It is a fitting metaphor for the experience of Native people today.

Equally significant is that Throssel's work was relatively unknown. So this kind of reflective 'resistance' image did not have a large audience. A similar circumstance curtails the impact of the work of Kiowa photographer, Horace Poolaw, (1906-84).[13] During the period of time that Poolaw was most active, the United States continued to pressure Native people to assimilate. The photograph of *Trecil Poolaw Unap, Mountain View, OK* 1929 (pl.34b) represents active resistance in the 20th century. A young Kiowa woman leaning against a sign emphatically marked, 'Stop State Law'. Gone are the guns and ponies of the 19th century, now signs and 'legal' systems are the battlefield of Indian resistance. This sign calls for the US government to recognise its Nation-to-Nation obligation.

Less obvious but equally significant, is the modern, permed hair of the young woman. Her stance is a fluid almost sensuous pose. Her head is turned away from the camera but her eyes return the gaze. The shadow of the photographer touches the shadow of the young woman, forming an interesting connection.

But, the figure and sign become larger than that moment and represent the struggle of the 20th century for Native people. The position of the young Native women's floral covered body leaning against the signpost is provocative. A subtle recognition of woman as representative of the land for both Native and non-Native imaginations. In this case, the ownership of the space is reclaimed by the Native by patently rejecting the 'state'. The overt defiance of the sign is powerfully punctuated by the presence of the original holders of this 'place'. This image is another demonstration of the intricate tie between the US legal political space and the inherent right to land by Native people.

Due to the massive amount of material in this exhibition one is left with the sense that this is a 'complete' mapping of Indigenous America. The use of a single medium,

PLATE 34B

HORACE POOLAW

Trecil Poolaw Unap, Mountain View, Oklahoma, 1929

Silver gelatin print. Courtesy of the Horace Poolaw Photography Collection, Stanford University and the Poolaw family

like the photograph, is a modernist notion that is consistent with the way in which the philosophical 'West' organises information. How does this represent Native philosophies? Perhaps, only tangentially can insight be gleamed from these documents. In order to embrace a 360-degree perspective one could incorporate Lakota calendars and historic records like buffalo robes in dialogue with survey expedition and landscape photographs. Comanche ledger drawings could be juxtaposed against war and internment images. Oral histories of the descendants of the people of the Lakota, Paiute, Shoshone, Hopi, Pueblo and others could be playing against the backdrop of these images. By setting up these didactic dialogues it underscores the reality that Native people expressed their histories in multiple mediums.

Although not a Native photographer, Hiller's photograph of *San Juan Pueblo, New Mexico, 1880* (pl.34c) is simultaneously a document of the US government's assessment of the land and Tewa philosophy. The angle of the camera provides the audience with a view of the 'navel' of the pueblo. It also locates the pueblo in a much broader landscape upon which the Tewa have consciously located. The architectural organisation of the pueblo is aligned on an axis that is coordinated with the four sacred mountains. Hiller's intent to capture the landscape is compatible with the Tewa world-view. They organise their relationship to space, time and being in three dimensions or plateaux. The underworld, the middle world and the upperworld. Ironically, the angle of the photograph in a sense mirrors this organisation. The corn is on the closest or 'underworld' layer and represents the first mothers of all the Tewa, known as 'Blue Corn Woman, near to summer', or the 'Summer mother', and 'White Corn Maiden, near to ice', or the 'Winter mother'.[14] The 'middle layer' or actual pueblo is where the Tewa spend most of their life both physically and spiritually. The 'upper' layer is formed by the mountain plateau. These mountains represent the four sacred directions. It is believed that both life and death or the movement of the soul into the spirit realm takes place through these sacred sites. A US government land surveillance bears witness to the cosmological mapping of the Tewa world.

The corn has multiple positions in this piece. It is the agricultural backbone of civilisation in the Americas. The migration of corn in the Americas is the story of inter-hemispheric trade and sustainability. The corn has endured through the ages and is a symbol of knowledge. Corn represents the beginning of time for the Tewa. It is a seed that will be planted and which sustains both the body and the spirit. This photograph may be a document of colonisation but ultimately it is a witness to the owners of this place, the Tewa. If it was Hiller's intent to document this space as vacant, the presence of the Tewa prevails.

A single seed can feed an entire culture. The tobacco seed is that nourishment for most Indigenous peoples of the Americas. Some cultures, like the Iroquois, believe that the tobacco seed was a gift from the Creator, or the Grandfather to the people. It was instructed that our words could be heard by the Creator if they were sent on the

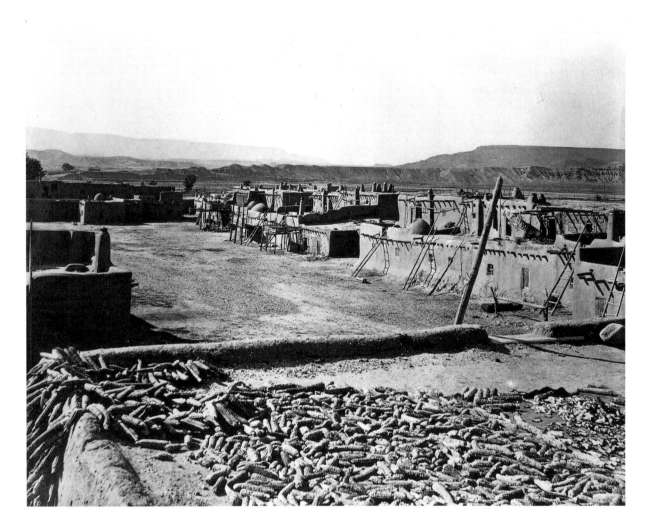

PLATE 34C

JOHN K HILLERS

San Juan Pueblo, New Mexico, 1880

Albumen print. National Anthropological Archives, Smithsonian Institution

smoke of the burning tobacco leaf. Throssel's photograph *Mixing the tobacco seed for planting* 1905-11 (pl.31), a documentation of the ceremony before planting the sacred seed, provides a glimpse into the importance of this plant in Crow cosmology. The Crow call it, bacu sua or 'the soaking of the seed'.[15] The ceremony is accompanied by individual songs and ends in a race to claim the best planting ground.

The photograph provides a rare and uncomfortable glimpse into this very powerful act. The tobacco is thought to provide protection. It is thought to be a very 'shy' plant that is very private. Throssel's access revealed this moment but not its secrets. To understand the power of this ceremony one would have to be a participant. Alas, the camera can only mediate the experience, it is not an actual experience. The Crow people gathered around the fire to soak their seeds are inside the camera's frame but conceptually beyond the grasp of most observers. The intimate space of the illuminous tipi masks the ideological divide between the imposing West and Indigenous America. The sticks thrust in the ground are called the fence and only members of the Tobacco Society can sit behind it.[16]

The sticks are a metaphor for the photograph and its relationship to Indigenous knowledge. The photograph stakes a frame or boundary around the subject. It is a demonstration of the West's propensity for categorisation. The photograph captures and unwittingly categorises organic systems. The photograph has seduced many into believing they can understand Native people based on this observation. 'Understanding' in the case of America means the right to occupy Native space. I am suggesting that the occupation, although catastrophic, was not complete.

The political and spiritual consciousness of First Nations and Native Americans in North America is often unacknowledged but clearly present. The hegemonic influence of America on the entire world is also felt in Native communities, but so is the resistance to it. Many Native Nations have taken their issues to a global forum. An early example is the 1924 appeal by the Iroquois to the League of Nations in Geneva, Switzerland, which began a process of creating international awareness of Indigenous rights. However, by not having a formal seat in the United Nations Indigenous people globally suffer. Although the United Nations declared the 1990s 'The Decade of Indigenous People' it did little to clarify what was meant by this claim. At the close of the decade many feel it has just been political window dressing to avoid the urgent discussion of the assault on Indigenous, Native, First Nations and Aboriginal people globally.

If one focuses too much on the counter narrative, the discussion is often undermined as being polemical. The mention of the conceptual foundation of multiple 'world-views' signals an uncomfortable binary. But uncomfortable for whom? Contemporary Native people live in multiple world-views simultaneously. It is not an easy integration and often there are jagged edges between the divide. The photograph acts like a piece of tape holding together fragments of experience within and between cultures. Unlocking the 'knowledge' documented in these photographs requires an awareness of other world-

views. Ironically, we continue to lock the knowledge held in these photographs into the existing framework of the West's hegemony. An empowering interpretation of these documents, beyond the anthropological, geographic survey and ethnocentric intent is what we can struggle to move towards.

The ongoing construction of Native people as victims needs to be counterbalanced with strategies that they have used to maintain their world-view. The images I have selected represent the strategies used to continue on the Native road; societal and environmental integration as represented by the woman with a basket and the Tewa Pueblo images, remembering our responsibility to the ancestors in the burial image, and the continuous assertion of our political rights as demonstrated in Poolaw's 'Stop State Law' photograph. Perhaps the most profound image in the selection is Throssel's *Mixing the tobacco seed for planting*. The photograph defined a border between Native and non-Native beliefs. The scratching sticks for planting formed a border between the sacred and profane.

The burning tobacco defines our mundane borders and opens the ears of the universe to our words. The time has come to open our minds to see the compression of multiple realities in these photographs.

NOTES

1 See Theresa Harlan, Message Carriers: Native American Photographic Messages VIEWS: The Journal of Photography in New England, Photographic Resource Center at Boston University, Boston, MA, Volume 13-4/14-1, Winter, 1993, p.3

2 See William H Truettner *The West as America: Reinterpreting Image of the Frontier 1820-1920* Smithsonian Institution Press, Washington, DC, 1991

3 Edited by Oren Lyons, John Mohawk, *Exile in the Land of the Free: Democracy, Indian Nations and the US Constitution*, Clear Light Publishing, Santa Fe, NM, 1992, p.11

4 Ward Churchill, essay 'The Earth is our Mother' in *The State of Native America: Genocide, Colonization and Resistance*, edited by Annette Jaimes, South End Press, Boston, MA, 1992

5 Vine Deloria Jr., *Exile in the Land of the Free: Democracy, Indian Nations and the US Constitution* Clear Light Publishing, Santa Fe, NM, 1992, p.283

6 Vine Deloria Jr. and Clifford Lytle *The Nation Within: The Past and Future of American Indian Sovereignty* Pantheon, NY p.19

7 Vine Deloria Jr., see discussion on 'Doctrine of Discovery', *Exile in the Land of the Free: Democracy, Indian Nations and the US Constitution*, Clear Light Publishing, Santa Fe, NM 1992, p.299

8 Vine Deloria Jr., *Exile in the Land of the Free: Democracy, Indian Nations and the US Constitution*, Clear Light Publishing, Santa Fe, NM 1992, p.190

9 See *The Vanishing Race and Other Illusions*, by Christopher Lyman, Smithsonian Institution Press, Washington, DC, 1982

10 Linda F Witmer, *The Indian Industrial School: Carlisle, Pennsylvania 1879-1918*, Plank's Suburban Press, Inc. Camp Hill, PA, 1993 p.xiv

11 See *Handbook of North American Indians History of Indian-White Relations*, Vol. 4, general editor, William C Sturtevant, Smithsonian Institution Press, Washington, DC, 1988, pp.175-6 (General account of the Battle at Little Bighorn.)

12 Peggy Albright, *Crow Indian Photographer: The Work of Richard Throssel*, University of New Mexico Press, NM, p.126

13 Linda Poolaw, *War Bonnets, Tin Lizzies and Patent Leather Pumps: Kiowa Culture in Transition 1925-1955*, Stanford University and the American Federation of Arts, Palo Alto, CA, 1991

14 Alfonso Ortiz, *The Tewa World: Space, Time and Becoming in a Pueblo Society*, The University of Chicago Press, Chicago, MI, 1969, p.13

15 Peggy Albright, *Crow Indian Photographer: The Work of Richard Throssel*, University of New Mexico Press, NM, p.116

16 Peggy Albright, *Crow Indian Photographer: The Work of Richard Throssel*, University of New Mexico Press, NM, p.118

EXPOSURES
PHOTOGRAPHS OF NATIVE AMERICANS

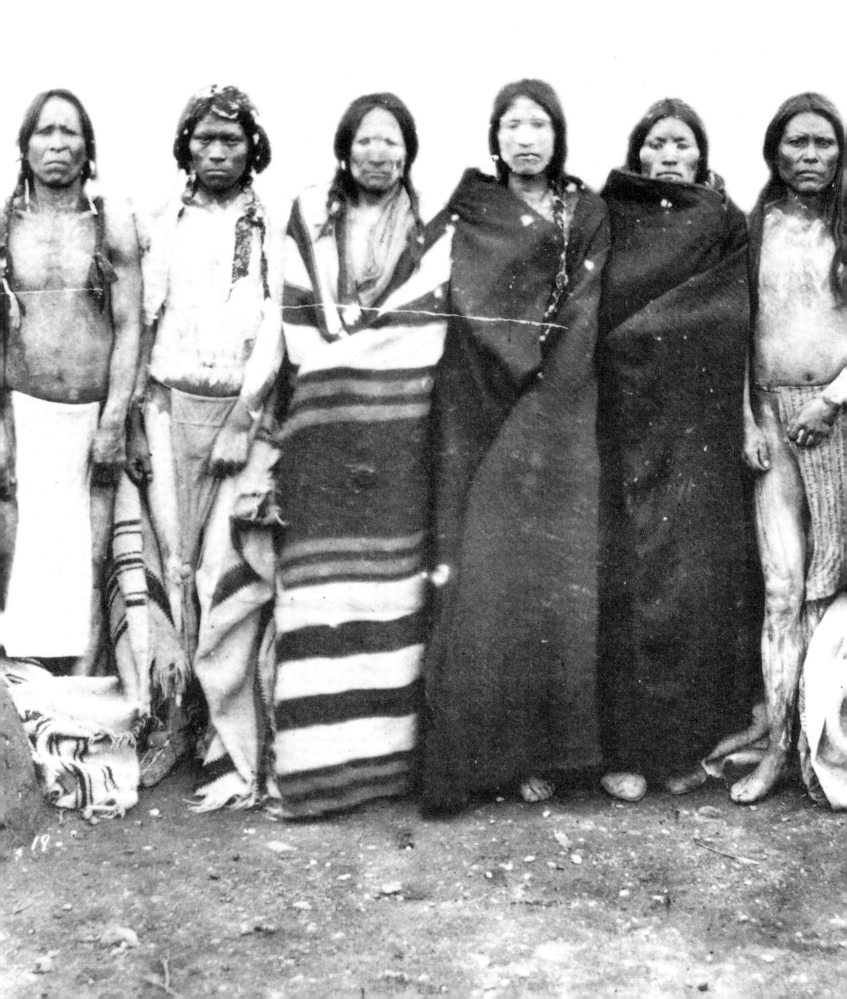

INVADED SPACES

BY MID-19TH CENTURY THE US GOVERNMENT HAD DECIDED that all Native peoples should be moved to reservations where they would cease to be a problem to white settlers and land and railroad speculators. Indeed, the government was intent on upholding the belief in it being the 'Manifest Destiny' of white immigrants to populate the entire North American continent. Photographs for the US government and commercially sponsored surveys, prevalent from the 1850s to 1880, served to illustrate the attractions of the 'great American West'. Whether survey photographs are deemed records of observation or surveillance, they emphasised the idea of the Native as 'primitive' and 'uncivilised' and their effect was to accelerate the violations perpetrated against indigenous communities. Native histories and Native survival are hereafter obscured by mythic accounts of 'how the West was won'. These are photographs from the edge, not just the physical frontier, but, on another level, that which exists between the photographer and the exotic 'other'. In some sense the photographic endeavour, which required the invasion of space to achieve its objective, mirrors the wider encroachments made upon the land itself.

PLATE 35

ORLOFF R WESTMAN

N'de [Apache] group at Taos Pueblo, 30 September 1871

Albumen print in Dr F V Hayden's album 'Photographic Portraits of Indians of the United States of North America'. (A photographic selection of images from a catalogue by William Henry Jackson). The Royal Anthropological Institute, London

PLATE 36

ANDREW J RUSSELL

*Embankment, east of granite
canyon, 1868*

Albumen print. Plate 2 from
Russell's *The Great West
Illustrated in a series of
photographic views across the
Continent: taken along the line
of the Union Pacific Railroad,
west from Omaha, Nebraska*
Vol. 1, published 1869,
including 50 leaves of
albumen prints by Russell.
Union Pacific Museum,
Omaha

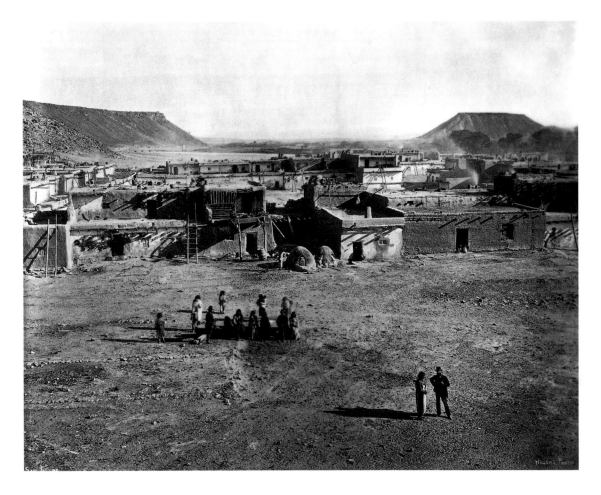

PLATE 37

JOHN K HILLERS

San Felipe Pueblo, New Mexico, 1880

Albumen print. National Anthropological Archives, Smithsonian Institution

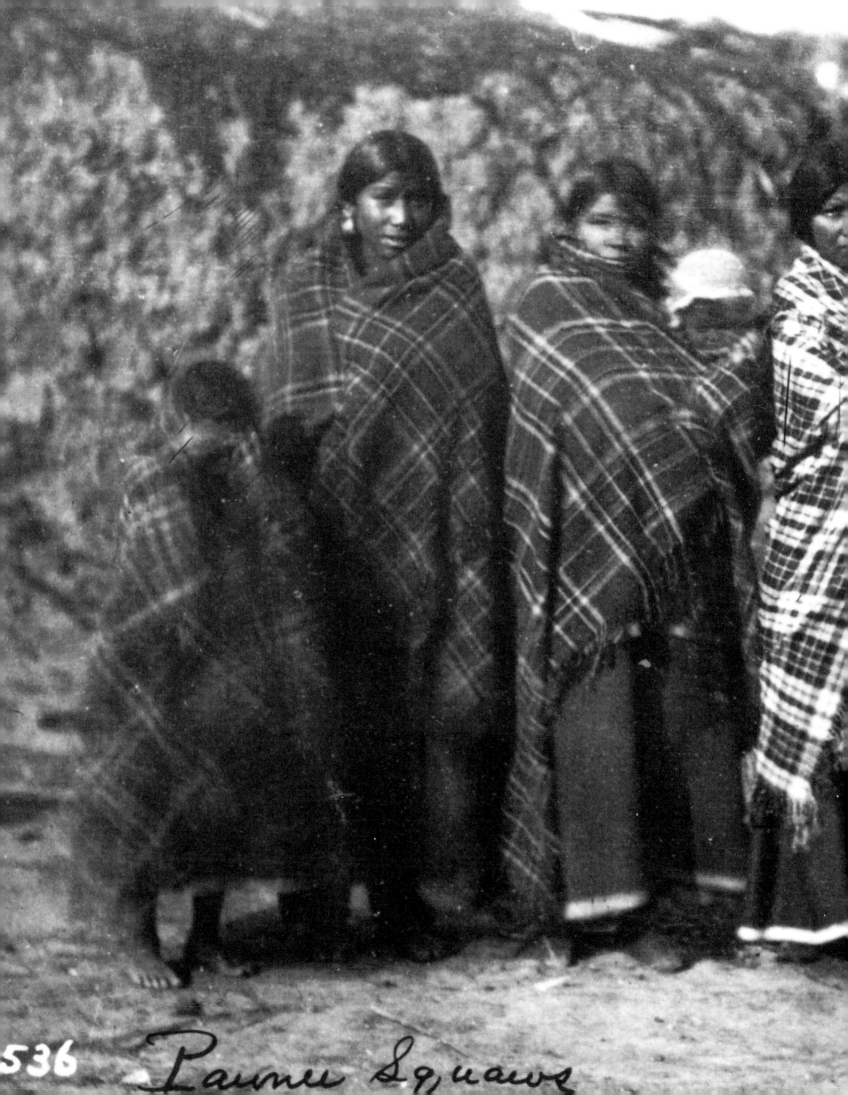

536 Pawnee Squaws

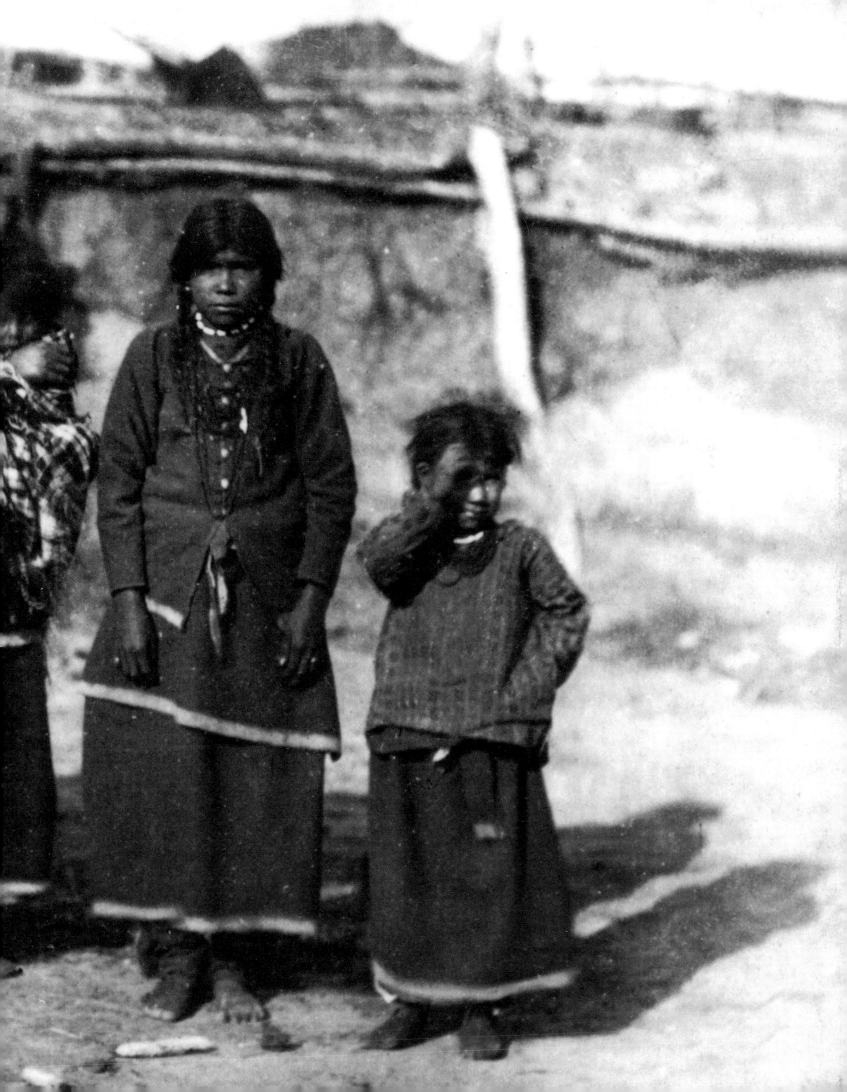

Previous page:

PLATE 38

WILLIAM HENRY
JACKSON

*Pawnee women and children,
1871. Taken while Jackson was
a member of the Department of
the Interior funded Geological
and Geographical Survey of the
Territories, under the direction
of Dr Ferdinand Vandiveer
Hayden (Hayden Survey
1870-79)*

Albumen print in Dr F V
Hayden's Album
'Photographic Portraits of
the Indians of the United
States of North America.'
(A photographic selection of
images from a catalogue by
William Henry Jackson).
The Royal Anthropological
Institute London

PLATE 39

UNIDENTIFIED ROYAL
ENGINEER

*'Indian encampment at The
Dalles, left bank of the
Columbia River,' 1860-61*

Albumen print. Plate 17,
Vol. I of the 'Anglo-
American Northwest
Boundary Commission
Survey of the 49th Parallel',
1857-62. Possibly under the
direction of John Keast
Lord, the Commission's
Naturalist. Royal Engineers
Library, Chatham

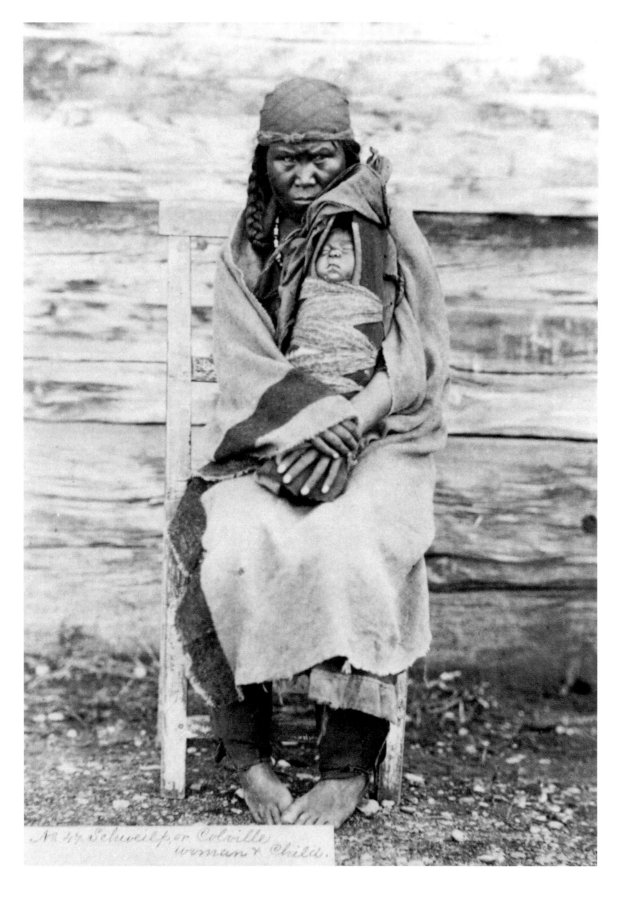

No. 47 Schweilp, or Colville woman & Child.

PLATE 40

UNIDENTIFIED ROYAL
ENGINEER

*'Schweilp or Colville woman
and child,' 1860-61*

Albumen print. Plate 47,
Vol. II of the Anglo-
American Northwest
Boundary Commission
Survey of the 49th Parallel,
1857-62. Possibly taken
under the direction of John
Keast Lord, the
Commission's Naturalist.
Royal Engineers Library,
Chatham

PLATE 41

PAUL-EMILE MIOT

Unidentified Mi'kmaq man, taken on a French naval survey of the coastal topography and ethnology of Newfoundland, 1857-59

Albumen print. Pitt Rivers Museum, University of Oxford

PLATE 42

PAUL-EMILE MIOT

Three unidentified Mi'kmaq women, Cape St George, 1859, taken on a French naval survey of the coastal topography and ethnology of Newfoundland, 1857-59

Albumen print. Pitt Rivers Museum, University of Oxford

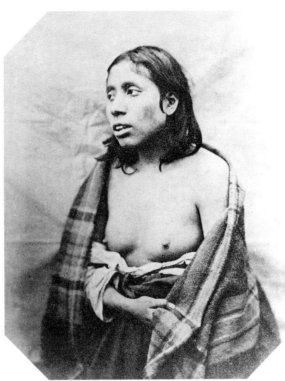

PLATE 43

PAUL-EMILE MIOT

*Unidentified Mi'kmaq woman,
taken on a French naval survey
of the coastal topography and
ethnology of Newfoundland,
1857-59*

Albumen print. Pitt Rivers
Museum, University of
Oxford

PLATE 44

PAUL-EMILE MIOT

*Unidentified Mi'kmaq woman,
taken on a French naval survey
of the coastal topography and
ethnology of Newfoundland,
1857-59*

Albumen print. Pitt Rivers
Museum, University of
Oxford

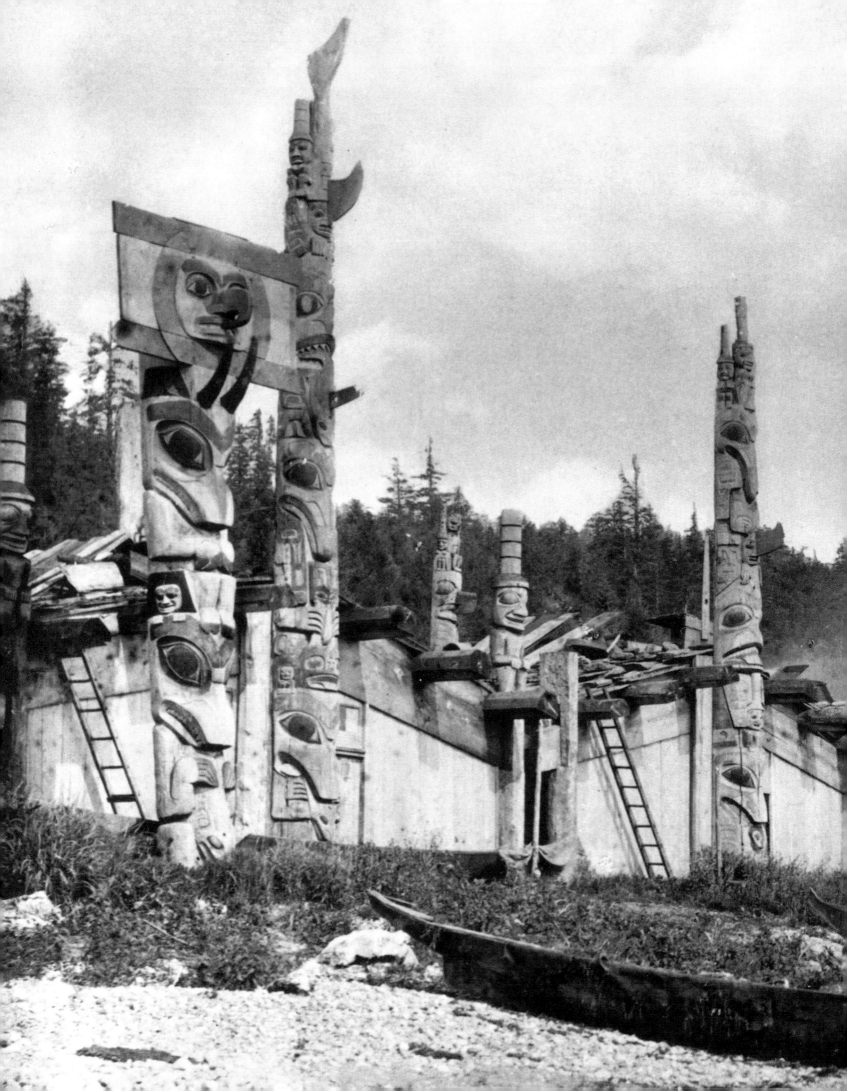

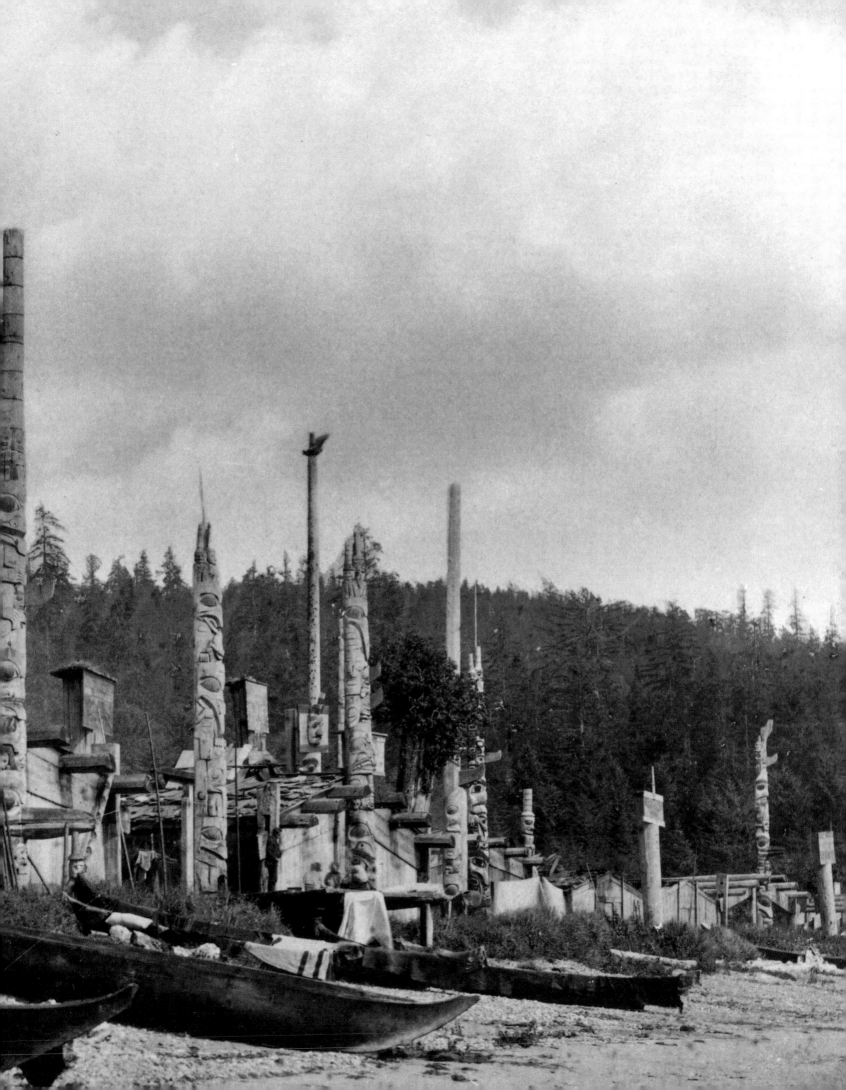

Previous page:

PLATE 45

GEORGE M DAWSON

Skidegate Village, Queen Charlotte Islands, 26 July 1878 (Haida Gwaii)

Albumen print. Royal Anthropological Institute London

PLATE 46

ALEXANDER GARDNER

Unidentified Lakota women and children, taken at the Fort Laramie Peace Council of 1868

Albumen print. National Anthropological Archives, Smithsonian Institution

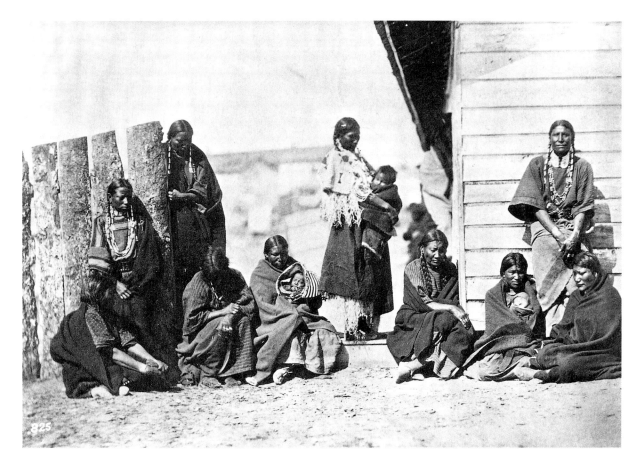

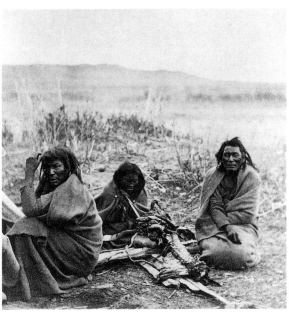

PLATE 47

ALEXANDER GARDNER

*Interior of a Crow lodge,
woman sewing,
Fort Laramie, 1868*

Albumen print.
William Blackmore
Collection. Trustees of the
British Museum

PLATE 48

ALEXANDER GARDNER

*A group of unidentified Crow
men. Fort Laramie, 1868*

Albumen print.
William Blackmore
Collection Trustees of the
British Museum

Overleaf:

PLATE 49

MAY CLARK, under the
direction of the
anthropologist, MATHILDA
COXE STEVENSON

*Sia priests of the Giant Society,
Medicine Division, in their
ceremonial chamber invoking
the power of the bear to cure a
sick boy of a sore throat, Sia
Pueblo, New Mexico, 1890*

Modern print from a
negative in the collection
of the National
Anthropological Archives,
Smithsonian Institution

PLATE 50

ALEXANDER GARDNER

An unidentified Comanche
woman delegate to Washington,
DC, 1872

Albumen print. National
Anthropological Archives,
Smithsonian Institution

THEATRE OF DIPLOMACY

INTOLERABLE CIRCUMSTANCES AT HOME, ENTIRE TRIBAL NATIONS DISPLACED, deprived of their livelihoods and made to feel vulnerable and worthless in their own land, brought Native leaders as official delegates to Washington, DC to try to make peace. The enclosed interior spaces and the juxtaposition of Native American dress and the swirling Axminster-style carpets adorning the photographic studio of James E. McClees sets up a strangely surreal dynamic in the image which is a powerful reminder of a meeting of white and Native American cultures adrift from each other. Although taken for official purposes, it wasn't long before these images found their way onto the open market. Charles M. Bell's photographs of Perits-Shinakpas [Medicine Crow], full-face and in profile, are a good example of a delegation portrait influenced by the 'scientific' emphasis on anatomical description of racial types.

PLATE 51

UNIDENTIFIED
PHOTOGRAPHER

*A Lakota delegation led by
Spotted Tail, Sicangu [Brulé]
and Makhpiya Lúta [Red
Cloud], Oglala, at the Corcoran
Gallery of Art, Washington, DC,
30 October 1877*

Modern print from a
negative at the National
Anthropological Archives,
Smithsonian Institution

PLATE 52

JULIAN VANNERSON
AND SAMUEL COHNER
OF THE JAMES E
McCLEES STUDIO

*Tshe-tan' Wa-ku'wa Ma'ni
[Little Crow], the
Mdewakanton Dakota Chief,
a delegate to Washington, DC,
16 April, 1858. In response to
treaty promises being broken
and the continuing violation of
Native land and peoples,
Tshe-tan' Wa-ku'wa Ma'ni
became leader of the Minnesota
Uprising of 1862 for which he
was butchered and scalped, his
skull and wrist bones put on
exhibition (see Paula Fleming's
essay pp.168-184)*

Albumen print.
Pitt Rivers Museum,
University of Oxford

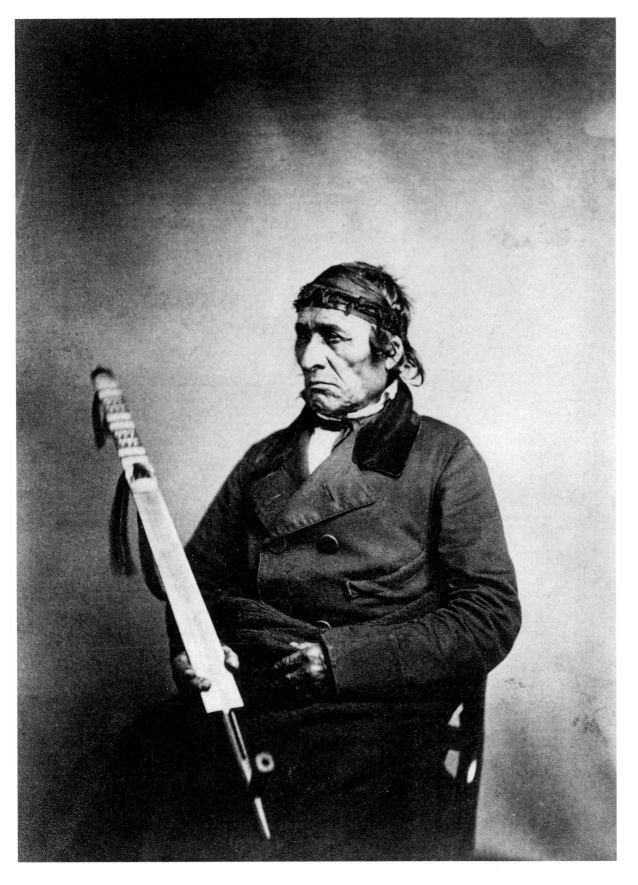

PLATE 53

THE JAMES E McCLEES
STUDIO

*Sha-kpe' [Six], a
Mdewakanton Dakota delegate
to Washington, DC, 13 March –
16 April, 1858. Later hanged
for his part in the Minnesota
Uprising of 1862 (see Paula
Fleming's essay pp.168-184)*

Albumen print.
Pitt Rivers Museum,
University of Oxford

PLATE 54

JULIAN VANNERSON
AND SAMUEL COHNER
OF THE JAMES E
McCLEES STUDIO

Ne-sha-re-ru-re-ra' Hi-kute
[The Brave Chief], a Pawnee
delegate to Washington, DC,
between 21 December 1857 –
6 April 1858

Albumen print.
Pitt Rivers Museum,
University of Oxford

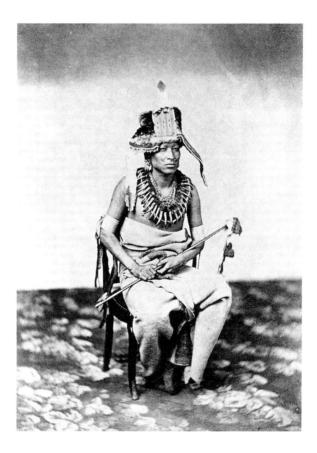

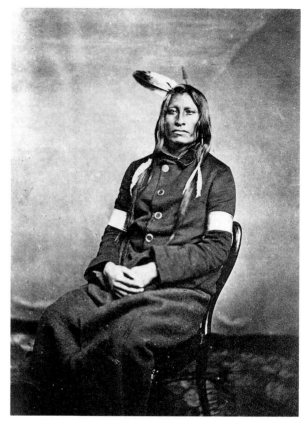

PLATE 55

JULIAN VANNERSON
AND SAMUEL COHNER
OF THE JAMES E
McCLEES STUDIO

Psicha Wakinyan [Jumping
Thunder], a Yankton Nakota
delegate to Washington, DC,
between 13 March –
16 April 1858

Albumen print. Pitt Rivers
Museum, University of
Oxford

PLATE 56

JULIAN VANNERSON
AND SAMUEL COHNER
OF THE JAMES E
McCLEES STUDIO

A-ki'-pa [The Meeter], a
Sisseton Dakota delegate to
Washington, DC, between
13 March – 16 April 1858

Albumen print.
Pitt Rivers Museum,
University of Oxford

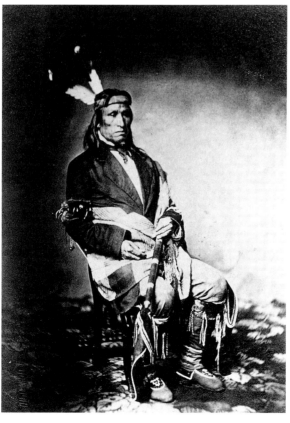

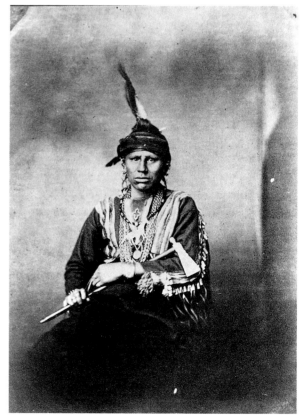

PLATE 57

JULIAN VANNERSON
AND SAMUEL COHNER
OF THE JAMES E
McCLEES STUDIO

Ki'wi-i-ku [Buffalo Bull] a
Pawnee delegate to
Washington, DC, between 21
December 1857 – 6 April 1858

Albumen print.
Pitt Rivers Museum,
University of Oxford

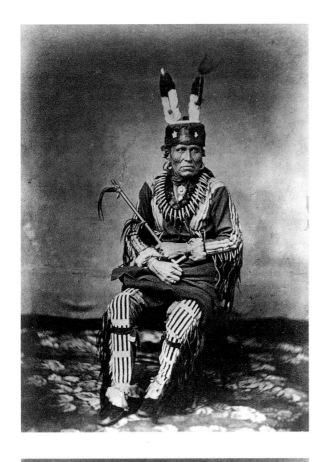

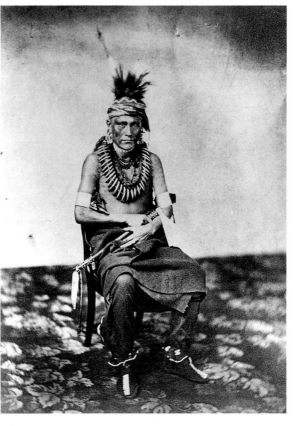

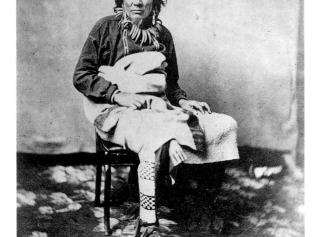

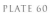

PLATE 58

JULIAN VANNERSON
AND SAMUEL COHNER
OF THE JAMES E
McCLEES STUDIO

*Peta-la-sha-ro [Man and Chief]
a Pawnee Chief, delegate to
Washington, DC, between 21
December 1857 – 6 April 1858*

Albumen print.
Pitt Rivers Museum,
University of Oxford

PLATE 59

JULIAN VANNERSON
AND SAMUEL COHNER
OF THE JAMES E
McCLEES STUDIO

*La'hic'-ta-ha-la-sha [Medicine
Chief], a Pawnee delegate to
Washington, DC, between 21
December 1857 – 6 April 1858*

Albumen print.
Pitt Rivers Museum,
University of Oxford

PLATE 60

JULIAN VANNERSON
AND SAMUEL COHNER
OF THE JAMES E
McCLEES STUDIO

*We'ga-sa-pi [Iron Whip], a
Ponca delegate to Washington,
DC, between 23 December 1857
– 13 March 1858*

Albumen print.
Pitt Rivers Museum,
University of Oxford

PLATE 61

JULIAN VANNERSON
AND SAMUEL COHNER
OF THE JAMES E
McCLEES STUDIO

*Pko-ne-gi-zhik' [Hole in the
Sky], an Ojibwa delegate to
Washington, DC, 1857-58*

Albumen print.
Pitt Rivers Museum,
University of Oxford

PLATES 62 AND 63

CHARLES MILTON BELL

Perits-Shinakpas [Medicine Crow], a Crow warrior and visionary 'medicine man'

Taken whilst Perits-Shinakpas was a delegate to Washington, DC, between 10 April – 18 May 1880

Modern prints from negatives in the collection of the National Anthropological Archives, Smithsonian Institution

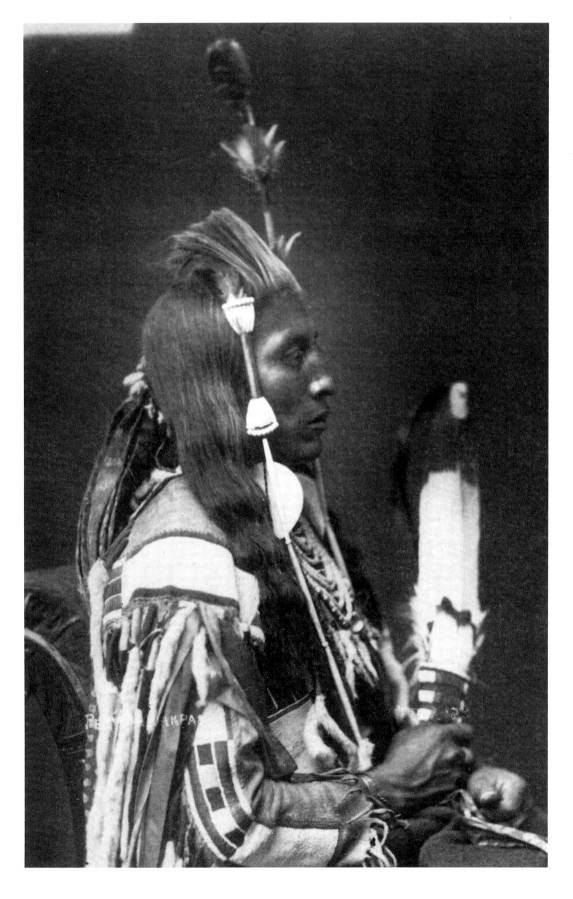

PLATE 64

JULIAN VANNERSON
AND SAMUEL COHNER
OF THE JAMES E
McCLEES STUDIO

*Wa-su-hi-ya-dan [Passing
Hail], a Mdewakanton Dakota
delegate to Washington, DC,
between 13 March –
16 April 1858*

Albumen print.
William Blackmore
Collection. Trustees of the
British Museum

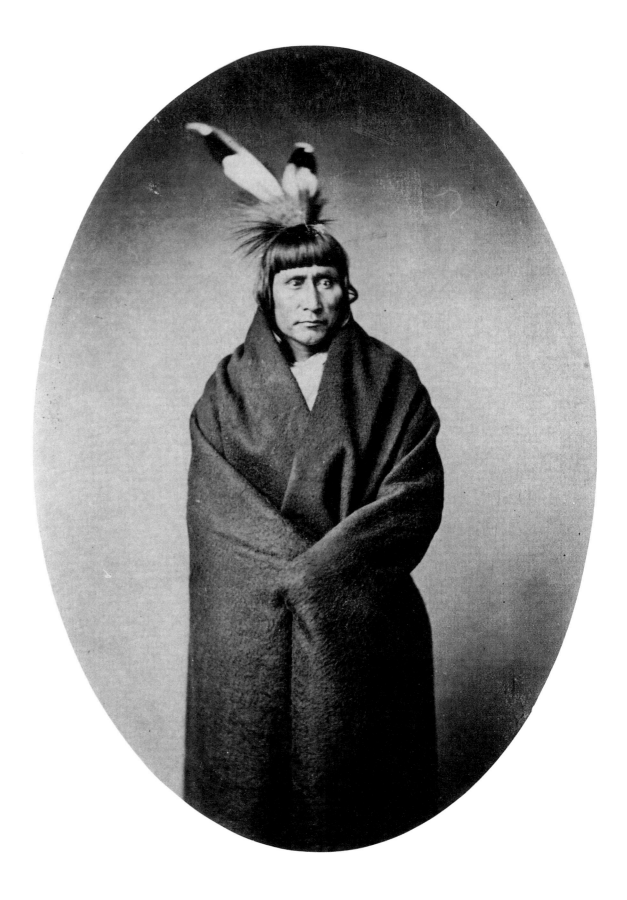

PLATE 65

ANTONIO ZENO
SHINDLER

Sanford W Perryman, a
Muskogee, Creek delegate to
Washington, DC, 1868

Albumen print.
William Blackmore
Collection. Trustees of the
British Museum

PLATE 66

WILLIAM HENRY
JACKSON

*Chief Washakie's Shoshone
village in the Wind River
Mountains near the Sweetwater
River, Fort Stambaugh,
Wyoming. Taken while Jackson
was a member of the
Department of the Interior
funded Geological and
Geographical Survey of the
Territories, under the direction
of Dr Ferdinand Vandiveer
Hayden (Hayden Survey 1870-
79) September 1870*

Albumen print. National
Anthropological Archives,
Smithsonian Institution

THE AMERICAN DREAM

IN THE LAST TWO DECADES OF THE 19TH CENTURY, writers, artists, historians, anthropologists, entrepreneurs and government employees became excited and inspired by the sensational accounts of the richly spiritual and creative lives being led by Native American communities, especially on the Plains and in the Southwest and Northwest. Here was the last American frontier, where they could witness what they generally, mistakenly, believed to be the last of a 'vanishing race'. Increasingly utilising the new Kodak hand-held camera – easy to use, with film that could be developed separately – these adventurer-photographers were collectors of images but at the same time often genuine in their passion and support for indigenous peoples. Kate Cory and Sumner Matteson were true independent spirits who were welcomed into Native communities where they took extraordinary photographs, richly descriptive of Native American cultural life. The Pueblo communities of the Southwest were a great draw to anthropologists; John K. Hiller's photographs taken under the auspices of the Bureau of American Ethnology are imbued with a romantic sensibility and a strong visual aesthetic, while May Clark and Mathilda Coxe Stevenson took some of the most memorable photographs of ritual practices. George Wharton James was a traveller-writer-photographer, whereas John Alvin Anderson and Fred Miller both lived and worked in one Native community where they gained an intimate understanding and affection for their photographic subjects.

PLATE 67

KATE CORY

'From the Kiskya or passageway through the centre of Walpi, a Hopi girl looks across the wide valley of Polacca Wash. Dressed in the fabrics of the white man's school she goes barefoot in the manner of her own people', between 1905-12

Modern print from a negative in the collection of the Museum of Northern Arizona Photo Archives

PLATE 68

KATE CORY

'A Navajo woman attends a Hopi horse race at First Mesa', between 1905-12

Modern print from a negative in the collection of the Museum of Northern Arizona Photo Archives

PLATE 69

JOHN K HILLERS

*Zuni man with eagle. Taken at
Zuni Pueblo, 1879*

Albumen print.
Pitt Rivers Museum,
University of Oxford

PLATE 70

ABY WARBURG

*Hopi and Western schoolgirls
at Keam's Canyon, Arizona,
April 1896*

Modern print from a
negative in the collection of
The Warburg Institute,
London

PLATE 71

ABY WARBURG

*A Hopi man with children
waiting for the dance to start,
Oraibi, Arizona, May 1896*

Modern print from a
negative in the collection of
The Warburg Institute,
London

PLATE 72

ABY WARBURG

*Diné [Navajo] man and boys,
Arizona, April 1896*

Modern print from a
negative in the collection of
The Warburg Institute,
London

PLATE 73

ABY WARBURG

*Diné [Navajo] woman making
pitas, Arizona, April 1896*

Modern print from a
negative in the collection of
The Warburg Institute,
London

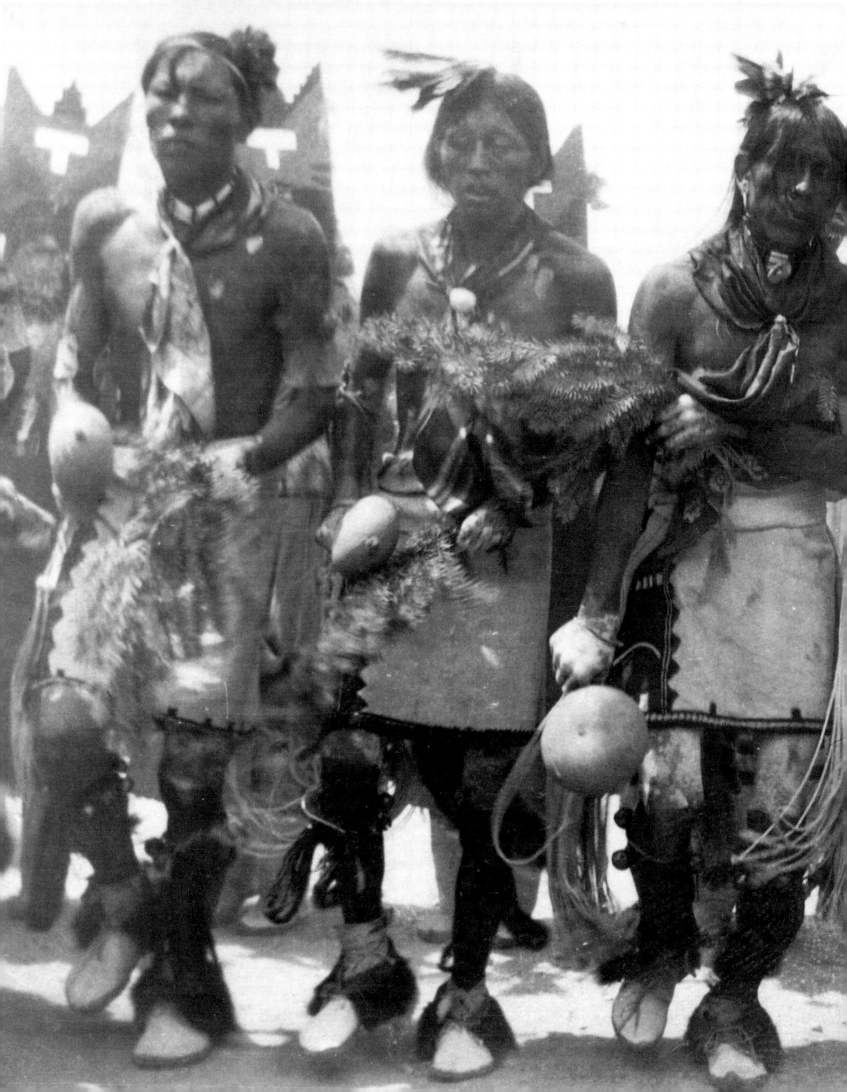

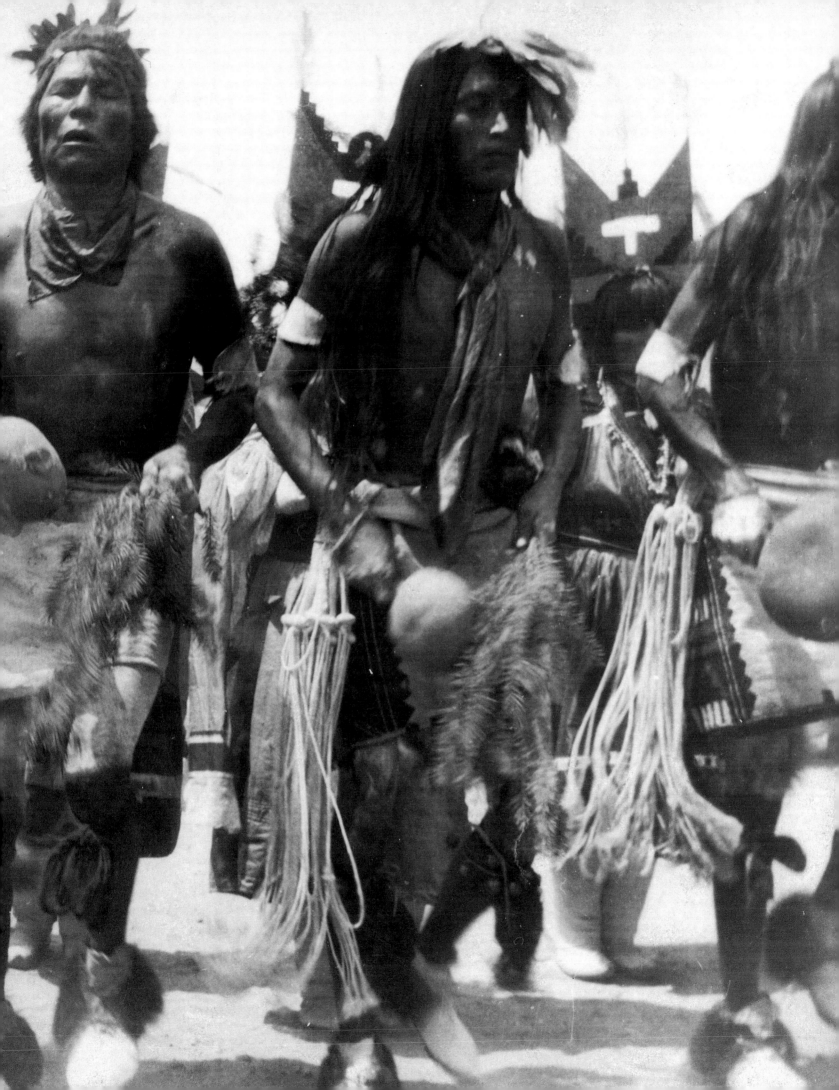

Previous page:

PLATE 74

MATHILDE COXE
STEVENSON

*The Corn dance (Santa Clara),
Santa Clara Pueblo, New
Mexico, December 1911*

Modern print from a
negative in the collection of
the National
Anthropological Archives,
Smithsonian Institute

PLATE 75

GEORGE WHARTON
JAMES

A Hopi weaver, 1898

Albumen print. National
Anthropological Archives,
Smithsonian Institution

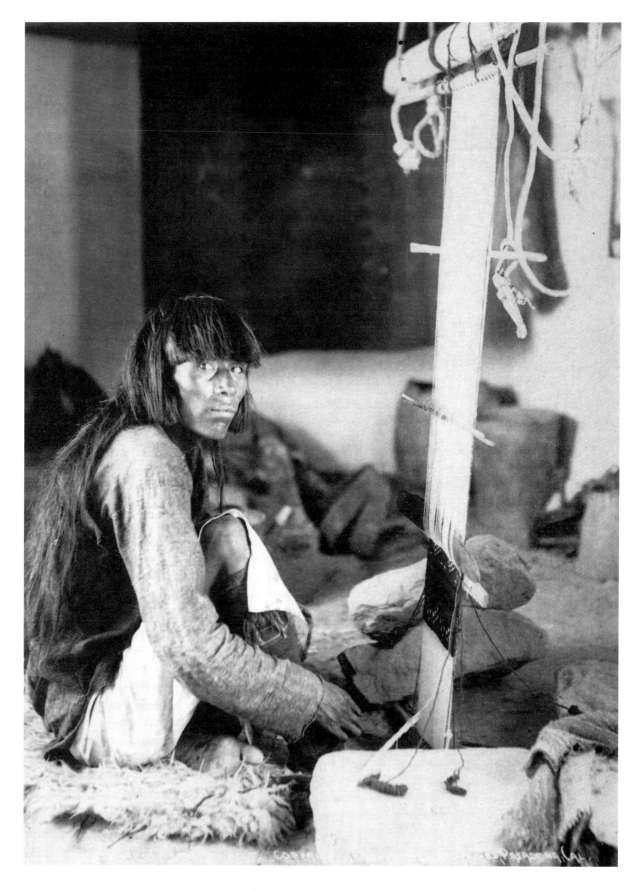

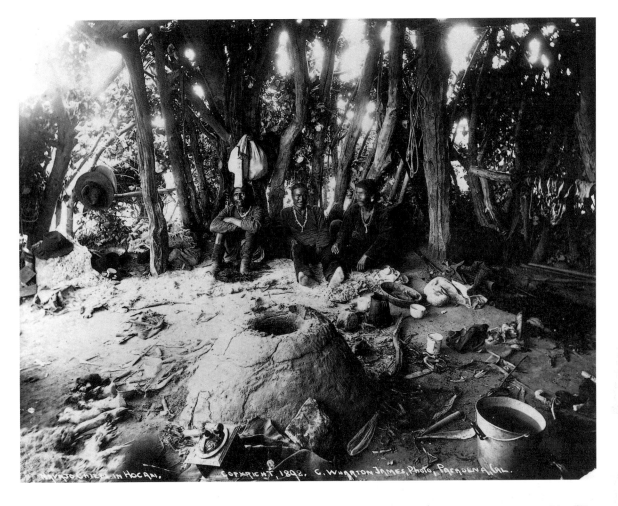

PLATE 76

GEORGE WHARTON
JAMES

*Dine´ [Navajo] Chiefs inside a
Hogan, 1892*

Albumen print. National
Anthropological Archives,
Smithsonian Institution

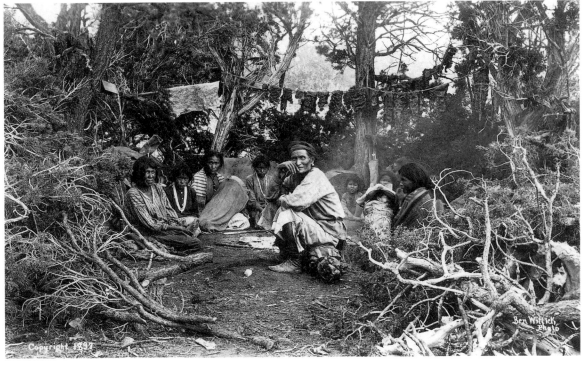

PLATE 77

GEORGE BEN WITTICK

Dine´ [Navajo] camp, c.1895

Modern print from a
negative in the collection
of the National
Anthropological Archives,
Smithsonian Institution

PLATE 78

SUMNER MATTESON

*A Sun dancer receiving gifts,
July 4 celebrations, Fort
Belknap Reservation, Montana,
home to the Assiniboine
Nakota and the A'ani
[Gros Ventre], 1906*

Modern print from a
negative in the collection
of the National
Anthropological Archives,
Smithsonian Institution

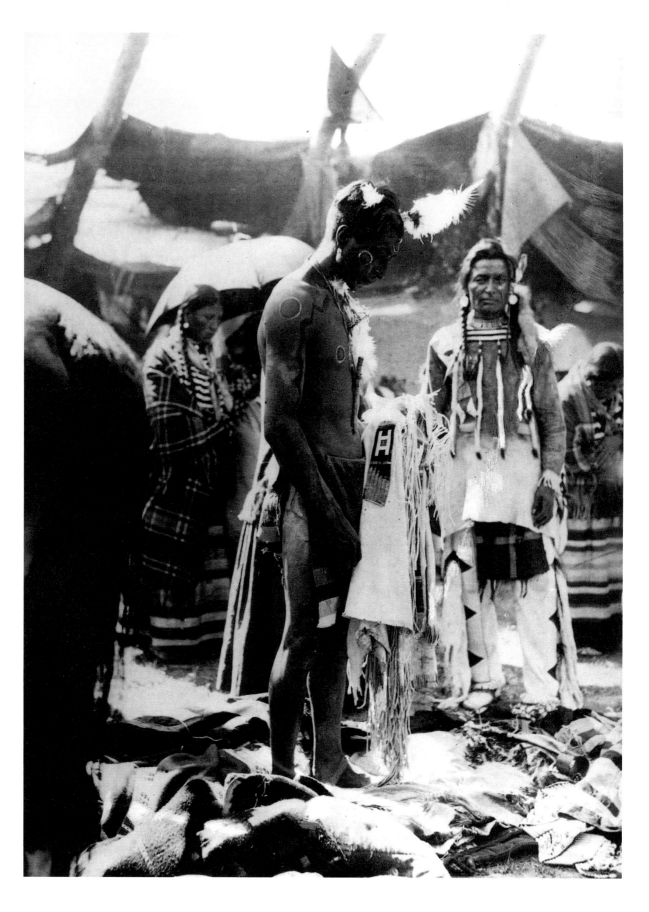

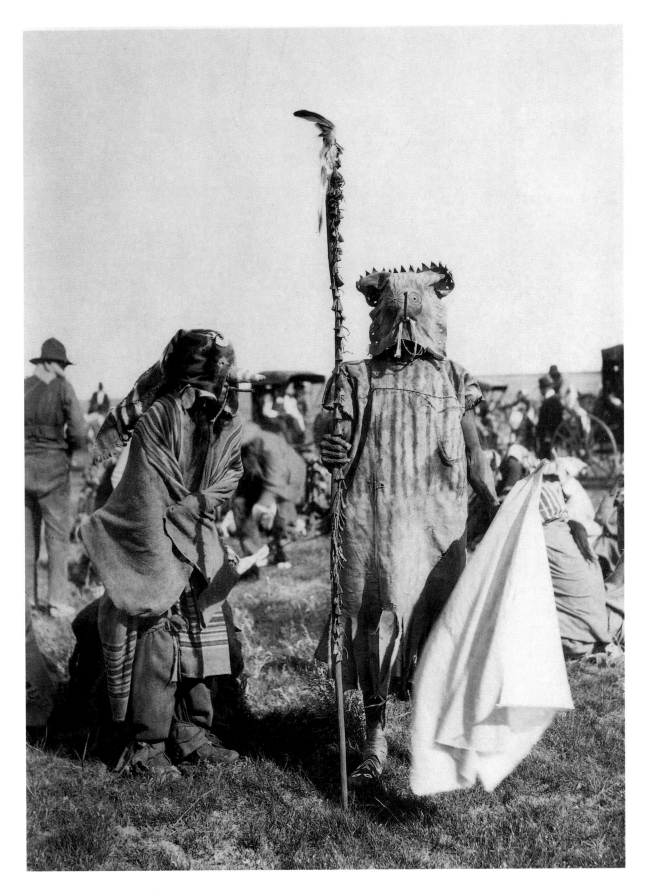

PLATE 79

SUMNER MATTESON

Fool dancers, Fort Belknap Reservation, Montana, home to the Assiniboine Nakota and the A'ani [Gros Ventre], 1906

Modern print from a negative in the collection of the National Anthropological Archives, Smithsonian Institution

PLATE 80

FRED MILLER

*Crow girl on the prairie,
between 1898-1910*

Modern print from a
negative in the
Fred E Miller collection:
Nancy F O'Connor

PLATE 81

FRED MILLER

*Crow burial scaffold,
between 1898-1910*

Modern printing-out paper
print from an original
glass negative in the
Fred E Miller collection:
Nancy F O'Connor

PLATE 82

FRED E MILLER

*Crow Chief Black Hair
with his daughter Mary,
between 1898-1910*

Modern print from a
negative in the
Fred E Miller collection:
Nancy F O'Connor

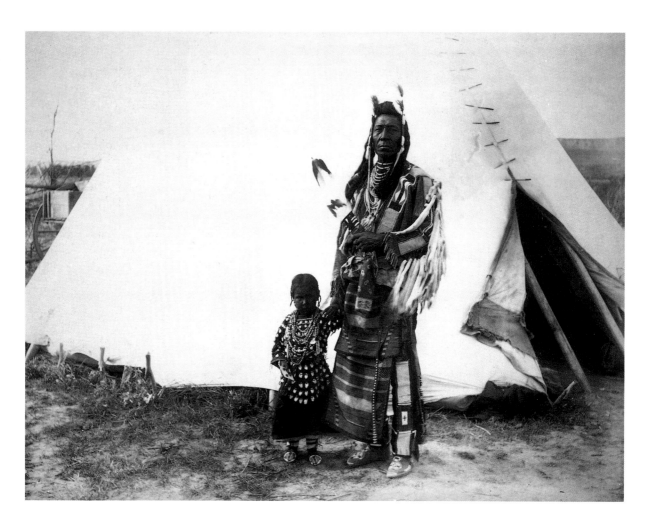

PLATE 83

FRED E MILLER

Chief Pretty Eagle,
between 1898-1910

Modern print from a
negative in the
Fred E Miller collection:
Nancy F O'Connor

PLATE 84

MARY SCHARPLES
SCHAFFER WARREN

*Sampson, Frances Louise, and
Leah Beaver, 1907 ('Stoney')*

Modern print from a
negative in the collection of
the Whyte Museum, Banff
British Columbia

PL-214 No.152.

PLATE 85

JESSE HASTINGS
BRATLEY

*Harry with Horns, a
Dakota boy, on the Rosebud
Reservation, South Dakota,
1895-9*

Modern print from a
negative in the collection
of the National
Anthropological Archives,
Smithsonian Institution

PLATE 86

JOSEPH KOSSUTH DIXON

'War Memories' taken on the
Wanamaker Expeditions 1908-17

Modern print. From a
negative in the collection
of the National
Anthropological Archives

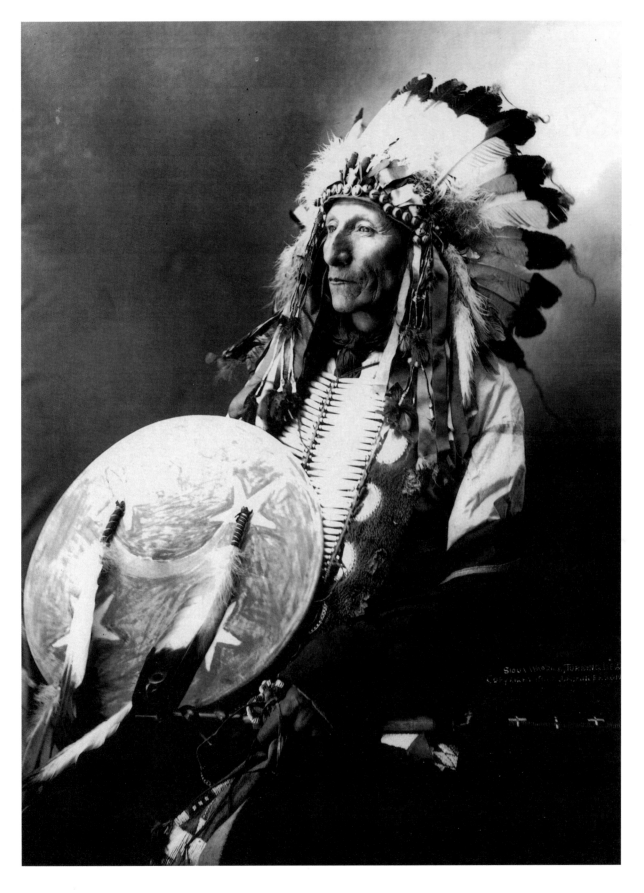

PLATE 87

JOHN ALVIN ANDERSON

Turning Bear (1848-1911) a Sicangu (Brulé) Lakota, 1900

Modern print from a negative in the collection of the National Anthropological Archives

Overleaf:

PLATE 88

LLOYD WINTER AND PERCY POND

Interior of the Chilkat Whale House at Klukwan, Alaska 1895. The standing figure in the centre is probably the Chilkat Chief, Coudahwot

Modern print from a negative in the collection of the Alaska State Library

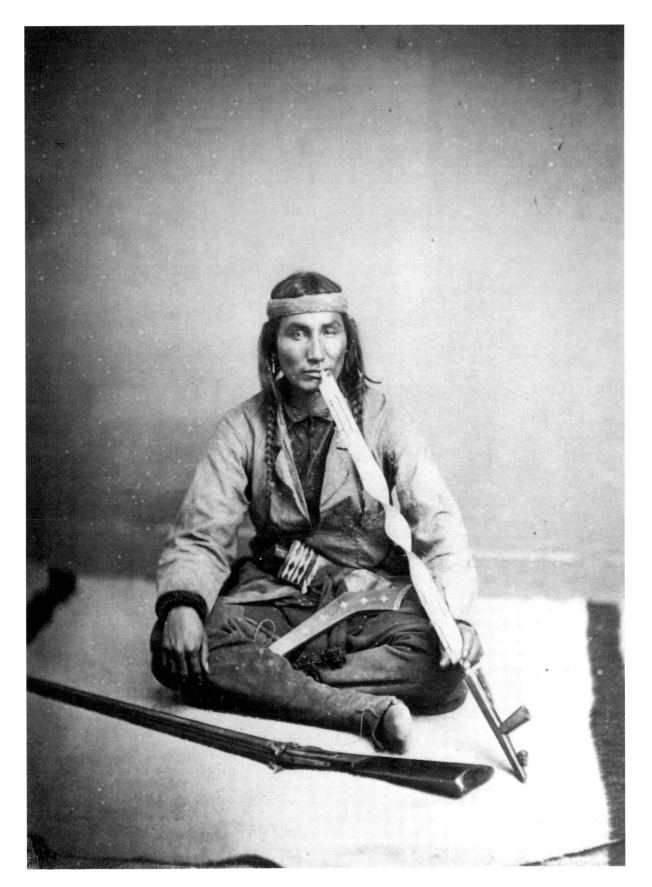

DESIRABLE OBJECTS

As the century progressed, native Americans found themselves not just under close governmental, corporate and anthropological observation, but the subject of intense popular interest. Photographs, increasingly taken and reproduced in larger and larger numbers, made Native peoples available in this way; its black and white muted two dimensionality rendered them harmless as well as visitable. The consumer or collector of photographs became a voyeur of the exotic – a traveller of dreams. The so-called *carte-de-visite*, a small albumen print mounted on card, was fashionable through the 1860s. Family photographs were taken and collected in albums alongside those that could be bought in bookshops, galleries and newsagents depicting celebrities of the day and scenes from all corners of the country. Native 'braves' and 'beauties' as well as recreated scalpings were typical of the genre. Competing in the popularity stakes, the stereograph – a double image that when observed through a stereoscopic viewer creates the illusion of three-dimensional space – was available for purchase from the late 1850s and also became incredibly popular in the 1860s, becoming the preferred method of viewing images when the *carte-de-visite* craze waned around 1866. Thousands of newsworthy and exotic subjects were produced, and again Native peoples became objects of curiosity and entertainment. The stereograph brought about the pleasure induced by a sense of really being there – but at a safe distance. For those that didn't have the traveller instinct, the appetite for seeing Native peoples in the flesh resulted in them becoming live exhibits at expositions across the world and participants in a new form of entertainment: the Wild West show.

PLATE 90

JOHN K HILLERS

'Game of Wolf and Deer'
(Paiute). No.19 from the series
'Indians in the Colorado
Valley.' Taken on the
Department of the Interior
funded Geographical and
Geological survey of the Rocky
Mountain Region, led by John
Wesley Powell (The Powell
Survey, 1871-79)

Albumen stereograph.
National Anthropological
Archives, Smithsonian
Institution

PLATE 91

JOHN K HILLERS

'The Messenger in full dress'
(Ute). No. 99 from the series
'Indians in the Colorado
Valley.' Taken on the
Department of the Interior
funded Geographical and
Geological survey of the Rocky
Mountain Region, led by John
Wesley Powell (The Powell
Survey, 1871-79)

Albumen stereograph.
National Anthropological
Archives, Smithsonian
Institution

America.

North American Indian
Ka-ka-oongue (Sparrow Hawk)
Chippewa Chief

Gray Wolf
A Winnebago Chief

New. York.

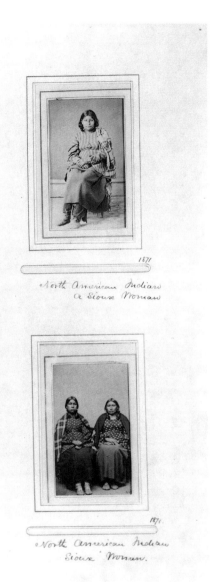

North American Indian
A Sioux Woman

North American Indian
Sioux Woman.

PLATE 92

The North American pages from the album 'The Sir John Benjamin Stone Collection of Photographs: Photographs of Types of Various Races of Mankind' 1870-83

Cabinet prints of New York belles are here juxtaposed with cartes-de-visite images of Native subjects, some relating to the Sioux Revolt or Minnesota Uprising of 1862 (see Paula Fleming's essay pp.168-184)

For a further discussion of this album see Elizabeth Edward's essay pp.186-203

Original album of albumen prints from the Sir Benjamin Stone Collection, Birmingham Central Library

A selection of cartes-de-visite images from the William Blackmore Collection. Trustees of the British Museum (except pl.103, Pitt Rivers Museum, University of Oxford)

All albumen prints

Left to right, upper row first:

PLATE 93

JOEL EMMONS WHITNEY

'Old Bets'

PLATE 94

NICHOLAS BROWN

Unidentified Dine' [Navajo] ? boy, c.1866-72

PLATE 95

JOEL EMMONS WHITNEY

'Te-na-ze-pa – Sioux Dandy'

PLATE 96

UNIDENTIFIED PHOTOGRAPHER

'Cayote – Wolf, a Southern Ute'

PLATE 97

JOEL EMMONS WHITNEY

'Sha-Kpe' [Six] (Mdewankanton Dakota)

PLATE 98

JOEL EMMONS WHITNEY

'Ma-za-oo-nie – (The Little Bird Hunter)'

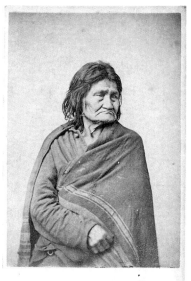

OLD BETS.
A Sioux Squaw 120 years old, will long be remembered with gratitude by many of the Minnesota Captives for her kindness to them while among the Sioux in 1862.
Whitney & Zimmerman, Photographers, St. Paul, Minn.

N. BROWN & SON, SANTA FE, N. M.

Te-na-ze-pa,—Sioux Dandy.
Executed at Mankato for participation in the Massacre of 1862.
Whitney & Zimmerman, Photographers, St. Paul, Minn.

Cayote - wolf a Southern Ute

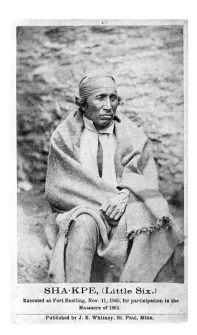

SHA-KPE, (Little Six.)
Executed at Fort Snelling, Nov. 11, 1865, for participation in the Massacre of 1862.
Published by J. E. Whitney, St. Paul, Minn.

MA-ZA-OO-NIE,
(THE LITTLE BIRD HUNTER.)
WHITNEY'S GALLERY, ST. PAUL, MINN.

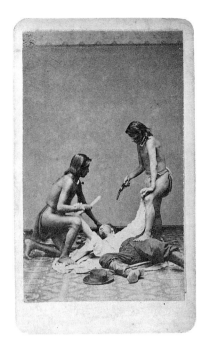

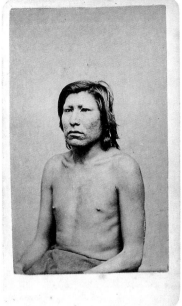

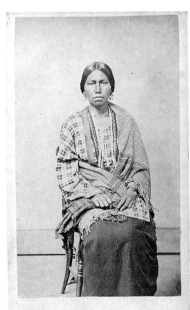

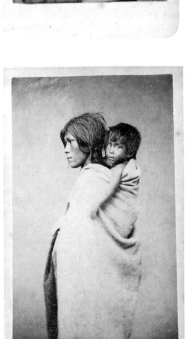

Left to right, upper row first:

PLATE 99

BENJAMIN FRANKLIN UPTON?

Winnesheick, Winnebago Chief, 1863

PLATE 100

UNIDENTIFIED PHOTOGRAPHER

Staged shooting

PLATE 101

UNIDENTIFIED PHOTOGRAPHER

Pawnee man

PLATE 102

UNIDENTIFIED PHOTOGRAPHER

A Yankton Nakota woman taken at Fort Randall, 1866

PLATE 103

E L EATON

Shoshone man and woman, sold bearing caption 'Venus and Adonis', c.1860

Circulated by Savage and Ottinger of Salt Lake City and Edric Eaton of Omaha, Nebraska, among others, in the 1860s and 1870s

PLATE 104

UNIDENTIFIED PHOTOGRAPHER

Pawnee woman and baby

PLATE 105

HAMILTON AND
KODYLEK

*Unidentified Omaha man,
c.1880*

Albumen stereograph. Sir
Benjamin Stone Collection,
Birmingham Central Library

PLATE 106

HAMILTON AND
KODYLEK

*Unidentified Omaha man,
c.1880*

Albumen stereograph. Sir
Benjamin Stone Collection,
Birmingham Central Library

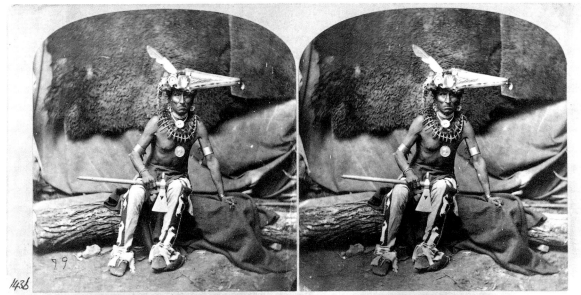

PLATE 107

HAMILTON AND
KODYLEK

*Unidentified Omaha woman,
c.1880*

Albumen stereograph. Sir
Benjamin Stone Collection,
Birmingham Central Library

PLATE 108

HAMILTON AND
KODYLEK

*Unidentified Omaha boy,
c.1880*

Albumen stereograph. Sir
Benjamin Stone Collection,
Birmingham Central Library

133

PLATE 109 AND 110

PRINCE ROLAND
BONAPARTE

*Ingh-Rhangra, an Omaha
woman of eighteen, with
her son, David Canby,
representatives at le Jardin
d'Acclimatation, Paris 1883*

Albumen prints.
Pitt Rivers Museum,
University of Oxford

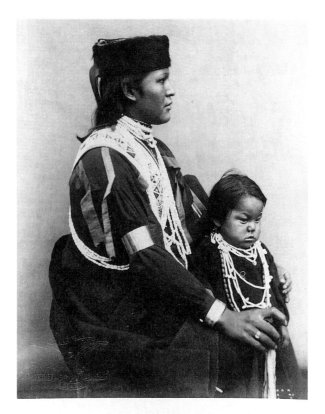

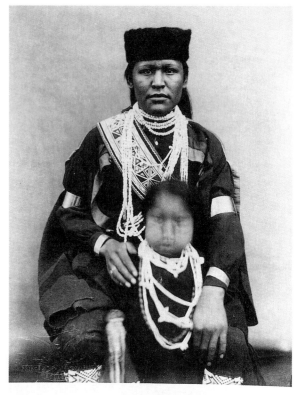

Collection anthropologique du Prince Roland Bonaparte. *Collection anthropologique du Prince Roland Bonaparte.*

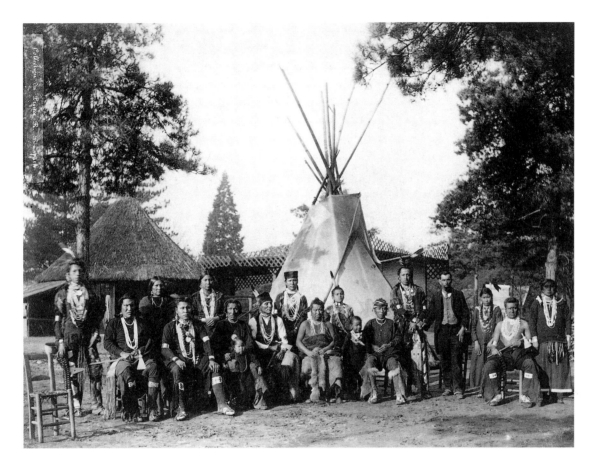

PLATE 111

PRINCE ROLAND
BONAPARTE

The group of Omaha at le Jardin d'Acclimatation, Paris. The man in European dress is John Pelcher. leader and co-ordinator of the group. Pelcher had a white American father and a Native mother

Albumen print.
Pitt Rivers Museum,
University of Oxford

PLATE 112

FRANK A RINEHART
AND ADOLF F MUHR

*'Chief Mountain' Siksika
[Blackfeet] taken at the Trans-
Mississippi and International
Exposition, Omaha 1898*

One of over two hundred
photographs of Native
subjects, most probably
taken by Adolf Muhr,
under the overall direction
of James Mooney.
Platinum print. Liz Farrelly

PLATE 113

FRANK A RINEHART
AND ADOLF F MUHR

*Kiowa representative at the
Trans-Mississippi and
International Exposition,
Omaha, 1898*

Platinum print. Wellcome
Institute Library, London

PLATE 114

FRANK A RINEHART
AND ADOLF F MUHR

*Hattie Tom, Chiricahua
Apache, and Bonny Yela,
San Carlos Apache, taken at
the Trans-Mississippi and
International Exposition,
Omaha, 1898*

Platinum print. Wellcome
Institute Library, London

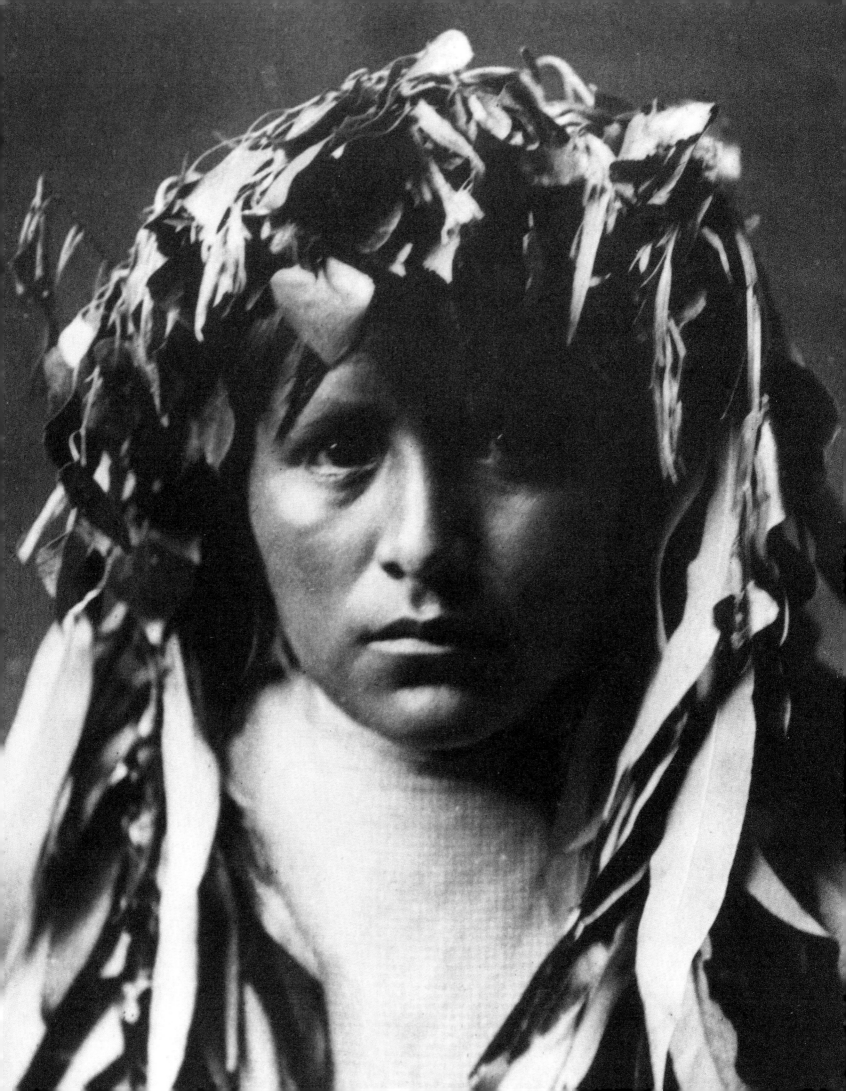

CURIOUS CURTIS

CURTIS, STRANGELY THE MOST FANCIED AND THE MOST DESPISED of photographers, had a mission to photographically record every Native Nation to populate the North American continent before they disappeared – at least that was what he thought. His mission, which took thirty years to complete, resulted in the taking of over forty thousand images, a selection of which were brought together in his magnum opus, *The North American Indian*, a twenty-volume photographic and textual account of his adventures and studies. His purpose was to fuse science and art: anthropological-pictorialism was his game. Curious by nature and curiously mistaken. The races never vanished and his dual intention was doomed to failure on at least one count. Nonetheless, what we have is a pictorially sumptuous body of work that is still a powerful point of reference – albeit much tampered with, posed and manipulated for artistic effect – for Native and non-Natives alike.

PLATE 115

EDWARD S CURTIS

'Apache Maiden' (N'de) 1906

Photogravure from the folio accompanying Vol. I of *The North American Indian*, published 1907. Guildhall Library, Corporation of London

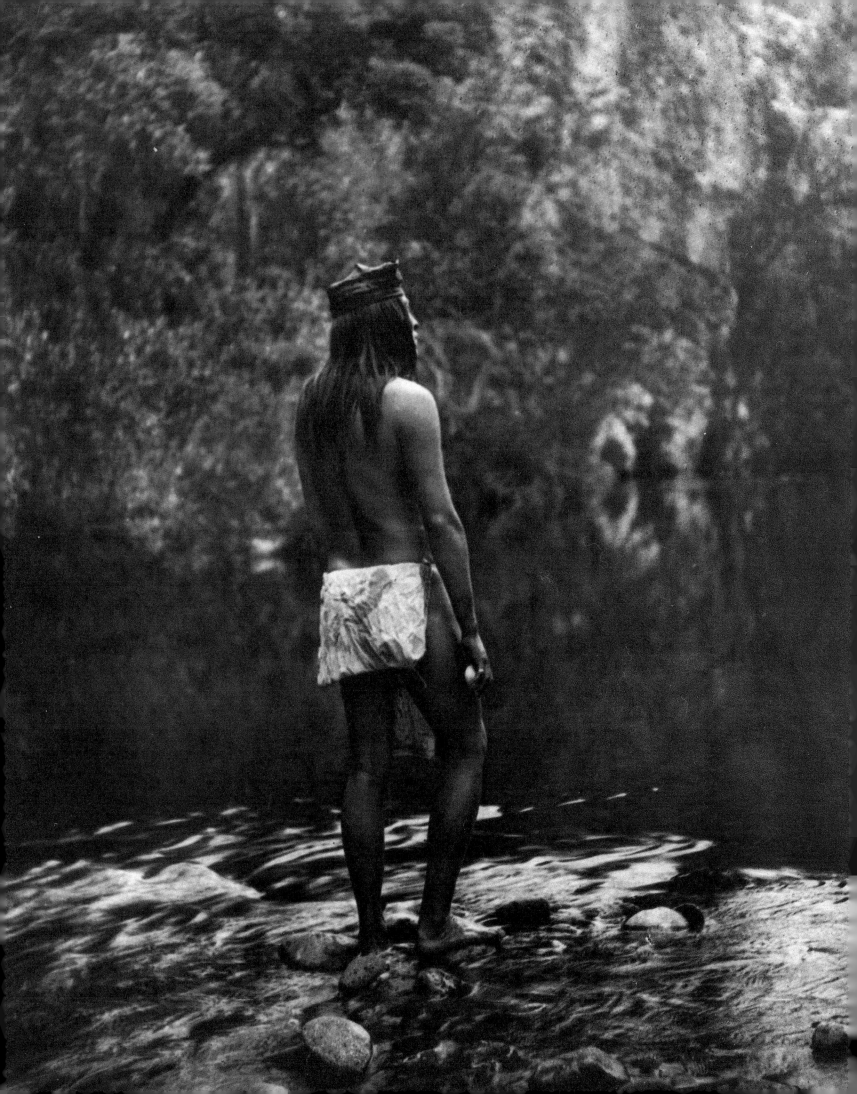

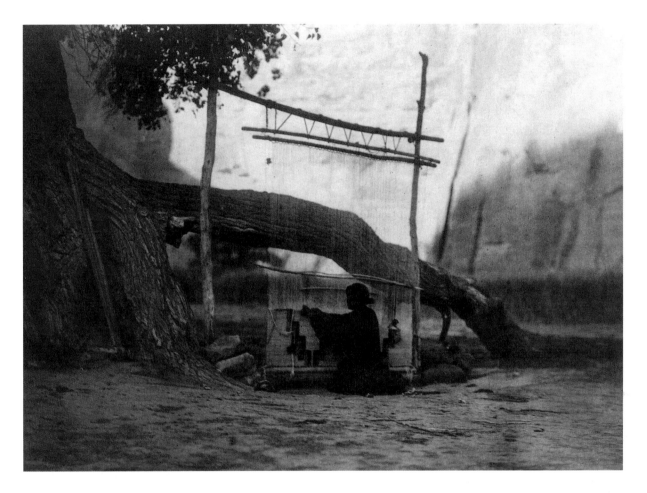

PLATE 116

EDWARD S CURTIS

'The Apache' (N'de) 1906

Photogravure from the folio accompanying Vol. I of *The North American Indian*, published 1907. Guildhall Library, Corporation of London

PLATE 117

EDWARD S CURTIS

'The Blanket Weaver – Navaho' (Diné) 1904

Photogravure from the folio accompanying Vol. I of *The North American Indian*, published 1907. Guildhall Library, Corporation of London

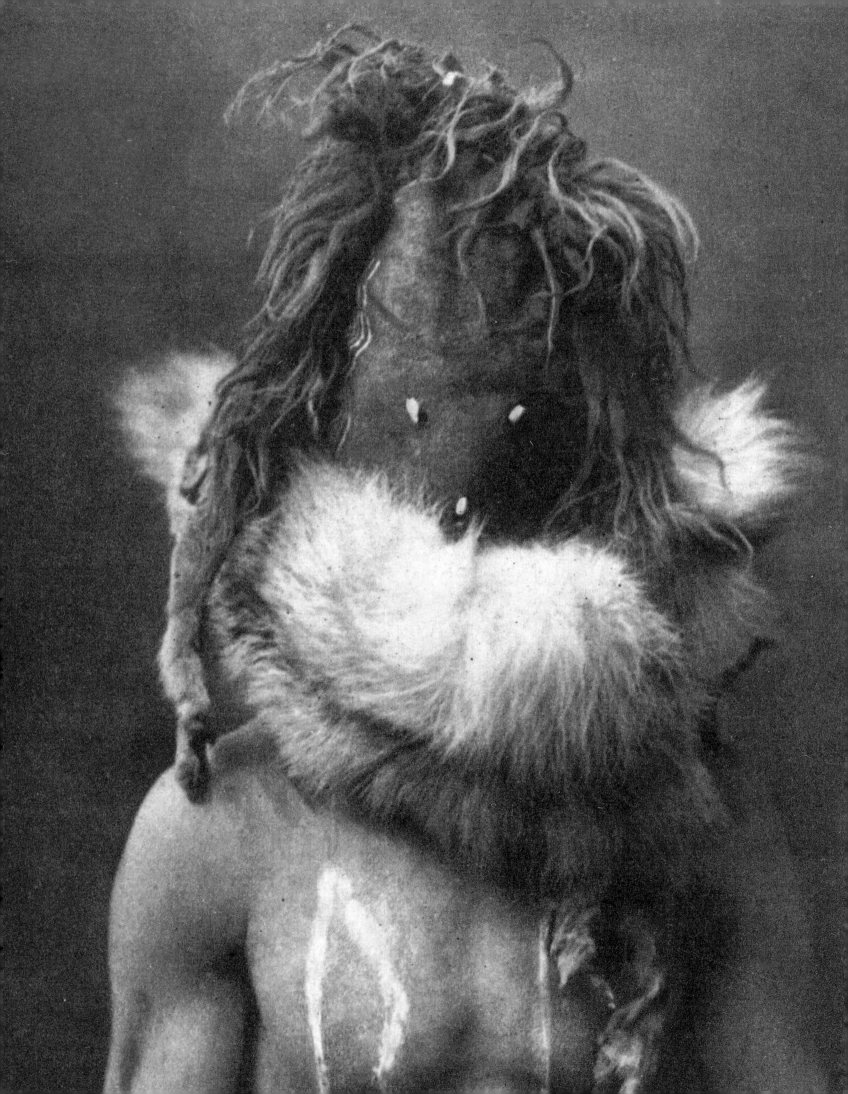

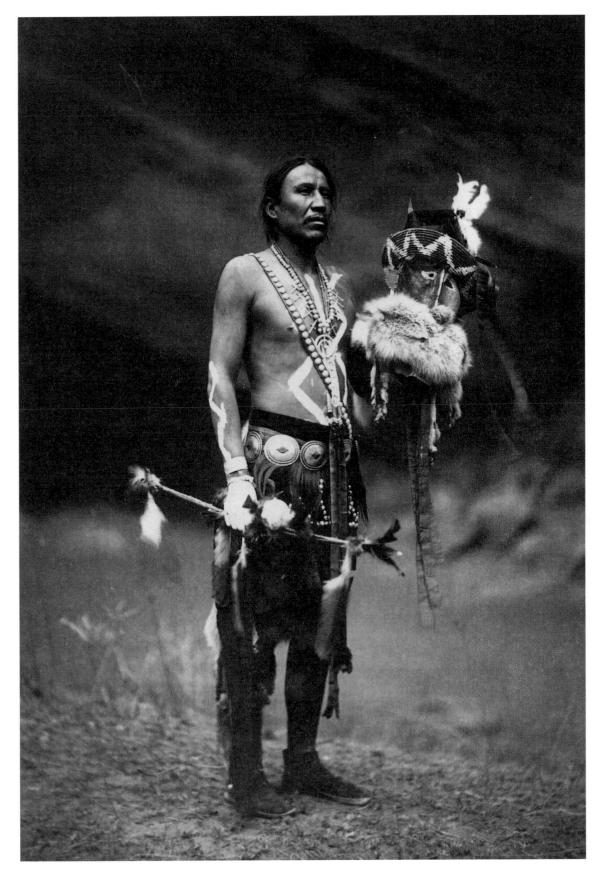

PLATE 118

EDWARD S CURTIS

*'Nayēnēzgani – Navaho'
(Dine´) 1906*

From Vol. I of *The North
American Indian*, published
1907. Guildhall Library,
Corporation of London

PLATE 119

EDWARD S CURTIS

*'Yebichai Za-Ha-Bol-Zi'
(Dine´) 1904*

Matt brown toned silver
gelatin print. The Wellcome
Institute Library, London

PLATE 120

EDWARD S CURTIS

'Two Whistles – Apsaroke'
(Apsaroke Crow) 1908

Photogravure from the folio
accompanying Vol. IV of
The North American Indian,
published 1909. Guildhall
Library, Corporation of
London

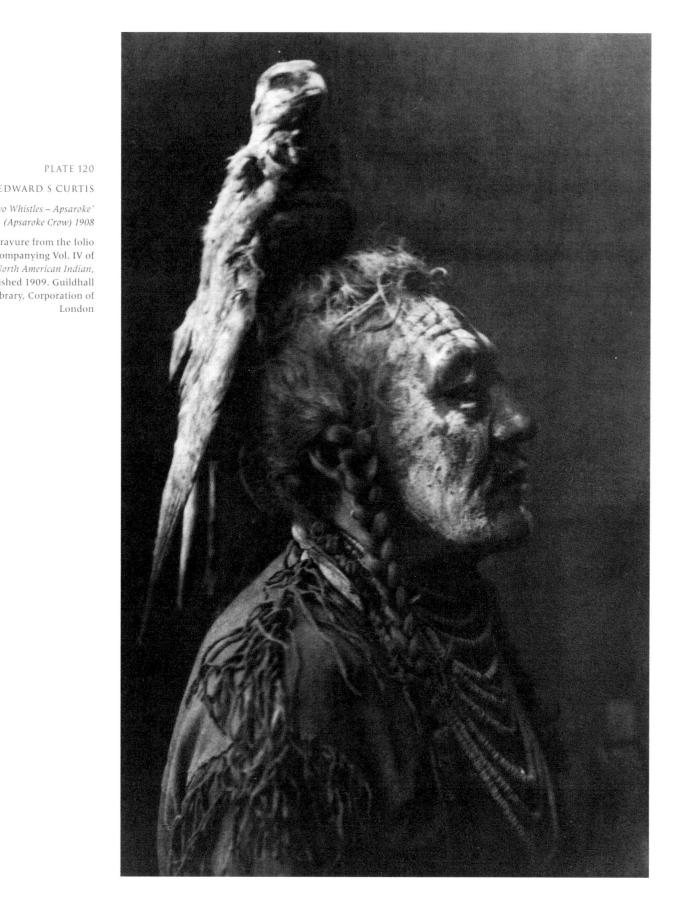

PLATE 121

EDWARD S CURTIS

'Waiting in the Forest –
Cheyenne' (Tististas) 1910

Photogravure from the folio
accompanying Vol. VI of
The North American Indian,
published 1911. Guildhall
Library, Corporation of
London

PLATE 122

EDWARD S CURTIS

'Tsawatenok Girl'
(Kwagiulth), 1914

From Vol. X of *The North*
American Indian, published
1915. Guildhall Library,
Corporation of London

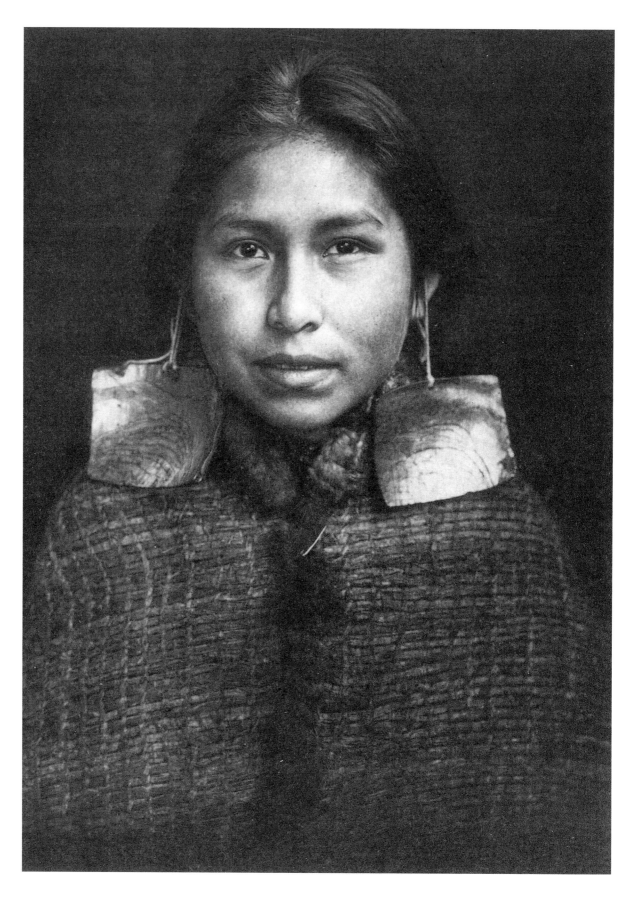

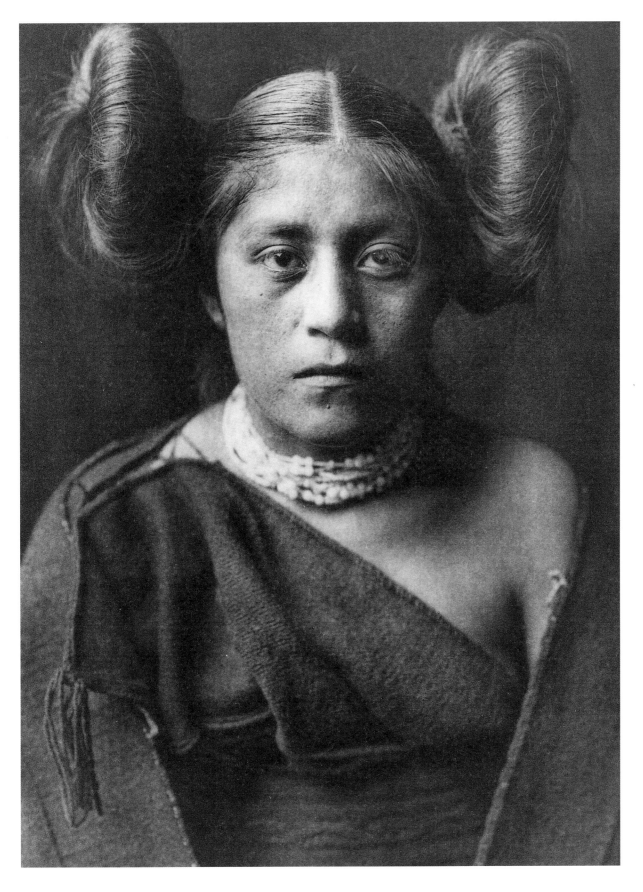

PLATE 123

EDWARD S CURTIS

'A Tewa Girl', 1921

Photogravure from the folio accompanying Vol. XII of *The North American Indian*, published 1922. Guildhall Library, Corporation of London

Opposite:

PLATE 125

EDWARD S CURTIS

'Watching the dancers – Hopi'
1906. Taken at Walpi Pueblo

Photogravure from the folio
accompanying Vol. XII of
The North American Indian,
published 1922. Guildhall
Library, Corporation of
London

PLATE 124

EDWARD S CURTIS

'The Water Carriers' 1921

Photogravure from the folio
accompanying Vol. XII of
The North American Indian,
published 1922. Guildhall
Library, Corporation of
London

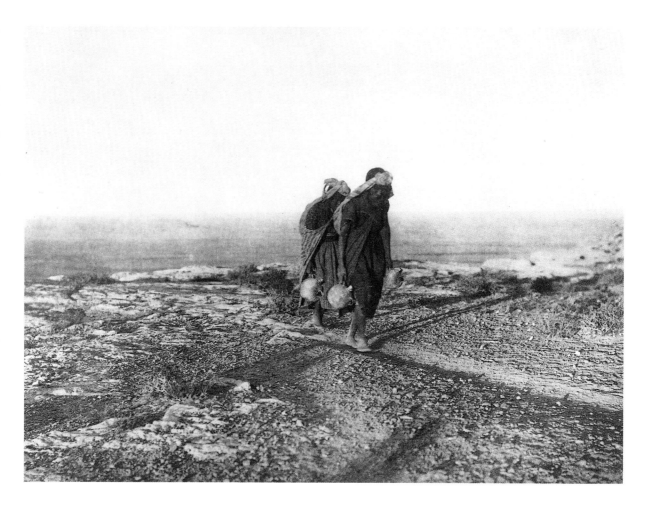

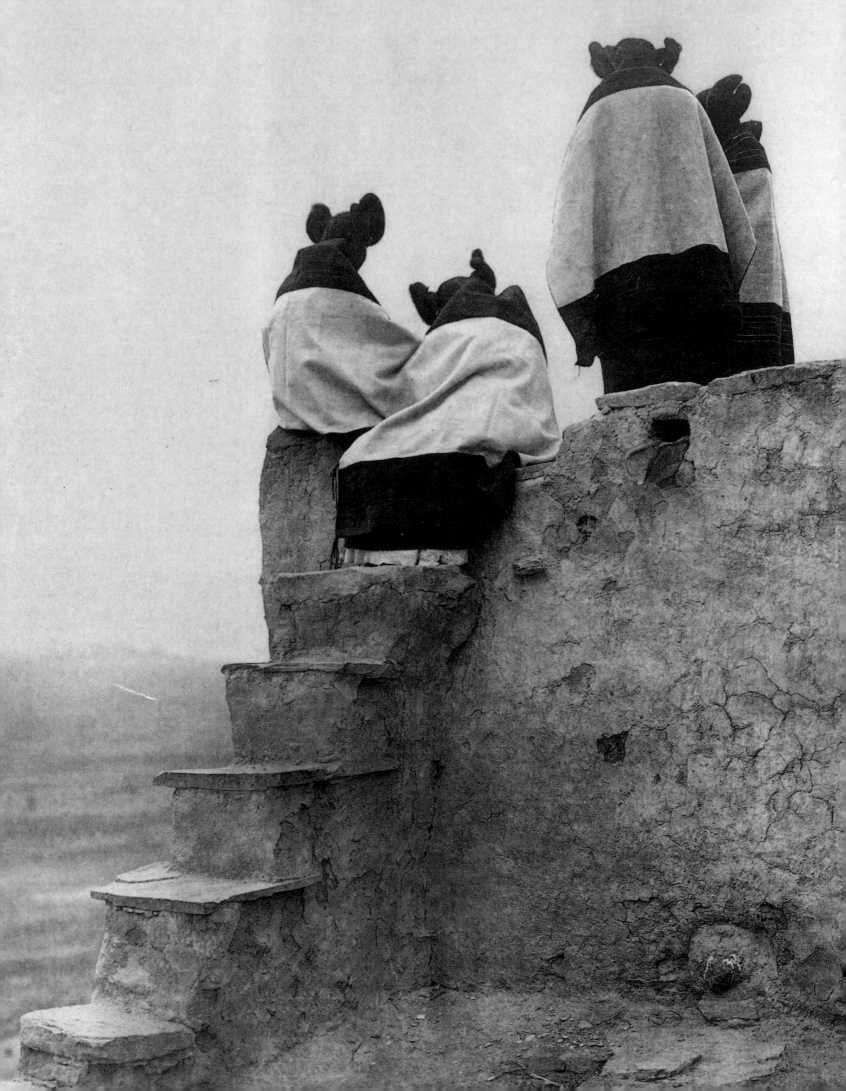

JOURNEYS

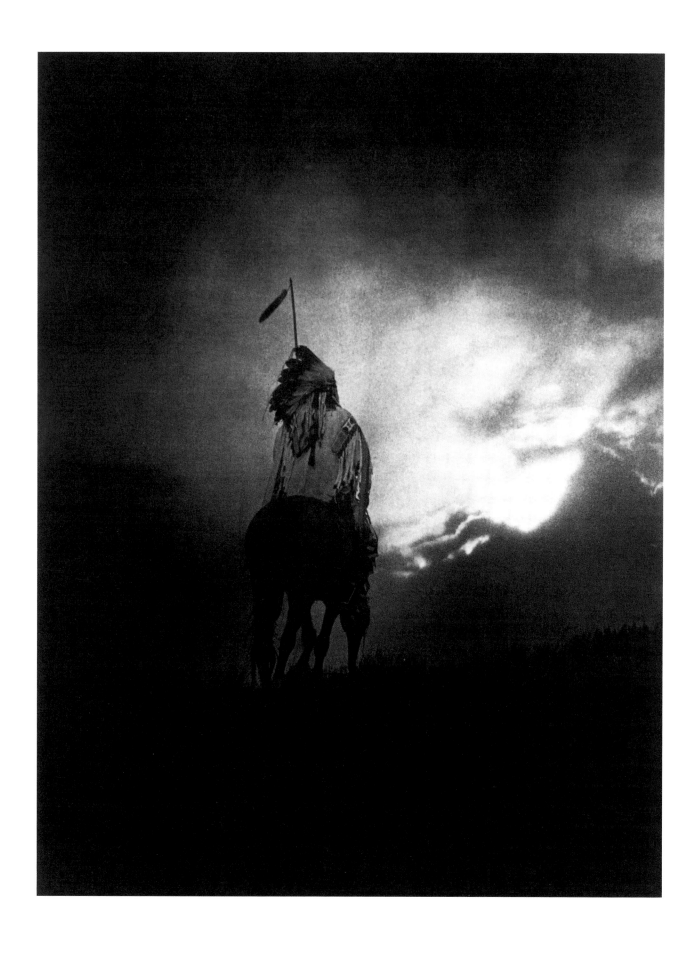

A HUNDRED YEARS IN THE LIFE OF AMERICAN INDIAN PHOTOGRAPHS

MICK GIDLEY

IN 1877, THE NEZ PERCE OF THE INTERIOR NORTHWEST fought a magnificent but ultimately losing campaign to preserve their right to their homelands in both Oregon and Idaho. In the course of the onslaught upon them – battles involving not just warriors but women, the elderly and children – they beat a strategic retreat over hundreds of miles. Chased by several armies, they crossed the Rocky Mountains, traversed the newly designated Yellowstone National Park, and only yielded as winter came on – to cannon, to cold and to hunger – a bitter few miles from the Canadian border and freedom. Under their spiritual leader, Chief Joseph, most of them were imprisoned on the southern Plains until, after much agitation, with support even from the generals who had defeated them, they were allowed to return to the Northwest. Once there, they were confined to the arid uplands of the Colville Reservation in eastern Washington, a reservation that already served both as home to a number of peoples indigenous to the area and as a dumping ground for other dispossessed groups. Joseph, an increasingly shrewd observer of Bureau of Indian Affairs personnel, instituted an annual gathering of any Nez Perces who wished to attend, both those who retained some of their own former lands as a reservation in Idaho and those exiled to eastern Washington. These annual assemblies at Nespelem, the Colville's Agency settlement – held to reinforce Nez Perce cultural identity – were scheduled, ironically, for 4 July, on the grounds that no US official could refuse Indian subjects the right to celebrate American independence. Joseph died in 1904, still in exile, and was reburied a year later under a small monument erected, with Nez Perce permission and participation, by certain white well-wishers.[1]

In 1977, a hundred years after the Nez Perce war, I set out for the Colville with a file of photographs taken in Nespelem around the turn of the century by Dr Edward Latham, the Agency physician. I did not know much about Latham, but I had realised he was the unnamed 'doctor' historians frequently credited with declaring that Joseph had died of 'a broken heart' because he had not been allowed to return to live in his

PLATE 126

JOSEPH KOSSUTH DIXON

'Sunset of a Dying Race'
after 1908

Modern print from a negative in the collection of the National Anthropological Archives, Smithsonian Institution

153

beloved Wallowa Valley in Oregon. (I later discovered that Latham was not even in Nespelem when Joseph died, and had talked to regional newspapers a little later in an attempt to sell some of his pictures of the Chief; but, as one of film director John Ford's characters says: 'This is the West, sir. When the legend becomes fact, print the legend.') I also did not know much about the Colville or the Native Americans who lived there. I had a vague sense of their complex histories but knew nothing of their equally complex current situation. I also did not know much about photography: I was deeply into researching it, but still thought of it either as an art form or as an incontrovertible record. I had, though, been reading letters by Latham, and had managed to match some of his identifications in those letters with a few of the subjects in the file of his images that the University of Washington library had recently acquired. These pictures, obviously related one to another, were potentially a collection, but without more complete identifications and more contextualisation, they were just random photographs. I had new prints made from the glass negatives and I annotated some few of these in pencil on the back. I needed help from Indians at Nespelem who might have memories of Latham's subjects. The best time to make contact, I thought, would be during the 4 July celebrations still held at Nespelem, so, accompanied by my wife and two small children, I set out to camp there for the duration of the festivities.

When we drove into Nespelem on a very hot, dusty day, the settlement seemed more like a ghost town than the Agency headquarters. The wooden buildings appeared mostly empty, and there was no one about. But I spotted an old man sitting on the doorstep, between the jambs, of a doorframe of a house that had otherwise fallen down. He was whittling wood, but seemed lost in his thoughts. I got out of the car, and felt physically assaulted by the heat of the wind as I walked up the path towards him. I said, 'Could you tell me where Chief Joseph's grave is, please?' He looked up at me. After a long pause, he said, 'I'm one of Joseph's people.' 'I know you are', I responded, 'you're Elijah Williams. I've got your picture.' He was astonished, and so was I. But the contours of his face, the look of his eyes, the imprint of his particular personality, were so distinctive that he was still recognisable as the same person that Latham had photographed and identified as a small child some seventy years earlier. I walked back to the car, the family alighted to seek shade under a nearby tree, and I pulled out the box of photographs. When I found Elijah's (pl.127), he gazed at it in bemusement for some time, then he said, 'Doctor took that picture.' Then, a wonderful thing happened: the next photograph in the pile, unidentified, depicted a proud-looking, powerful man atop a painted pony. 'That's my father, Chief David Williams,' Elijah murmured, and I could see that he was affected by the shock of recognition.

During the next few days, while we camped on the edge of the circle of tipis and tents that went up to the side of the main celebration area, in gaps of time between the dances, games and horse races, children would come up to me and say, 'Mister, are you the man with the pictures? My Grandma wants to see you.' I sat, pencil at the ready,

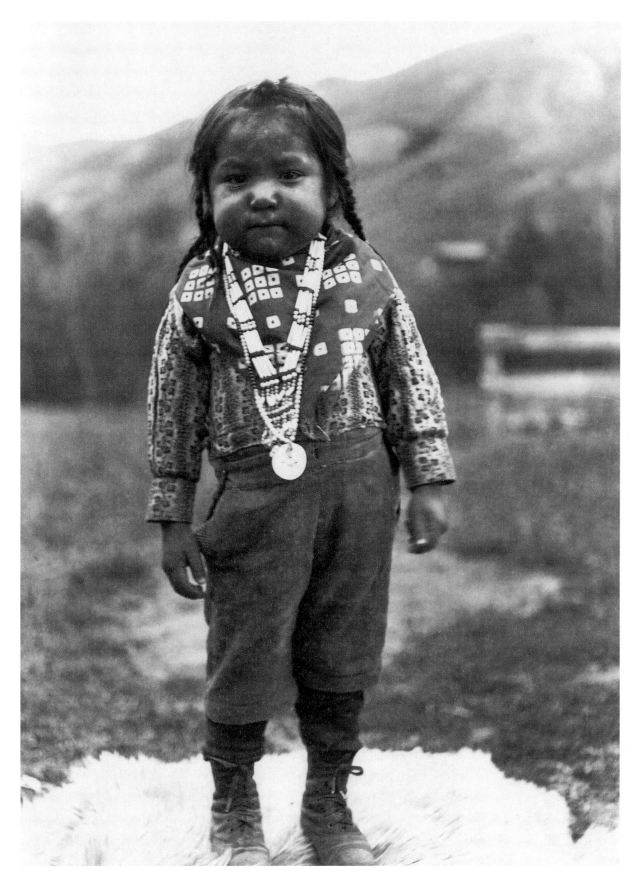

PLATE 127

DR EDWARD H LATHAM

Elijah Williams, c.1904

Modern print. Courtesy of the author

PLATE 128

ALEXANDER GARDNER

The Peace Commission Treaty members in negotiation with Tististas [Cherokee] and Hinano'ei [Arapaho] representatives, Fort Laramie, Wyoming, 10 May 1868

Silver gelatin print. National Anthropological Archives, Smithsonian Institution

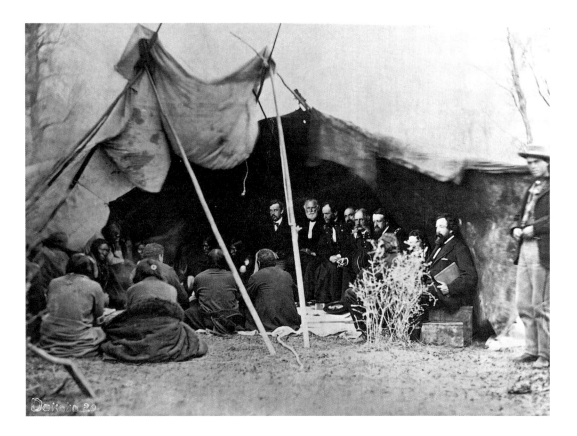

PLATE 129

WILLIAM S SOULE

Ralph Morrison, a hunter, photographed within an hour of being killed and scalped by Tististas [Cheyenne] Natives, near Fort Dodge, Kansas, 7 December 1868

Modern print from a negative in the collection of the National Anthropological Archives, Smithsonian Institution

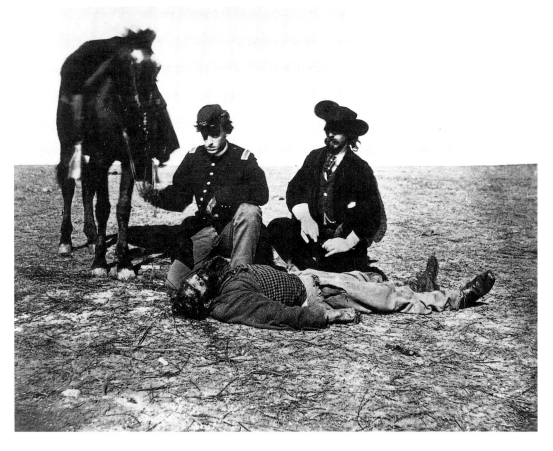

with elderly people – and, sometimes, with younger ones, either as independent informants or as interpreters for older folk – and wrote down what they told me. I remember well another session with Elijah, when he related some of his own experiences, and, especially, one with Annie Owhi. I calculated that Annie was terribly old, and she had an extraordinary memory: when she looked at the pictures, she would come out immediately with the names of people she knew, and if she did not recognise anyone she said nothing at all. It was possible, too, in the circumstance of the 4 July gathering, to cross-check the identifications – and, equally crucially, as I began to realise, the stories that accompanied the identifications. In fact, the data I gathered was so richly informative that, complemented by research in the Agency archives and other library collections, I was able to weave a book from and around the photographs; using a phrase from Joseph's most famous speech, I titled it *With One Sky Above Us: Life on an Indian Reservation at the Turn of the Century*.[2]

For the remainder of this 'journey', I do not intend to be so autobiographical, but several of the same emphases – the need to contextualise, the contingent nature of the photograph, its connection to memory, the uses to which it might be put, the role of other media in determining significance, and the ways in which this significance may change over time – will recur. I wish the journey could be longer: as an academic, concerned to try to understand complex issues, I am acutely aware that any selection of images cannot claim to be representative. Since photography is a mass medium, the selection is inevitably incomplete, a simplification, and risks being arbitrary; it must, in every sense, be partial. With white American expansion westwards in mind, Susan Sontag wrote, 'Faced with the awesome spread and alienness of a newly settled continent, people wielded cameras as a way of taking possession of the places they visited.'[3] In this overarching context, photography was part and parcel of a colonising movement which not only took possession of land from Native Americans but also appropriated – or attempted to appropriate – their cultures. Indians themselves did not generally 'wield cameras' and so were almost as powerless to keep control of the images made of them as they were of the land they had inherited. I would have liked to visit some photographs taken by Native Americans, but decided not to do because – however interesting and effective these are in countering American (or, more strictly, 'white' American) imagery – the dominant American imagery is still too often seen as an unbiased, incontrovertible record. I want to show that it was never that.

At the very least, American images of Indians more readily reflect the assumptions of the culture(s) of their makers than those of their subjects. If we look at Alexander Gardner's view of the Fort Laramie treaty council in 1868 (pl.128), for example, the controlling presences within the frame, the apparent focus of the picture, are the seated white officers, not any of the distinguished Tististas [Cheyenne] and Hinano'ei [Arapaho] leaders present. In fact, though they were gathered there on seemingly equal terms to the white negotiators – and at a previous treaty council had won a right to the

land under dispute that was apparently still binding – in Gardner's photograph they seem to sit at the officers' feet; they become – as was often claimed by white treaty-makers – the 'children' of the President, who is represented by the negotiators. As it happens, on the same occasion Gardner did make some images looking the other way, as it were, in which the Native American presence is stronger, but it is telling that the one reproduced here has survived as *the* record of the event. Whatever the intentions of the photographer – and these are usually unknowable in any case – we often find complete congruence between what seems an almost inevitable reading of the particular photographic text and its expansionist context.

One of Timothy O'Sullivan's 1871 views for the Wheeler Expedition (pl.130) is more ambiguous. Originally titled *Sleeping Mohave Guides*, it depicts expedition geologist Grove Karl Gilbert sitting almost upright on a rock in the middleground while three near-naked Mojaves lie somnolent on the sandy floor of the desert below him. The frame is extended sufficiently to include the sleeping figures and the image seems to have been titled with them in mind. It is tempting to read the picture as a kind of sideways prefiguration of the same photographer's 1873 depiction of some N'de [Apache] dotted around Arizona's Apache Lake, an image that underlines the way Indians were at one with – and could almost dissolve into – an ostensibly hostile natural environment. The vantage point certainly makes us look at these surrealistic Mohaves, perhaps makes us wonder whether they are alive or not, but it also speaks graphically of Gilbert's dominance of his surroundings: the earth scientist – whose very body-language seems to indicate thoughtfulness – considers the landforms, flora and fauna of the Californian desert, including the American Indians. Viewed in this way, the Mohaves are merely incidental to the 'real' action; they are, literally, marginalised.

The images I have discussed so far were first reproduced for larger audiences in ways that did not much alter or emphasise their 'meanings', if I can use such a loaded word. Sometimes, though, this was not the case. Let me give three examples. In 1868, during the Plains wars, army-employed photographer Will S. Soule took a picture of the corpse of a white hunter who had been scalped by hostile Tististas [Cheyenne] near Fort Dodge in Kansas (pl.129). The head of the scalped man is towards us, and we can discern from its shininess that something untoward has been done to it. The interesting thing is that Soule, by getting closer to the body, could have made the image more sensational, more of an object lesson in the 'savagery' of the American Indian enemy. But if he had done that it would have been difficult also to contain within the frame the two cavalry personnel who seem, in turn, to be vigilant, ready for action. The emphasis is on the juxtaposition of depredation and response, on the presence of the army. And in fact, when the image was reproduced as an engraving in an illustrated magazine of the period, this selfsame emphasis was not just apparent, it was pointed up in the captioning. Whatever the precise allocation of responsibility for the original interpretation of such an image – between photographer and (living) subjects, between

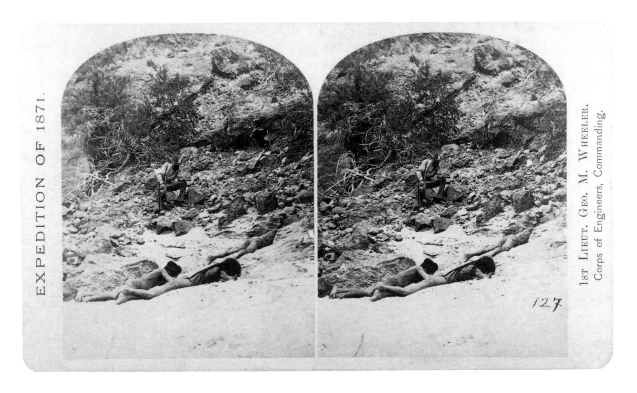

PLATE 130

TIMOTHY O'SULLIVAN

Stereograph no 10 from the series 'Geographical Explorations and Surveys of the 100th Meridien; Mohave Indians caught napping.' From the Wheeler Survey 1871-79

Albumen stereograph. National Anthropological Archives, Smithsonian Institution

PLATE 131

A J McDONALD

N'de [Apache] prisoners,
including Geronimo, in transit
to Fort Sam, Houston, Texas
and Fort Marion, Florida, 1886

Modern print from a
negative in the collection of
the National
Anthropological Archives,
Smithsonian Institution

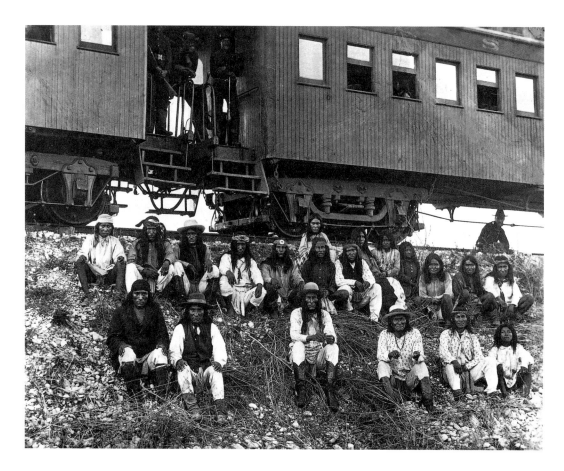

PLATE 132

JOHN C GRABILL

Sicangu [Brule] Lakota village
near Pine Ridge, South Dakota,
1891

Modern print from a
negative in the collection of
the Library of Congress

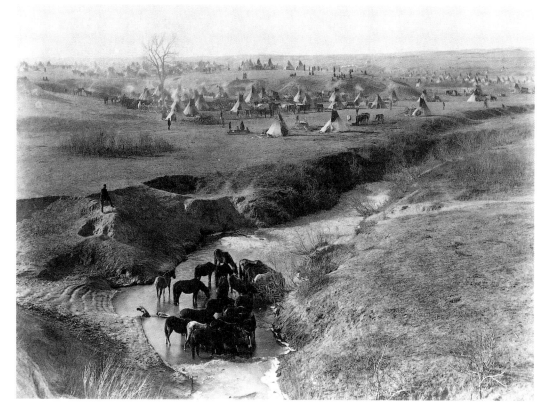

photographer and engraver, and between either and magazine editor – the image was used to canvass support for the army's role in the West. As an example of visual rhetoric, it supported the assumptions of those who were politically dominant in American society.

The same could be said of the famous shot of the defeated Chiricahua Apache leader Geronimo taken in 1888, probably by an army lensman, during a break in the long train journey towards incarceration in humid Florida, far from the N'de [Apache] homeland in the dry Southwestern borderlands (pl.131). The image includes both Geronimo (third from the right, front row) and some of his followers. He is not picked out or highlighted in any way. Indeed, the picture makes him diminutive, indistinguishable from the other Indians, each dressed similarly, and one can imagine that the effect of the image on its original viewers would have been to cut the feared and famous Geronimo down to size, as it were. However, in partial contrast to the Soule image, the Geronimo photograph has elements that – in the light of later events – could lead the modern viewer towards, if not fully to, a different reading. Fairly prominent within the frame are two of the train wagons in which the captive Indians were transported to their punishment. Each of these wagons is not quite a cattle truck – since the Holocaust one of the icons of modern state-sponsored murder – but it is visually analogous, and now that more present-day people appreciate the scale of Native American destruction at the hands of the American government, it may actually be seen for what it was, a mechanism of genocide.[4] I am suggesting that there is a subtle tension between the meaning of the image to us now and its meaning as it was originally conceived and received.

We do not know enough about the maker of the Geronimo image to speculate on individual motives, but in the case of self-made entrepreneur John C. Grabill, such considerations are definitely warranted. Grabill had a sense of history: realising that changing times would endow such pictures as 'The Last Run of the Deadwood Stage' (1890) with enduring interest, he copyrighted them. His *Villa of Brule* (pl.132), sometimes titled 'The Great Hostile Indian Camp on River Brule near Pine Ridge, South Dakota, February 1891', represents not just a large and beautifully composed winter landscape with American Indian figures, but the final free days of the Sioux nation. They had fled their reservation in the wake of Sitting Bull's assassination and the notorious army massacre of Big Foot's band at Wounded Knee, but soon afterwards they were rounded up by General Nelson Miles and transported back to the reservation. In this image, made in the interim, Grabill's opportunism – no matter what position he thought he was adopting – enabled him to provide testimony to a people's very last voluntarily chosen domicile. But in this case, perhaps not surprisingly, the stress I am giving to his image could so easily be lost. The image has in fact been reprinted several times as if it depicted nothing more than numerous tipis, an icy stream and picturesque ponies. It is only the inclusion of a careful narrative that releases what I am claiming is its deeper significance.

PLATE 133

FRANCES BENJAMIN
JOHNSTON

*'Class in American History'
1899, from the Hampton Album
of the Hampton Institute*

Modern print from a
negative in the collection of
the Library of Congress

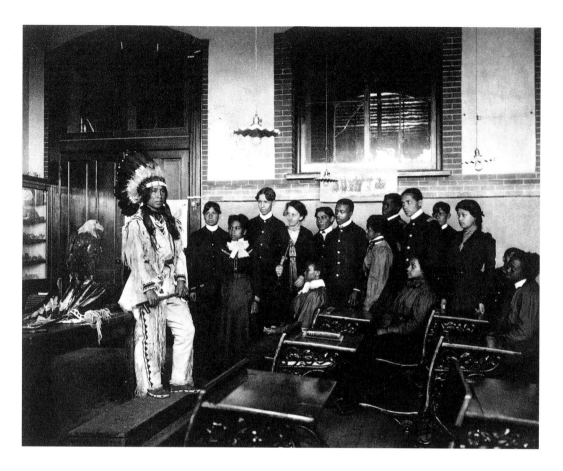

PLATE 134

GEORGE WHARTON
JAMES

*The Hopi Snake dance obscured
by onlookers and
photographers, Walpi Pueblo,
Arizona, 1891*

Albumen print. National
Anthropological Archives.
Smithsonian Institution

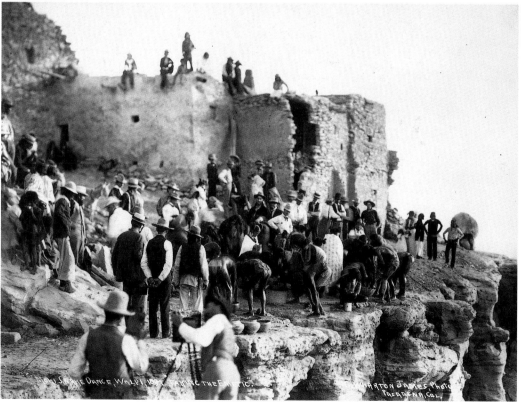

After the so-called Indian Wars were over, and the Dawes Act of 1887 – which was designed to extinguish communal ownership of reservation lands by allotting small parcels of it to individuals (enabling the 'surplus' land to be sold off cheaply to whites) – had begun to be enacted, the Bureau placed renewed stress on policies of 'assimilation'. This was the context in which Frances Benjamin Johnston, perhaps the first ever professional woman photographer, was invited in 1899 to document the Hampton Institute, a Virginia trade school for the descendants of former slaves and for Indians on the way to becoming 'citizens'. Johnston was very precise in her selection of captions for the resulting Hampton Album, so there is a marked pathos to *Class in American History* (pl.133). Here African American and Indian students gaze from the side of the classroom at a young Indian in full regalia. On the one hand, he is peacefully composed and the very embodiment of cultural pride; on the other, he is an exhibit from the past, 'history', and the other students' unsmiling faces hint at their – perhaps reluctant – acknowledgement of this 'fact'. What initially might seem an excessive amount of space in the foreground serves to accentuate our sense of the alienation of the befeathered figure, carved ceremonial pipe in hand, set alongside artefacts of material culture as if he, too, is a display. As viewers, we are able to move, visually, into the empty desks and participate in the enactment of a silent and tragic tableau vivant.

Johnston's Hampton Institute photographs were widely disseminated; they were even exhibited at the Paris Exposition of 1900. While *Class in American History* is actually about the problematic nature of assimilation in the then present, Indians more commonly elicited widespread interest for their presumed primitivism, or as they seemed to recede into the past. The less they were associated with the present, the more they became picturesque subjects. Nowhere is this more apparent than in photographs of the Snake dance of the Hopi of northern Arizona, which was often described as a sensational spectacle. Richard B. Townshend, an Englishman who witnessed it, said of one of the dancers: 'He actually was carrying a great live rattlesnake in his mouth,… and the flat venomous head wandered inquisitively up and down his cheek and in around his throat, and round his ear, as if seeking where to hide.' George Wharton James, who wrote a book about the ceremony, photographed dancers with rattlers and diamondbacks suspended from their mouths. He also captured them taking an emetic to make them vomit afterwards (pl.134) – not, as is commonly supposed, to rid themselves of venom, but as a spiritual purification rite. The Snake dance essentially enacts and symbolises mankind's need to have a right relationship with the whole of the natural world; if harmony is possible even with seemingly inevitable 'enemies', it is achievable throughout nature and the rains will come to the desert, the crops will grow, and life will fulfil itself.[5]

But, of course, to many observers the appeal of the dance lay not in its spiritual import, but in its apparent flirtation with danger and death and in its undoubted colour and spectacle. At any rate, from about 1883 onwards, it was increasingly photographed.

PLATE 135

EDWARD S CURTIS

'Chief Joseph – Nez Perce' 1903

Photogravure from the folio accompanying Vol. XIII of *The North American Indian* published 1911. Guildhall Library, Corporation of London

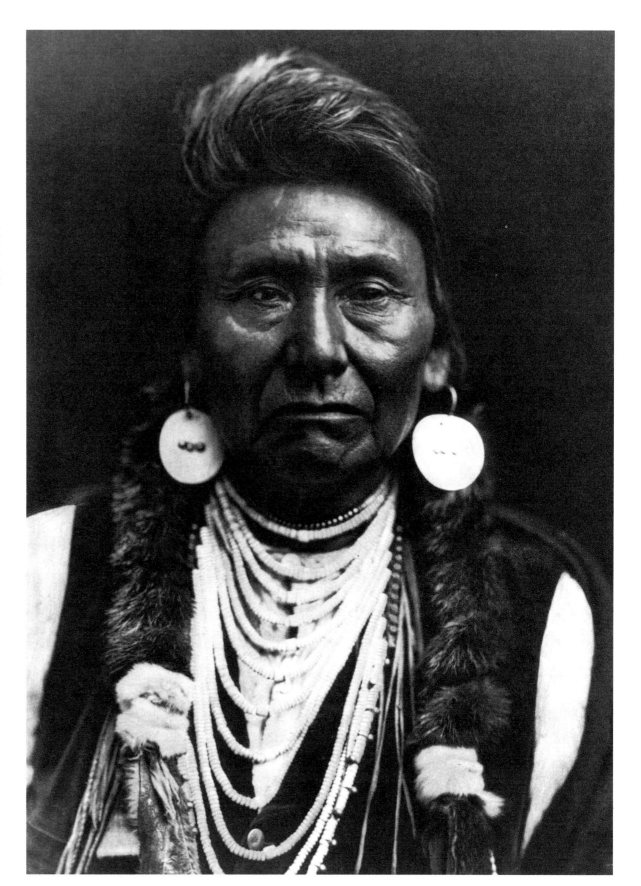

James, who depicted it in 1891, complained bitterly that other photographers hampered his own work. In one of Adam Clark Vroman's much-reprinted 1900 images of the rites, at the end of a line of Antelope dancers waiting for the Snake priests – indeed, at the focal point of the image – there, with tripod and gear, is another equally serious photographer. Townshend took two cameras on his 1903 trip and to his verbal description of a notably awe-inspiring moment in the ceremony he added: 'But you could hear our cameras snap.' In 1904 Edward S. Curtis, *the* 'photo-historian' of American Indians, even took movie footage of the dance. In James's image, a number of cameras are to be seen. Basically, improved road and rail links, increased settlement in the Southwest and the availability of inexpensive Kodak roll-film cameras, all led to turn-of-the-century Snake dances being covered by view-finders from numerous angles. In effect, by this point, the age of tourism was on the verge of reaching the Southwest and the Hopi were coming to be seen as a primary attraction. Thus, in James's image of the emetic being taken, the priests, though centrally located within the frame, are almost lost among the throng of onlookers, many of whom are white. It is not surprising that, in such a situation, Native American ceremonies were thought of as threatened by white incursions and, indeed, Indians themselves were evermore frequently considered as an endangered species, a 'vanishing race'.[6]

This powerful and oft-repeated notion of Indians has a history too elaborate to summarise here, but, as well as crucially determining actual government policy towards them, it also affected anthropology and the various other means by which the cultures of indigenous people were represented, including, of course, photography. Perhaps the most plangent and melodramatic images of Indians as a vanishing race were produced by Joseph Kossuth Dixon for the 'expeditions' funded by the heir to Wanamaker's department stores in Philadelphia and New York.[7] Witness his *Sunset of a Dying Race* (pl.126), taken during the teen years of the century, with its archetypal horseman, with feather head-dress and coup stick in hand, almost central in the frame. He is – as any figure in a photograph must be – still; yet he is also in motion, moving away from us with his back to us, riding towards the effulgent circle in the sky, as if he will be taken up into the heavens. Indeed, for the final illustration in his book *The Vanishing Race* (1913), Dixon chose *The Empty Saddle*, a photograph of two Indian ponies left riderless on the windswept plain, as if to signify their owners' demise.

Edward S. Curtis was probably the single most important and influential photographer of Indians. Though he did not write the bulk of it, he was the prime mover behind his *The North American Indian* (1907-30), twenty volumes of illustrated text and twenty portfolios of photogravures, and he produced magazine articles, children's texts, an elaborate 'picture-opera', movies and countless still images. He was more restrained, more subtle, and more various than Dixon in his fusion of the aesthetics of photographic pictorialism with the ideology of the vanishing race. True, there seems to be an initial similarity: Curtis's 1904 keynote image *The Vanishing Race*,

for example, rather obviously presents a line of Navajos receding from us into the darkness of a canyon, the penultimate figure turning in the saddle as if to look back at us with regret. Curtis himself believed that, in general, Dixon plagiarised his ideas, his use of symbolic titles and his photographic style, and insofar as Dixon's work suggests that this was the case, it is further testimony to Curtis's centrality.[8] When Curtis's vast photographic output was 'rediscovered' in the 1970s, it was at first lauded as an accurate and affirmative record of Native American life. When this view was questioned, it tended to be replaced by its opposite: Curtis, often fraudulently, had marketed a dangerous illusion of stage Indians that bore little relation to the actual peoples he had encountered. Needless to say, I think the truth lies somewhere between, and on this occasion, in order to complete my journey by looking at a photograph which has some connection to that with which I began, I want to examine one of Curtis's more straightforward images: a portrait of Chief Joseph.

It was taken in November 1903, not out in the field at Nespelem but in Curtis's studio, when Professor Edmond S. Meany of the University of Washington brought the Chief to Seattle so that he could try to gain support for his campaign to be allowed to return to his Oregon homeland. Joseph made eloquent and, apparently, well-received speeches at the University and to the general public. He was both fêted and maligned by the press. On the final Sunday morning of the visit, he was taken to Curtis's studio. Curtis first made group portraits, with Meany and with Joseph's nephew Red Thunder. Next, according to the local newspaper, Curtis 'took [a] picture of the chief wearing the elaborate head-dress, and then he had Joseph take off his feathers for a picture of the plain head'. This image (pl.135) is haunting. The camera is close in, and there is no discernible background, so that – beads and earrings apart – the head is indeed 'plain': as viewers, we both look directly at Joseph and are confronted by him. Curtis, apparently, would have preferred to have caught him unawares, 'thinking only of his wrongs'.[9] But here Joseph is unmistakably aware. Therefore, once we acknowledge his identity – and for many of us this means also acknowledging his otherness – the image compels an interaction. Photographs such as these do constitute a historical record, but it is not a record of an unchanging truth. It is, at least partly, a record of our own responses – perhaps changing over time – to a deeply troubling history.

NOTES

1 Details in Mick Gidley, *Kopet: A Documentary Narrative of Chief Joseph's Last Years,* Seattle and London: University of Washington Press, 1981.

2 Gidley, *With One Sky Above Us,* London: Windward; New York: Putnam's, 1979; repr. Seattle: University of Washington Press, 1985.

3 Sontag, *On Photography,* Harmondsworth: Penguin, 1979, p.65. Valuable collections and studies of the photography of Indians include Joanna Cohan Scherer, Indians: *The Great Photographs that Reveal North American Indian Life,* 1847-1929, New York: Crown, 1973; and *The North American Indians in Early Photographs,* New York: Barnes & Noble, 1986 and *Grand Endeavours of American Indian Photography,* Washington, DC: Smithsonian Institution, 1993, both by Paula R Fleming and Judith L Luskey. I have written more fully on the topic in 'The Figure of the Indian in Photographic Landscapes', in Gidley and Robert Lawson-Peebles, eds, *Views of American Landscapes,* Cambridge and New York: Cambridge University Press, 1989, pp. 199-220. Information in this essay has been taken from these texts or results from research in primary sources too numerous to cite.

4 See also Tsinhnahjinnie, Hulleah, in this volume

5 Townshend quoted in Gidley, 'R B Townshend's 1903 Snake Dance Photographs in Context', European Review of Native American Studies, 1:2, 1987, 9-14; quotation, p.9. James, *Indians of the Painted Desert,* Boston: Little Brown, 1907.

6 Townshend quoted in Gidley, 'R B Townshend', p.10. For a full treatment of the idea of the vanishing race, see Brian W Dippie, *The Vanishing American: White Attitudes and US Indian Policy,* Middletown, CT: Wesleyan University Press, 1982.

7 A penetrating recent discussion of Dixon may be found in Alan Trachtenberg, 'Wanamaker Indians', Yale Review, 86:2, 1998, 1-24.

8 For Curtis in general, and for connections with Dixon, see Gidley, *Edward S Curtis and The North American Indian, Incorporated,* New York and Cambridge: Cambridge University Press, 1998.

9 Post-Intelligencer, quoted in Gidley, *Kopet,* p.59.

PLATE 136

ADRIAN J EBELL

White people escaping from the Riggs and Williamson missions near the upper agency, during the Sioux Revolt of 1862

Albumen stereograph. National Anthropological Archives, Smithsonian Institution

'A PORTION OF THE PROMISES MADE TO US HAVE NOT BEEN FULFILLED': LITTLE CROW AND THE SIOUX REVOLT

PAULA RICHARDSON FLEMING

THE STUDY AND RESTUDY OF VINTAGE PHOTOGRAPHY has developed rapidly in the last thirty years. Once photographs were viewed as 'never lying' and 'worth a thousand words'. When researchers realised that photographs were useful as historical resources, the first task was to make sure that the basic questions of 'who? what? where? and when?' were correctly answered before the 'why?' could be attempted.

Scholars have now engaged photographs on new levels, answering some of the 'whys?' and demonstrating that the photographers and sometimes the subjects themselves are factors in framing the photographic story that is presented to the viewer, whose own background and reactions are also relevant. Postmodernistic interpretations of photography have thus provided insights into images and opened up new avenues of discourse, but as with any trend we must step back and see where we are going as well as where we have been.

Obviously we can no longer view the camera as an impartial 'truth' unit that provides an unbiased view of the world. Our eyes have been opened, but we must guard against getting carried away with our newly found understanding and losing sight of the basics. Our viewpoint can become so distant that we are in danger of not being able to see the proverbial wood for the trees. We must make the photographs live again by remembering the basic stories surrounding their creation. Photographs documenting the tragedies of war are highly emotive windows. Today we can visualise incidents in other parts of the world by turning on the TV, or reading photographically illustrated reports, but in the 1800s, newspapers and magazines were illustrated only with line drawings, if at all. Photographs, especially stereographs (the 'virtual reality' of the day), provided the mode by which people put faces on stories they read. No doubt each viewer reacted differently and as for the photographer, other than a profit motive, we probably cannot document what compelled them to make their portraits. Ultimately, many of these images acquired an exotic appeal and were used for anthropological purposes but their original creation was most likely as a photo journalistic endeavour

PLATE 137

ADRIAN J EBELL

'Squaws guarding Corn from blackbirds... this picture was taken near the Indian Mission on the Minnesota River on the morning of the day of the massacre of 1862'.
No 70 from the series 'Gems of Minnesota Scenery'.

Albumen stereograph. Sir Benjamin Stone Collection, Birmingham Central Library

PLATE 138

ADRIAN J EBELL

Dr Thomas S Williamson (in white hat) with his wife (also wearing hat) with Sioux Natives in front of the Mission house at Yellow Medicine, Sunday 17 August 1862. The photographer himself later fled alongside the subjects of the photograph.
No 69 from the series 'Gems of Minnesota Scenery'

Albumen stereograph. Sir Benjamin Stone Collection, Birmingham Central Library

Squaws guarding Corn from Blackbirds.

providing a focus for stories in the news.

As a case in point, I offer a series of photographs taken mainly in 1862 and 1863. These photographs are not outstandingly artistic, they are faded, and not very eye-catching, yet they document a series of incidents on the Plains that killed more people than the Custer Battle and Wounded Knee combined. Nearly five hundred whites, mostly settlers, would be killed, and hundreds more taken hostage. Twenty-three counties in Minnesota would be virtually depopulated and nearly six thousand Native American Indians living on reservations would either flee the area, be imprisoned, or executed. Yet very few people have ever heard of the Sioux Revolt, or as it is sometimes called, the Minnesota Uprising.

My journey is to make these images live again by using the words of the original participants as much as possible to tell the events surrounding this. It is an emotional journey, yet it is not an apology for wrongs done to either side. Rather it is written with the hope that we will not get overly involved in interpretation and lose sight of historical context.

In 1858 Little Crow (pl.52), Sha-kpe' (also known as Six) (pl.53, 97) and other delegates from the Upper and Lower Sioux tribes,[1] came to Washington, DC at the request of the US government to further discuss their land and to negotiate yet one more treaty with regards to their territory and annuities. This was the fourth meeting dealing with the matter and Little Crow had been involved in many of the negotiations. By the Treaty of 1837, the Treaty of Traverse des Sioux (1851) and the Treaty of Mendota (1851) the Dakota Sioux peoples relinquished claims to nearly twenty-four million acres of land, agreeing to live on a narrow strip of fertile land on both sides of the Minnesota River twenty miles wide. In 1854 Little Crow had come to Washington to deal with unclear title aspects and to discuss provisions that had never been fulfilled.

The issues were simple enough, but when caught in governmental red tape, successive administrations, an inability or lack of desire to deliver on promises made, and by all appearances negotiation in bad faith, the situation put two cultures on a collision course.

By 1858 half of the original agreement from the earlier treaties had been carried out – the North American Indian's land was gone; transferred to the US government, but most of the provisions and money had not been received in payment. Delegations from both the Upper and Lower Sioux came to the capital with the hopes of finally getting their due, while the government, wanted to negotiate for even more land. Thus Little Crow, Sha-kpe' and others had to negotiate one more time with the United States in an attempt to save their land and their people.

Little Crow was an astute and eloquent representative. Dr Asa Daniels, a physician who worked with him on the reservation for many years, described him as being 'restless and active, intelligent, of strong personality, of great physical vigour, and vainly confident of his own superiority and that of his people'.[2] He was also 'a gifted, ready and

eloquent speaker, and in council was always ready to answer any demand made by the government… His appeals in these addresses to the government and to the Great Spirit that justice be done to his people, with his rugged eloquence, the lighting up of his countenance, the graceful pose of his person, and the expressive gestures, presented a scene wonderfully dramatic. He was possessed of a remarkably retentive memory, enabling him to state accurately promises made years before to these Native American Indians by government officials and to give the exact amount of money owing them, to the dollar and cent… He was truthful and strictly honourable in his dealing with the government and traders.'[3]

He was also fearless. When the question of the succession of leadership arose after his father died, Little Crow was opposed by his half-brother. Although carrying a gun, Little Crow confronted him with arms crossed, openly challenging him to shoot. He did. The bullet passed through both of Little Crow's forearms shattering the bones of his wrists and wounding his chest and face. A surgeon recommended that both hands be amputated, but Little Crow would not allow this as a leader must have hands. He recovered but his face was permanently scarred and he always covered his deformed arms. His great courage, however, had demonstrated to the tribal elders that he was worthy of being their leader.

Such was the man that came to Washington, DC in a last-gasp diplomatic effort to save a situation soon to spiral out of control. Little Crow was accompanied by other chiefs and headmen of the Upper and Lower Sioux as well as the agent for the Native American Indians, Joseph Renshaw Brown, Rev. Thomas S. Williamson who had a mission and school near the Yellow Medicine (Upper Sioux) Agency (pl.138), and several traders apparently including Andrew J. Myrick of whom more will be told.

The assembled delegation left the agency on 27 February 1858 and arrived in Washington, DC on 13 March. Their first meeting was with the Acting Commissioner of Indian Affairs, Charles Mix. Little Crow, dressed in the white calico hunting shirt in which he was photographed, started the proceedings by saying, 'Your good advice has reached our ears, we listened and heard what you said… We have business to transact … we will tell you what we came for.'[4]

Another delegate, Mazaomani, expressed the general feeling of the delegates, 'I am pleased to stand here today, in your presence, in my Great Father's country. I understood if I came here, that any thing I wanted, I would get, and I therefore feel that it is a great thing for my people that I am here,'[5] to which the Commissioner responded, 'say to the delegation that their Great Father never withholds anything that is just from his red children, that his only desire is to benefit them, and promote their welfare; that, if they do not attend to his advise, and take advantage of his efforts to serve them, it is their own fault, and not his, and that it is the intention of the Great Father to be not only just, but generous to them.'[6]

With these statements, the proceedings began. The first real meeting with the

Commissioner began on 27 March. Little Crow started the negotiations by reminding the Commissioner that they had never been fully paid for their land: 'In 1858, their Great Father sent a commissioner to treat with them to Mendota, and a treaty was made, and that said he is the reason our people ought never be poor... Of course our Great Father has plenty of funds belonging to us in his hands, and it takes plenty to enable a person to act like a man and not like a poor beggar.'[7] The Commissioner responded, 'say to them that, as a people, as a band, they have a large fund at the disposal of their great father...and that it is the purpose of the great father, to apply it as the treaty stipulates. The time is near at hand, when their great father will forward for their use provisions, blankets and other things intrusted for their comfort and support.'[8]

Further he asked Little Crow how he intended to spend the money should it be given to him. I will tell you... We have stores in our country, and we have families to feed and clothe; and, when we return to our homes, we will lay out the money for the support of our families, and buy what we want. This is what we intend to do with the money we get.'[9] The next meeting did not occur until the middle of April.

Little Crow began that meeting by explaining why his people were hungry and predicted that they would starve again in the coming year: 'Last winter we were badly off, but it was because, in compliance with your wishes, we went in pursuit of Inkpadutah, (a renegade who had massacred settlers) and neglected our corn fields. The land upon which we ought to have planted corn was neglected on that account... I said that our going after Inkpadutah would involve us in want; and now that, by your kindness, I stand here, I hope you will not keep us long, because if you do we will be too late to attend to our planting, and our people will suffer again from the same cause.'[10]

He continued, 'Twenty-one years ago Wabashaw, the father of these young men, and my father placed in writing on this table, and the promises made in this writing, I have come here to see about. The good advice you then gave to my father and his children entered into our ears, but a portion of the promises made to us have not been fulfilled.'[11] He then listed sums of money due, schools, horses, cattle and even blankets that did not arrive. The list was so long that Little Crow felt it would take all night if he went into more detail. 'All things of which we speak have fallen short of the promises made, or well of [sic] our reasonable expectations... I will sit down, and smoke, and listen to your words; and, after I hear you, will know whether my tribe will be benefitted or not.'[12]

The Commissioner agreed to look into these allegations but as to the money, it 'is safely kept in the strong box of the Treasury, and the reason it has not been paid is, that it could not be expended to their advantage. When the proper time occurs, it will be expended to their benefit.'[13] In addition to provisions and funds not being received, the Native American Indians also complained about settlers moving into lands they still believed they owned. The Commissioner reminded Little Crow that he had signed away these lands to the government and if there was a problem it was Little Crow's fault for

making the agreement.

The Native American Indians had to wait until the end of May for their next meeting. Commissioner Mix addressed the issue of title and boundaries of the 1851 treaties first: 'In respect to the treaty of 1851, and of their understanding of the clause giving the president authority to mack [sic] the boundaries… I propose on behalf of their Great Father, to assign to them as a permanent home the South and West part of their Reserve, dividing it by the River.'[14] In other words dividing the small portion of the land left to the Native American Indians, and still not paid for, in half. In addition, the small section of land that would be theirs would be divided into farms and allotted to the Native American Indians in severalty.

In early June the Native American Indians countered the proposed government treaty with one of their own which included an unstated amount in appropriations. When the Commissioner asked Little Crow to state a sum of money that would be acceptable to settle their affairs so that the proposal could be taken to the president, he was not prepared to do so. Another pertinent section dealt with funding that was owed to the traders. Little Crow was willing to set aside $50,000 against their rightful debts assuming that this money would come out of the large amounts of money already due to them. The Commissioner agreed but the funds would have to come out of the proceeds from the sale of more of their land.

By mid-June a final treaty was prepared by the government which allowed for the sale of half of the land, the price of which would be set not by the Native American Indians but by the Senate. In addition, a sum of money to be determined by the Native American Indians themselves representing the amount they felt was owed to the traders would be included and further, a consolidation of past annuities would be placed under the control of the Secretary of the Interior for the purchase of food and tools as needed by the Native American Indians. Little Crow was of a mind to leave without signing any papers since in all the treaties they had made, none had been carried out in good faith, to which the Commissioner responded, '… you may go home as soon as you please… but you must recollect that the entire responsibility of breaking off negociations [sic] so beneficial and so necessary to the security and protection of your people, will rest alone on your own head,' he then went on to state one fact Little Crow knew to be true, 'If you don't like it, you can go home, and you will find that the whites will take from you by force, what your Great Father proposes to buy and pay for.'[15]

On 19 June, the Sioux had little choice but to sign the treaties. On June 21 they were given medals as evidence of their good conduct, guns for 'procuring game for subsistence, but never to be used against white men,'[16] and told that the president and congress would make proper appropriations and take care of them.

Little Crow had tried to send many letters to the president telling him of problems on the reservation but was convinced that none of them were ever received let alone mailed. He made one final attempt at discussing these problems, but the commissioner

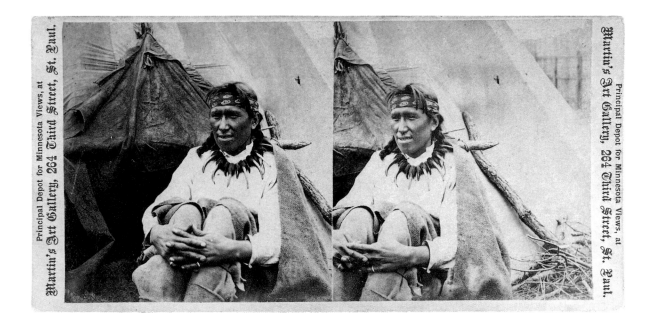

PLATE 139

JAMES E MARTIN

Unktomiska [White Spider, also known as John C Wakeham], the half-brother of the Mdwekanton Dakota Chief, Little Crow, 1863

Albumen stereograph. National Anthropological Archives, Smithsonian Institution

PLATE 140

BENJAMIN FRANKLIN UPTON

He who Sprinkles the Land, Sioux. Taken whilst he was held in captivity at Fort Snelling in 1862-63. From the series: 'Indian Portraits and Views'

Albumen stereograph. National Anthropological Archives, Smithsonian Institution

PLATE 141

BENJAMIN FRANKLIN
UPTON

*Sioux wife and children of
Little Crow. Taken whilst they
were held in captivity at Fort
Snelling during the period of
1862-63. The woman is
probably Saiceyewin (Isabelle
Wakeman) or Makatowin (Eva
Rice). From the series 'Indian
Portraits and Views'*

Albumen stereograph.
National Anthropological
Archives, Smithsonian
Institution

PLATE 142

BENJAMIN FRANKLIN
UPTON

*Litte Crow's son, Wowinape,
and other Mdewakanton,
Dakota men. Taken whilst they
were held in captivity at Fort
Snelling 1863-64. From the
series 'Indian Portraits and
Views'*

Albumen stereograph.
National Anthropological
Archives, Smithsonian
Institution

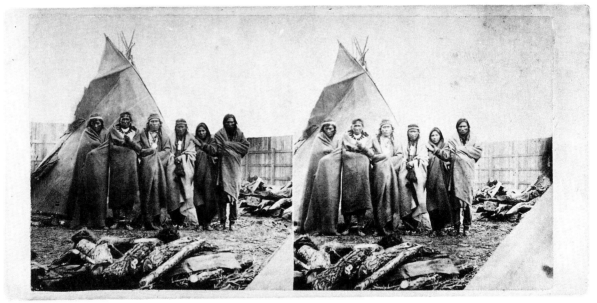

would not listen. Little Crow and the rest of the delegation departed the capital empty-handed and with little faith in what had transpired. By the time they got home it was late in the year for planting.

For the land ceded by the 1851 treaties, the Native American Indians were promised a total price of $3,075,000 but that was held in trust and only the interest of five per cent a year was to be paid for a term of 50 years at which time the principal was to revert to the government. The amount paid immediately was $555,000, $210,000 of which was allowed to the traders,[17] and the interest, which amounted to $126,000 yearly, was paid partly in provisions with only $70,000 actually being paid in cash.

It took congress two years after the 1858 treaty to set the price for the additional land it acquired. Although valued between $1 and $5 an acre, the price set by congress for the additional million acres amounted to approximately thirty-cents per acre. After traders' claims, which were neither set nor approved by the Native American Indians as agreed by the treaty, the Sioux received about half what had been voted.[18] Annuities were due in late June or early July which was especially important in 1862 after another winter of near starvation. They were late, however, because congress waited to appropriate the funds and then spent a month discussing whether to pay in paper currency or gold coin. The much needed money did not reach St. Paul until 16 August by which point it was too late.[19]

As more and more settlers expanded westwards and railroads started to criss-cross the country, the US government had a difficult situation on its hands. What to do with the Native American Indians? Theories ranged from annihilation to 'civilisation', with the latter being espoused in treaties. A civilised Native American Indian would have no need to millions of acres over which to roam and hunt, nor would they require annuities and rations to replace buffaloes. They could farm and become self-sufficient, enjoying the riches of settled society. Native American Indian delegations to the East were always treated to a display of the riches that could be earned by adopting this foreign life style. At the same time they were also shown demonstrations of military might and, tied with the sheer size of the cities and the number of the people, the underlying theme was always that it was better to join than to fight. In Little Crow's own words, 'We are only little herds of buffaloes left scattered... the white men are like the locusts when they fly so thick that the whole sky is a snow-storm. You may kill one – two – ten; yes, as many as the leaves in the forest yonder, and their brothers will not miss them.'[20]

Thus with guidance and some equipment, some Native American Indians tried farming. Indeed, some agents for the Native American Indians made annuity payments only to those Natives who would cut their hair, wear white clothing and farm. They became known as 'farmer' Indians whereas those who kept their traditional lifestyle were known as 'blanket' Indians.

While the new Native farmers met with some success, to survive, many had to turn

to Indian traders, purchasing food on credit while they waited to be paid by the US government.

Combined with the inflated figures supplied by the traders, most, if not all of the money received for their lands went directly into their pockets leaving the Native American Indians unable to purchase more food or provide for themselves. Those Native American Indians who chose to hunt instead of farm still had sufficient hunting areas within the reservation, but encroaching settlers frequently hunted in these regions and either drove away or killed most of the game leaving the 'blanket Indians' starved as well.

It was against this backdrop that events rapidly moved to an unavoidable encounter between the Native American Indians and the settlers in what was to become one of the bloodiest massacres in American history.

In July and August several thousand Native American Indians had come to the Upper Agency to find out why they could not be fed from the warehouse full of provisions that belonged to them. The Agent relented and distributed a few goods, but clearly that was not enough. Meanwhile at the Lower Agency provisions due in early June had still not arrived. Little Crow demanded that the traders further extend their credit so they could eat but they refused. Andrew J. Myrick, one of the traders who came from Washington, DC, further inflamed the situation by remarking, 'If they are hungry, let them eat grass.'[21]

Starved from failed crops, loss of game and the lack of annuities; frustrated by broken promises, squeezed into ever smaller tracts of land and financially unable to buy their way out of the situation, the Native American Indians were in an explosive situation that needed just a spark to set things off. That spark occurred on 17 August. The incident was recounted by Big Eagle one of the 'farmer' Indians at the Redwood Agency:

'You know how the war started – by the killing of some white people near Acton, in Meeker county. I will tell you how this was done, as it was told me by all of the four young men who did the killing. These young fellows all belonged to Shakopee's band… They told me they went over into the Big Woods to hunt… they came to a settler's fence, and here they found a hen's nest with some eggs in it. One of them took the eggs, when another said: "Don't take them, for they belong to a white man and we may get into trouble." The other was angry, for he was very hungry and wanted to eat the eggs, and he dashed them to the ground and replied: "You are a coward. You are afraid of the white man. You are afraid to take even an egg from him, though you are half-starved"… The other replied: "I am not a coward. I am not afraid of the white man, and to show you that I am not I will go to the house and shoot him. Are you brave enough to go with me?"… They all went to the house of the white man, but he got alarmed and went to another house where there were some other white men and women. The four Native American Indians followed them and killed three men and two women.'[22]

After murdering the five people, they went to Sha-kpe's camp and told what had happened. The members of the soldier's lodge debated what should be done, ultimately deciding to fight the encroaching whites and reclaim their lands. Sha-kpe' then took them to Little Crow, who knew that fighting would bring disaster. First he tried to bring them to their senses, 'You are full of the white man's devil-water. You are like dogs in the Hot Moon when they run mad and snap at their own shadows,'[23] and then reasoned with them about the futility of trying to outfight the whites. Their response was to call him a coward, to which he replied, 'You will die like the rabbits when the hungry wolves hunt them in the Hard Moon (January). Ta-o-ya-te-du-ta (one of Little Crow's names) is not a coward: He will die with you'.[24] The next day Little Crow led the first assault on the Lower Agency at Redwood.

Some of the events that occurred were recorded in text and images by a little-known frontier photographer by the name of Adrian J. Ebell. Ebell was accompanied on his photographic expedition by Edwin Lawton, a student. Lawton's diary tells of their 'Phantasmagorical Exhibitions'(lantern-slide shows), and their adventures to the Upper Missouri region photographing the Native American Indians and scenery. Along the way they encountered immense swarms of mosquitoes, thunder storms with torrential rains, and axle-deep mud. Their travels took them through the Lower or Redwood Agency where Lawton saw his first Native American Indians. Beyond that they passed Little Crow's village, and 'several civilised Indian houses where the squaws are engaged in the fields seated on a platform raised up above the top of the grain (commonly corn) engaged in the very interesting occupation of scarecrows to frighten off the black-birds from the grain'.[25] Lawton or Ebell photographed these women scarecrows (pl.137) which was later circulated by Whitney, as well as Indian women winnowing wheat.

Their ultimate destination, however, was the Upper Agency at Yellow Medicine. Lawton's entry for 13 August reads, '… met two companies of soldiers, then but a few miles ahead of us, on their way back from the Upper Agency, whither they had been to subdue a disturbance among the Native American Indians, who getting unruly had attempted to break open the government warehouse.'[26] His last entry is dated 15 August and reads,'… we rested half an hour, and then started on our way again anxious to see our place of destination the long expected 'Upper Agency'.[27] Little did they realise what lay ahead for them.

Ebell recounted much of the tragedy in the June 1863 issue of Harper's New Monthly Magazine. The massacre started after midnight at the Lower Agency and spread like wildfire. Once the signal had been given the Native American Indians broke into the stores and warehouses. While the women carried off the food, the men attacked the people. The first to die was a clerk at the store of the hated trader, Andrew Myrick. Myrick himself managed to escape from a second-story window, but was killed before he could reach cover. His corpse was later found with grass stuffed in his mouth – a reminder of his harsh words. 'Some were hewed to pieces ere they had scarce left

their beds... But who can tell the story of that hour? Of the massacre of helpless women and children, imploring mercy from those whom their own hands had fed, but whose blood-dripping hatchets the next moment crashed pitilessly through their flesh and bone – of the abominations too hellish to rehearse – of the cruelties, the tortures, the shrieks of agony, the death-groans, of that single hour?'[28]

A village of several thousand people formed around Little Crow's house including over three hundred captives. Some of the Native American Indians, even Little Crow, not only felt compassion for the captives but also sheltered and saved many of them. White Spider, (pl.139) told how Little Crow, his half-brother, instructed him to gather up what white women and children he could and guide them to safety. 'I had no moccasins on my feet, but I went a long way. I went seven miles... the Little Crow kept a good many of the captives in his own home, and treated them the same as he treated his own children, and had them eat with him.'[29]

Those that did escape spread the alarm. The Native American Indians followed the entire line of settlements over hundreds of miles committing unheard of atrocities. Cut Nose (pl.92) and two others leapt into a wagon of fleeing settlers, mostly children, and tomahawked them all.

One infant was taken from its mother's arms, before her eyes, with a bolt from one of the wagons, they riveted it through its body to the fence, and left it there to die, writhing in agony. After holding for a while the mother before this agonising spectacle, they chopped off her arms and legs and left her to bleed to death.[30]

Narcis Gerrian, a settler, leapt from the window of the mill to the river. Before he reached the water he was shot twice in the chest. He managed to swim across, almost drowning and then dragged himself through woods and swamps for sixty-five miles without food, before being rescued.[31]

Over five-hundred settlers sought protection from the military at Fort Ridgley, which was itself doomed as there were only thirty soldiers, few arms or ammunition and little provisions. In the meantime people at Yellow Medicine were unaware of the approaching danger. On Sunday 17 August, Ebell took a photograph of the missionary Thomas S. Williamson and some of the farmer Native American Indians outside the mission house (pl.138).

Ebell recounts the flight of forty unarmed people including Dr Williamson, the physician, and Stephen Riggs, the missionary. A war party tried to follow them but fortunately a thunderstorm obliterated their tracks. Meeting other fleeing settlers they learned of many horrors. They had no provisions and the rain, at first a saving grace, continued through the night. 'It is easy for one to keep up courage when his blood is warm; but in a half freezing, drizzling rain, trickling drop by drop through the clothes, and seemingly to the very bones, lying in a puddle of mud and water, courage, if it exist, is truly a genuine article.'[32]

The next morning, 21 August, they drove through mud, crossed streams with

PLATE 143

BENJAMIN FRANKLIN
UPTON

*O-te-dun, Sioux, Taken whilst
he was held in captivity at Fort
Snelling. From the series: '
Indian Portraits and Views'*

Albumen stereograph.
National Anthropological
Archives, Smithsonian
Institution

PLATE 144

BENJAMIN FRANKLIN
UPTON

*Circular Cloud, Sioux. Taken
whilst he was held in captivity
at Fort Snelling in 1862-63
for his part in the Sioux Revolt
of 1862. From the series
'Minnesota and Northwestern
Views'*

Albumen stereograph.
National Anthropological
Archives, Smithsonian
Institution

difficulty, and finally stopped for '… our only chance for breakfast… we killed a calf, and at about three in the afternoon had our breakfast of partly roasted or smoked veal'.[33] Ebell photographed them while they stopped to eat (pl.136). This amazing image is the only photograph known to have been taken during the flight of the settlers.

The little group's path took them past scenes of massacre and plunder but somehow they managed to escape the Native American Indians and eventually were in sight of Fort Ridgely. A rocket from the fort, meant as a distress signal, was interpreted as a beacon to guide them. They finally managed to reach the fort only to be told that they could not be accommodated as hundreds of other settlers were already there and they would have to move on. They were not alone.

The entire population of approximately 40,000 settlers from Fort Ridgley, New Ulm, and the Norwegian Grove, almost to St. Paul, fled panic-stricken as wave after wave of massacres occurred. Some, including Ebell and the little group of settlers made it to safety. Soon after they were turned out of Fort Ridgely it was attacked and could not be defended. Attacks continued for eight weeks, until the Native American Indians were eventually outnumbered and outgunned by the military led by Henry Sibley.

Four thousand Native American Indians then fled to the West, and to the North into Canada including Inkpadutah, Little Crow and his son, Wowinape, Sha-kpe' and Medicine Bottle. The remaining two thousand Native American Indians, mostly women and children, were force-marched to prison at Fort Snelling forming a four-mile long line. Along the way the settlers stoned, clubbed, and stabbed them with pitchforks.

A military commission tried 392 Native American Indian prisoners in a log-cabin courtroom at the Lower Agency. Of these, 307 were sentenced to death and moved first to Camp Lincoln and then to a make-shift prison at Mankato. The names of the Native American Indians found guilty were sent to President Lincoln for approval of a death sentence. Not wishing to make a hasty decision he was, 'anxious to not act with so much clemency as to encourage another outbreak on the one hand; nor with so much severity as to be real cruelty on the other, I caused a careful examination of the records of trials to be made [to determine] who were proven to have participated in massacres, as distinguished from participation in battles'.[34] On 6 December, he approved the death sentence for only 39 of the prisoners, one of which was later respited. On 26 December, the 38 prisoners were hanged at Mankato, in the largest mass hanging in American History.

The remaining 1,700 Native American Indians were placed in a fenced enclosure at Fort Snelling where they lived in tipis for the remainder of the winter. (pl.139-144) Lacking sufficient food and heat, an additional 300 died that winter.

In the meantime, Little Crow and Wowinape, his son, were in Canada trying to enlist British help while the US government placed a bounty on all renegade Native American Indians. In the summer of 1863 Little Crow and his son returned to Minnesota. On 3 July while picking raspberries, Little Crow was shot by Nathan Lamson who was also in

the patch with his son, Chauncey. Wary of all Native American Indians and interested in obtaining the bounty money, Nathan shot the elder of the two without knowing who he was.

Wowinape later recounted the event. His father had been shot above the hip and returned fire. He was then shot a second time and realising that he was mortally wounded whispered to his son for a drink of water and then died.[35] The boy then dressed his father's feet in new moccasins, covered the body with a blanket and left to find food and shelter for himself.

The people of Hutchinson brought the unidentified body into town and left it lying in the middle of the street. Boys celebrated the Fourth of July by placing firecrackers in the ears and nose. Lamson collected the $75 bounty and although rumoured to be Little Crow, identification was not possible as the head had been scalped. The local doctor buried the body and although the torso disappeared, he later retrieved the skull and arm bones which showed the massive damage done many years earlier and established the identity of the body.[36]

Wowinape wandered around nearly starving to death until captured twenty-six days after his father's shooting. He was sent to prison where he learned to read and converted to Christianity. Eventually he was pardoned and became active in the local Presbyterian church, devoting the rest of his life to the development of a Dakota Indian YMCA.

Sha-kpe', another of the proud diplomats who had once negotiated with the USA, and Medicine Bottle (pl.158) also fled to Canada. They were eventually captured, drugged and smuggled across the border on dog sleds and brought to Fort Snelling in 1864. Their execution took place on 11 November 1865 at the site where the Mendota treaty of 1851 had negotiated away much of their land.

The tragic story of the 1862 Sioux revolt was documented by several photographers. At one end of the scale are the elegant portraits made before the revolt in Washington, DC by the McClees studio such as those of Little Crow, Sha-kpe' and other diplomats. The works by Adrian Ebell and Lawton show a world just before and during destruction. At the other end of the scale are the haunting portraits made by Benjamin Upton, James Martin (who later formed a partnership with Upton), and Joel Emmons Whitney (later Whitney and Zimmerman) of the prisoners in their captivity at Fort Snelling. Some of the portraits made were of Little Crow's half-brother, White Spider, (pl.139); one of Little Crow's wives and some of his children (pl.141), and his son Wowinape with other imprisoned Native American Indians (pl.142). Some of the most poignant are those of former diplomats such as Sha-kpe' before they were to be hanged (pl.97). Native American Indians remembered for their assistance to the settlers were also photographed such as Old Bets (pl.93) and John Other Day, another of the 'farmer' Indians living near the Upper Agency who organised and led a party of 62 people to safety.

Once their histories are known, these images speak for themselves. We do not know what either the photographers or the subjects were thinking or feeling when these portraits were made. I suspect they were pretty straightforward reactions. While we must explore the deeper nuances of images and how they are used, we must remember that once these were real people in very real situations. It is critical that we do not forget to tell the rest of the history.

NOTES

1 Santee = Upper and Lower Sioux together; Upper Sioux = Wahpeton and Sisseton; Lower Sioux = Mdewakanton and Wahpekute.

2 Asa Daniels, 'Reminiscences of Little Crow', Minnesota Historical Society, Vol. 12, 1908, p.514.

3 Daniels, 'Reminiscences of Little Crow', 1908 pp.517-18.

4 'Sioux Delegation from Minnesota in the Indian Office' Documents Relating to the Negotiations of Ratified and Unratified Treaties with Various Indian Tribes (hereafter, Documents), National Archives and Records Administration (NARA), microfilm (mf) T494, 15 March 1858, p.7.

5 Ibid., p.8.

6 Ibid., p.9.

7 'The Sioux Native American Indians from Brown County Minnesota', Documents, NARA mf T494, 27 March 1858, p.2.

8 Ibid., p.3.

9 Ibid., p.4.

10 'Sioux from Brown County, Minnesota in Indian Office,' Documents, NARA mf T494, 9 April 1858, pp.1-2.

11 Ibid., p.2.

12 Ibid., p.4.

13 Ibid., p.5.

14 'Medawahkanton and Wahpekotay Sioux,' Documents, NARA mf T494, 25 May1858 p.2.

15 'Lower Sioux Treaty Meeting,' Documents, NARA m'flm. T494, 19 June 1858, p.7.

16 'Delegation of the Lower Sioux. Final Interview,' Documents, NARA mf T494, 21 June 1858, p.1.

17 Gary Clayton Anderson, *Little Crow: Spokesman For The Sioux*, Minnesota Historical Society Press, 1986, pp.64, 68-9.

18 Kenneth Carley, *The Sioux Uprising of 1862*, Minnesota Historical Society Press, 1961, p.13.

19 Ibid., p.14.

20 Anderson, *Little Crow*, 1986, p.132.

21 Carley, *The Sioux Uprising*, 1961, p.15.

22 Big Eagle, 'A Sioux Story of the War,' St. Paul Pioneer, 1 July 1894; repr. in 'Chief Big Eagle's Story of the Sioux Outbreak of 1862,' Minnesota Historical Society Collections, Vol. 6, 1894, pp.388-9 and Anderson and Woolworth, *Through Dakota Eyes: Narrative Accounts of the Minnesota Indian War of 1862*, Minnesota Historical Society Press, 1988, p.35-6.

23 Anderson, *Little Crow*, 1986, p.132.

24 Ibid., p.132.

25 'Diary Journal of E R Lawton, 1862,' p.100. Original ms in Minnesota Historical Society.

26 Ibid., p.82.

27 Ibid., pp.109-10.

28 Ebell, 'The Indian Massacres and War of 1862,' Harper's, Vol. 27:157, June 1863, p.8.

29 White Spider, quoted in Anderson and Woolworth, *Through Dakota Eyes*, 1988, pp.61-2.

30 Ebell, 'The Indian Massacres', 1863, p.9.

31 Ibid., p.9.

32 Ibid., p.12.

33 Ibid., p.13.

34 'Lincoln's Sioux War Order,' Minnesota History, Vol. 33:2, 1952, pp.77-8.

35 'Statement of Wo-wi-nap-a: translated by Joseph De Marais, Jr.', St. Paul Pioneer, August 13, 1863; quoted in Anderson and Woolworth, *Through Dakota Eyes*, 1988, p.280.

36 Anderson, *Little Crow*, 1986, p.8. The scalp, skull and arm bones were deposited in the Minnesota Historical Society where they were placed on exhibit.

PLATE 145

JULIAN VANNERSON
AND SAMUEL COHNER
OF THE JAMES E
McCLEES STUDIO

*He-kha'ka Nang'-zhe
[Standing Elk] a Yankton,
Nakota delegate to Washington,
DC, 1857-58*

Albumen print. Pitt Rivers
Museum, University of
Oxford

THE RESONANCE OF ANTHROPOLOGY

ELIZABETH EDWARDS

THE EMERGENCE OF ANTHROPOLOGY IN THE 19TH CENTURY is complex and often contradictory. It is also integrally related to the photographic inscription, description and definition of Native American peoples in a symbiotic relationship. The central focus of my 'journey' is this relationship and the way in which, through the realist nature of photography and mutability of its meanings, there was a currency of images whereby general assumptions about racial and cultural hierarchies, political expediency and the ultimate destiny of Native American people shaped anthropology and the images produced in its name. On the other hand, the way in which anthropological science was visualised through photography informed the production and legitimised the consumption of images of Native American peoples outside anthropology itself. While this is inevitably a very considerable generalisation of a series of complex, historically specific and dynamic ideas, it nonetheless constitutes a broad context in which the visual economy of photographic truth operated and through which political and ideological discourses were embedded in the conflation of scientific and photographic naturalism. Thus if the photographic agendas operating within anthropology were complex and ambiguous, so was anthropology itself. It comprised a fluid coming together of different lines of enquiry into the physical and cultural origins of the human race and the explanation of human difference, both physical and cultural, in this context the nature of Native American peoples. There were anthropological concerns, for instance, in anatomy, biology, archaeology, philology, technology and religion. These concerns were further stimulated by the evolutionary, or at least 'progressivist' assumption that certain races were doomed to extinction, confronted with the technological (and, by implication, an assumed moral) superiority of the white race. In the case of Native American peoples this was also integrally, and somewhat paradoxically, entwined with the emergence of national consciousness as the 'land of the free' – the land of tolerance and cultural eclecticism, which characterised the emergent USA.

PLATE 146

JOHN K HILLERS

Three unmarried Hopi girls,
Hopi Pueblo, 1879

Albumen print. Pitt Rivers
Museum, University of
Oxford

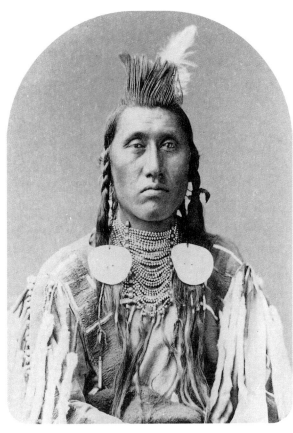

PLATE 147 AND 148

CHARLES M BELL

Pretty Eagle, Crow 1880

In profile: Modern print from a negative in the collection of the National Anthropological Archives, Smithsonian Institution

Face on: Albumen print. Pitt Rivers Museum, University of Oxford

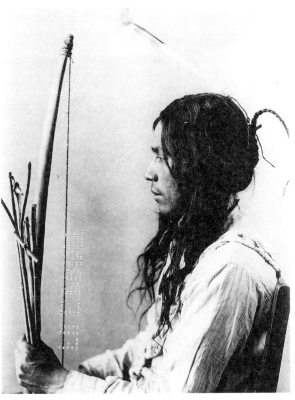

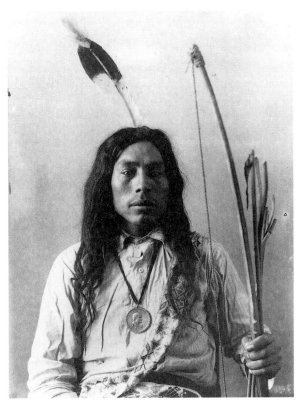

PLATE 149 AND 150

DE LANCEY GILL

No Liver, also known as James Arketah Jr. (Oto)

Modern prints from negatives in the collection of the National Anthropological Archives, Smithsonian Institution

Some of the earliest photography of Native American peoples endows them with dignity as well as difference, Vannerson and McClees studio portraits taken during the 1858 delegations to Washington, for example. Native peoples were still, in the eyes of the US law, sovereign peoples, consequently while the exotic element of difference is never far from the surface, the photographic portrait iconography is similar to that employed for other 'great men', sitters such as Abraham Lincoln. The portrait of *Hekhaka-Nang-zhe [Standing Elk]* (pl.145), depicts a leader of the Yankton Nakota. In this, like others in the series, the individuality of the sitter is allowed to emerge despite the overall stylistic consistency. The light is subtle, lending aura to the subject, the figure is arranged comfortably in the frame without the harsh frontality typical of later imaging. When viewing the series as a whole, the differences in demeanour, pose and body language are striking. Nonetheless the images are invested with a sense of 'pastness' in the tensions between quiet self-presentation to the camera and representation. It is the latter that exerts itself. However the discourses of difference were such that, soon after these images were made they were absorbed into the discourses of the dying race in a way which raises the subject/object dichotomy inherent in photography. The photographs were marketed by Vannerson as such, despite the honorific style of the portraits themselves, as documents of an emerging anthropology,'... as mementoes of the race of red men, now rapidly fading away, this series is of great value'.[1]

The way these fine portraits shift category and become anthropological by classification of their subject matter at both popular and scientific levels marks the course of my journey. The ambiguities of the photograph, enabled images of Native American peoples produced as delegations photographs, as survey photographs, as exotica and in science to be absorbed into anthropology. The shift in meaning was premised on the analogical nature of photographic inscription, a classification of knowledge which could render its subject matter 'of anthropological interest', irrespective, in scientific terms, of the intentions which created it and the audiences for which it was intended. Conversely, images made with anthropological intention, to explore and record cultural difference observed among Native American peoples, had a currency beyond science itself and the visual dialects/styles which science demanded. These similarly and simultaneously informed the making of images and legitimated them.

Much photographic effort was put into salvage ethnography, recording traditional ways of life faced with major and destructive change. This was institutionalised in 1879 with the establishment of the Bureau of American Ethnology (BAE). It grew out of the US Geological Surveys which had been recording the 'new lands' of the West and southwest. While at one level its operations might be characterised as objectifying and appropriating, at another many of those working within the BAE were genuinely motivated by the belief that it was necessary to understand Native American cultures in all their diversity in order to ameliorate the plight of indigenous peoples. Although this

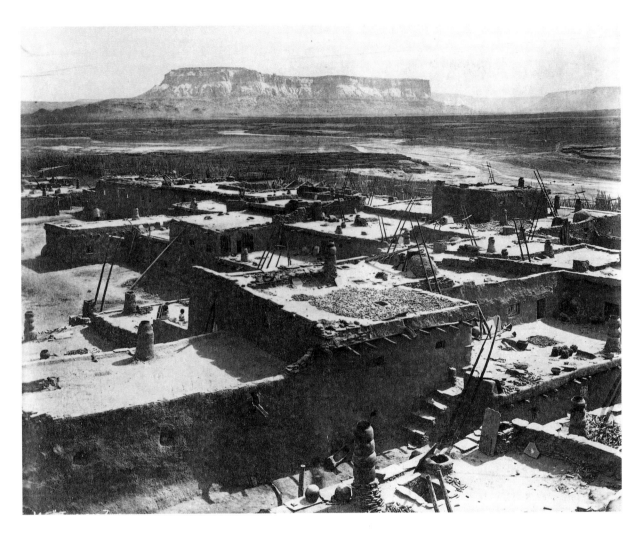

PLATE 151

JOHN K HILLERS

Zuni Pueblo with the mesa of Taaiyalone in the distance, New Mexico, 1880

Published in Lewis Henry Morgan's 'House Life of the American Aborigine', Bureau of American Ethnology, 1881 (see p.228). Albumen print. National Anthropological Archives, Smithsonian Institution

did not change the power relations inherent in the record, it perhaps explains some of the ambiguity in the imagery produced in the name of the BAE surveys.

Perhaps this is most marked in the work of John Hillers. Hillers had started working as a photographer for the surveys in the early 1870s. The surveys included surveying not only the land as the US frontier moved westward, but the indigenous peoples who inhabited it. Yet the field situation did not necessarily reproduce the closely defined scientific reference. While there is certainly ambiguity in some of the portraiture, there is a strong picturesque aesthetic and almost pictorialist composition, cultural narrative, sweeping landscapes resonating with the enormity of nature and the frailty of human existence which plays on the traditional western aesthetic of 'natural man in the landscape', a trope which emerged so strongly in Curtis's work.[2]

The view of *Zuni Pueblo* (pl.151), taken on the 1879 survey of the southwest, operates at one level as a visual mapping of the townscape, the shape of settlement and by implication the Zuni social production of space. However, the sweeping landscape beyond the pueblo, the sharp diagonals criss-crossing the image, the way the dramatic contrasts of light and shade (characteristic of the light in the Southwest) are used to dynamic and energising effect and the closing of the vista with the next mesa are aesthetic devices creating a certain affective tone in the image. The photograph functions equally well as ethnographic and aesthetic readings, but they are interdependent in their affective tone.

Hillers's carefully posed narrative pieces, taken to 'show how' in ethnographic detail, are humanised through their everyday quality. The photograph of the three Hopi Girls (pl.146) is redolent with the tensions between scientific and aesthetic discourses. A caption from 1885 reads: 'A group of girls, showing their characteristic head-dress and apparel. The hair is worn in this way so long as they remain unmarried, after which it was worn down.'[3] They are in front of a 'carelessly' arranged blanket, which naturalises the ethnographic observation. Yet the aesthetic translation of the ethnographic realism is clear, in the conventional pyramid composition with carefully arranged limbs establishing a linking geometry. The arrangement of the girls' heads while part of this geometry, also 'show' hair dressing from full face and profile perspectives, a placing which also has scientific reference.

The photograph emerges as a complex and paradoxical descriptive or performative piece as Hopi people play out tableaux of their everyday existence for the camera, an act of description, a momentarily stilled life, a quiet theatricality achieved through the aesthetic arrangement of ethnographic information.

But if Hillers's are deeply suffused with a romantic nobility there was simultaneously a hardening of attitude towards Native American peoples in the wake of the Plains Wars, in the firmer base of anthropological science and in the representational norms which had become absorbed into the photographing of Native American peoples. This perhaps is evident in the photographs taken by Charles Milton Bell for the BAE taken

mostly between 1880 and 1886. It is portraiture of a very different order when compared with that of Vannerson and McClees. While the individual portraits, such as that of *Pretty Eagle* (Oglala Lakota) taken in 1884 (pl.148), might appear noble and direct with a self-contained, even resistant, quality, when viewed as a series their oppressive, mapping quality becomes apparent. When one sees the full-face portrait resonate with its profile companion (pl.147), the scientific reference is unmistakable, despite the rich cultural elements of clothing and ornament – the abalone shell pendants, quill embroidery and hair dressed with buffalo grease.[4] The lighting of the subject is, when compared with the Vannerson and McClees portrait, strong and even, maximising the mapping of surface features. The visual dialects of portrait photography are conflated with the scientific reference which itself is a photographic translation of the full-face and profile views, which are the classic poses of anatomical description. Thus they reach back in their visual associations through the Enlightenment to western scientific traditions of the 17th century. The figure is isolated in a shallow pictorial space, the delineation almost equivalent with the picture plane against a plain-light background, projecting the figure visually. But ideas of both scientific and the aesthetic operate simultaneously, the nuances of meaning shifting according to the contexts in which the photographs 'performed'. Just as Hillers's aesthetically saturated images both sold commercially and were used extensively in government publications, so Bell's portraits made under government instruction were sold to visitors to Washington as exotic souvenirs.

Portraits by other photographers working for the BAE, such as Gardner and, later, De Lancey Gill, are very similar in mood and composition to those of Bell, suggesting the firm instructions which informed the making of these portraits as scientific documents. De Lancey Gill's full-face and profile images of *No Liver* (pl.149, 150) share the same plain background, and direct presentation to the camera. Like Bell's portraits, the cultural intrudes. While at one level this confuses the photographic genre, at another the images conflate the biological and the cultural through their equivalence within the surface of the photograph. In terms of true somatic mapping, these images are meaningless; their meaning emerges from the style of scientific resonance within the images, the moral values attributed to those surfaces of racial and cultural difference mapped within the image. Many such photographs taken of non-European peoples around the world were more scientifically overt and oppressive than Bell or De Lancey Gill's. But this 'scientific reference' became normalised within the representational tropes, the resonance of which are both more generalised and generalising in the way in which they permeate many levels of imaging.

Prince Roland Bonaparte's series of photographs of Omaha people are particularly revealing in this context. While photographs made within anthropology as it was defined at any one historical moment and those drawing their legitimacy from it were mutually sustaining, so, as was evident in Bell and De Lancey Gill's portraits, within the

PLATE 152

PRINCE ROLAND
BONAPARTE

*Va-shesh-na-bá [Beautiful
Hill], aged 35, daughter of
Inshta-Tanga [Big-Eye] with
her five year old son, Omaha
representatives at le Jardin
d'Acclimatation, Paris*

Albumen print. Pitt Rivers
Museum, University of
Oxford

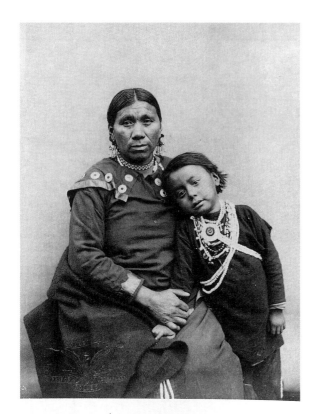

Collection anthropologique du Prince Roland Bonaparte.

Collection anthropologique du Prince Roland Bonaparte.

Collection anthropologique du Prince Roland Bonaparte.

PLATE 153 AND 154

PRINCE ROLAND
BONAPARTE

*Iga-she [Traveller], aged 13,
son of Va-shesh-na-bá, Omaha
representative at le Jardin
d'Acclimatation, Paris*

Albumen print. Pitt Rivers
Museum, University of
Oxford

same discourse photographic genre punctuate each other. Bonaparte's photographs were taken in Paris in 1883 at the Jardin d'Acclimatation where a group of Omaha were, literally, performing their culture for popular educational entertainment.[5] The format of the photographs follows scientific reference, in the use of full-face and profile portraits of each person photographed against a plain background. A leaflet at the front of the red, gold-embossed portfolio in which the photographs were disseminated, gave the names and ages of the subject. While at one level this operates as a precise labelling of a scientific specimen, at another is has the potential for individuation, of reinsertion of the photographs into individual and collective histories, precisely the site of meaning engaged with by many late 20th century Native American people. Some of Bonaparte's portraits, like Bell's, employ the blank backdrop to isolate or deculturise the subject, but others allow the possibility of fracture. The gentle natural pose of the portrait of *Va-shesh-ne-bé [Beautiful Hill]* (pl.152)[6] and her five-year-old son defies the making of the anthropological object despite the contexts of the making and the potential isolation of the stark background. The portraits of *Iga-she [Traveller]* (pl.153, 154), thirteen-year-old son of Va-shesh-ne-bé, also have this quality, which for me, is their point of interest. Iga-she is in his full dress, a cultural expression but one, with the buckskins and feathers, capable of operating, like the photograph, within the theatre of 'Indianness'. In the conflation of photographic styles and contextual detail, this is suggestive of the biological basis of culture. For while the full face and profile suggest the desire for a physical mapping of the body, the materiality of the encounter and the context of making photographs is nonetheless felt. The edge of the backdrop, the context of physical containment, is revealed to show another level – the wire fence and the Exposition ground beyond. The buckskins, beads, feathers and face paint intersect with a pretty conservatory chair. Here we have an intersection of the scientific intention and popular experience, etched in the ambiguity of the image, destabilising meaning.

If the Bonaparte photographs point to the interpenetrating of photographic styles, nowhere is this more marked than in the circulation of the humble *carte-de-visite*. Many hundreds of thousands of these photographic objects were produced in the mid-19th century. Yet at one level they took their authority from the popular circulation of scientific anthropological ideas within the popular domain. The three *cartes* produced in the mid-1860s by Eaton of Omaha, Nebraska (pl.155-157), are both typical and illustrative. The subject is posed with little of the subtlety offered by even the most basic of photographic competence. The decultured subject/object is posed, against a blank studio backdrop, isolated, the focus onto which viewers could project their own meanings, be they the fantasies of science, exoticism, nostalgia, fear or triumphalism. In looking at these three images together on my 'journey', the consistency or representational form are foregrounded. The ethnographic 'massing' gives clear ideological shape. The broad equivalences of pose and composition that dominate much *carte-de-visite* production of this kind can be related back, convincingly,

*Three cartes-de-visite:
left to right*

PLATE 155

E L EATON

*Studio portrait of young man
c.1865*

Albumen print. Pitt Rivers
Museum, University of
Oxford

PLATE 156

E L EATON

*Studio portrait of young man
c.1865*

Albumen print. William
Blackmore Collection.
Trustees of the British
Museum

PLATE 157

UNIDENTIFIED
PHOTOGRAPHER

Pawnee man

Albumen print. Pitt Rivers
Museum, University of
Oxford

to the conceptualising groundwork which can be found in the precisely anthropometric production of craniometry and somatic mapping.[7] Examples of these include the tabulations and engravings in Morton's *Crania Americana* (1839)[8] and in a less overt form in Bell's portrait photographs.

A *carte-de-visite* of a different order is that of Medicine Bottle (pl.158), a dignified photograph, made by Whitney & Zimmerman of St. Paul Minnesota, soon before Medicine Bottle's execution at Fort Snelling on 11 November 1865 for his part in the Minnesota Uprising of 1862. The image might be seen as an exotic souvenir of danger contained and ultimately of the largest mass execution in US history. Photographic containment and objectification echoes political containment and objectification. This image was widely disseminated in *carte-de-visite* and cabinet formats. However, by 1870 it was considered of 'anthropological interest'. In its dissemination a print reached Germany where it was copied by Carl Dammann, a Hamburg photographer working with the Berliner Gesellschaft für Anthropologie, for sale to universities, museums, and learned societies with an interest in anthropology. It was included in the German folio edition of *Anthropologisch-Ethnologisches Album in Photographien,* as were other images from the same studio and context including that given the generalising and exoticising title 'Sioux Dandy' (pl.195). Even more significant is the presence of this latter image in Sir Benjamin Stone's album 'Photographs of the Types of Various Races of Mankind' (pl.92) which he collected together between about 1870-83. The similarity in format and the duplication of images suggests that the small English edition of the Dammann album may have been his inspiration. However crucially, the pages of Native American *cartes-de-visite* 'types' are grouped around a central and larger image of white 'society beauties'. This juxtaposition, the different spatial dynamics and the differing modes of action and passivity within the images establish a tense taxonomic counterpoint of racial difference and thus cultural and moral distance. Like the Vannerson and McClees images, the portrait of Medicine Bottle and others remained an object of fascination but the contexts shifted, from that of exotic curiosity into institutionally sanctioned anthropology. The content of the image alone, separated from its intentions, was sufficient to classify it in a range of meanings which cohered around the image of Medicine Bottle as 'Native American'.

If the image of Medicine Bottle is symbolic of the 'taming' of the Plains, Alice Fletcher's suggest cultural survival through the containment of assimilation. Fletcher worked among Omaha on the Plains, the very group whose people who had been performing in Paris (see above). She in many ways exemplifies the tension and paradoxes within anthropology in the late 19th century between interests in traditional culture and the reality of Native American experience. Trained as a scientific anthropologist linked to the Smithsonian and then with the Peabody Museum in Harvard, she espoused assimilationist beliefs which structured her anthropology and imaging. By the end of the 19th century it was clear to many that Native American

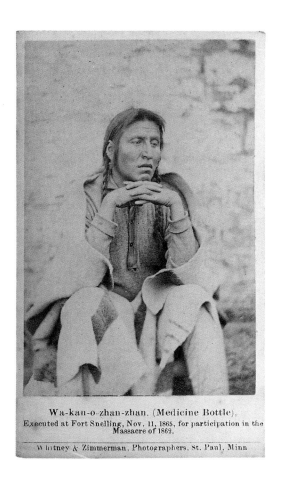

Wa-kan-o-zhan-zhan. (Medicine Bottle),
Executed at Fort Snelling, Nov. 11, 1865, for participation in the
Massacre of 1862.

Whitney & Zimmerman, Photographers, St. Paul, Minn

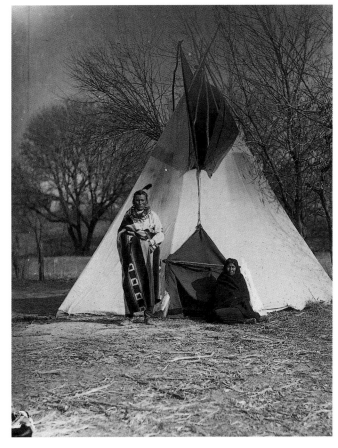

PLATE 158

JOEL EMMONS
WHITNEY

Medicine Bottle (Mdewakanton Dakota), taken at Fort Snelling, Minnesota on 17 June 1864 while he was a prisoner. Later hanged for his part in the Minnesota uprising, 1862 (see also Paula Fleming's essay pp. 168-184)

Albumen carte-de-visite. William Blackmore Collection. Trustees of the British Museum

PLATE 159

COMMISSIONED BY
ALICE FLETCHER

Shown at the 1885 New Orleans Exposition as part of a photographic exhibit entitled Indian Civilisation set up by Fletcher.

Modern print from a negative in the collection of the National Anthropological Archives, Smithsonian Institution

PLATE 160

OREGON COLUMBUS
HASTINGS

Noo-Nlemala [Fool Dancers] of
the Kwagiulth participating in
a winter initiation ceremony in
the forest at Fort Rupert,
Vancouver Island, British
Columbia, November 1894

Albumen print. National
Anthropological Archives,
Smithsonian Institution

peoples faced a stark choice between extermination in the face of 'the march of civilisation', or assimilation. While anthropology had a complex emergence among the social sciences, it shared at a deep level with political economy and sociology, a common source in both the recognition of peoples considered less fortunate and doomed and their political and moral meaning for the US.[9] Photographs made by and for Fletcher, were based on very considerable knowledge of Omaha culture, but privileged certain forms of visual information and thus preferred readings of her images, to present assimilationist possibilities. This is most overtly and self-consciously so in the work made for the 1885 New Orleans Exposition (pl.159). These photographs amounted to anthropologically informed assimilationist propaganda, intended to create a positive view of Native American peoples with a future. The positioning of the figures suggests a nuclear family with a gender hierarchy, in an isolated tipi, mirroring the white settler in the farmstead. The visual language of frontier vernacular photography, the proud homesteaders outside their home, merges with that of anthropological recording. While giving the appearance of the latter, the photograph uses the former to suggest the gradual developmental shift of Omaha people from 'wandering tribe' to settled agrarians with 'civilised values'. The beguiling realism of the photograph and its tranquil containing quality is integral to its intended role in creating the preconditions for the acceptance of its content as 'truth'.

But there were other ways of doing anthropology by the 1880s. More relativist thinking was emerging in anthropology, linked strongly to a salvage ethnography, the recording and describing of cultures which were perceived as being in the process of dying out, either through the inevitable progression of evolution or through assimilation. This gradual shift in thinking was linked to the emergence of anthropology as an increasingly specialist and professionalised discipline. This process had begun early in the US under the Geological Surveys and the BAE, but the scientific dynamism was beginning to shift towards the universities and major research museums. Photography, as a tool of this emerging anthropological perspective, was used increasingly in spontaneous, apparently unmediated, field situations. Technological advances in photography, with the development of increasingly light hand-held cameras, provide a partial explanation for this shift. But there was at the same time an intellectual shift in ideas about culture. While ideas about culture were often still expressed in a hierarchical form through the concepts of civilised and non-civilised, cultural difference was presented through the work of anthropologists such as Franz Boas and his students, as valid, dynamic, with elements of culture integrated into whole systems rather than separated to be classified. Boas was the single most influential figure in the shaping of American anthropology, shifting from an evolutionary or at least hierarchical basis towards a cultural relativist view.[10] From his earliest days Boas had used photography as an important tool in his work. He was not necessarily interested in visual effect, as Hillers had been for example, but in record and document. Boas worked with

photographers making images for him, notably Oregon C. Hastings and George Hunt, a Kwakiutl photographer. The image of five *Noo-Nlemala [Fool Dancers]* (pl.160) at the winter initiation ceremony at Fort Rupert in November 1894, despite Hastings's careful groups, has an unmediated quality suggestive, if not actually, of the arrested moment of action. Although Hastings actually took the photographs and was responsible for the final framing of the image, Boas directed the photography, attributing significance, setting the anthropological agenda and through that the representational agenda. This photograph has a strong portrait element, with a visual rhythm running through the groups of the figures and their relationship to the background trees. The foreground is held by a branch running diagonally in front of the group from frame edge to frame edge. Boas's notion of cultural completeness meant that like other anthropologists working in field situations at this date, such as Mooney (pl.24) and Stevenson (pl.49, 74), he exploited the sequencing of photographs to build a narrative and infuse the images with ethnographic honesty, trying to make the record as complete and thorough as possible. However, somewhat contradictorily, Boas believed that such notions of completeness must be built on empirically observed phenomena, thus arguably his notion of culture was embedded in isolated forms. At one level the photographs stress this, the contradiction and tension between whole and parts, of ceremonial as a contextualising narrative for objects, mirrors the relationship between the whole and the fragment inherent in photography. The photograph of the Noo-Nlemala [Fool Dancers] exemplifies this, the feeling of action stilled, of narrative beyond the frame and the tension between surface and depth which itself was emerging as a major concern within anthropology at this period.[11]

The complexities of the mutually sustaining discourses of anthropology and photography cannot be easily disentangled, nor can they be homogenised. My 'journey' has been concerned with some of these complexities and just as images linger within museums and archives long after anthropological thinking and relations with Native American peoples have changed in many different ways, so deposits of the associated imagery live on as active parts of popular consciousness, refracted through changing socio-economic and political environments. Native American peoples are trapped within this imagery. Paul Chaat Smith summed up this legacy thus: 'Heck, we're just plain folks, but no one wants to hear that. But how could it be different? The confusion and ambivalence, the amnesia and wistful romanticism make perfect sense. We are shape-shifters of national consciousness, accidental survivors unwanted reminders of disagreeable events. Indians have to be explained and accounted for, and somehow fit into the creation myth of the most powerful, benevolent nation ever, the last best hope for man on earth.'[12]

Anthropology was integral to the creation of that consciousness.

NOTES

1 Advertising leaflet in the collections of the National Anthropological Archives, Smithsonian Institution.

2 Hillers had worked first in the early 1870s with the artist, Thomas Moran, who had been responsible for posing Native American people for the camera.

3 Accession information, provided by John Welsey Powell, BAE, for Pitt Rivers Museum, University of Oxford.

4 It was not uncommon for photographers to dress and arrange their Native American sitters to stress the exotic and as a mark of 'authenticity' within a scientific context. There is no evidence that Bell did this.

5 Bonaparte photographed a number of groups re-enacting culture as spectacle in the shows and exhibitions of western Europe, for instance those from Surinam at the Amsterdam Colonial Exhibition of 1883 and the Australian Aboriginal group toured by Cunningham in 1885. He also travelled to northern Scandinavia and made a similar series of Sami Lappish peoples in 1884. For detailed study of the context of making of the Omaha photographs see *'Peaux-Rouges': Autour de la collection anthropologique du Prince Roland Bonaparte*. Thonon-les-Bains: L'Albaron/Photothèque du Musée de l'Homme.

6 She was daughter of the celebrated Omaha chief Inshta-Tanga [Big Eye].

7 Deborah Poole explores this 'conceptualising groundwork' in relation to photography of Andean peoples: *Vision, Race and Modernity: A Visual Economy of the Andean Image World,* Princeton University Press, 1997, pp.133-7.

8 For an outline of Morton's work and Crania Americana, see Stephen Jay Gould *The Mismeasure of Man* Harmondsworth: Penguin, 1984, pp.62-92.

9 Curtis Hinsley *The Smithsonian and the American Indian: Making a Moral Anthropology in Victorian America* Washington: Smithsonian Institution Press, 1981, p.145.

10 For a useful collection of key writings and analysis of Boas's anthropology see George Stocking (ed.) *A Franz Boas Reader: The Shaping of American Anthropology 1883-1911* Chicago: University of Chicago Press, 1974.

11 For an extended study of Boas's use of photography see Ira Jacknis 'Franz Boas and Photography, Studies in the Anthropology of Visual Communication, 10 (1): 2-60, 1984. For analysis of the work of George Hunt see Ira Jacknis 'George Hunt, Kwakiutl Photographer' in E Edwards, (ed.), *Anthropology and Photography 1860-1920* New Haven and London: Yale University Press, 1992, pp.143-51. See also A Jonaitis, 'Chiefly Feasts', Amer. Mus. Nat. Hist. & Washington UP, 1991.

12 Paul Chaat Smith 'The Ghost in the Machine'. *In Strong Hearts: Native American Visions and Voices* New York: Aperture, 1995, p.9.

WO'WAPI WAŚTE [1]

ACTING THE PART: IMAGE MAKERS OF THE NORTH AMERICAN INDIAN

COLIN TAYLOR

EXOTIC IMAGES

There has long been a great interest in the North American Indian in Europe and not least in the UK. Ever since Christopher Columbus's 'discovery' in 1492,[2] the Americas have been viewed as exotic lands whose flora and fauna, terrain and most of all their people, were vastly different from Europe. This 'New Golden Land', as the art historian Hugh Honour[3] described it, captured the imagination of Europeans leading to the production of often vivid and dramatic, figurative depictions of men and animals.

The range of these images was enormous – from John White's paintings produced in 1585-7 of Raleigh's Virginia colony,[4] to Tiepolo's *America* painted on the ceiling of the Residenz in Würzburg in 1753, to the explorer Jonathan Carver's book (published in London in 1778) and illustrated with views of Sioux and Chippewa men, women and children and the habitations of both the Woodland and Plains tribes.[5] In more recent times, a vast display of North American Indian portraits and scenes was exhibited by the American artist and explorer, George Catlin, in Egyptian Hall, Piccadilly, for more than three years (1839-43).[6]

GEORGE CATLIN

More than anything else, perhaps it was George Catlin's impressive exhibitions which finally set the seal on the romantic image of the North American Indian and 'Catlin's Indians' became the 'standard', popular source for at least three generations of readers (pl.162).[7] Not only was Catlin patronised by royalty – Queen Victoria was one of the subscribers to the first of his many books[8] – but writers such as Charles Dickens and Francis Parkman were among the many visitors. When interest started to wane, Catlin, forever the showman, initiated a kind of Wild West show – possibly the first of its kind – with real North American Indians, Ojibwa and later Iowa, to perform dances and demonstrate other tribal customs. Times, however, were changing; paintings and sketches of individuals were now rapidly being replaced by the advent of photography.

PLATE 161

Programme cover for The Buffalo Bill Wild West show, c.1903

Courtesy of the Taylor North American Indian Archives, Hastings

Of great interest in this analysis of North American Indian images is that the first photograph ever taken of one of them was probably in the UK, more precisely in Edinburgh on 4 August 1845, when two calotypes were made of the Mississauga [Ojibwa] leader, Kahkewaquonaby [Sacred Feathers] by Hill and Adamson. The historian, Professor Donald Smith of the University of Calgary, describes them as the oldest surviving (photographic) portraits of a North American Indian. Sacred Feathers's costume was typically Ojibwa – a shot bag decorated with a Thunderbird in porcupine quills, quilled moccasins and a pipe tomahawk, which was given to him by Sir Augustus d'Este, Queen Victoria's cousin.[9] This much respected leader travelled widely in the UK raising funds for North American Indian Schools; he tended to emphasise the 'popular' concept of the North American Indian lecturing on the manners, customs and religion of his people. He also exhibited specimens of 'Heathen Gods' as well as North American Indian Curiosities (pl.169). Admission was 6d; crowds flocked to see him.

WILLIAM BLACKMORE

Doubtless the young William Blackmore, a trained solicitor of Salisbury, England, visited the Catlin exhibition in London. Born in 1827, Blackmore travelled widely in the US where he was a specualtor in land and railroads: he had a deep interest in the North American Indian which was expressed in a passion for collecting photographic images of these people, eventually amassing, by the time of his death in 1878, at least upwards of two thousand photographs of North American Indians.[10] One component of this collection – much of which is now in the Ethnographical Department of the British Museum – was an extensive collection of *cartes-de-visite*, the precursor of the picture postcard.

William Blackmore was certainly among the first Englishmen to initiate the whole 'modern' love-affair with the North American Indian (pl.163,164). Not only did he arrange for the publication of a significant book written by the 'Indian fighter' Colonel Richard Irving Dodge, which was published in London in 1877,[11] but he travelled extensively in North America (1863-74), befriending many North American Indians such as the Oglala Sioux chief, Makhpiya lúta, (Red Cloud – 'Scarlet' is more precise) (pl.163). He formed a strong association with the scientists at the Smithsonian Institution in Washington and opened a museum in Salisbury, Wiltshire, which prominently displayed North American Indian regalia and accoutrements. Blackmore's activities were a very important factor in reinforcing the already established idyllic image of the North American Indian and, particularly appropriate to the theme of this exhibition, was his emphasis on obtaining photographic images of these people which, in later years, were to be used extensively on picture postcards.

BUFFALO BILL

So strong was the interest in the North American Indian that, even before the end of the

The Author painting a Chief at the base of the Rocky Mountains.

G. Catlin.

PLATE 162

The artist and explorer, George Catlin, painting the Mandan Chief Mato-tope [Four Bears] in July 1832

Courtesy of the Taylor North American Indian Archives, Hastings

PLATE 163

ALEXANDER GARDNER

The Englishman, William Blackmore and the Oglala Lakota Chief Makhpiya lúta [Red Cloud], Washington, DC, May 1872

Albumen print. William Blackmore Collection. Trustees of the British Museum

PLATE 164

William Blackmore dressed in Native North American regalia, c.1875. The headdress which he is wearing is now in the Pitt Rivers Museum, University of Oxford

Courtesy of the Taylor North American Indian Archives, Hastings

PLATE 165

UNIDENTIFIED PHOTOGRAPHER

Sioux Indians on their first visit to Europe, c.1887 to perform in Buffalo Bill's Wild West show. (Most probably Sinte Maza [Iron Tail] standing centre wearing the stetson)

Courtesy of the Taylor North American Indian Archives, Hastings

PLATE 166

Sinte Maza [Iron Tail], an Oglala Lakota warrior who worked for Buffalo Bill for many years, the two becoming close friends

Courtesy of the Taylor North American Indian Archives, Hastings

PLATE 167

The Buffalo Bill Wild West show travelled widely, creating great interest in Victorian England. Native Americans were particularly popular and '100 redskin Braves' from Sioux, Tististas [Cheyenne] and Hinano'ei [Arapaho] tribes, visited many towns such as Hastings in 1903. It was there that the young Archie Belaney (see pl.178) was enthralled by the Native Americans he saw.

Courtesy of the Taylor North American Indian Archives, Hastings

BUFFALO BILL'S
WILD WEST
AMERICA'S NATIONAL ENTERTAINMENT.
ANIMATED ILLUSTRATIONS OF HISTORICAL FACTS AND SKETCHES.

COL. W. F. CODY ("BUFFALO BILL") - - - - - - - - - President.
NATE SALSBURY - - - - - - - - - Vice-President and Director.
JOHN M. BURKE - - - - - - - - - General Manager.
ALBERT E. SHEIBLE - - - Business Representative. H. M. CLIFFORD - - Orator.
CARTER COUTURIER - - Advertising Agent. LEW PARKER - Contracting Agent.
JULE KEEN - - Treasurer. WILLIAM LANGAN - Supply Agent.
WILD WEST SCENERY BY W. GLOVER.

PROGRAMME.

OVERTURE - "Star Spangled Banner" - - COWBOY BAND
WM. SWEENY, Leader.
1.—GRAND REVIEW and introduction of the Rough Riders of the World.
2.—MISS ANNIE OAKLEY, Celebrated Shot, who will illustrate her dexterity in the use of Fire-arms.
3.—HORSE RACE between a Cowboy, a Cossack, a Mexican, a Gaucho, and an Indian, on Spanish-Mexican, Broncho, Russian, and Indian Ponies.
4.—PONY EXPRESS. The Former Pony Post Rider will show how the Letters and Telegrams of the Republic were distributed across the immense Continent previous to the Railways and Telegraph.
5.—ILLUSTRATING A PRAIRIE EMIGRANT TRAIN CROSSING THE PLAINS. The Camp—Preparing the Meal—The Surprise by Indians—The Capture—Running the Gauntlet—Burning at the Stake—The Scalp Dance—Capture of Prairie Maiden—"BUFFALO BILL" and his Scouts to the Rescue.
N.B.—The Wagons are the same as used 35 Years ago.
6.—CAPTAIN JACK BURTZ'S Lightning Drill.
7.—COWBOY FUN. Picking Objects from the Ground. Lassoing Wild Horses. Riding the Buckers.
8.—ACROSS COUNTRY, with Riders of all Nations.
9.—JOHNNY BAKER, Celebrated Young American Marksman.
10.—THE DESERTER. Lone Cowboy—Stealing the Horse—Capture of the Thief—Western Justice (Judge Lynch presiding)—Soldiers discover Deserter's body.

11.—RUSSIAN COSSACKS, in Feats of Horsemanship, Native Dances, &c., &c.
12.—RACING BETWEEN PRAIRIE, SPANISH, AND INDIAN GIRLS.
13.—TROUPE OF GAUCHOS in Feats of Horsemanship, Throwing the Lasso, and the use of the Native Weapon, called the Bolas.
14.—CAPTURE OF THE DEADWOOD MAIL COACH BY THE INDIANS, which will be rescued by "BUFFALO BILL" and his Attendant Cowboys.
N.B.—This is the identical old DEADWOOD COACH, called the Mail Coach, which is famous on account of having carried the great number of people who lost their lives on the road between DEADWOOD and Cheyenne 18 Years ago. Now the most Famed Vehicle extant.
15.—RACING BETWEEN INDIAN BOYS ON BAREBACK HORSES.
16.—LIFE CUSTOMS OF THE INDIANS. Indian Settlement on the Field and "Path."
17.—COL. W. F. CODY ("Buffalo Bill"), in his unique Feats of Sharpshooting.
18.—BUFFALO HUNT, as it is in the Far West of North America—"BUFFALO BILL" and Indians. The last of the only known Native Herd.
19.—ATTACK ON A SETTLER'S CABIN—Capture by the Indians—Rescue by "BUFFALO BILL" and the Cowboys.
20.—SALUTE.

NATIONAL ANTHEM—CONCLUSION.

PLATE 168

A poster advertising a lecture to be given by the Mississauga [Ojibwa] leader, Peter Jones, or Kahkewaquonaby [Sacred Feathers]. Poster published in Hastings in 1845

Courtesy of the Taylor North American Indian Archives, Hastings

PLATE 169

A disc of buckskin records the many towns visited throughout England in 1902-3 by the Buffalo Bill Wild west Show. (This original is in the Buffalo Bill Ranch House on the North Platte, Nebraska; photograph by Colin Taylor)

Courtesy of the Taylor North American Indian Archives, Hastings

NORTH AMERICAN INDIANS.
A LECTURE
(IN AID OF THE INDIAN MANUAL LABOR SCHOOLS)
ON THE
MANNERS, CUSTOMS, & RELIGION,
OF THE ABOVE
INTERESTING PEOPLE,
WILL BE DELIVERED IN THE
Swan Assembly Room,
On Monday, Dec. 1st, 1845,
BY
KAHKEWAQUONABY,
(PETER JONES)
Indian Chief, from Canada, who has laboured as a Missionary for twenty years among his countrymen.

Several specimens of Heathen Gods and Indian Curiosities will be exhibited.---Lecture to commence at 7 o'clock.

Admission, 6d. each.---At the close of the meeting, a collection will be made for the object above stated.

Printed by H. Weston, Stationer, 37 George Street, Hastings.

wars in the West and the final closing of the American Frontier, the 'popular' romantic image of the North American Indian was being appropriated. Foremost among these promoters was William F. Cody, better known as 'Buffalo Bill' who in 1869 was first introduced to the potential for money to made in the fictionalisation of the American West, by the dime novelist Ned Buntline. By 1872, Cody had taken to the stage in *Scouts of the Prairie* which was to delight audiences and amuse critics for more than a decade. By 1882, the stage presentation had evolved into an outdoor Wild West show complete with Indians who, with wry and bemused effort matched the already well-established stereotypes, particularly those somewhat mindless and cruel attackers of forts, stagecoaches and cavalry, who invariably lost the fight in the end – with, of course, Buffalo Bill the hero!

Behind the scenes, however, things were somewhat different. Buffalo Bill, in fact, was on the whole a staunch friend of the North American Indian. He formed, for example, a strong alliance with Tatanka Iyotanka [Sitting Bull], the spiritual leader of the independent Sioux who had annihilated George Armstrong Custer on the Little Bighorn river in June 1876.[12] Cody recruited North American Indians from the Reservations who, now largely in an anomic state, were generally more than happy to leave their grim environment and earn some money. The men once again became warriors (if only make-believe ones) while the women had a good opportunity to supplement their incomes by selling beaded items, particularly moccasins, to a vast and generally appreciative public.[13]

PEOPLE OF THE BUFFALO

The 'standard Indians' of Buffalo Bill's shows were largely Sioux – North American Indians from the Plains, recruited from the Pine Ridge, Standing Rock and Cheyenne River Reservations in North and South Dakota – and a number of these former buffalo-hunting Indians had also been warriors concerned with fighting for their homelands against invading whites in such conflicts as the Fetterman Battle (1866), Wagon Box Fight (1867), the Fort Laramie Treaty (April 1868), the closing of the Bozeman Trail (November 1868) and the Custer Battle of June 1876. Of course, at this time, 1882, the Massacre of Big Foot's Minneconjou at Wounded Knee together with the gunning down of Sitting Bull in December 1890 was still to come.[14]

Other North American Indians were, however, also recruited – such as [Apaches] and several non-Plains tribes – and even these people, largely pedestrians, were turned into horseback Indians wearing flowing warbonnets.[15]

By 1887, Buffalo Bill's circus was travelling to Europe, complete with a considerable number of Sioux, [Arapaho] and Pawnee. Foremost among the North American Indians employed by the Circus, was the Oglala warrior, Sinte Maza [Iron Tail], who became a lifelong friend and companion of Buffalo Bill. Born in 1847 in a buffalo-hide tipi, Iron Tail epitomised the image of the American Indian, invariably appearing in beaded

Top row, left to right:

PLATE 170

Long Wolf, an Oglala Lakota participant in Buffalo Bill's Circus. Tragically, Long Wolf died of pneumonia in London at the age of fifty-nine while performing in Buffalo Bill's Wild West show. He was buried in Brompton Cemetery, London but in September 1997, his body was finally returned to South Dakota

Courtesy of the Taylor North American Indian Archives, Hastings

PLATE 171

Willie Spotted Horse who travelled with his parents in the Buffalo Bill Wild West show, c.1909 (Earls Court, London)

Courtesy of the Taylor North American Indian Archives, Hastings. Photograph by F B Hackett

PLATE 172

Black Hawk, an Oglala Lakota Chief, a participant in Buffalo Bill's Wild West show, c.1915

Courtesy of the Taylor North American Indian Archives, Hastings. Photograph by F B Hackett

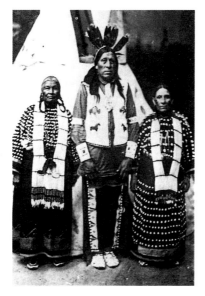
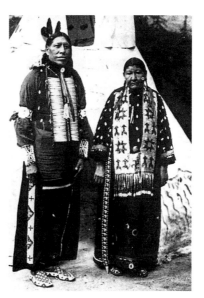
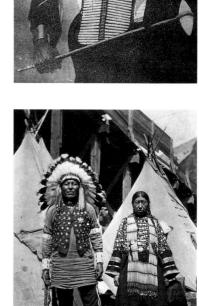

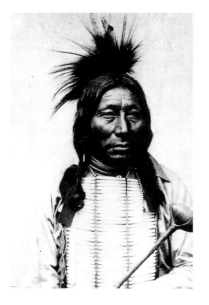

buckskin regalia and wearing a magnificent flowing eagle feather warbonnet (pl.166). While a genuine warrior – he is said to have fought in the Custer Battle), Iron Tail obviously 'acted the part', leading the North American Indian cavalcade into the arena as if on a war-party, attacking the covered wagons or stagecoach, riding down the buffalo and, as expected by the audience, finally being chased off the scene by rough riders or cavalry. The evidence suggests that Iron Tail's fine sense of humour and humanity carried him through, perhaps more so than others such as Sitting Bull, who joined these circus acts for but a comparatively short time and then somewhat disillusioned of the 'game', never returned.

Although much concerned about travelling across the Atlantic (pl.165), the Indians 'recalled the old tribal superstitions which held that disaster would befall them if they crossed the ocean'.[16] The experience on the whole was a happy one and they enjoyed the adulation of the audiences who, as with Catlin's exhibition some forty years earlier, were captivated by these 'image makers'. The year 1887 was Britain's Golden Jubilee year and although obviously extremely busy, Queen Victoria visited the Show at Earls Court on 12 May just three days after the premier and although intending to stay only one hour, remained for the whole performance. Later, the Queen requested a Command Performance at Windsor Castle, which took place on the morning of 20 June 1887, before an invited audience which included among Queen Victoria's guests, kings, queens, princes, princesses and dukes from more than a dozen European countries.[17] After the performance, Red Shirt (an impressive and highly esteemed Sioux chief) together with Sioux women and children, were presented to the Queen. Black Elk, who in later years was to emerge as a distinguished interpreter of his Sioux people's religion, recalled that Queen Victoria (whom he referred to as 'Grandmother England'), told them that she wished 'that I owned you people, for I would not carry you round as beasts to show to the people'. Clearly, the exploitative elements of such shows were recognised. There was sadness too, such as with the death of Long Wolf of pneumonia in 1892 (pl.170) and a seventeen-month-old Sioux girl, White Star, who was killed in a riding accident. Both were buried in Brompton Cemetery.[18]

The shows were enormously successful and there were three further visits – in 1891, 1892 and 1893 – to England. Advertisements and publicity leaflets conjured exotic scenes and many were indeed that – buffalo hunts, war dances, magnificent regalia and North American Indian villages (pl.161, 167), not to mention the cowboys, US Cavalry, Rough Riders and Cossacks, to name a few.

The pace was gruelling: in the 1902-3 tour, for example (pl.169), there were twelve separate shows in as many days and, in total, more than one hundred performances in some four months. Reports were enthusiastic; it was possible also for the public to visit the North American Indian village, thus extending on what they saw in the performances (pl.170-175) – there might also have been some surprises! (pl.185). Little wonder that the whole love-affair with the North American Indian was perpetuated.

Left to right, from top:

PLATE 176

An interesting postcard of the Snake Dance performed by Moki (Hopi) Indians from northeastern Arizona

Original postcard, courtesy of the Taylor North American Indian Archives, Hastings

PLATE 177

F B HACKETT

Two of the North American Indians (probably Sioux) in the 101 Ranch Wild West Anglo-American exposition held in Shepherd's Bush, London, in 1914. Ranch 101 was owned by the Miller brothers and organised shows similar to that of Buffalo Bill's, but if anything put a greater emphasis on the North American Indian

Original postcard, courtesy of the Taylor North American Indian Archives, Hastings

PLATE 178

Mrs Wigwas and daughter

Original postcard, courtesy of the Taylor North American Indian Archives, Hastings

PLATE 179

The Englishman, Archie Belaney who, after going to Canada in 1906, returned as a North American Indian. Author, authority on American Indians, but above all an ardent conservationist, he was much influenced by Buffalo Bill's Indians whom he saw in Hastings in 1903.

Courtesy of the Taylor North American Indian Archives, Hastings

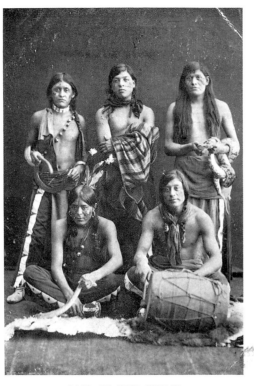

BAND OF MOKI INDIANS.
Snake Dancers from the Painted Desert of America.
In the Mammoth Fun City, Olympia.

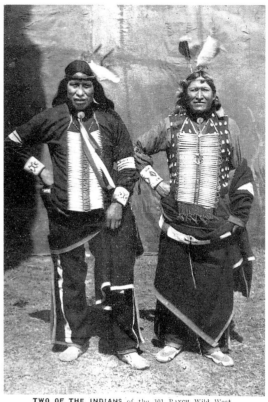

TWO OF THE INDIANS of the 101 RANCH Wild West.
Anglo-American Exposition, Shepherd's Bush, London, Eng.

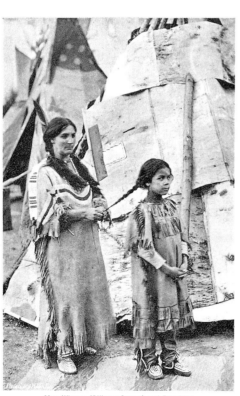

Mrs. Wigwas (Ojibway Squaw) and Daughter.
Indian Village, Earl's Court.

GREY OWL

IRON TAIL

As previously mentioned, dominant in creating such images was Sinte Maza, [Iron Tail], the Oglala Sioux. In addition, Iron Tail had the distinction of being one of the models for the buffalo-Indian nickel.[19] He also took a keen interest in his tribe's history and culture acting as an informant for anthropologists. Iron Tail emerges as a very real, if somewhat romanticised, individual whose projected image of the Plains Indian has clearly influenced several generations, both white and red, an image of a flamboyant feather-bedecked warrior society which fiercely opposed the oncoming white man.[20]

WA-SHA-QUON-ASIN [GREY OWL]

Deeply influenced by such images was the Englishman, Archibald Belaney, better known as 'Grey Owl' (pl.179).[21] Born in Hastings, Sussex, in 1888 he was an avid reader of the books, both idyllic and factual, written at the time on the North American Indian and was further deeply influenced by a visit to Buffalo Bill's Circus when it went to Hastings in 1903. By 1906, he had left England for Canada in the nostalgic pursuit of a vanishing reality. He subsequently adopted North American Indian dress and ways. Initially, Archie Belaney earned his living in the thriving fur trade of northern Ontario but by 1928 he had turned from a trapper of beaver to a conservationist, ultimately gaining international fame with his books and lectures on North American Indians and wild animals.

Grey Owl returned to England in 1935 and 1937 travelling and lecturing widely. He virtually became a household name and he personally pleaded the cause of the North American Indian and conservation to King George VI at Buckingham Palace. In all these endeavours, Grey Owl lived a dream, projecting the 'expected' image of the American Indian – stoic, warrior-like, buckskin-clad, tomahawk in hand and invariably wearing the eagle feather warbonnet so characteristic of the image of the Plains Indian who so strongly influenced him. A generous and much gifted man, who wrote four books with a strong North American Indian theme, Grey Owl tragically died in April 1938, a few months before his fiftieth birthday. As with Catlin, Buffalo Bill, Iron Tail and the like, Grey Owl 'played the part': dream rather than true reality. But of them all we can surely say, theirs was a gentle masquerade. They projected creative, rich and powerful visual representations of the North American Indian and the American scene, much of which was captured as photographic images.

THE POSTCARD

Such experiences demanded from the public, more tangible souvenirs of things and people seen; the picture postcard largely fulfilled that need. Although picture card graphics were circulated widely from about 1850, it was not until the 1880s that picture postcards with images of North American Indians appeared. At the height of their popularity (1890-1920) 'billions of postcards were printed in the United States and

PLATE 180

A decidedly romanticised image of the North American Indian – a modern day Minni-ha-ha. Women did not, traditionally at least, wear feathered head-dresses of this type

Original postcard, courtesy of the Taylor North American Indian Archives, Hastings

PLATE 181

A somewhat strange, but eyecatching, image of a Plains Indian of the type popular on postcards at the turn of the century

Original postcard, courtesy of the Taylor North American Indian Archives, Hastings

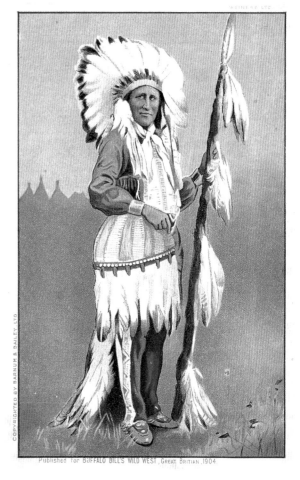

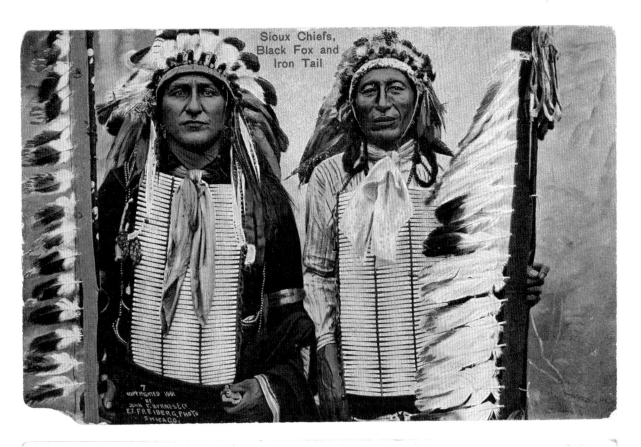

Sioux Chiefs, Black Fox and Iron Tail

PLATE 182

Sioux 'Chiefs' Black Fox and Iron Tail

Original postcard, courtesy of the Taylor North American Indian Archives, Hastings

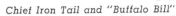

Chief Iron Tail and "Buffalo Bill"

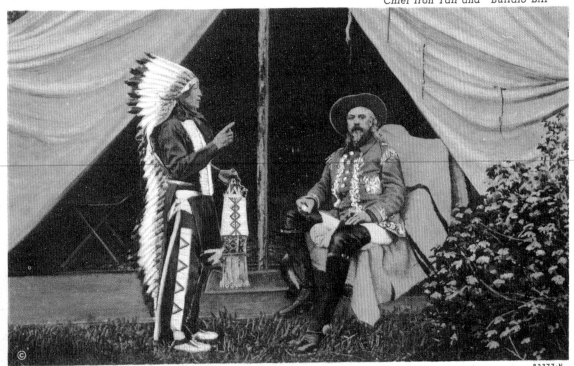

PLATE 183

Iron Tail and Buffalo Bill. Both men worked together in the Wild West show for many years and became firm and loyal friends

Original postcard, courtesy of the Taylor North American Indian Archives, Hastings

PLATE 184

Although simply identified as 'Northwest Indians', these are obviously Plateau people, probably of the Yakima and Nez Perce tribes, c.1910. This is a good example of a 'local' view postcard which in general accurately reflected the true lifestyle and costumes

Original postcard, courtesy of the Taylor North American Indian Archives, Hastings

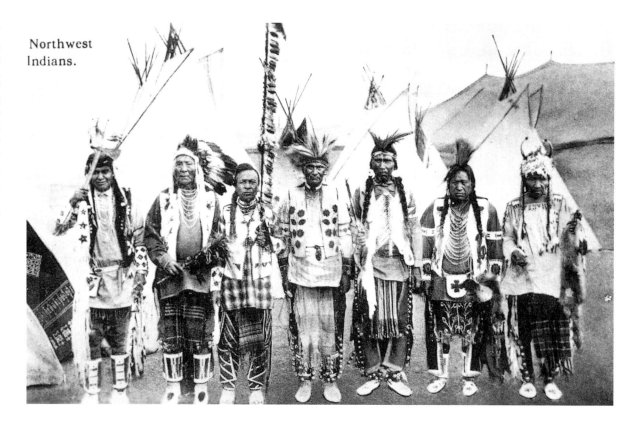

Northwest
Indians.

PLATE 185

Sinte Maza [Iron Tail] fast asleep! (After a busy day projecting the romantic image of the North American Indian?)

Courtesy of the Taylor North American Indian Archives, Hastings. Photograph by F B Hackett

imported from Europe'.[22] Further, it has been estimated that over ten thousand different postcards were devoted to North American Indian subjects. The Sioux, generally in eagle-feather warbonnets, figured predominately in six of the ten different North American Indian Series issued by the British firm, Rapheal Tuck and Sons Ltd in the 1890s; later issues commonly dressed such tribes as the Iroquois, Mohawk, and Penobscot in the Plains warbonnet (pl.180,181). Indeed, in one sample of postcards purporting to show North American Indians from the northeastern regions of the USA '43 per cent depicted Indian men in Sioux-style warbonnets'.[23] Others, however, were sometimes more accurately dressed as seen in the postcards of the Moki (Hopi) Indians at Olympia, the Plateau tribes of Idaho and Washington and the Apaches from Arizona as well as Sioux women and children (pl.176,184). A number were beautifully reproduced in colour, although identification of some individuals is dubious!

Iron Tail figured prominently on a number of these postcards sometimes with Buffalo Bill himself (pl.182,183). Two friends, red and white, who like many others before and since, acted a part – image makers of the North American Indian, nevertheless *Wo'wapi Waśte*!

ACKNOWLEDGEMENTS

I must acknowledge the 'introduction' that the late Tex McLeod gave me to the romantic image of the American Indian through the activities of Buffalo Bill and Iron Tail. Mr McLeod was in Buffalo Bill's outfit in the early 1900s. He was also a friend of Iron Tail from whom he obtained a magnificent bonnet. As a teenager in the 1950s, Tex McLeod told me many interesting anecdotes of the Buffalo Bill show – he, together with Buffalo Bill, Iron Tail and many others, were obviously among the 'inventors' of the romanticised view of the American West and projected the 'popular' image of its indigenous inhabitants – the Plains Indian in all their regalia.

I must also express thanks to my friend Kingsley Bray – an expert without equal on Lakota history – who has been willing to discuss and help with language, history and terminology.

Another friend was F. B. Hackett who travelled with Buffalo Bill and arranged the funeral of Iron Tail when he died in 1916. Years ago, Mr Hackett generously gave me a number of the photographs which are reproduced in this chapter.

Finally, my thanks to my wife Betty who, as with all these projects, has advised, discussed and helped in many ways. In that respect she is the co-author of this paper.

NOTES

1 Wo'wapi Waśte is Lakota. It may be literally rendered as 'good picture' although it is far richer in connotations and can refer to a letter, flag or book. Wo'wapi is a powerful Lakota word with visual impact.

2 There is very little doubt that the Americas have been 'discovered' at least three, if not more times. Erik the Red founded a colony in Greenland about AD 980 and from there, travels were made to present-day Newfoundland where smaller colonies were set up.

3 A recommended volume on the Americas (which was based on the bicentennial exhibit prepared by Hugh Honour for the National Gallery in Washington and the Cleveland Museum) is H Honour, *The New Golden Land: European Images of America from the Discoveries to the Present Time*, New York: Pantheon Books, 1975. The book, however, goes beyond the original exhibit.

4 No less than 75 of White's original watercolours have survived. Now in the British Museum, the emphasis is on the North American Indian peoples and their customs. See P Hulton, *America 1585. The Complete Drawings of John White*, University of North Carolina Press and British Museum Publications, 1984.

5 The original Carver ms with highly interesting sketches – probably produced under Carver's direction – is now in the British Museum. See, J Parker, (ed.), *The Journals of Jonathan Carver: and Related Documents 1766-1770*, St Paul, Minnesota: Minnesota Historical Society Press, 1976.

6 For a recent evaluation of the impact of 'Catlin's Indians' on the British public, see B W Dippie, *Catlin and his Contemporaries: the Politics of Patronage*, Lincoln and London: University of Nebraska Press, 1990, esp. pp.96-105.

7 On a somewhat more scholarly level but less accessible, were the writings of the German prince and scientist Maximilian, Prince of Wied which were profusely illustrated with exquisite paintings – based on sketches made in the field – by the Swiss artist, Karl Bodmer. See *Travels in the Interior of North America*, trans. H Evans Lloyd, London: Ackermann and Company, 1843. Several other British writers of the 19th century maintained and stimulated the interest in North American Indians, such as W. Bell, *New Tracks in North America*, London, 2 vols, 1869; Colonel W F Butler, *The Great Lone Land*, London: Sampson Low, Marston & Company, 1891; and R M Ballantyne, *The Young Fur-Traders*; or *Snowflakes and Sunbeams from the Far North*, London: T Nelson & Sons, 1893.

8 This impressive book, in 2 vols, was published by Catlin at the Egyptian Hall, Piccadilly, London in 1841. It was profusely illustrated with 400 line drawings engraved on steel. It became a standard resource for many subsequent artists and illustrators, the majority of whom had never been to America. There was a Command Performance at Windsor Castle in 1843 when Catlin explained Ojibwa war dances to Queen Victoria (see, Dippie, *Catlin and his Contemporaries: the Politics of Patronage* 1990, pp.101–2).

9 See D B Smith, *Sacred Feathers: the Reverend Peter Jones (a Kahkewaquonaby) and the Mississauga Indians*, Toronto and London; University of Toronto Press, 1987, opp. p.226.

10 Blackmore travelled widely in the USA. He commissioned photographers such as Gardner and Shindler to take photographic portraits of North American Indians. In later years he befriended George Catlin when the latter fell on hard times.

For a detailed analysis of Blackmore and his contributions to North American Indian ethnology, see C Taylor, 'Ho, for the Great West!', title essay in B C Johnson, (ed.), Silver Jubilee Publication of the English Westerners' Society, London, 1980.

11 This book, *The Hunting Grounds of the Great West*, was published by Chatto & Windus in London, 1877. The publishers, who had been glad to publish this work, expressed the great interest at the time in the exotic American West as 'Sport and Adventure amongst the Indians and on the Plains of the Far West'. It was extensively illustrated 'in a very liberal manner with woodcuts to be taken from the photographs and sketches...' It was, as with Catlin's volumes a generation or so later, an important factor in reinforcing the already established romantic image of the American West and its Indians (see Taylor, 'Ho, for the Great West!' 1980).

12 Sitting Bull joined the Buffalo Bill Circus in June 1885 (Sitting Bull called Cody, *Pahaska*, [Long Hair]). He was treated fairly and well by Colonel Cody and, over a four-month period, Sitting Bull would 'receive $50 a week, a bonus of $125, and exclusive rights to the sale of his portraits and autographs – a source of handsome revenue' (see R M Utley, *The Lance and the Shield: the Life and Times of Sitting Bull*, New York: Ballantine Books, 1993, p.264). A photograph taken in Montreal, which later became the subject of a postcard, showed the two, clasping hands, and was widely displayed on publicity posters with the caption, 'Foes in '76, Friends in '85'. As the season closed, however, Sitting Bull had 'tired of the noise and bustle... and longed for the fresh air of the prairie' (ibid. p.265). Both Red Cloud and American Horse also joined Buffalo Bill in June 1886 where they rode together at the Madison Square Garden. Both North American Indians wore eagle feather warbonnets (see V Weybright and H B Sell, *Buffalo Bill and the Wild West*, London: Hamish Hamilton, 1956, opp. p.108).

13 Much beadwork was being produced at this time by Sioux women but their sales were limited when confined to the Reservations – travel with Buffalo Bill opened up another very important outlet.

14 The killing of Sitting Bull is a shameful chapter in the handling of the Plains Indians. A man of great independence and status, he stood his ground against the Indian Agent, James McLaughlin who much resented his influence among the Standing Rock Sioux. Blamed for the unrest of the Sioux at the time the Ghost Dance swept the Plains in 1890, McLaughlin requested the arrest of Sitting Bull. In the ensuing fray, Sitting Bull was killed (15 Dec. 1890). Buffalo Bill had been requested by General Nelson Miles to visit Sitting Bull and discuss with him the possibility of calming the unrest. Cody readily agreed to this request; however, Major McLaughlin considered it unwarranted interference and Buffalo Bill was forced to abandon the mission. It is highly probable he would have averted his old friend's early and tragic end (Sitting Bull was only 56 at the time of his death).

15 Warbonnets were essential regalia; developed by the Plains tribes they came to be a symbol of the North American Indian. By the 1890s, tribes as widely spaced as the Pueblo in New Mexico to the Penobscot of Maine, donned the Plains bonnet – it was expected of them. Indeed, it is well documented that contacts with Plains Indian showmen in the Pan-American Exposition in Buffalo in 1901, encouraged Seneca Indians 'to substitute the Plains type of feather bonnet for their traditional

crown of upright feathers'. See J C Ewers, *The Emergence of the Plains Indian as the Symbol of the North American Indian*, publication 4636, Smithsonian Report for 1964, 1965, p.541.

16 See V Weybright and H B Sell, *Buffalo Bill and the Wild West*, 1956, p.148.

17 It was during the 12 May performance that, as Buffalo Bill rode into the arena carrying a large American flag, Queen Victoria rose and bowed impressively as he waved the flag above his head. It was the first time in history 'since the Declaration of Independence a sovereign of Great Britain saluted the Star-Spangled Banner' (see Weybright and Sell, *Buffalo Bill and the Wild West*, 1956, p.157). During the 20 June performance, four European kings rode on the Deadwood Stage, with the Prince of Wales on the seat high up front next to Buffalo Bill. Chased by warbonneted Plains Indians, another near myth – but certainly a dramatic image – was perpetuated.

18 In September 1997, Long Wolf's body, together with that of White Star, was exhumed from the Brompton Cemetery. Long Wolf was reburied at Wolf Creek on the Pine Ridge Reservation. After a 4,000-mile journey and more than a century later, Long Wolf finally rests in the shadow of his ancestral hunting grounds in the Black Hills of South Dakota, see the Daily Telegraph, 29 Sept. 1997, p.8.

19 See J C Ewers, *The Emergence of the Plains Indian as the Symbol of the North American Indian*, publication 4636, Smithsonian Report for 1964, 1965, pp.542.

20 As the late ethnologist, Dr John C Ewers of the Smithsonian Institution remarked 'the warbonneted Plains Indian emerged as the widely recognized symbol of the North American Indian', see Ewers, 1965, p.543.

21 There is an epic film currently being made on the life and times of Grey Owl. It is being co-produced and directed by Richard Attenborough with Pierce Brosnan in the leading role. The lifestyle and image of both Plains Indians and Woodland Indians has been carefully researched and portrayed in a sensitive way. The warbonneted Plains Indian – so typical of 'Indianness' in the minds of many people – figures prominently in one of the most dramatic episodes in the movie.

22 P C Albers and W R James, 'The Dominance of Plains Indian Imagery on the Picture Postcard', in the Fifth Annual Plains Indian Seminar in Honour of Dr John C. Ewers, in G P Horse Capture and G. Ball, (eds), 1984, p.75. See also R. Green, 'The Indian in Popular American Culture in History of Indian -White Relations', vol. 4, *Handbook of North American Indians*, W E Washburn, (ed.), Washington: Smithsonian Institution, 1988, pp.587-606. As Green observes, almost all figures on postcards showing American Indians were 'Plains males'. Portraits of chiefs and medicine men were the most popular, followed by scenes of daily life, hunting buffalo and dancing, ibid. p 600.

23 Ibid, p.79.

PLATE 186

CHARLES FLETCHER
LUMMIS

'Carlota, a Tigua maiden'
Isleta Pueblo, 1890

Modern print from a
negative in the collection of
the Southwest Museum, Los
Angeles

THE PEN AND THE GAZE

NARRATIVES OF THE SOUTHWEST AT THE TURN OF THE 19TH CENTURY

BENEDETTA CESTELLI GUIDI

'These are a few of the Strange Corners of our Country. There are very many more, of which others can tell you much better that I do' Charles F. Lummis[1]

LITERATURE ON THE AMERICAN SOUTHWEST produced between the last two decades of the 19th century and the first two of the 20th is extremely varied, both in graphic form and content. In printed literature, photographs were employed as a relevant narrative medium in visualising the Southwest to a growing public.

FIRST PHOTOGRAPHIC IMAGES IN PUBLICATIONS

The extensive use of images in books was designed from the first to attract white Americans to discover a national heritage still little known. During the 1880s visual accounts in the form of photographs and occasionally etchings and coloured drawings were reproduced in ethnographic studies, tourist literature and novels. Preferable to printed words alone, images were used to promote the 'exotic' regions of the Southwest; its deserts, its Native peoples, its architecture and its archaeological sites. Images reproduced in the novels and books encouraging tourism tended to have only a loose relation to the text, whereas in ethnographical studies text and illustration were closely linked; the photograph an aid to the narrative. The photographic medium seemed to offer evidence of reality, something that the text alone could not.

The use of images in books might be expected to change according to the intent of the author and the market the publication was aimed at. However, this assumption is undermined on closer scrutiny of the books themselves. For instance, there is often a similar way of reproducing and mounting images on the page in publications that differ in both material and conceptual terms. This phenomenon can only be explained as being due to the growing consciousness of the power of the image, resulting in their abundant and often indiscriminate use in the texts.

Both in tourist-orientated publications of the region and in census Bulletins printed

by the government office in Washington, DC, what's immediately noticeable is the large numbers of photographs published. In both cases these images were taken by contemporary photographers and were mounted on the page in composite form. The indiscriminate use of photographs together with their composition on the page testify to a need for visual description that could convey to the audience a more direct message. In *The Moki Snake Dance, a popular account of that unparalleled dramatic pagan ceremony of the Pueblo Indians of Tusayan, Arizona with incidental mention of their life and customs* the anthropologist Walter Hough, working together with the Santa Fe railroad, chose sixty-four photographs by contemporary photographers to illustrate the snake dance. Given the small format of the book the number of published photographs is impressive, explicable in terms of the sensational account given of an event that strongly captured the contemporary imagination. An even larger number of images were reproduced in the *Extra Census Bulletin. Moqui Pueblo Indians of Arizona and Pueblo Indians of New Mexico*. Descriptions of New Mexico and Arizona's populations are interrupted by pages entirely filled with photographs, etchings and drawings, designed to give a broad account, encompassing the social and geographical features of these territories which had only recently, within the last fifty years, been scientifically scrutinised by central administration.

THE PHOTOGRAPHER'S ROLE AND THE IMPACT OF TECHNOLOGY

Both these books show the importance that photographic images were now playing in printed literature, especially from the 1880s onwards when the camera became a more readily available tool, thanks to Kodak's new easy-to-use hand held cameras. The new Kodak made photography more commonplace, giving many the chance to take their own images, albeit as amateurs. Photographer-authors and printing houses created a booming market in the buying and selling of images.

The practice of government and corporations commissioning photographers to take part in surveys was disappearing. A project like A. J. Russell's *The Great West Illustrated* of 1869 (pl.36, 37) would have been too expensive to support in the 1890s, when compared to the cost of buying some of the photographs available on the market. Equally, once the Southwestern territories had been surveyed by both government and corporations there was no longer any need for such costly limited-edition publishing enterprises. Edward S. Curtis's project to record Native populations of the entire American territory (pl.115-125) is a testament to his tenacity. He eventually had to find a private sponsor for his twenty volumes completed over a thirty-year period, since no corporate company or central administration would have paid for such a gargantuan project when images of Natives and southern landscapes were available, cheaper to buy and reproduce than to make anew.

The increase of cameras on the market and of amateur photographers gave birth to a new kind of book, in which images became an essential part of the narrative. From the

1880s onward, writers, pseudo-ethnographers and tourists passionate about the Southwestern regions produced books of their own, illustrated with images they had taken or those bought from or exchanged with their acquaintances. The novelty of half-tone printing reduced the cost of book production, allowing the establishment of a growing market of illustrated literature on American regions.

LUMMIS IN WONDERLAND

In one of his most widely illustrated books on the Southwest, *The Wonderland of the Southwest: Mesa, Canon and Pueblo,* Charles Fletcher Lummis reproduced nearly 100 photographs taken not only from his own large collection, but also images by A. C. Vroman, Jess L. Nausbaum, A. J. Baker, E. Bibo and G. B. Wittick. Lummis selected the reproductions by these other photographers and it is the material he omitted which shows clearly the message he wanted to convey. Vroman's photograph 'A Moqui (sic) coiffeure is a good example of an aesthetic choice shared with many others. The photograph is an eight-shot sequence, a valid ethnographic study in contemporary Hopi hairdressing. It is the one in which the two women do not interact with the photographer, staring away from the camera, not even looking at each other. Their outward looking gazes emphasise a meditative mood where time is suspended. The fact that Lummis chose to publish this image is telling of the already established aesthetic choice conforming to the dictates of the Pictorialist movement, which promoted a strongly romanticised image of Native peoples.

The Wonderland is the last and most famous product of Lummis's life-long interest in the promotion of the Southwest. In the introduction he states that even the term 'Southwest' was his own invention, adding that 'my books were the first to make widely known most of the marvels of the incomparable Wonder Land, which I began to explore eagerly on my "Tramp across the Continent" in 1884. Through the decades since, I have made the Southwest a study...' Although some of his early books were not illustrated, Lummis became aware of the relevance that visual narrative had when mingled with text: when he reprinted Adolph F. A. Bandelier's *The Delight Makers*, an ethno-historical novel set in the cliff-dwellings of the Sito des Frijoles, discovered in 1890 by Bandelier himself, Lummis reproduced his photographs taken during the journey made with Bandelier, to which he added photographs taken after the first excavation of the 1910s.

GEORGE WHARTON JAMES IN AND AROUND THE GRAND CANYON

Lummis is the most well known of a group of dilettanti who made the promotion of the Southwest their *raison d'être*. George Wharton James (pl.75,76,134) used the camera and pen with the same purpose, producing texts aimed at the promotion of tourism, using a narrative style that reveals his debt to Lummis. In *In and Around the Grand Canyon,* one hundred images were reproduced, mostly landscapes taken by the author,

by F. H. Maude, O. Lippicott and H. G. Peabody. The book is a beautiful example of a product expressly made for a readership who could afford a moderate price. In the later *The Indians of the painted Desert Region. Hopis, Navahoes, Wallapis, Havasnpais* of 1903, Wharton James gathered sixty-six photographs to illustrate the lifestyles of Arizona's Native peoples, some taken by him. The use of a large number of photographs and etchings is better illustrated in another of his books: *Indian Basketry and how to make Indian and other Baskets* of 1903, in which the author published more than six hundred illustrations, both photographs and etchings, to explain this traditional craft and to encourage the collecting of such Native baskets.

PHOTOGRAPHIC IMAGES IN ETHNOGRAPHIC NARRATIVE (AND A NEW WAVE OF PHOTOGRAPHERS)

There was a further literary genre for which photographs became an essential tool and in which they had a firm adherence to the narrative of the text. Ethnographic texts were mingled with photographs, often taken in the field by their authors or their author's photographers. The importance that visual records had for this discipline resulted in a number of images which were more original and immediate than those printed in contemporary literature.

Possibly one of the first to have recognised the importance of photographic image in ethnographic discourse was the influential Franz Boas, who, in his early work, *The Social Organisation and the Secret Societies of the Kwakiutl Indians,* first issued in 1895, had some of the photographs of costumes and Native ceremonies retouched. Their background was erased to avoid any reference to historical and geographical context that might have interfered with the ethnographic data he wanted to draw attention to. In contrast with some of his contemporaries, Boas was exceptionally sensitive to the photographic medium; although he was conscious of the difficulty in rendering through images a deep and complete understanding of Native cultures, he nevertheless used them in still frames or motion pictures as an important visual aid to his texts. Ethnography and photography were becoming two parallel sciences.

THE BOUNDARIES OF THE PHOTOGRAPHIC ENDEAVOUR

The Mennonite pastor H. R. Voth became a passionate ethnographer during his five-year stay in Hopi territory. Armed with his Kodak he took the largest existing collection of photographs of rituals and dances performed by the Hopi, publishing them to support his ethnographical texts. His typical round format images render even the Hopi rituals in a daily life kind of way, given the photographer's familiarity with the places, peoples and rituals. Although Voth was – and still is, a disdained figure – by Hopi Natives, he had the privilege – obtained only thanks to his Christian mission – to witness five entire years of Hopi life; still mostly unpublished, his photographs are extremely interesting not only as ethnographic reportages, but also from a visual viewpoint. Voth had often to

take them in poor lighting conditions, and from vantage points not always chosen in advance. The sense of both intimacy and immediacy in Voth's images render them a rarity in contemporary ethno-photography. His relevance as a visual guide to the Hopi rituals, is to be seen in the work of many tourists and ethnographers who visited the mesas during his assignment. In *The Mishongovi ceremonies of the Snake and Antelope Fraternities,* 1902, Voth and George A. Dorsey (curator of the Field Columbian Museum in Chicago) published a selection of photographs taken during the McCormick Hopi Expedition of 1901 by the independent photographer and adventurer, Sumner Matteson and the Museum photographer Charles Carpenter, which captured some phases of the rituals which were seldom recorded. Voth's long-lasting influence in the pueblos allowed the recording of phases of the rituals that were otherwise kept secret. Not all of them portray forbidden moments of Hopi ritual life, but they are nevertheless the result of an invasion of private moments, some of which were soon to be off limits to photographers.

 In printed books of the Southwestern regions, images soon became an essential narrative medium. Their relation with the narration was never too close, especially in novels. It was only in ethnographic books that images were meant to clarify and to strengthen the ethnographer's reports, allowing even today a parallel reading of text and image. Their extensive use in all sorts of published texts is a further gauge from which we can evaluate the power that photography had on contemporary culture.

NOTES

1 From *Some Strange Corners of our Country; The Wonderland of the Southwest,* 1892

VOLUMES IN EXHIBITION:

ADOLPH BANDELIER
 The Delight Makers
 Text by A Bandelier with an introduction by C F Lummis. Twelve photographs of Rito de los Frijoles taken by C F Lummis, six photographs of Zuni by F C Hicks. New York, Dadd, Mead and Company, 1918 (1 ed. 1916; original edition without images 1890) Library Collection, Whitney Museum of American Art, New York

FRANZ BOAS
 The Social Organisation and the Secret Societies of the Kwakiutl Indians
 Text by F Boas. Photographs taken in 1893 by John H Grabill; anonymous etchings. Washington, Government Printing Office, Smithsonian Institution, United States National Museum, 1897 (from the 'Report of the US National Museum for 1895') The Warburg Institute, University of London.

THOMAS DONALDSON ED.
 Extra Census Bulletin, Moqui Pueblo Indians of Arizona and Pueblo Indians of New Mexico.
 Text by Thomas Donaldson, E S Clark, J Scott, H R Poore, P Moran; notes by A M Stephen and C F Lummis. Photographs by J K Hiller, A D Marchand; photographs of Zuni by Ben Wittick;

drawings from photographs by Ben Wittick and C F Lummis; one coloured drawing by Julien Scott dated 1891 Washington, DC, United State Census Printing Office, 1893 The Warburg Institute, University of London DLC260

GEORGE A.DORSEY AND H. R VOTH
 The Mishongovi Ceremonies of the Snake and Antelope Fraternities
 Text by George A Dorsey and H R Voth. Photographs taken during the McCormick Hopi Expedition in 1901 by Charles H.Carpenter and Summer W Matteson Chicago, Field Columbian Museum publication (n.66), 1902 The Warburg Institute, University of London

F V HAYDEN
 Sun Pictures of Rocky Mountain Sceneries with a description of the Geographical and Geological Features, and some Account of the Resources of the Great West.
 Text by F V Hayden, photographs by A J Russell. New York, Julius Bian, 1870 Union Pacific Museum Collection

WALTER HOUGH
 The Moki Snake Dance. A popular account of that unparalleled dramatic pagan ceremony of the Pueblo Indians of Tusayan, Arizona, with incidental mention of their life and customs.
 Text by Walter Hough. Sixty-four half-tone photographs by G Wharton James, Higgins, J K Hillers, A C Vroman, F H Maude, H R Voth, Map of the Santa Fe Route

Santa Fe, The Passenger Department of Santa Fe Route, 1898
The Warburg Institute, University of London

CHARLES FLETCHER LUMMIS
A New Mexico David and other Stories and Sketches of the Southwest.
Text and eight photographs by Charles F Lummis.
New York, Charles Scribner's Sons, 1891
The Warburg Institute, University of London

A Tramp Across the Continent
Text by Charles F Lummis, no photographs included. New York,
Charles Scribner's Sons, 1892
The Warburg Institute, University of London

The Man who married the Moon and other Pueblo Indian folk-Stories
Text by Charles F Lummis. Etchings from drawings by George
Wharton Edwards after photographs by the author. New York,
The Century Co., 1894
The Warburg Institute, University of London

*Mesa, Canon and Pueblo. Our Wonderland of the SouthWest, Its
Marvels of Nature, Its Pageant of the earth Building, Its Strange
Peoples, Its Centuried Romance*
Text by C F Lummis. Photographs by C F Lummis,
A C Vroman, B Wittick and others. New York, The Century Co.,
1925
Library Collection, Whitney Museum of American Art, New
York

*Some Strange Corners of our Country. The Wonderland of the
Southwest*
Text by Charles. F. Lummis. Etchings drawn by T Moran,
W C Fitler, W Taber, W H Holmes, J A Fraser, J M Nugent,
F E Sitts and engraved by W.J. Linton, J. A. Bogert, P Annin,
E Bookhout, T Schussler, E Heinemann. New York,
The Century Co., 1892
The Warburg Institute, University of London

The Wonderland of the South-West (Mesa, Canon and Pueblo)
Text by Charles F Lummis. Nearly ninety photographs by
C F Lummis, A C Vroman, Jesse L Nusbaum, A J Baker,
E Bibo
London, George Allen & Unwin, 1926 (1 ed. 1925 Mesa, Canon
and Pueblo)
The Warburg Institute, University of London

L H MORGAN
Houses and House Life of the American Aborigines
Text by L H Morgan. Four heliotypes of Taos, Walpi, Zuni,
San Dominigo Pueblos from photographs taken by J K Hillers
Washington, Contribution to North American Ethnology,
(vol.4), 1881
Library Collection, Whitney Museum of American Art,
New York

GUSTAF E A NORDENSKIOLD
*The Cliff Dwellers of the Mesa Verde, Southwestern Colorado, Their
Pottery and Implements*
Text by Gustaf E A Nordenskiold (translated into English by D
Lloyd Morgan). Photogravures and autotypes from photographs
by G. Nordenskiold of the ruins of the Mesa Verde, heliotypes
from photographs by C Westphal of ethnographic objects found
in the ruins. Stockholm and Chicago, P.A. Norstedt &
Soner/Royal Printing Officer, 1893
The Warburg Institute, University of London

A J RUSSELL
*The Great West Illustrated in a Series of Photographic Views Across the
Continent. Taken along the Line of the Union Pacific Railroad West
from Omaha, Nebraska, with an Annotated table of Contents Giving
Brief Descriptions of Each View. Its Peculiarities, Characteristic and
Connection with the Different Points on the Road*
Text by A J Russell. Fifty albumen printed from photographs by
A. J. Russell. New York, Union Pacific Railroad Company, 1869
Union Pacific Museum Collection

R B TOWNSHEND
The Tenderfoot in New Mexico
Text by R B Townshend. Photographs of Jemez Pueblo taken by
R B Townshend in 1903
London, John Lane, 1923

HENRY R. VOTH
The Oraibi Powamu Ceremony
Text by Henry R Voth. Photographs taken by Henry R Voth
during his five-years stay at Oraibi (1883-1889) drawings after
photographs from Voth. Chicago, Field Columbian Museum
publication (n.61), 1901
The Warburg Institute, University of London

G WHARTON JAMES
*In and Around the Grand Canyon. The Grand Canyon of the Colorado
River in Arizona*
Text by G Wharton James. One hundred photographs, mostly
landscapes, by G Wharton James, H G Peabody, O Lippicott,
F H Maude. Boston, Little, Brown and Company, 1901
Library Collection, Whitney Museum of American Art,
New York

Indian Basketry and how to make Indian and other Baskets
Text by G Wharton James. Six hundred illustrations, mostly
etchings, a few full-page photographs by G Wharton James and
others. New York, 1903 (3 ed.)
Museum of Mankind Library, London

*The Indians of the painted Desert Region. Hopis, Navahoes, Wallapis,
Havasnpais*
Text by G Wharton James. Sixty-six photographs by G Wharton
James and Pierce, by F H Maude and E E Hall. London, 1903
Museum of Mankind Library, London

NATIVE VISIONS

PHOTOGRAPHIC SOVEREIGNTY IN THE 20TH CENTURY

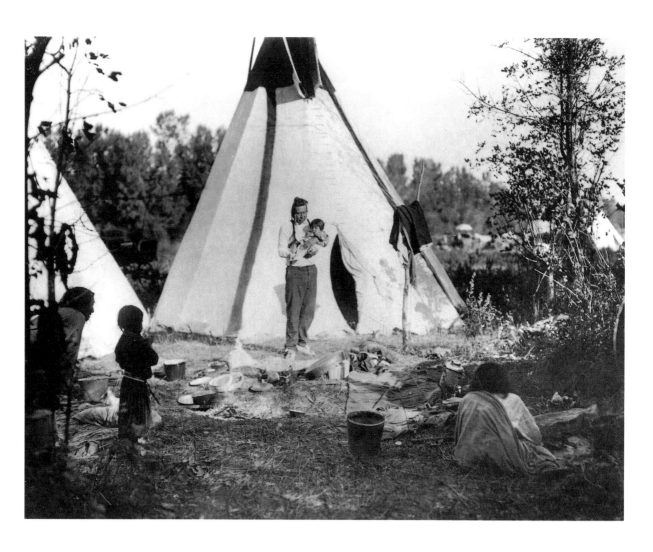

INDIGENOUS PHOTOGRAPHIES: A SPACE FOR INDIGENOUS REALITIES

THERESA HARLAN

PHOTOGRAPHS OF NATIVE AMERICANS[1] HOLD A SURREAL MAGNETISM for many. A surreal magnetism coloured with fantasy, hate, romance, irony, sex, regret, nostalgia and a desire to escape reality through photographic journeys. Despite photography's supposed realism and guise of authority, photographs of American Indians are surrealistic in the sense of what is 'seen and unseen'. For Native people the seen represents family members and familial and clan relationships – a familiar world. The unseen is the presence of foreign occupation and the experience of being watched and recorded by the penetrating stare of the invaders. The annual productions of books and calendars of photographs of American Indians can offer little in the way of a realistic understanding of Indigenous peoples of North America because of what is unseen.

The weight and girth of early photographic representations of Indigenous people of North America still occupy the minds and imaginations of 21st century non-Natives, so that most still look to Edward Sherriff Curtis for images of North American Indians. This leaves little room for 21st century Native photographers and their representations. As colonists and settlers cut paths through Indigenous villages to make room for their infant settler nation, art patrons and artists likewise cut a path of representations that mirrored frontier myths and imaginations. Photography followed this same path of representations which included stereotypes of: the noble savage, blood-thirsty Indian and the vanishing Indian. While such stereotypes are implied male, they do have female counterparts such as the brutish squaw and sexualised maiden. Julie Schimmel's[2] work on the history of frontier representations of Native Americans maps out this standardised path. When colonists first arrived in North America the land and resources appeared to be endless, and following 18th century French philosophers' imaginations of the 'Noble Savage', Indigenous people were depicted as such. Once it became evident to the expansionists that land and resources were finite, then the depiction of Native people became, shall we say, more blood-thirsty. As military campaigns ravaged across

Indian territories, reservation boundaries mapped out, missionaries baptised 'heathens', and Native children were swept away to assimilationist boarding schools; the depiction of Native people shifted to the vanishing Indian.

Photography took some of its first steps with its use by various agents including: studio photographers commissioned by the United States to take portraits of visiting Native delegations to Washington, DC, military photographers documenting the mass burial of frozen Native bodies at Wounded Knee in 1890, fledgling anthropologists photographing frontal and side views of Native faces, expedition photographers trekking across Indian territories looking for a 'vanishing' moment, and not to overlook the male interest in photographing bare-breasted Native women. British photo-historian John Tagg's argument that photography has no identity of its own, but only that of the agency it serves rings clear when one thinks about the use of photography and its resulting messages about Native people. According to Tagg, 'The representations it [the camera] produces are highly coded, and the power it wields is never its own... but the power of the apparatuses of the local state which deploy it and guarantee the authority of the images it constructs to stand as evidence to register a truth.'[3] As photographs of Native people are constructions of codes perpetuating ideology and myths believed by non-Natives about Native people it is little wonder such photographs reveal little about Native people and more about the agent of the camera.

It's ironic that American photography found life through the portrayal of the death of Native people. Photography did well as a means to portray one of the greatest lies about Native people and that lie was the prediction of their extinction. Joseph Kossuth Dixon and Edward Sherriff Curtis both depicted a picturesque Native extinction with Native people depicted as passive participants relinquished to their fate, (see Dixon's *Sunset of a Dying Race* (pl.126). Despite the 'good intentions' of assimilationists who believed that Native people would die if they did not relinquish their Indigenous ways, allegorically picturesque photographs made the forced assimilation of Indigenous people palatable, righteous and even commemorative. Why else would the market demand annual Curtis wall calendars each year?

On the one hundred and fiftieth anniversary of photography, Muskogee, Seminole and Diné [Navajo] photographer Hulleah Tsinhnahjinnie marked the beginning of a shift in the deployment of photography and an emergence of empowered messages created by Native American photographers in a 1990 exhibition she titled, *Compensating Imbalances*. Tsinhnahjinnie well understood the power relationships carried by photography, 'Photography has the ability to control the direction of one's thinking by presenting itself as the truth. Prejudices can be quickly confirmed by staged, manipulated, or misinterpreted photographs. An imbalance of information is presented as the truth. No longer is the camera held by an outsider looking in, the camera is held with brown hands opening familiar worlds. We document ourselves with a humanising eye, we create new visions with ease, and we can turn the camera and show how we

see you.'[4]

This humanising eye that Tsinhnahjinnie speaks of is clearly evident in the photographs of Richard Throssel, a Native Cree, who, as an adult. moved to the Crow reservation and was later adopted into the Crow Nation. Throssel began photographing in 1902 and even for a short while worked with Curtis according to Throssel's biographer Peggy Albright. Throssel's photographs of Crow couples, families and children are especially striking as the love and warmth expressed by the families are so contrary to how we normally see Native men, women and children depicted in early photography. Throssel's *Crow Indian Camp* (1910) (pl.187) depicts a father holding his child with his wife and family watching in the foreground. The mother leans towards her daughter as if she is explaining the event. In Throssel's biography[5] Mardell Hogan Plainsfeather comments 'It may have been a naming of a child, a tradition of the Crow that is still honored in these modern days. No matter what white society did to acculturate the Crow, it could not break down the strong beliefs in this sacred occasion. It had to do with the strong parental love for a child, the sharing of food, the giving of gifts to the namers, the prayers offered for the future of the child, dream sharing, and the clan system, all of which strengthen the ties that still bind the tribe.'[6] Throssel's photographs show us how Indigenous self-awareness is developed within the context of community, ceremony and place. Throssel's work by contrast illustrates how degrading and harmful misrepresentations such as the noble savage, blood-thirsty Indian, vanishing Indian, brutish squaw and sexualised maiden really are when projected on to Native men, women and children.

Such fully humanising and self-affirming representations of Native people offered to us by Throssel are also present in the works of Kiowa photographer Horace Poolaw, whose photographic career spanned the years 1925 to 1954, in Anadarko, Oklahoma and photographer Lee Marmon who began photographing after his return from World War II and continued to photograph at Laguna Pueblo in New Mexico. Throssel, Poolaw and Marmon all picked up the camera and with their photography celebrated their communities and the relationships held within each community. Their approach and use of photography reflects an Indigenous aesthetic which includes respect and appreciation for Indigenous people and beauty. This statement may appear a bit romantic, but don't be too quick to judge. For Indian people to respect and appreciate their way of life, language and culture including their own physicality of dark skin and hair is an act of resistance when one considers the persistent attempt of assimilationists to convince Indian people to reject their Indian selves. In Horace Poolaw's photograph *Cletus Poolaw's Honor Dance, Carnegie, OK* 1952 (pl.188) we see a Native community gathered to honour a member of their community. Poolaw's achievement is not considered solely the result of his individual achievement, but that of the support he received from his circle of family, friends and community. Family and friends share in his experience by joining him as he walked before his community. Such events continue

to this day for individuals who may be returning home from service in the military, graduation from college or for service to their community. Lee Marmon's photographs of the old people at Laguna Pueblo are representational testimonies of Native survival and persistence. Marmon's daughter, writer Leslie Marmon Silko writes, 'My father liked to take informal portraits: the old man with his prize watermelon, the old woman with her oven bread on a board. He knew these old folks, who had loved him and watched out for him as a child, would pass on to Cliff House soon. We all meet at Cliff House someday, but I think my father couldn't bear to wait that long to see their beloved faces again.'[7]

It was these very people and their way of life that assimilationists predicted would die without a trace. Thankfully this prediction was empty and false. In the face of such predictions Native people continue to persist by following the ways of their traditions, holding on to the stories told to them by their parents and never surrendering the land as their creative source of life. It's poetic justice that this generation would give life to a generation of Native photographers who would use photography to celebrate and affirm an Indigenous existence.

The strategic use of the camera to '...show how we see you.' is Shelley Niro's intent in her 1992 series *This Land is Mime Land* (pls.215-219). She begins by laying out ideological differences that distinguish how Native and non-Natives experience the world and the differences in development of: personal, cultural and national identity. She employs the context of mime, to show that much of what North America calls its own experience and identity is really based on appearance. Niro's title *This Land is Mime Land* makes reference to American folk songwriter Woody Guthrie's song *This Land is My Land, This land is Your Land*. Guthrie's song is about the disenfranchisement of the American working poor and the monopoly of land, resources and wealth by the rich. For Native people it's not just the rich who monopolise land and resources, but immigrant settlers who declare this land 'their land'. Such pertinacious declarations were and are sustained by Christian belief in doctrines of discovery, divine right, and God's plan while at the same time rejecting Indigenous divine rights as superstitions.

In *North American Welcome* (pl.216) one of twelve of the series Niro contrasts a familiar American icon, the Statue of Liberty with an image of an Indigenous woman. Niro's costumed parody of the Statue of Liberty is sardonic. Think about the irony in Niro's representation of herself, an Indigenous woman dressed as the Statue of Liberty a symbol of American liberty created in 1868 for America by the French. Now add the painful irony of Native people forced to witness immigrant settlers occupy and settle on their land.

The middle image is of Niro's mother, a member of the Mohawk Nation which is part of the Six Nations Iroquois Confederacy. Niro's photograph of her mother is a representation of the Iroquois creation and what Tuscarora photographer and writer Jolene Rickard refers to as Mature Flowers, the first mother, '... it was a woman called

PLATE 188

HORACE POOLAW
(KIOWA)

*Cletus Poolaw's honour dance,
Carnegie, Oklahoma c.1952*

Silver gelatin print.
Courtesy of the Horace
Poolaw Photography
Collection, Stanford
University and the
Poolaw Family

Mature Flowers, or Mature Earth, who first tumbled through the sky world to this world. Her fall was broken by the united backs of waterfowl, and she was gently eased onto the back of a great turtle. On this tiny earth, she began at once to walk about, throwing dirt, causing it to grow. Mature Flowers, the first mother, brought with her the seeds of our life – corn, beans, squash and tobacco – and so it continues...'[8] Niro's unassuming photograph of her mother as the 'first mother' reflects the embodiment of Indigenous peoples' understanding and connection to place. In an artist statement Niro explains, 'In my culture there are no monuments, no man-made structures, no tourist sites, one visits, burns tobacco, says a prayer, we think of our elders and ancestors, remind ourselves of the importance, the significance this space holds, we don't need reminders.'[9]

The last frame is Niro herself. The seriousness of her statement is accentuated by a dark background which she uses to shield herself from the penetrating gaze of the viewer. Her presence is deliberate because she wants us to realise the full impact of Euro-centric ideology carried by myth and symbolism.

Native people are land-based people. Lakota writer Vine Deloria, Jr. explains the significance of this land-based identity 'The structure of their [American Indians] religious traditions is taken directly from the world around them, from their relationship with other forms of life. Context is therefore all-important for both practice and the understanding of reality. The places where revelations were experienced were remembered and set aside as locations where, through rituals and ceremonials, the people could once again communicate with the spirits. Thousands of years of occupancy of their lands taught tribal peoples the sacred landscapes for which they were responsible and gradually the structure of ceremonial reality became clear. It was not what people believed to be true that was important but what they experienced as true'.[10]

Dugan Aguilar's 1996 *Pomo Dancers Preparing to Dance at Chaw'se Roundhouse* (pl.189) is an example of 'ceremonial reality' that Deloria speaks of. Aguilar shares with us this experience of space as articulated by Northern Californian people at Chaw'se roundhouse. Never mind that some of the participants in Aguilar's photograph are wearing jeans, tee-shirts, and base-ball caps. If such clothing conjures incongruities for you, the viewer, then it is time to realise the reach and hold of stereotypes that impede your perception of Native peoples. Aguilar links his own photographic process to the creative process of basket weaving. 'I was inspired by the process of basket weaving as it requires a lot of time and effort. Photographs take a lot of time and work to get the right contrast with dodging and burning. Now when I go into my darkroom, I say a prayer just like the basket weavers. They pray to the Creator for the materials and reflect on what they are creating. I do the same.'[11]

One approach used by Native photographers to fix the imbalance of Euro-centric representations and coded messages is to revisit early photographs and infuse them with

PLATE 189

DUGAN AGUILAR (PIT
RIVER/MAIDU/PAIUTE)

*Pomo dancers preparing to
dance at Chaw'se, 1995*

*Left to right, Robert Salas
(Pomo), Joe Gonzales (Pomo),
Craig LaPena (Nomtipom-
Wintu), Andy Gonzales (Pomo),
Sean Smith (Pomo)*

Selenium toned print.
Courtesy of the artist

PLATE 190

HULLEAH
TSINHNAHJINNIE
(SEMINOLE/MUSKOGEE/
DINE´)

*Damn! There goes the
Neighbourhood!*

Digital print.
Courtesy of the artist

PLATE 190A

PAMELA SHIELDS
(BLACKFOOT/
BLOOD BAND)

Bird Woman, 1997

Digitally manipulated print.
Courtesy of the artist

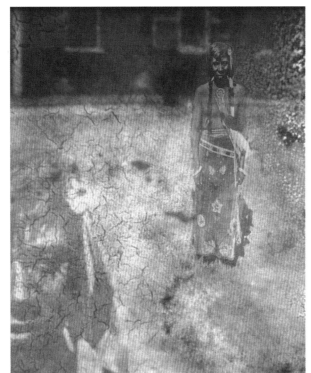

the presence of an Indigenous experiential existence. Pamela Shields's series of digital portraits are almost archaeological in origin as she searched through the photography archives of the National Museum of the American Indian of the Smithsonian Institution looking for images of Native people from her tribe, the Blood (now referred to as Kanai). Using a palette of red, green, and gold with layers of photographic images of trains, buildings and archival portraits of Indigenous people, Shields sublimely portrays the complex and oftentimes disrupted relationship between memory and place. In her diptych *Bird Woman* (pl.190a), Shields shelters an unidentified woman by lending her own personal memories and experiences of place to this lone woman. In the left side of the diptych the woman appears twice. Once off-centre standing in a courtyard of a brick building and then again as a close-up of the woman's face in the lower left corner. The woman's ephemeral presence is restless because she has been cut off from the context of her Indigenous place in the world. The original photograph does not and cannot tell us who she really was as a Kanai woman with family and community. The brick building in the background symbolises Shields's boarding-school experience in Canada – the harsh site of assimilation for many Native youths – a place of disruption. In the right side of the diptych we see a bird in the courtyard that is barely visible in the scene from the left. The bird represents an Indigenous place, specifically Bird Woman Falls, Montana an important place for Kanai people. With *Bird Woman* Shields reaches out to a woman caught in a warp of photographic time and pulls her back to the land of her origin, reconnecting her to Kanai memories and place.

Hulleah Tsinhnahjinnie's digitally collaged *Damn Series* (pl.220-222) brings a full force of life and voice to early photographs. Tsinhnahjinnie peruses through 19th and 20th century portraits with the purpose of finding irony and humour in seemingly self-explanatory photographs through her use of captions. In one digital collage Tsinhnahjinnie appropriates a photograph of a Native man. He holds a smoking gun in his left hand. The man stands looking directly at the viewer with a sly grin. Tsinhnahjinnie leaves the image of the man in black-and-white so there is no mistaking that he is from another time. The background image is in full colour. Behind him is an Oscar Meyer wiener-mobile, a car modified to look like a hot-dog and bun – very clearly on the side of the car are bullet holes. The caption reads ' Damn! There Goes the Neighborhood!' (pl.190)

Tsinhnahjinnie's use of captioning is a strategic move to deconstruct and decode condescending captions which carry and disseminate Euro-centric ideologies and myths. For example how can anyone Native or non-Native identify or empathise with images of Native people captioned as squaw or brave? Such misrepresentations only feed racist attitudes that lock 21st century Native people to 19th century stereotypes and attitudes which side-step any real understanding of history and the impact of Euro-American colonisation of Indigenous peoples.

Tsinhnahjinnie wields irony to expose how Native sovereignty is still misunderstood,

ridiculed and ignored by the US government and public opinion. 'Damn, I Keep Dreaming of Three Cherries' (pl.220) may seem to be an unsuitable title for a portrait of a Native man in deep contemplation. This man, Little Six, a Mdewakanton Dakota, has much to think about as he awaits his execution for his participation in the 1862 Sioux revolt in Minnesota. Wars, revolts, and numerous battles against England, France, Spain, Mexico, and the United States must be understood not as 'American Indian problems' or 'Indians on the war-path' but as national actions taken by leaders to protect their sovereignty, territories, and way of life of their people from foreign intrusion. What more of an honourable reason would one need for a call for war? Now we only need a plane to wander off course before an order is sent to shoot it down.

Here we are in 1998, 136 years after Little Six's death – and Native people are still struggling and pushing the American government to live up to treaty agreements and still trying to protect their national sovereignty and people. Lately, one way for Indian nations to accrue economic and political power has been through the development of casinos on reservations. When the Mdewakanton Dakota opened its first casino, they named it after Little Six. Now state governments are working to shut down Indian casino operations with the help of large cash pockets of gambling interests from Las Vegas, Nevada. So dreaming about three cherries spinning on a slot machine is not much different from dreaming about sovereignty.

Through these virtual encounters Tsinhnahjinnie links her work to a form of Northern Plains battle called counting coup,[12] '... having been the object of observation for so long. Many times Native people will let their pictures be taken while thinking, 'Damn! Another tourist.' Not too many people will say it aloud. I enjoy giving voice to the apprehensions of those who are being observed. I know non-Natives are never going to get it right because they come in with their own agenda. They think they already know what they will find and you can't change their mind, even if you try. So to give voice to the other side for me is really important. You can make fun of the outsider, laughing, while counting coup.'[13]

Larry McNeil also counts coup so to speak although his method is stylishly Tlingit. McNeil born in Juneau, Alaska and a member of the Eagle Killerwhale clan has allied himself with Raven, an important figure in Northwest Indigenous cultures. Raven is credited with bringing light to the people. In the creation story Raven steals the sun from a greedy chief who keeps the sun locked away in a box. Raven earns the chief's trust by disguising himself as the chief's grandson. When Raven has enough fun tormenting the Chief he steals the sun from the box and releases it to the sky. In McNeil's *Long House Scene* the greedy chief is again dancing about possessions he keeps in a special box convincing Raven the box holds a moon. We the viewer are surprised with Raven that the box only holds the message, 'The only moon here is the one under your raven's tail (robe).'

With the *Raven Series* (pl.225-229) McNeil skilfully uses Raven's infamous reputation

PLATE 191

LARRY McNEIL
(TLINGIT/NISGAA)

*Billy Graham and Raven go
cruising, Raven series, 1998*

Digital pigment print.
Courtesy of the artist

for knowing how to make things happen by way of his delight to toy with adorned leaders. This time Raven's chosen leader is Christian evangelist Billy Graham (pl.191). Christian missionaries unbeknownst to them entered into an eternal relationship with Northwest Coast Indigenous people far different than what they expected when they began their missions. According to McNeil, when the missionaries subverted Northwest Coast Indigenous religious traditions and leaders, the descendants of those leaders are entitled and encouraged to ridicule Christian religions and leaders. This is why Raven has befriended Billy Graham and travels with him to such hot spots as the Vatican. McNeil and Raven cleverly point out that the world is still Indigenous despite Christian evangelists spouting on about the evils of worshipping nature. In fact, according to McNeil Graham is so taken by Raven he invites Raven to drive his new Cadillac. Raven clearly knows his 'avian cosmology' and proves it. In his *Cosmology Report* (pl.228,229) Raven reveals documentary evidence at the Smithsonian Institution that 'man' is made in the image of Raven – from wingtip to fingertip. With science and Christian religion in his back pocket Raven has only to decide who to choose as his next object of entertainment.

Don't be mistaken – its not all simply a game of wits, as colonisation is now cleverly disguised as 'minority politics'.[14] Jolene Rickard from the Tuscarora Nation of the Haudenosaune (Six Nations Iroquois Confederacy) self-identifies her photography as the work of a sovereigntist. Rickard is the granddaughter of Chief Clinton Rickard, a 20th century leader who led the formation of the Indian Defense League of America[15] in 1926. Rickard sees her art and the art of other Native artists not simply as a network of aesthetic symbols, meanings and representations, but rather as agents of Indigenous sovereignty. She gives the Haudenosaune Two Row Wampum belt as an example, 'The creation of the belt represents a visual marking of ideological and physical space, an understanding of difference, yet acceptance...It is significant that this moment, that is, contact with the West, was marked in this way; the creation of the belt reflects a recognition of a different way of understanding life and the clarity and confidence to claim the difference. Isn't that, in part, what Indigenous art does today?'

Needless to say, contemporary Native photographers do more than snap pictures to enable viewers to escape their own reality. Instead Native photographers create images and representations that are solidly rooted in an Indigenous reality – a reality based upon their own personal experiences as Indigenous people. As the world prepares itself to enter the 21st century, the 21st century in which many were convinced that Native people would only exist as nostalgic memories, it finds not only the continued existence of Native people, but the presence of Native photographers and image makers whose works reveal an unseen Indigenous world.

NOTES

1 There are multiple ways of referring to the first people of the North American continent including such terms as: Native American, American Indian, Native, Indian, First Nations, Indigenous and including specific names of nations (e.g. Kiowa, Crow). Most Native people have their own personal preference for any one or more of these.

2 Julie Schimmel, *Inventing the 'Indian', in The West as America: Reinterpreting Images of the Frontier*, 1820-1920, ed. William H Truettner (Washington: National Museum of American Art by Smithsonian Institution Press, 1991)

3 John Tagg, *The Burden of Misrepresentation: Essays on Photographies and Histories* (Minneapolis: University of Minnesota Press, 1993) p. 63-64

4 Hulleah Tsinhnahjinnie, 'Compensating Imbalances', in Exposure Vol. 29, No. 1, Fall 1993, p.30

5 Peggy Albright, *Crow Indian Photographer; The Work of Richard Throssel* (Albuquerque: University of New Mexico Press, 1997)

6 ibid., p.120

7 Leslie Marmon Silko, *Yellow Woman and A Beauty of the Spirit: Essays on Native American Life Today* (New York: Simon & Schuster, 1996) p. 186

8 Jolene Rickard, 'Cew Ete Haw I Tih: The Bird That Carries Language Back to Another, in *Partial Recall: Photographs of Native North Americans'*, ed. Lucy Lippard (New York: The New Press, 1992) p.105

9 Shelley Niro, 1998 artist statement for *For Fearless and Other Indians*.

10 Vine Deloria, Jr., God Is Red: A Native View of Religion, 2nd ed. (Golden Fulcrum Publishing, 1994) p.66-7

11 Dugan Aguilar artist interview in *Wa'tu Ah'lo: Dugan Aguilar, Northern California Indigenous Photography,* exhibition monograph, University of California, Davis, Carl Gorman Museum, 20 February – 5 April, 1996, p.4.

12 Counting Coup '… is striking an enemy with a coup stick – [it] showed more daring than slaying one from a distance.' Robert M.Utley, The Lance and the Shield: *The Life and Times of Sitting Bull* (New York: Henry Holt and Company, Inc., 1993) p.11.

13 Hulleah Tsinhnahjinnie interview with the author, June 1998.

14 In 1998 Senator Slade Gorton (more familiarly known in Indian country as 'Senator No-Hair') a republican from Washington state and who sits on the Senate Indian Affairs Committee proposed the bill, 'American Indian Equal Justice Act of 1998'. His bill would terminate much of the sovereign status of Native nations. Political and corporate interests persistently look for ways to mask treaty rights as 'minority' entitlements.

15 Six Nations people whose land occupies what is now Canada and the United States were denied entrance across the border and were treated as immigrants in their own country. The Indian Defense League of America was formed in 1926 as a means '… to secure border crossing rights… as guaranteed by… Article 3 of the Jay Treaty and Article 9 of the Treaty of Ghent of 1814…'; *Fighting Tuscarora: The Autobiography of Chief Clinton Rickard,* ed. Barbara Graymont (Syracuse: Syracuse University Press; 1984) p. 69.

JENNIE ROSS COBB

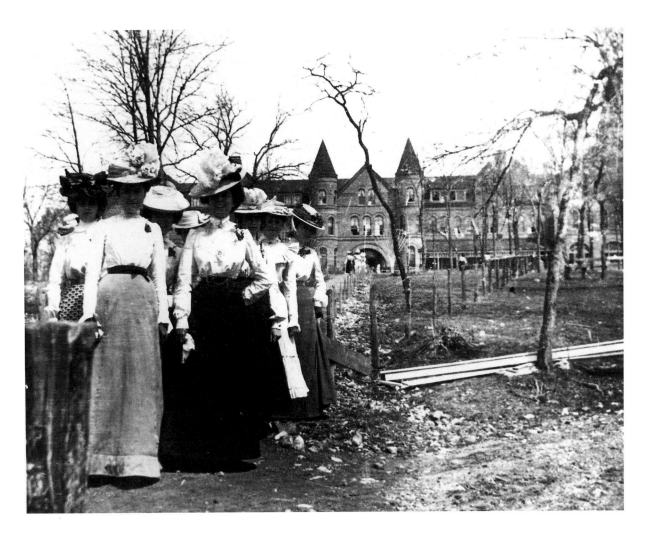

PLATE 192

JENNIE ROSS COBB
(ANIYUNWIYA)
[CHEROKEE]

Graduating class of 1902, Cherokee Female Seminary, Tahalquoh, I.T.

Modern print from a negative in the Archives and Manuscripts Division of the Oklahoma Historical Society

PLATE 193

JENNIE ROSS COBB
(ANIYUNWIYA)
[CHEROKEE]

*Back of the George M. Murrell
Home, Park Hill, I.T.
c.1896-1906*

Modern print from a
negative in the Archives and
Manuscripts Division of the
Oklahoma Historical Society

PLATE 194

JENNIE ROSS COBB
(ANIYUNWIYA)
[CHEROKEE]

*Watermelon picnic near Park
Hill, I.T. c.1896-1906*

Modern print from a
negative in the Archives and
Manuscripts Division of the
Oklahoma Historical Society

RICHARD THROSSEL

PLATE 195

RICHARD THROSSEL
(MÉTIS/CREE/ADOPTED
CROW/SCOTTISH/
ENGLISH)

*Interior of the best kitchen on
the Crow Reservation, 1910*

Modern print from a
negative in the collection of
the National
Anthropological Archives,
Smithsonian Institution

PLATE 196

RICHARD THROSSEL
(MÉTIS/CREE/ADOPTED
CROW/SCOTTISH/
ENGLISH)

Crow war dancers, c.1905-22

*In front with drum, Caleb Bull
Shows; left, his son Harry Bull
Shows, second from left, Frank
Hawk; right Mortimer Dreamer*

Modern print from a
negative in the collection of
the American Heritage
Center, University of
Wyoming

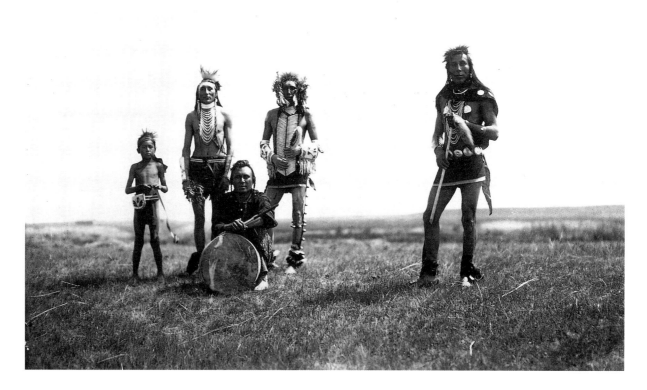

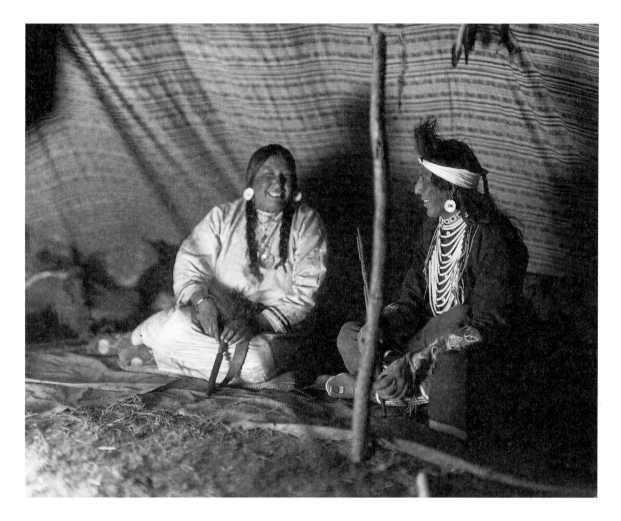

PLATE 197

RICHARD THROSSEL
(MÉTIS/CREE/ADOPTED
CROW/SCOTTISH/
ENGLISH)

*Unidentified Crow couple
sitting in a tipi, c.1905-11*

Modern print from a
negative in the collection
of the American Heritage
Center, University of
Wyoming

HORACE POOLAW

PLATE 198

HORACE POOLAW
(KIOWA)

*Billy Tichwy, Newton Poolaw,
Erwin Ware, Evalu Ware,
Thelma Poolaw, Rowena
Poolaw, Mountain View,
Oklahoma, c.1928*

Silver gelatin print.
Courtesy of the Horace
Poolaw Photography
Collection, Stanford
University and the Poolaw
family

PLATE 199

HORACE POOLAW
(KIOWA)

Carnegie Kiowa baseball team,
Carnegie, Oklahoma, c.1933

Silver gelatin print.
Courtesy of the Horace
Poolaw Photography
Collection, Stanford
University and the Poolaw
family

PLATE 200

HORACE POOLAW
(KIOWA)

'Alfalfa' Bill Murray's Gubernatorial Inauguration, Oklahoma City, Oklahoma, c.1930

Silver gelatin print. Courtesy of the Horace Poolaw Photography Collection, Stanford University and the Poolaw Family

PLATE 201

HORACE POOLAW
(KIOWA)

*Jerry and Newton Poolaw,
Mountain View, Oklahoma,
c.1927*

Silver gelatin print.
Courtesy of the Horace
Poolaw Photography
Collection, Stanford
University and the Poolaw
family

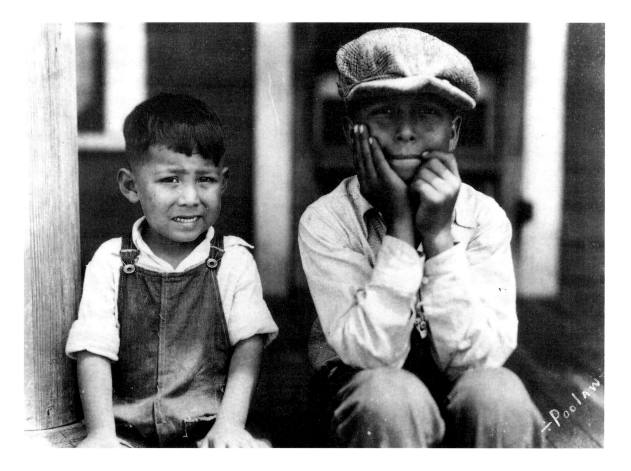

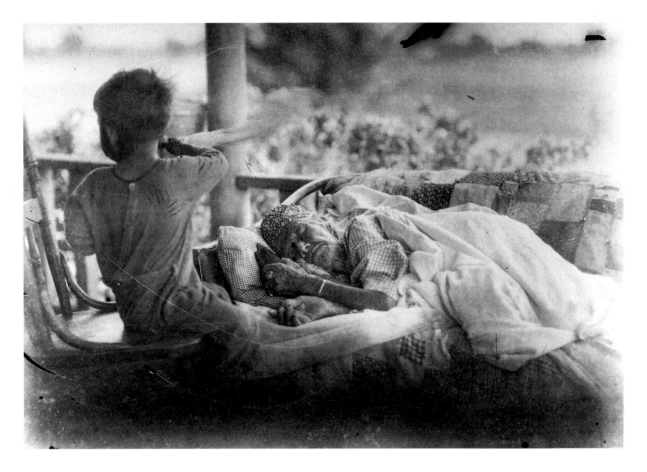

PLATE 202

HORACE POOLAW
(KIOWA)

*Kaw-au-in-on-tay and Great
Grandson Jerry Poolaw,
Mountain View, Oklahoma,
c.1928*

Silver gelatin print.
Courtesy of the Horace
Poolaw Photography
Collection, Stanford
University and the Poolaw
family

PLATE 203

HORACE POOLAW

Kiowa Group in American Indian Exposition Parade, Anadarko, Oklahoma, 1941

Silver gelatin print. Courtesy of the Horace Poolaw Photography Collection, Stanford University and the Poolaw family

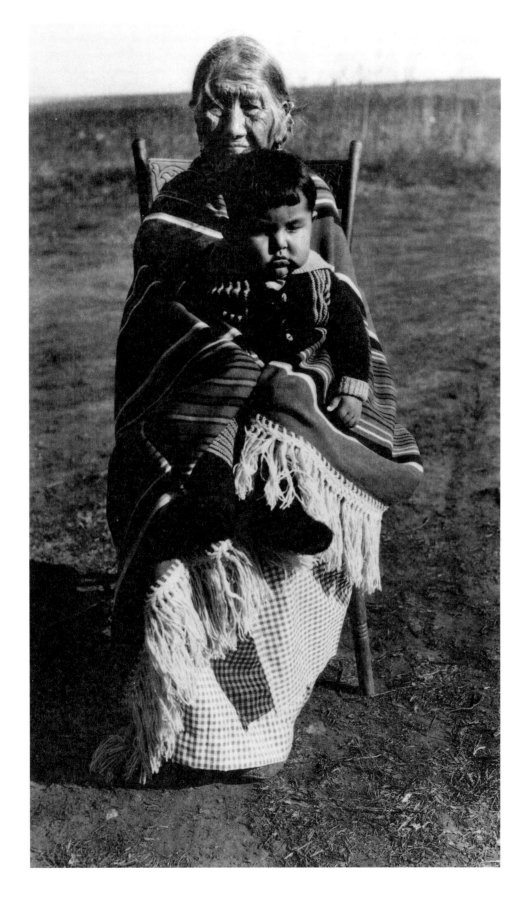

PLATE 204

HORACE POOLAW
(KIOWA)

*Kaw-au-in-on-tay and
Marland Aitson, Mountain
View, Oklahoma, c.1928*

Silver gelatin print.
Courtesy of the Horace
Poolaw Photography
Collection, Stanford
University and the Poolaw
Family

LEE MARMON

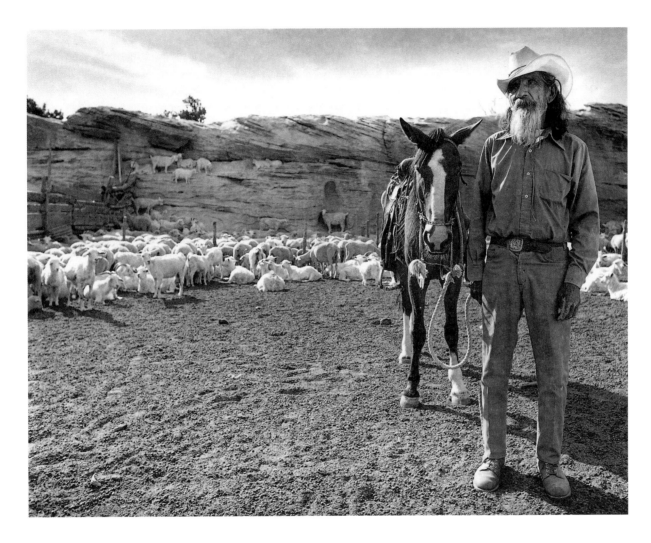

PLATE 205

LEE MARMON
(LAGUNA PUEBLO)

Bennie, Laguna Pueblo, 1985

Silver gelatin print.
Courtesy of the artist

PLATE 206

LEE MARMON
(LAGUNA PUEBLO)

Laguna Eagle dancers, 1949

Silver gelatin print.
Courtesy of the artist

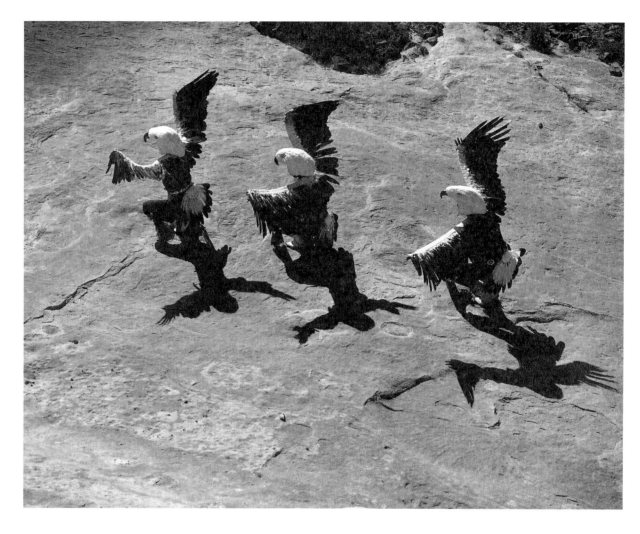

PLATE 207

LEE MARMON
(LAGUNA PUEBLO)

Acoma Mission, 1952

Silver gelatin print.
Courtesy of the artist

PLATE 208

LEE MARMON
(LAGUNA PUEBLO)

Platero (Diné) 1958

Silver gelatin print.
Courtesy of the artist

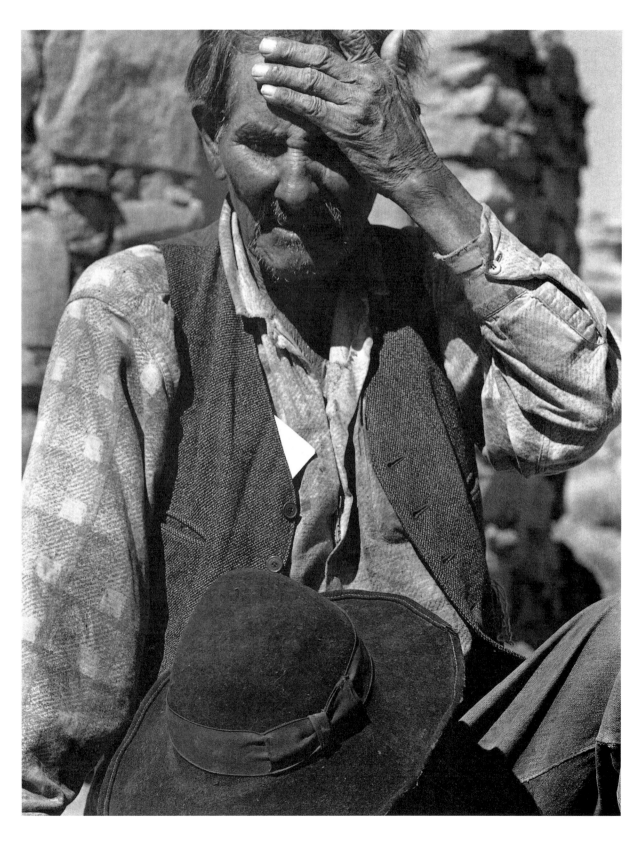

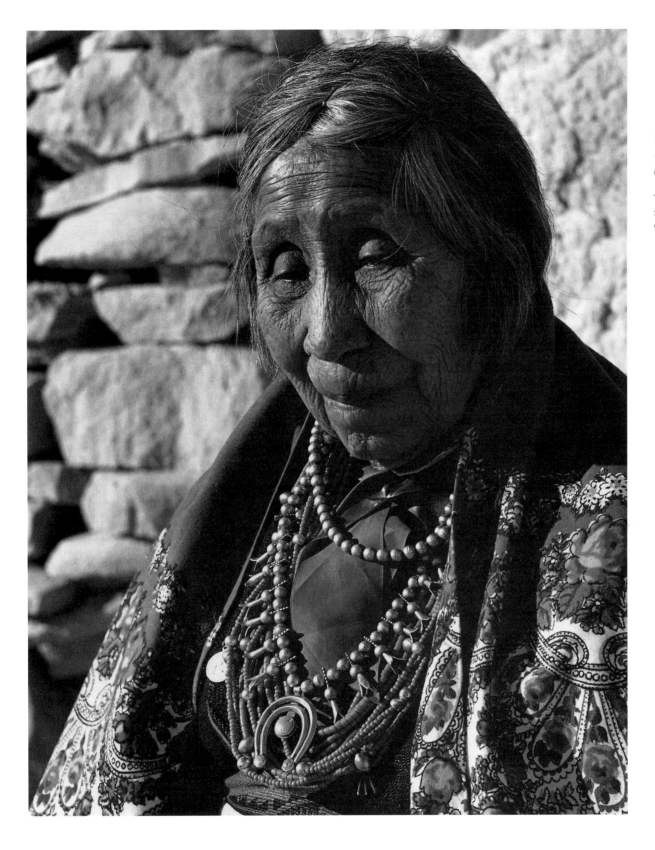

PLATE 209

LEE MARMON
(LAGUNA PUEBLO)

Juana, 1960

Silver gelatin print.
Courtesy of the artist

DUGAN AGUILAR

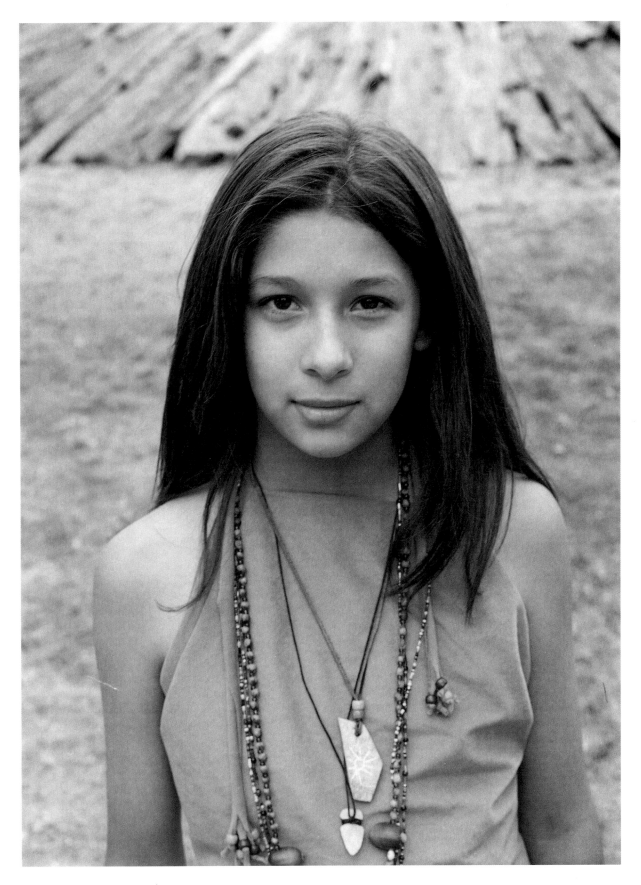

PLATE 210

DUGAN AGUILAR (PIT RIVER/MAIDU/PAIUTE)

Andrea Vera (Miwok), Chaw'se 24 September 1995

Selenium toned print. Courtesy of the artist

PLATE 211
DUGAN AGUILAR (PIT
RIVER/MAIDU/PAIUTE)

Amanda Few (Maidu), Chaw'se
24 September 1995

Selenium toned print.
Courtesy of the artist

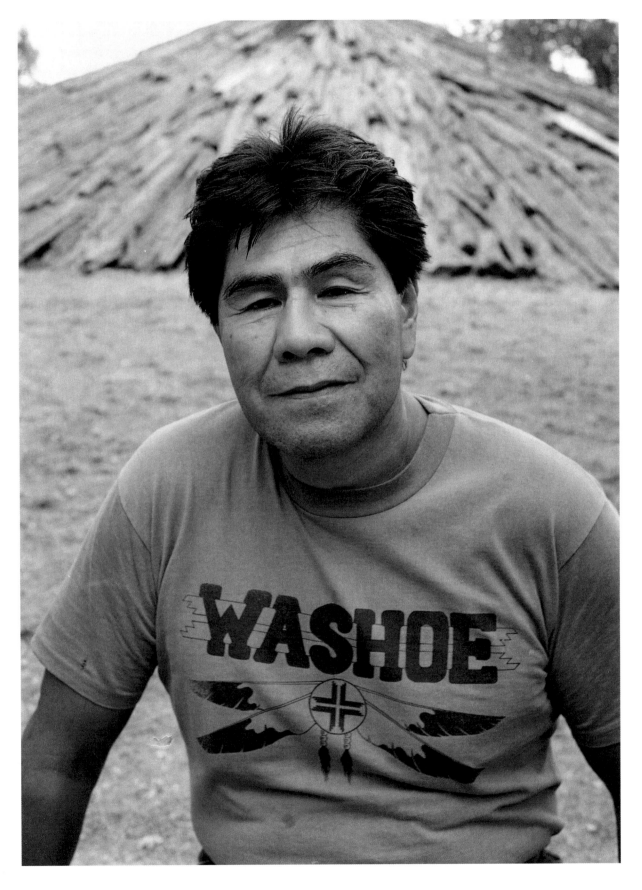

PLATE 212

DUGAN AGUILAR (PIT
RIVER/MAIDU/PAIUTE)

*Rocky Jim (Washoe), Chaw'se
24 September 1995*

Selenium toned print.
Courtesy of the artist

PLATE 213

DUGAN AGUILAR (PIT
RIVER/MAIDU/PAIUTE)

*Sara Keller (Seneca), Chaw'se
24 September 1995*

Selenium toned print.
Courtesy of the artist

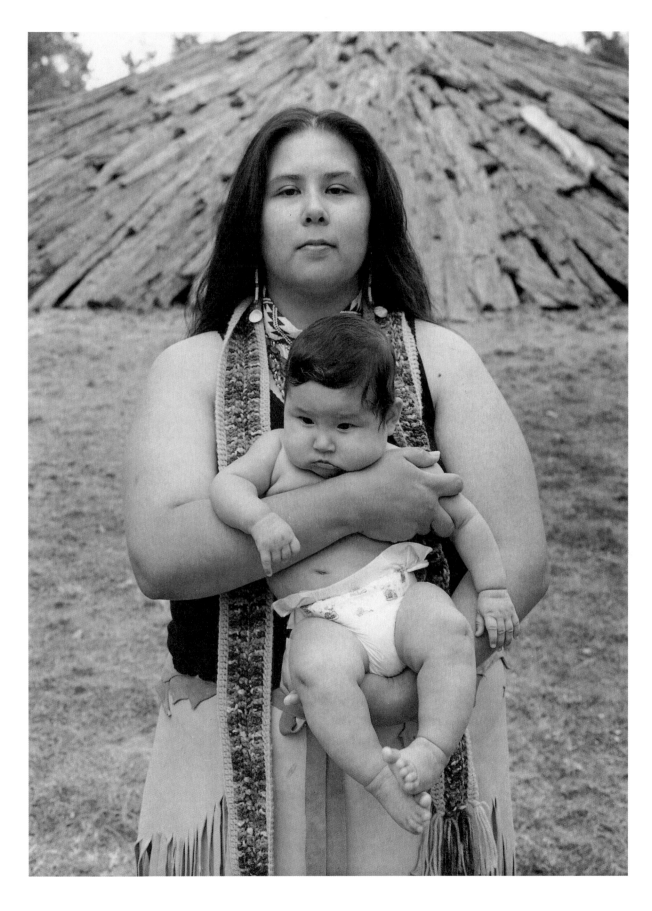

PLATE 214

DUGAN AGUILAR (PIT RIVER/MAIDU/PAIUTE)

Alana Spencer and baby Tecellah (Pit River and Maidu), Chaw'se, 24 September 1995

Selenium toned print. Courtesy of the artist

SHELLEY NIRO

PLATE 215

SHELLEY NIRO
(MOHAWK)

Survivor, 1992

Mixed media. Courtesy of
the artist

275

PLATE 216

SHELLEY NIRO
(MOHAWK)

North American Welcome, 1992

Mixed media. Courtesy of
the artist

PLATE 217

SHELLEY NIRO
(MOHAWK)

Final Frontier, 1992

Mixed media. Courtesy of
the artist

PLATE 218

SHELLEY NIRO
(MOHAWK)

This Land is Mime Land, 1992

Mixed media. Courtesy of
the artist

PLATE 219

SHELLEY NIRO
(MOHAWK)

Always a Gentleman, 1992

Mixed media. Courtesy of
the artist

HULLEAH TSINHNAHJINNIE

Damn, I keep dreaming
of three cherries!

PLATE 221

HULLEAH
TSINHNAHJINNIE
(SEMINOLE/MUSKOGEE/
DINE´)

*This is not a commercial, this is
my homeland, 1998*

Digital print.
Courtesy of the artist

PLATE 222

HULLEAH
TSINHNAHJINNIE
(SEMINOLE/MUSKOGEE/
DINE´)

Damn! What does E=mc² mean?, 1998

Digital print.
Courtesy of the artist

PLATE 223-224

HULLEAH
TSINHNAHJINNIE
(SEMINOLE/MUSKOGEE/
DINE´)

*Pages from 'Photographic
memoirs of an Aboriginal savant
(living on occupied land)' 1994*

*'The vision of a 40 year old
female aboriginal savant.
Thought provoking pages
photographically illustrated
with unexpected post-
assimilation grace. Journey to
the center of an aboriginal mind
without fear of being confronted
by the aboriginal herself'*

Digital prints on aged paper
Courtesy of the artist

PALM TREES

BEACHES

GATORS

"It's time to go home"

EVERGLADES

ART DECO

SEMINOLES

EGRETS

GERITOL

DISNEY

WORLD

MANATEES

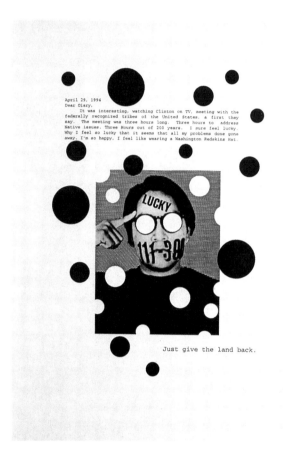

April 29, 1994
Dear Diary,
 It was interesting, watching Clinton on TV, meeting with the
federally recognized tribes of the United States. a first they
say. The meeting was three hours long. Three hours to address
Native issues. Three Hours out of 500 years. I sure feel lucky.
Why I feel so lucky that it seems that all my problems done gone
away. I'm so happy, I feel like wearing a Washington Redskins Hat.

Just give the land back.

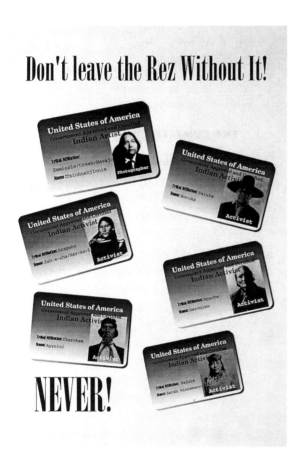

Left to right:

Geronimo in Florida, 1994

Dear Diary, 1994

Don't Leave the Rez Without It, 1994

Chinle High, 1994

LARRY McNEIL

PLATE 226

LARRY MᴄNEIL
(TLINGIT/NISGÀA)

Kincolith, from the Raven series, 1998

Digital pigment print.
Courtesy of the artist

PLATE 227

LARRY McNEIL
(TLINGIT/NISGÀA)

*Fly Don't walk, from the Raven
series, 1998*

Digital pigment print.
Courtesy of the artist

fly
don't
walk

...after watching a
bird and shadow
dance on a very white
wall, I was going to
cross the street, but
came to a "don't walk"
sign.

Finally, the red hand
turned into the figure
of a white man walking.

Not wanting to offend
anyone, I did my best
imitation of a white
man walking, and
crossed the street.

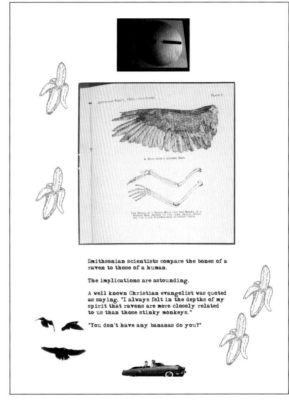

PLATE 228

LARRY McNEIL
(TLINGIT/NISGÀA)

*Cosmology report, from the
Raven series, 1998*

Digital pigment print.
Courtesy of the artist

PLATE 229

LARRY McNEIL
(TLINGIT/NISGÀA)

*Smithsonian plate 1, from the
Raven series, 1998*

Digital pigment print.
Courtesy of the artist

PAMELA SHIELDS

PLATE 231

PAMELA SHIELDS
(BLACKFOOT/
BLOOD BAND)

Motoki in Soho, 1997

Iris print
Courtesy of the artist

PLATE 232

PAMELA SHIELDS
(BLACKFOOT/
BLOOD BAND)

Sun dance tipi, 1997

Digitally manipulated iris
print. Courtesy of the artist

PLATE 233

PAMELA SHIELDS
(BLACKFOOT/
BLOOD BAND)

Kainawa, 1997

Digitally manipulated print.
Courtesy of the artist

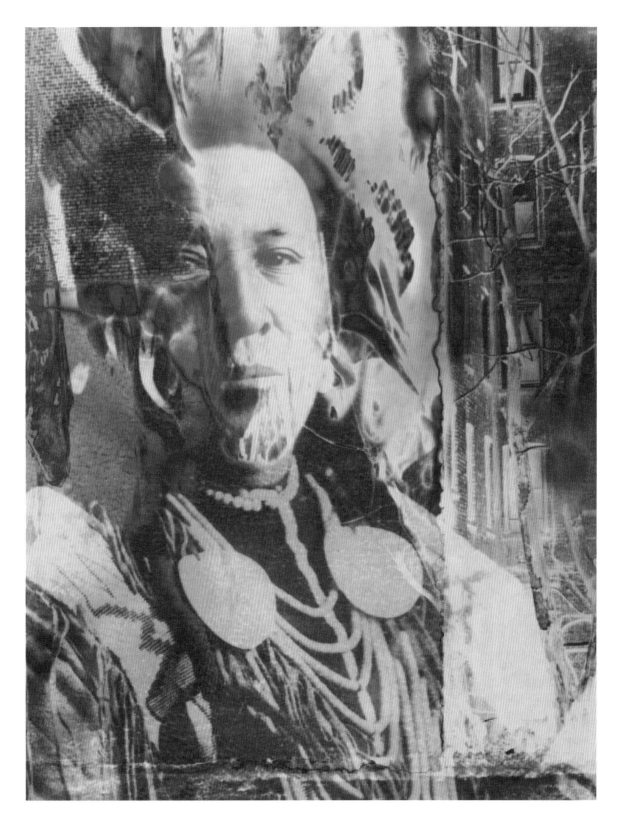

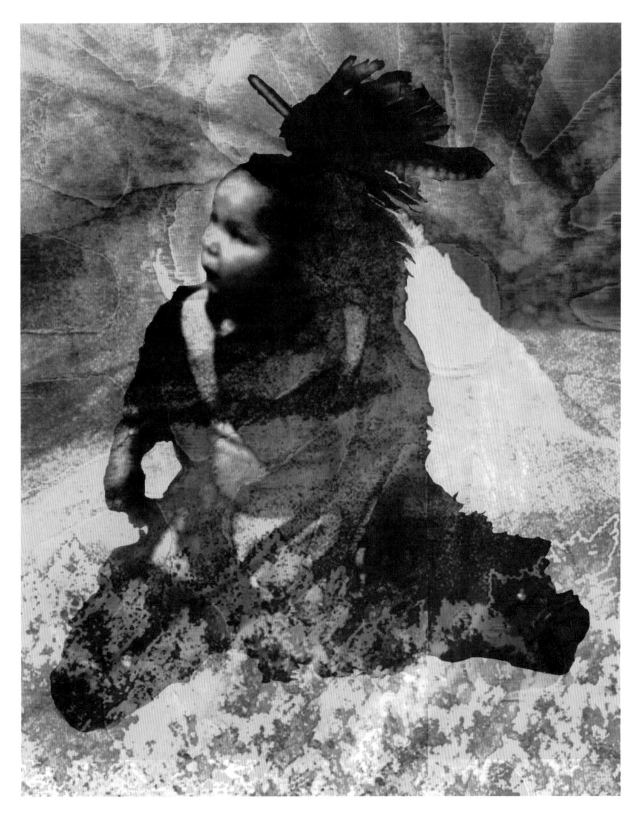

PLATE 234

PAMELA SHIELDS
(BLACKFOOT/
BLOOD BAND)

Trickster child, 1997

Digitally manipulated print.
Courtesy of the artist

JOLENE RICKARD

PLATE 235-244

JOLENE RICKARD
(TUSCARORA TURTLE
CLAN)

The Corn Blue Room, 1998.

CD-rom installation
digital prints

The Corn Blue Room is the
composition of the Americas
today. If jazz is America's
contribution to music,
I am suggesting it is time
to embrace Indigenous
knowledge.

Native Nations are situated
on 'reservation territories.'
These territories have
definite borders that have
become the staging ground
for the assertion of our
'Nationhood' or
sovereignty... *The Corn Blue*

Room is the cultural and political space for Indigenous people globally. It is about the struggle to maintain traditional knowledge in a contemptuous world.

Corn is a central element in this piece because it is the way that my family has maintained their understanding of these traditions. Knowledge is in the seed. Corn is also a metaphor for the Americas in that it is an indigenous seed. A number of creation stories are based on corn. The corn seen in this piece is not a commercial seed. It has been handed down since Sky woman fell from upperworld to this world. These seeds represent the power of the 'good mind'.

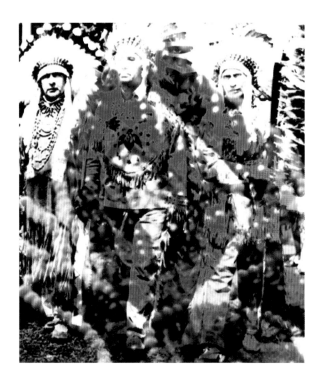

The white corn hangs in large braids in my Uncle's barn and represents the true wealth of my people.

The hydro tower represents the taking of Native land in the 20th century. Although in other centuries the symbols would be different, the result is the same. When the Robert Moses Power Authority moved in to take Tuscarora land, we fought back...It never stops, Indigenous survival is poised against the usurpation of our lands for consumable resources. What is displaced is traditional or ancient seeds of knowledge. Perhaps the seeds of our survival as *Ong we Ong we* or human beings is really what is being lost.

Jolene Rickard

BIOGRAPHIES & INFORMATION

SELECTED 19TH CENTURY BIOGRAPHIES

LOUISE VAUGHAN

ANDERSON, JOHN ALVIN (1869–1948)

Born in Sweden, Anderson emigrated with his family to the United States in 1884 and settled in Nebraska, where he married in 1895. In 1885 he had been commissioned as a civilian photographer for

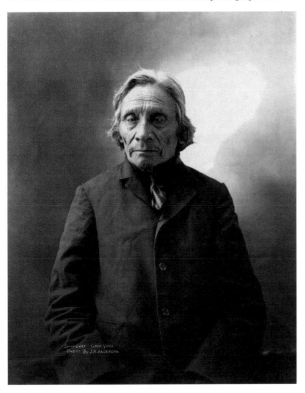

the US Army at Fort Niobrara, which had been established in 1880. By the end of the decade Anderson had established his own studio and in 1889 photographed the Crook Treaty Commission at the Rosebud Reservation, South Dakota. After spending a year in Pennsylvania, Anderson returned to Nebraska and lived on the Rosebud Reservation, working as a clerk at the Trading Post. It was during this time that Anderson began to record photographically the lives of the Sicangu [Brulé] Lakota who lived on the Reservation and in 1896 Anderson produced a small photographic book entitled *Among the Sioux*.

His early work had been documentary in nature, but as he developed as a photographer and forged a closer relationship with the Native community, his work became more romantic as he tried to recreate images of a traditional life which he felt was in danger of being lost forever. In 1900 Anderson produced striking portraits of notable individuals on the Reservation, such as the one of *Good Voice, c.1900* (pl.245). By 1911 his work had become even more romanticised. He invited Natives to participate in reconstructions of idealised traditional tableaux of daily and ceremonial life, which they most probably agreed to do as they realised too that there was a need to preserve them for future generations.

In the late 1920s the Andersons were struck by two disasters: in 1925 their only son died and in 1928 their home burnt down destroying almost all of Anderson's negatives. Possibly as a response

to the death of their son, the Andersons began to encourage and financially support a Sioux boy called Ben Reifel, who went on to gain a doctoral degree from Harvard and was elected to the House of Representatives. In 1929 Anderson published *Sioux Memory Gems* which consisted of poems written by his wife, Myrtle, accompanied by clearly staged romantic photographs. However, the style reflects the tone of the book and also testifies to the close emotional ties they had with the Native community. In the 1930s the Andersons moved to Rapid City, South Dakota to manage the Sioux Indian Museum, which had been built to house their own ethnographic collection, before finally moving to California. When John Anderson died in 1948 a stained-glass memorial window was erected, to commemorate not only John but his wife and son as well, in the Trinity Episcopal Church on the Rosebud Reservation. *Plates: 16, 87, 245.*

BELL, CHARLES MILTON (1848–1893)

Born into a family of Washington-based photographers, Bell entered into a number of partnerships before eventually becoming the sole owner of Bell & Brothers. As with other Washington photographic studios, Bell was involved in taking photographs of the visiting Native delegates who came to Washington to meet with politicians and sign peace treaties. Bell's work was featured along with other photographers in William Henry Jackson's Catalogue, a comprehensive photographic record of portraits, which was published by the Unites States Department of Interior in 1877. *Plates: 62, 63,147, 148.*

BONAPARTE, PRINCE ROLAND NAPOLEON (1858–1924)

Grandson of Lucien Bonaparte, Prince Roland was born in Paris on 19 May 1858 and was a man of the 19th century. Curious to learn about other races he studied geography and the social sciences including anthropology and was keenly interested in travel and the new technologies which were being developed, especially in photography. His first practical fieldwork was to make anthropometric descriptions of the Native peoples of Surinam, India, who were taking part in an exposition in Amsterdam in 1883. That same year he made photographs of visiting Omaha peoples at the Jardin d'Acclimatation de Paris, (pl.109-111,152-154)

In 1887 Bonaparte travelled to America to study and photograph the Natives of North America. He also sponsored expeditions to Africa, Asia and Australia and had pictures taken of their indigenous peoples at the 1889 Paris Universal Exposition.

By 1906 Bonaparte had amassed a collection of over seven thousand negatives. His North American Indians album, *Peaux Rouges*, was presented to the Smithsonian Institution.

He died on 15 April 1924 and was remembered for his scientific publications and his photographs of Native people from around the world.

See Elizabeth Edward's essay, pp.187-203. Plates: 109-111, 152-154.

KATE CORY (1861–1958)

Kate Cory was an artist who lived and worked among the Hopi of northern Arizona. For seven years, between 1905 and 1912, she lived at the pueblos of Oraibi and Walpi where she was welcomed into the daily lives of the Hopi.

Trained at Cooper Union and the Art Students' League in New York, she had met in 1904 the artist Louis Akin at the Pen and

PLATE 246

EDWARD S CURTIS

*The Oglala Lakota Chief,
Makhpiya lúta [Red Cloud],
1905*

Photogravure from the folio
accompanying Vol. III of
The North American Indian,
published 1908. Guildhall
Library, Corporation
of London

Brush Club, who inspired her with his enthusiastic descriptions of
the beauty and culture of the Hopis. Through her photographs,
Cory captures not only the rhythms of the Hopi day, but social and
sacred events; some images being the only visual record of customs
no longer practised. Working in isolation, with access to equipment
and supplies limited, she nonetheless produced outstanding images
and recorded people as they were.

Cory also spent time painting and writing about the Hopi culture
as well as composing a dictionary of the difficult Hopi language. In
1912 at the age of fifty-one Cory left the mesas and eventually
settled in Prescott, Arizona. She lived a private life surrounded by
books and paintings in process and dressed in flowing tattered
skirts. Although not wealthy herself, she was known to give away
money to people she believed needed it more.

She died on 12 June 1958 at the age of ninety-seven. Buried on
a knoll overlooking the town, the bronze plaque on her tombstone
reads: 'Kate Cory, Artist of Arizona. Hers was the joy of giving.'
Plates: 12, 67, 68.

COXE STEVENSON, MATILDA (1850-1915)

Matilda Coxe Stevenson was regarded as a forceful woman who,
after the death of her husband, James Stevenson in 1888, used
influential friends in Congress to make John Wesley Powell appoint
her to the scientific staff of the Bureau of American Ethnology
(BAE). Matilda had accompanied her husband, since the Hayden
surveys of 1870-79 and had gathered ethnographic information at
Zuni on BAE expeditions from 1879-88. In 1890 she returned to the
Southwest accompanied by the Bureau's stenographer, May Clark,
and a new Kodak camera. As with *Sia priests of the Giant Society of
1890* (pl.49) it is thought that Clark probably took many of the
earlier photographs, but under Stevenson's direction. Later
photographs were taken by Matilda.

Matilda, or Tilly as she was called, had learned the Zuni
language while on the survey expeditions, and this enabled her to
develop a closer relationship with and interest in the daily lives of
the Pueblo people. Initially Matilda believed, along with most of the
'forward-looking' thinkers of her day, that the Natives needed to be
helped to become civilised. However, as she lived among them, she
gradually gained an understanding and respect for the culture she
was photographing. She was to become one of the first government
staff to campaign for the preservation of Native religion.

In 1892 Tilly travelled with the BAE anthropologist James
Mooney to the Southwest to gather information for the World's
Columbian Exposition in Chicago, during which time they both
witnessed and photographed the ceremonies and daily activities at
Zuni and Hopi pueblos. *Plates: 49, 74.*

CURTIS, EDWARD S (SHERRIFF) (1868–1952)

Curtis's thirty-year mission to photograph the majority of Western
Native peoples (i.e., west of the Mississippi River) was begun in the
closing years of the 19th century and brought together in a vast
twenty-volume publication entitled *The North American Indian*
(1907–30). This has come to stand as testimony to both a private
passion and the wider public interest at the turn of the century in
the indigenous peoples of North America.

Curtis's desire was to capture for preservation the traditional
lives, appearance and customs of the Native American, and to
recreate a harmonious image of a people in communion with their
landscape.

Ironically, it was through the financial backing of the banker J.
Pierpont Morgan and the support of other eastern financial elites,
who exploited the material resources of the West – thereby bringing
about the wholesale destruction of traditional indigenous lifestyles

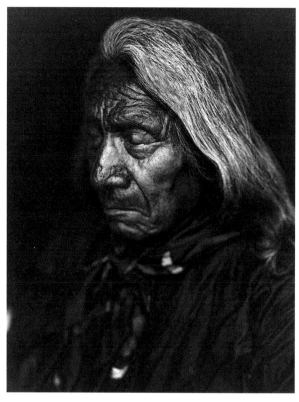

– that Curtis was able to undertake his project at all.

Curtis's style of photography was romantic almost from the start
and for this reason he is seen as a leading figure among the
'Pictoralists' who, during the early years of the 20th century, were
developing an aesthetic approach to the photographic medium.

Born in Wisconsin, Curtis grew up in Minnesota, a region rich in
Native American history which had, like the rest of the country,
seen at first hand the effects of a policy underpinned by the idea of
'Manifest Destiny' with Native peoples forced to live on reservations
and denied their traditional culture. In his early years it appears
that he taught himself photography and worked as an apprentice in
a photographic studio in St Paul, Minnesota.

After migrating to Puget Sound in 1887, Curtis eventually
became the sole owner of a commercial photography business in
Seattle, known as Edward S. Curtis, Photographer and Photograver,
which specialised in portraits and romantic landscapes. A turning
point in his career came when, after successfully documenting the
Alaska gold rush, he was appointed official photographer to the
Harriman Alaska Expedition in 1899. He became friendly with its
leader, C. Hart Merriam, and other scientific members, such as Dr
George Bird Grinnell. It was during this voyage that Curtis noted his
developing interest in the different ethnic groups he encountered,
learned the techniques of scientific investigation and ethnographic
study of other cultures and made contact with wealthy and
influential patrons back in the East.

By 1900 Curtis had decided that his life's work was to be the
photographing of Native Americans and recording all that he could
about their lives, inspired by the need to try and record a diversity
of cultures that were, as he saw it, in danger of being lost forever.
Curtis took photographs of the Northwest, Southwest and Plains
peoples. In 1904 he hired Adolf Muhr as his darkroom assistant and
manager of his Seattle studio. Throughout 1905 Curtis gave lantern
slide lectures in Washington, DC to encourage interest and raise
money for his project. He won the attention of President Roosevelt

who became an ardent supporter and declared Curtis's work both of artistic merit and a valuable historic document.

In 1906 Pierpont Morgan agreed to subsidise the fieldwork for *The North American Indian* on the condition that it was sold on a subscription basis by a company, The North American Indian, Inc., to which and for which Curtis was responsible. Curtis also published in conjunction with the project magazine articles, expensive-looking goldtone prints, postcards, popular books and a 'picture-opera' entertainment.

Curtis, like others of his generation, wanted to combine ethnographic study and artistic intent to create images of a traditional and idyllic past. This approach is also to be found in his silent film based on the Kwagiulth of the Northwest coast, *In the Land of the Head-Hunters* which was filmed between 1910 and 1914. Although based on legends and oral histories, it was dramatically presented with romance and violence added to appeal to a contemporary audience. Despite being a commercial failure, it had an impact on future ethnographic films including Robert Flaherty's *Nanook of the North*, 1921.

After a divorce from his wife, Clara, Curtis moved to Los Angeles in 1920 with his daughter, Beth and tried to build a new clientele. During the 1920s Curtis became involved with Hollywood movies but by the 1930s had stopped working; the strain of publishing and financing the volumes exacerbated by personal difficulties had taken their toll. By this time he had covered approximately 80 tribes, made 40,000 images and had written or supervised numerous books and had made or directed more then 10,000 recordings of Native speech and music.

His work has been much criticised since it was rediscovered in the early 1970s, for attempting to present a false and idealised image of Native American life at the turn of the century. He would, for instance, ask his subjects to dress in traditional costume and adornments and arrange his composition and manipulate it to create an image of his subjects wedded to a timeless Arcadian landscape. Nonetheless, his work is also admired for recording elements of Native American culture which would have been otherwise lost forever and it remains an important point of reference for Native and non-Native peoples alike.

See Mick Gidley's essay, pp.153-167. Plates: cover, 13, 23, 27, 115-125, 135, 246.

DIXON, JOSEPH KOSSUTH (1858–1926)

By the end of the 19th century, with the development of the hand-held Kodak camera, professional photographers were having to find their place among a growing number of amateurs. Pictorialist clubs devoted to creating atmospheric photographs which stood more as works of art than documentary photography sprang up around the country. Members experimented with different compositions, special lighting and close-up portraits, soft-focus lenses and abstract or non-existent backgrounds. Joseph Kossuth Dixon was among those who incorporated these ideals in his work.

In 1908 Joseph Dixon and his son, Rollin Lester, were commissioned by Rodman Wanamaker, heir to the Philadelphia department store empire, to journey to the Valley of the Little Bighorn. While Rollin filmed a movie version of Longfellow's Hiawatha his father took over a thousand photographs of the landscape and daily life of Native peoples. In 1909 Dixon returned to the Valley to record the final meeting of the surviving chiefs from almost all the Western reservations. They represented the last generation who would remember a truly traditional way of life. There was a desire among them to preserve their manners and customs for future generations.

In February 1913 a gathering at Fort Wadsworth, Staten Island,

to commemorate the dedication of a site for a huge (unbuilt) statue of the Native American, intended to rival the Statue of Liberty, brought together thirty-two chiefs from eleven tribes to sign a Declaration of Allegiance to the US government. Later that year, Wanamaker sponsored the Expedition of Citizenship which was again led by Dixon whose mission it was to take the American flag as its symbol from Fort Wadsworth to every one of the existing 189 tribes. He led a photographic unit to record the various tribes and their stories and later published these images in a book called The Vanishing Race. Dixon exhibited these images at the San Francisco Panama–Pacific Exposition of 1915 and lectured enthusiastically to over three million people during the five months of the exposition.

The photographs produced by Dixon and other Pictorialists became symbols of a time when human values were in harmony with nature. *See Mick Gidley's essay, pp.153-167. Plates: 86, 126.*

GARDNER, ALEXANDER (1821–82)

Born in Paisley, Scotland, Alexander Gardner worked as a reporter and editor for the *Glasgow Sentinel*. Prior to emigrating to the USA in 1849 Gardner was already an accomplished photographer, with an interest in optics, astronomy and chemistry. On moving to New York in 1856, he made a decisive and shrewd career move by introducing himself to Matthew Brady the leading photographic pioneer of his day. Brady initially opened a photographic studio in New York in 1844 and after a first failed attempt, opened a second in Washington in 1858 which continued until 1881. These studios served as training grounds for numerous photographers who developed their careers in America during the latter half of the 19th century. Gardner worked at Brady's New York photographic gallery before moving to Washington, DC to manage the new studio. It was here that he met and worked with another aspiring young photographer Timothy O'Sullivan, when after a disagreement over the attribution of his work, Gardner left in 1862 to establish his own studio and was joined by O'Sullivan. Initially photographing the Civil War, Gardner later worked with the Kansas Pacific Railroad and photographed Native delegates. In 1866 Gardner published Gardner's *Photographic Sketch Book of the War*, two volumes with text and 100 images taken by himself and other photographers including Timothy O'Sullivan.

After the Civil War, the Kansas Pacific Railroad commissioned Gardner to record the landscape along the proposed rail route from Kansas to California. The photographs taken between 1867 and 1873, were intended to illustrate the topographical features of the route and promote support among potential investors as well as satisfying the public's romantic perception of the Western landscape. Gardner focused on the panoramic view and the emptiness of the American West which served as a metaphor for potential economic expansion. The resulting photographs were published by Gardner in stereographs and an album of prints entitled *Across the Continent on the Kansas Pacific Railroad (Route of the 35th Parallel)*. It comprised 127 photographic plates beginning in St Louis and ending in San Francisco, following Gardner's route, thereby enabling viewers to visually experience the journey. Gardner's photographs were also reproduced in William Palmer's 1869 Report of the Surveys that was organised according to the natural resources and topography as they related directly to the economic needs of the railroad.

Gardner also photographed Indian delegates who journeyed to Washington, DC to participate in the signing of peace treaties and in May 1868 Gardner travelled out to Fort Laramie to photograph the first treaty made between the Commission and the Crows, Tististas [Cheyenne] and Hinano'ei [Arapaho] as well as the Oglala Lakota capturing on record the ritual smoking of the pipe and the gathering

of the leaders from various Great Plains tribes.

Gardner died of tuberculosis in 1882. *Plates: 46-48, 150.*

HILLERS. JOHN K. (1843–1925)

John Hillers emigrated from Germany to the USA in 1852. In 1863 he enlisted with the New York Naval Brigade and later transferred to the Union Army during the Civil War. He re-enlisted at the end of the War and served with the Western garrisons until 1870.

In 1871 Hillers met Professor John Wesley Powell while in Salt Lake City and was hired to work on Powell's second Colorado River expedition. It was to be the first scientific exploration of that region with a photographer, E. O. Beaman and his assistant Walter Clement Powell. Hillers joined the expedition on 15 May and soon became fascinated by Beaman's camera and began to assist the two photographers with their work. In August 1871 Hillers travelled with Clement Powell to take photographs of the Hopi villages of Oraibi, Hotevilla and Moenkapi where they were to return in September 1872 for the winter dances. Hillers photographed the Tewa, Sichomovi, Mishongovi, Shongopovi, Shipaulovi, Walpi and Oraibi Pueblos and made two subsequent visits at the end of the summers of 1875 and 1876. The survey members called Hillers 'jolly jack' or 'Bismarck' because of his German background and he would entertain them with stories. Beaman left the survey in 1871 and was replaced by James Fennemore who was hired to take photographs along the rim of the Grand Canyon with Hillers as his assistant. Fennemore taught Hillers about photography, but had to resign due to ill health before their trip down the Colorado River and through the Grand Canyon.

By late 1872 Hillers became Powell's expedition photographer and during the trip through the Grand Canyon Hillers took successive negatives of the canyons from origin to end, an innovative method which implied continuity in these natural phenomenon. Hillers stayed with Powell until 1878 and it was a working relationship which continued for another thirty-one years. When in 1879 the Bureau of Ethnography (later changed to the Bureau of American Ethnography) was created under the Department of the Interior, the Smithsonian Institution was appointed as administrator and Powell became its first director. Hillers was hired as the staff photographer. When Powell was also named as director of the US Geological Survey in 1881 Hillers became chief photographer. Hillers served both departments until his retirement in 1900.

Hillers's portraits of the Paiute, Hopi and Diné [Navajo], as well as photographs of architecture, domestic life and rituals were accepted by the Bureau to record traditional ways of life despite the fact that some images were staged and unfavourable aspects of Native life – such as starvation on the reservations and disillusionment – were edited out.

See Elizabeth Edward's essay, pp.187-203. Plates: 26, 34c, 37, 69, 151.

JACKSON. WILLIAM HENRY (1843–1942)

William Henry Jackson developed his photographic skills during the Civil War and on the railroad and scientific surveys of the American West. His timeless and sublime landscape photography as well as his studio portraits won him international acclaim. Born in Keesville, New York, Jackson received his photographic training as a retoucher and colourist. During the Civil War Jackson became a staff artist for the Vermont Infantry and saw action until 1863. In 1866 he travelled to Omaha, Nebraska where, joined by his brother Edward, he opened a photographic portrait studio. While Edward ran the gallery William set out to record the region's scenery including the Winnebago, Omaha, Osage, Oto and Pawnee tribes.

The geologist and survey leader Dr Ferdinand Vandiveer Hayden recognised and valued the important role photography played in recording and conveying the geological and geographical features of the landscape in the West as well as its immensity and beauty. Impressed with Jackson's work and having chanced to met him in 1870 Hayden invited the photographer to join his next trip to the Great Basin. After a year Jackson became the Survey's official photographer and spent the next seven summers with Hayden. Jackson travelled to Colorado and Wyoming to document the tipi villages of the Shoshone (pl.66) and in 1874 he photographed members of the Uncompahgre Ute tribe and became the first man to photograph the ancient cliff dwelling of Mesa Verde. Jackson was to return to these ancient cliff dwelling in 1875 to prepare an exhibition on the ruins for The International Centennial Exhibition in Philadelphia, which was to celebrate the 100th Anniversary of America's Independence. In 1877 the US Department of the Interior published an expanded catalogue of Jackson's Native American portraits with accompanying text, including biographical details, and anthropological measurements. Jackson's Catalogue, as it became known, did not only contain work by Jackson, but also work by a number of other leading photographers. Unfortunately, owing to a lack of proper accreditation, Jackson gradually became associated with all the images.

After leaving the Hayden Survey, Jackson opened a studio in Denver and became the leading photographer for the Western Railroads. He continued to travel through the Southwest, visiting New Mexico's Acoma and Laguna pueblos in 1899. That year Jackson also became a partner and director of the Detroit Publishing Company, leasing them his negatives and services and leading them to success in the picture postcard industry.

At the Explorers' Club in 1942, the ninety-nine year old Jackson was honoured for his some eighty thousand images of the American West, and just before he died in June 1842 his work was exhibited at the Museum of Modern Art, New York. *Plates: 8, 38, 66.*

JAMES. GEORGE WHARTON (1858–1923)

Born in Gainsborough, near Lincoln, England, James became active in the local Methodist Church, preaching and teaching at the Sunday school. In 1880 he married and a year later emigrated to America and settled in Nevada where he was ordained. Through his early work as an itinerant preacher in Nevada and California, he made his first contact with Native Americans, Paiute and Washo peoples, and when in 1887 he moved with his family to California he was again introduced to the Native Americans of the Franciscan mission. Here he could see for himself the dramatic changes which had been forced upon the Native American people.

Unfortunately for James, his wife accused him of adultery in 1889 and though later exonerated he was defrocked and deeply shattered by the experience. In self-imposed exile in the desert, he travelled with William Wallace Bass to the Grand Canyon and further to an isolated area where the Havasupai lived. Here James saw a community coexisting with nature in a symbiotic relationship which could not have been more at odds with the crowded and threatening nature of Chicago which he also visited during his absence from California. This convinced him that society's decay was connected to industrialisation and that social salvation lay in following the example of the Native Americans of the Southwest.

In 1892 he moved back to Pasadena, California, and took the opportunity to explore and photograph the Grand Canyon and the Native people of the region, all the while developing his skills as a photographer. James set about his objective with determination and frequently visited the Hopi, Diné [Navaho], Walapai and Zuni in order to gather all he could about their thoughts and lives, social customs and rituals, dances and legends. He became known by the

Hopi as 'Black Bear' because of his full beard.

Although he did not think of the Native American as his cultural equal he was nonetheless impressed by their lives which he saw as strong, natural and therefore healthy. This and other causes James brought together in a lecture, later published as a book entitled *What The White Man May Learn from the Indian*, (1908). His forthright approach, which seemed to show little regard for those he photographed has been condemned, but James was driven not by mere commercialism or straightforward ethnographic intent; rather he wanted to preach the virtues of Native American life and further their rights.

By his death in 1923 James had written over forty books and an extensive number of pamphlets and articles. He has been described as an explorer, amateur ethnologist and photographer whose tireless persistence enabled him to create photographs which are now regarded as important documents on Native American life.

See Benedetta Cestelli Guidi's essay, pp.223-228 and Mick Gidley's, pp.153-167. Plates: 75, 76, 134.

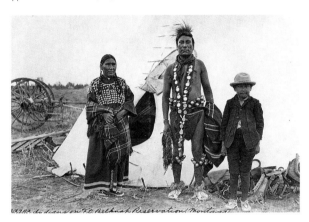

MATTESON, SUMNER W. (1867–1920)

Matteson was an adventurer who, for over ten years, travelled around the American West photographing the indigenous peoples of the Southwest and the Great Plains. He graduated in 1888 from the University of Minnesota with a Bachelor of Science degree and returned to Iowa to train as a bank clerk in the family tradition. When his father died in 1895 Matteson left to work for the Overman Wheel Company selling Victor bicycles in St Paul, Minnesota and by 1896 he had become the manager of the company in Denver, Colorado. Overman's also sold Kodak cameras in portable cases which could be attached to bicycles. When the Overman company pulled out of Denver in 1899 Matteson decided to put the company merchandise to good use and set off with his bicycle and camera to build a career as a 'travelling correspondent.' By the early 1900s he was selling his photographs to magazines and other publications.

As with many of his contemporaries, Matteson travelled to the Southwest in 1900 to photograph the Hopi Snake and Flute dances and in 1901 returned there as a back-up photographer for the Field Colombian Museum Expedition when he recorded every phase of the Hopi Snake and Antelope ceremonies over a nine-day period.

In 1902 he joined William Henry Jackson's Photochrom company and accompanied the now highly renowned photographer across the West. He soon left to begin photographing the Great Plains. In 1905-6 he produced his second significant series of Native photographs when he recorded the Sun dance of the A'ani [Gros Ventre] and Assiniboine Nakota at Fort Belknap reservation in Montana. These photographs combine both ethnographic detail and an artistic eye to produce vivid images testifying to Matteson's deep interest in tribal traditions and the welfare of the people.

By 1909 Matteson had settled in Milwaukee, working as a book-keeper for the Milwaukee Coke and Gas Company. He had virtually given up photography, although he made one final trip in 1920 to Mexico to climb Mount Ppocatepetl, which is where he died from lung failure.

In 1976 the Sumner W. Matteson Jr. Native American Scholarship was established for students of the Fort Belknap Reservation in Montana. *Plates: 21, 78, 79, 247.*

McCLEES, JAMES (STUDIO) (ACTIVE BETWEEN 1857–60)

James McClees, born in 1821, was among the first to experiment with new processes of photography during his training as a daguerreotypist in 1844. McClees's name and work soon became well known both in Philadelphia, where his career began, and in other cities. It has been suggested that McClees may have taken the earliest known delegation photograph in 1852 when nineteen delegates stopped in Philadelphia on their return from Washington, DC.

In September 1857 McClees moved to Washington, DC to open a new photographic gallery which remained active until 1860 when McClees returned to Philadelphia.

The McClees Studio reputation developed through their studio portraits of the Native delegates who visited Washington, DC in 1857-58. More than ninety delegates representing thirteen tribes came to Washington and before they left they were involved in the first systematic effort to photograph Native delegations to the capital. These photographs were incorrectly attributed to A. Zeno Shindler who managed the studio after McLees returned to Philadelphia. They were in fact taken by Julian Vannerson and Samuel A. Cohner who both worked for the studio. Vannerson came to Washington from Richmond, Virginia in about 1852 and worked with various photographic studios. Samuel Cohner was also a respected photographic technician. It was noted that with such talented staff the McClees studio was destined to succeed. McClees recognised the importance of recording the delegates, not only for the profit resulting from the sale of these portraits to an increasingly curious public, but also as a record of a culture in danger of extinction.

See Elizabeth Edward's essay, pp.187-203. Plates: 52-61, 64, 145.

MILLER, FRED (1868–1936)

Born in Chicago in 1868, Miller moved with his family to Iowa where he studied photography, having graduated from the University of Iowa, Iowa City. Believing that he would be more commercially successful in Helena, Montana, he moved there in 1896 but still had to earn a living doing other jobs. In 1898 Miller was appointed assistant clerk and recorder for the Bureau of Indian Affairs on the Crow Reservation in southern Montana. Despite his role, Miller and his wife became trusted and accepted by many of those in the Crow community; they named him Boxpotapesh (High Kicker) because he used to teach the children football skills as well as entertaining them by playing his piccolo and in the winter with his skating.

Between 1898 and 1912 he created an intimate photographic record of the Crow people and their lives, both documenting various activities as a government employee but also recording the effect of the cultural transition the Crow people had been forced to make. His work, though intimate, is documentary in approach. He did not attempt to condemn or romanticise the people he photographed, which sets him apart from other photographers working at the beginning of the century – most famously Curtis – who became known as Pictoralists.

See introduction, pp.11-21. Plates: 10, 11, 80-83.

PLATE 247

SUMNER MATTESON

Three family members, Fort Belknap Reservation, Montana 1905-06 (Assìniboine Nakota and A'ani [Gros Ventre])

Modern print from a negative in the collection of the Milwaukee Public Museum

PLATE 248

JAMES MOONEY

Hinano'ei [Arapaho] followers of the Ghost Dance religion, Darlington, Oklahoma, 1891

Modern print from a negative in the National Anthropological Archives, Smithsonian Institution

MIOT, PAUL-EMILE (1827–1900)

Paul-Emile Miot was born in 1827 in Trinidad, in the West Indies. His father's family was from the Bordeaux region of France and his mother was a Martinican. Miot entered naval college at the age of sixteen in 1843 and over the next fifty years pursued a highly distinguished military career. He was especially noted for the quality of his hydrographic surveys, as well as his skill and influence as a photographer at the Dépôt des Cartes et Plans de la Marine. Between March and November 1857, on board the Ardent, Miot carried out his first coastal topographical survey of Newfoundland.

Significantly, it was during this period that Miot was to produce his first known series of photographs, including panoramic views of the shoreline, prominent icebergs and the surrounding land as well as the Mi'kmaq men and women who lived there. Some of these photographs were published in France as woodcuts in *Le Monde Illustré* (10 April 1858) and *Illustration* (19 March 1859). Despite the fact that there is little evidence of Miot's work as a photographer before this date, it has been suggested that because of his technical skill, he must have carried out some photography prior to his trip in 1857. It is possible that Miot had met Eugène René Collet-Corbinière, a naval professor and member of the Société Française de Photographie (SFP) an organisation which Miot joined in 1858 just before his second trip to Newfoundland. Certainly, his photography reflects the observant eye of a trained surveyor.

Voyages to Newfoundland continued between 1858 and 1862, and when combined with photographs taken on other trips to Oceania, South America and Senegal, his output was substantial. Miot's photographs of the Mi'kmaq people conform to the documentary and pseudo-scientific attitude towards the depiction of people considered primitive. He often shows his subjects as examples of ethnographic 'types', isolated, detached from their natural environment and daily lives, which would have given them a context and status otherwise lacking.

Upon Miot's return to Paris in 1862 he confirmed his position within the Dépôt des Cartes et Plans de la Marine by making official the first photographic atelier which had up until then been functioning informally on his initiative since 1857. Between 1868 and 1871 Miot travelled to numerous countries and continued to take an abundance of photographs. His naval career steadily progressed and by 1888 he was designated Vice-Admiral, and in 1891 he received the title of Grand Officer in the Legion of Honour. In May 1894 he was appointed curator of the Musée de la Marine et de l'Ethnographie at the Louvre. Six years later on 7 December 1900 Miot, aged 73, died in Paris.

His works can be found in the Musée de l'Homme, Paris, Musée d'Orsay, Paris and in the Canadian National Archives. *Plates: 41-44.*

MOONEY, JAMES (1861–1921)

As a child, James Mooney had an insatiable curiosity and would devise lists about the world, one being a list of Native tribes, their names, languages, boundaries and treaties. This same attitude led him to undertake a comprehensive study of the Plains people. In 1879 (the year the Bureau of American Ethnology was established) Mooney began his career as a journalist for a Richmond newspaper, but his real ambition was to travel to South America to study the Natives of Brazil. In order to realise his dream, he constantly wrote to the Smithsonian Institution between 1882 and 1884 and finally he was brought to the attention of John Wesley Powell, director of the Bureau. Powell was very impressed by Mooney's independent research and his list of three thousand tribes, but owing to insufficient funds Mooney was invited to join the Bureau as a volunteer, which he did for a year. In 1886 Mooney became

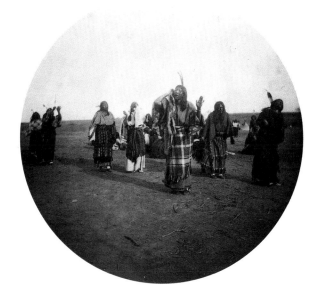

officially connected with the Bureau and began his work to reconstruct the history of the Native peoples of the North American continent.

Mooney first took a camera into the field in 1888 to photograph the Aniyunwiya [Cherokee] Corn Dance, an annual celebration of thanksgiving. In 1889 he began to collect plants and songs used by Aniyunwiya shamans in curing ceremonies. He developed a close relationship with one of the 'medicine men', Ayyuini (Swimmer) also called Ayasta (Spoiler) or Tsisiwa (Bird) (pl.22) and managed to obtain the first notebook of sacred curing formulas written in the Aniyunwiya language.

In the summer of 1890 Mooney worked in the North Carolina and Tennessee Mountains with the eastern branch of the Aniyunwiya and was planning to carry out a comparative study with the western branch in Indian Territory during the winter. This plan was to be sidelined by a request from the government to investigate a religion that had sprung up among the tribes, which was known as the Ghost dance. It sought to unify all Native Americans in brotherhood against their impending extinction by assimilation and the deprivation brought about by the invading white man (pl.24,247). What was meant to be a short exploration developed into a comprehensive study of the indigenous peoples of the Plains region. In 1892 Mooney met and took the first photograph of Wovoka, the prophet of the Ghost dance. Over the next thirty years Mooney successfully campaigned for religious freedom which led to the recognition of the Native American Church, which uses peyote, as an official religion. He also wrote an authoritative study of the decline of the Native American population.

During the winter of 1892 Mooney travelled to the Southwest with Matilda Coxe Stevenson to gather information for the World's Colombian Exposition in Chicago, photographing Zuni and Hopi Pueblos as well as nearby Diné [Navajo] in Keam's Canyon, Arizona. In the 1893 exposition a record number of Mooney's photographs were displayed.

See Hulleah Tsinhahjinnie's essay, pp.41-55. *Plates: 22, 24, 247.*

RINEHART, FRANK A. (1861–1929), ADOLF MUHR (ACTIVE c.1890–1913)

Born in Illinois into a photographic family, Frank Rinehart moved in 1878 to Denver, Colorado, and from 1881 to 1885 worked at his

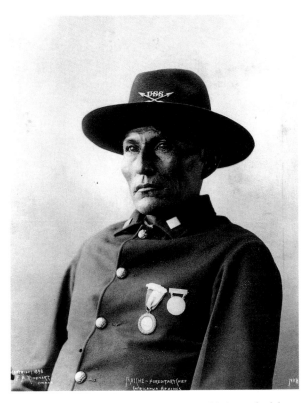

brother's studio, where he came into contact with the work of the influential photographer William Henry Jackson, whose photographs must have had an impact on Rinehart, just starting out on his career. In 1886 he married the studio receptionist and moved to Omaha, Nebraska where he opened a studio of his own specialising in commercial portraits.

Commissioned by the government in 1898 Rinehart became the official photographer of the Trans-Mississippi and International Exposition held in Omaha, Nebraska from 1 June to 31 October 1898, where he was given his own small studio in the grounds of the exposition. In total 545 Native delegates from 36 tribes attended the exposition for what had been planned as an 'Indian Congress' Rinehart believed that the exposition offered an ideal opportunity to study Native peoples before they were totally absorbed into white culture. The ethnographic aspect to the exposition, under the direction of James Mooney, began with the serious intent to educate the visiting public. However, somewhere along the line there was a shift in emphasis and the Indian Congress degenerated into a Wild West show.

During the last week of the exposition, the government commissioned Rinehart to photograph the congress delegates, but owing to the fact that Rinehart was occupied with recording other events it is likely that his assistant Adolf Muhr produced almost all of the five hundred portraits of the visiting Natives. The portraits are staged depictions, such as 'Hattie Tom and Bonny Yela' (pl.114), with Natives posed in ceremonial dress in front of incongruous studio backdrops of painted architectural settings. The US Bureau of American Ethnography contracted a complete set of the photographs while Rinehart copyrighted another set. Muhr contested the copyright and in 1903 left to work with Edward Curtis. These photographs constitute one of the best photographic documents of Native leaders at the turn of the century. In them, the original purpose of the Indian Congress was realised.

Rinehart died in New Haven, Connecticut. His studio remained

in operation until 1906 under the management of his former partner George Marsden. *Plates: 112-114, 249.*

RUSSELL, ANDREW JOSEPH (1830-1902)

Captain A. J. Russell became the first Civil War officer to be officially appointed as a photographer, when he was assigned to document the US Military Railroad Construction Corps between 1862 and 1865. After the Civil War, Russell was commissioned by the Union Pacific Railroad to photograph its construction culminating in Utah in 1869 where it met the Central Pacific Railroad creating the first transcontinental rail route. The same year the railroad published an album of Russell's photographs *The Great West Illustrated* accompanied by captions which together emphasised the wealth of natural resources which would be made available by the railroad. Even one of the most desolate images in the album, Embankment, East of Granite Canyon, was accompanied somewhat unconvincingly by a caption which places it at the head 'of a beautiful valley fifteen miles in width, which extends north and east fifty miles' so encouraging the notion of the suitability of the area for settlement and development.

Russell was also a painter and journalist, but valued the camera's ability to capture the beauty and immensity of the landscape through which the railroad had now forged. He saw with an artist's eye and juxtaposed monumental geological elements with man-made structures such as the railroad. By acknowledging both modern technological triumph and the grandeur of the landscape Russell's photographs suggest the possibility of their peaceful coexistence. History was to show that that was not to be the case.

While in Utah, Russell met Clarence King, director of the United States Geological Exploration of the 40th Parallel with whom he worked for a brief period. By the early 1870s Russell had returned to New York where he opened a studio and was a regular contributor to Frank Leslie's Illustrated Newspaper. Russell's photographs were not only used to inform potential investors and politicians, or as documentary records for the railroad, but also as enticing travel images for an increasingly interested public. His stereoscopic views, taken for the Union Pacific, were converted to lantern-slides and used by Stephen J. Sedgwick in his lecture tour on the railroad which was presented throughout New England, New York and Pennsylvania between 1870 and 1879. At the age of sixty-one Russell retired to Brooklyn where he died in 1902. *Plate: 36.*

WARBURG, ABY (1866-1929)

The eldest son of one of the biggest Jewish Banking families of Hamburg, Aby Warburg's life-long interest was focused on the fruitful relations between literary sources and visual representation in late Mediaeval and Renaissance art. Convinced that art history was not to be focused on purely formal issues, he believed it necessary to make a reading of it through the lenses of a historian of culture. He started and consolidated a new method of image-reading, later called Iconology. Paramount for this method was a deep knowledge of the history, religion, aesthetic theories and even the economic exchanges of the period whose art he was studying.

At the age of thirteen, he gave his brother Max the right to primogeniture: in exchange he asked his brother to buy him all the books he needed for his research – at his death 60,000 volumes were kept in his Hamburg library.

At the age of twenty-nine, Warburg went to America; where he spent eight months (September 1895 – May 1896) visiting first the eastern Pueblo villages of New Mexico and then the Hopi villages of Arizona. He bought a camera and took nearly two hundred photographs during the journey, which underline the socio-cultural diversity of Western and Native ways of life. He never published the

PLATE 249

FRANK A RINEHART
AND ADOLF F MUHR

*'Naiche – Hereditary Chief',
Chiricahua Apache, taken
taken at the Trans-Mississippi
and International Exposition,
Omaha, 1898*

Platinum print. Wellcome
Institute Library, London

photographs nor his thoughts on the American experience, both
published at a later date by his assistant. Still, the American journey
had a deep impact on his intellectual development; nearly thirty
years later, in 1923, he gave a slide-lecture on this experience based
mainly on what he had seen and photographed, although he
decided to focus his argument on the Snake dance – which he never
saw. The reason for such a choice was that through the symbol of
the snake he could draw comparisons between Hopi and ancient
civilisation, like the Greek one, central to his studies on the
Renaissance. One of his principal ideas was the survival of pagan
forms in 'civilised' populations, i.e., a Renaissance painter might
use forms borrowed from classical statuary each time they wanted
to express a strong emotion. In the Hopi dances he saw for the first
and possibly the only time in his life, a survival of a form of thought
that the 'civilisation' of the West had erased from personal
consciousness.

Back in Hamburg, he resumed his studies on Renaissance
culture, founding a library and a photographic collection, both
unique for their cataloguing order which took no account of
author's names or titles of works but was ordered purely according
to subjects as they related to each other. In 1933, immediately after
Hitler became Chancellor, the contents of his library were moved to
London. The Warburg Institute later became part of the University
of London. *Plates: 70-73.*

WINTER. LLOYD AND PERCY POND (1866-1943) (1872-1945)

Lloyd Winter trained as a portrait painter at the California School of
Design in San Francisco and in 1893, aged twenty-seven, travelled
to Juneau, Alaska in the hope of taking advantage of the gold
discovered there. A meeting with George Landerking, who invited
him to become a business partner in his photographic studio,
directed his career on an altogether different path. Within a few
months Landerking sold his stake in the business and Winter was
joined by a friend from California, Percy Pond, and together they
operated the studio, Winter and Pond, until Pond's death in 1943.

In 1894, Winter and Pond unwittingly watched a secret Chilkat
dance and because outsiders were forbidden to see it they were
initiated into the Chilkat tribe. Winter was named Kinda [Winter]
and Percy was named Kitch-ka [Crow Man]. This special position,
coupled with the fact that they both spoke the Native Chilkat
language and lived all year round in the local community, enabled
the two photographers to record intimately the Tlingit and Haida
Gwaii people of Alaska. In this, their work differs from the images
taken by the many transient summer visitors and amateur
photographers. The trust between the community and the
photographers is evident by the fact they were invited to attend and
photograph ceremonial events such as potlatches, which
commemorate significant stages in the life of a person.

Most of their photography of indigenous peoples dates from the
decades around the turn of the century and offers a wealth of
information with regard to the rich traditional culture of Alaska
during a period of transition.

In 1928, Winter successfully applied for membership to the
Alaska Native Brotherhood, an all-Native American organisation.
Founded by Native Americans they sought citizenship and equal
rights for Native peoples. There aim was 'to assist and encourage the
Native in his advancement from his Native state to his place among
the cultivated races of the world, to oppose, discourage and
overcome the narrow injustice of race prejudice, and to aid in the
development of the Territory of Alaska'.

When Percy Pond died on 1 June 1943, aged 71, Lloyd Winter
handed their studio over to an assistant, and when he died on 18
November 1945 six of his Native friends were honorary pallbearers,
testifying to the close relationship the two photographers had built
with the Chilkat tribe which had adopted them. *Plates: 88, 250, 251.*

NATIVE AMERICAN BIOGRAPHIES

VERONICA PASSALACQUA

DUGAN AGUILAR (PIT RIVER/MAIDU/PAIUTE)

Born in 1947 in Susanville, California and now living in Elk Grove, California, Aguilar works as a commercial photographer and graphic designer. He learned his photography skills at the University of Nevada, Reno and the University of California Extension. Aguilar is especially grateful to the Ansel Adams Yosemite workshop for giving him a new way of 'thinking and feeling' and inspiring him to produce fine art photography.

The initial focus of the Aguilar's photography was his family, who are from the Californian tribe of Maidu and Pit River and the Walker River Paiute tribe of Nevada. His subject matter developed to include his friends and then the Native peoples of California and Nevada. His work has been widely exhibited and published, has gained several awards and prizes, and is represented in the collections of Princeton University.

Selected exhibitions:

1998 – Memory and Imagination: *The Legacy of Maidu Indian Artist Frank Day*, National Museum of the American Indian, New York
1997 – *Indian Casino:Slots and Sovereignty*, Carl Gorman Museum, University of California, Davis
1997 – *Nuppa – Acorn Soup*, Phoebe Hearst Museum of Anthropology, University of California, Berkeley
1997 – *Fire Makes It So*, California State Indian Museum, Sacramento
1996 – *Through the Native Lens*, Institute of American Indian Arts Museum, Santa Fe, New Mexico
1996 – *Wa'tu Ah'lo, Connecting People and Things Directly to the Earth*, Carl Gorman Museum, University of California, Davis
Plates: 189, 210-214.

LARRY McNEIL (TLINGIT/NISGÁA)

Born in 1955 into a family with a rich history, McNeil's culture 'was ancient when the Egyptian Pharaohs were dreaming of building the first pyramids and when their family car was a 1954 Buick Roadmaster, with all eight kids in the huge back seat.' He was Professor of Photography at the Institute of American Indian Arts in Santa Fe, New Mexico from 1992 to 1996, and is on the Board of Directors of the Native Indian/Inuit Photographers Association. Widely exhibited, his work is included in the collections of Princeton University; the Heard Museum; the University of Alaska, Fairbanks; and the Angoon (Alaska) Heritage Center.

McNeil's most recent work reflects upon both historical and contemporary aspects of mythological stories. 'By breathing renewed life into the Raven story of creation, ravens go on, and do they ever like the end of the 20th century. Raven, as trickster, loves the irony and contradictions that are ubiquitous in mainstream culture.'

Selected exhibitions:

1996 – Strong Hearts, Contemporary Native Visions and Voices, Smithsonian Ripley International Gallery, Washington, DC, and currently travelling
1996 – Pacific Connection, University of Alaska Museum, Fairbanks, Alaska
1996 – Positives and Negatives, Street Level Photography Gallery, Glasgow, Scotland
1994 – Traditions of Looking, Institute of American Indian Arts Museum, Santa Fe, New Mexico

1994 – Spirit of Native America, Contemporary Art Museum, Santiago, Chile and Museum of Modern Art, Sao Paolo, Brazil
1993 – Beauty Surrounds Me, American Indian Community House Gallery, New York
1991 – The Haida Project, Carl Gorman Museum, University of California, Davis
Plates: 2-6, 191, 225-229.

LEE MARMON (LAGUNA PUEBLO)

Born in 1925, Marmon began his professional career at 20 years of age. He is a photographer, film advisor and educator. His most famous work comprises of sensitive portraits, especially of old people living in his home community of Laguna Pueblo in New Mexico. His work has been exhibited throughout North America and has appeared in books and publications including the Los Angeles Times, Newsweek, Time and Southwest Art, and in 1993 he created a series of photo-murals for Denver International Airport. Marmon's diverse experience includes work with Columbia Pictures for the filming of 'Nightwing',being the official photographer for Bob Hope Desert Classic and several major golfing tournaments, a commission by the White House in 1972, and most recently photographing for the American Indian College Fund. Marmon still lives and works in Laguna Pueblo, where he owns and manages the Blue Eyes Indian Bookstore.

Selected exhibitions:

1999 – *National Museum of the American Indian*, Smithsonian Institution, New York
1999 – *300th Anniversary if San José Mission*, Laguna Pueblo, New Mexico
1996 – *Strong Hearts, Contemporary Native Visions and Voices*, Smithsonian Ripley International Gallery, Washington, DC
1993 – *A Circle of Nations:Voices and Visions of American Indians*, Beyond Words Press
1984 – *Fourth Annual Member's Invitational*, Artists Cooperative Gallery, Tuscon, Arizona
1977 – *Lee Marmon*, Indian Pueblo Cultural Center Museum, Albuquerque, New Mexico (solo)
Plates: 9, 205-209.

SHELLEY NIRO (MOHAWK)

Born in 1954 in Niagara Falls, New York, Niro grew up on the Six Nations Reserve and is a member of the Turtle Clan of the Mohawk. She is an artist, photographer and film-maker, and has won several awards for her work including the First Projects Grand and Photographers Exhibition Assistant Grand from the Ontario Arts Council. Her work is included in several collections which include the Canadian Museum of Civilization, Royal Ontario Museum, Iroquois Indian Museum, and the Canadian Museum of Contemporary Photography.

Storytelling through film and installation art, Niro creates roles for Native women that give them a voice of strength and community. She has exhibited widely and her work often addresses questions of identity and how it is constructed by the self and others. She currently lives in Brantford, Ontario.

Selected exhibitions:

1998 – *Reservation X*, Canadian Museum of Civilization, Hull,
 Quebec
1998 – *Iroquois Art, Visual Expressions of Contemporary Native American
 Artists*, Amerika haus, Frankfurt, Germany
1997 – *'Godi'nigoha', The Women's Mind*, Woodland Cultural Centre,
 Brantford, Ontario
1996 – *From the collections, The Portfolio:Luminance - Aboriginal
 Photographic Portraits*, National Archives of Canada, Ottawa,
 Ontario
1996 – *Nations in Urban Landscape*, Obero Gallery, Montreal, Quebec
1995 – *Native Love*, Montreal, Quebec
1995 – *AlterNATIVE*, McMichael Art Collection, Kleinburg, Ontario

Film and Videography:

1993-98 – *Honey Moccasin* (writer/director/producer)
1997 – *Overweight with Crooked Teeth* (writer/director/producer)
1993 – *It Starts with a Whisper* (writer/co-director/co-producer)
Plates: 215-219.

HORACE POOLAW (KIOWA) 1906-1984

Born in 1906, a time of great change and transition for the Kiowa,
Poolaw is the only Native American of his generation to be
recognised as a professional photographer. His interest in
photography prompted him to buy a small camera and enroll in a
correspondence course in photo oil colouring, and as a young man
in 1926 became an apprentice to the landscape photographer,
George Long.

Poolaw's early work focused on his family, especially his grand-
mother, Kaw-au-in-on-tay, and his son Jerry. With the influence of
Hollywood and Vaudeville, Poolaw's photographs from the late '20s
contain subjects striking self-consciously theatrical poses.

Poolaw enlisted in World War II, and after serving over 3 years
in the Army teaching aerial photography, he settles with his family
in Andarko, Oklahoma. There he documented the transitions in
Kiowa life within the context of post-War American culture. He
photographed the most significant events in his tribe, as well as the
everyday life of his family and friends until, when in 1978, his
failing eyesight forced him to put down his camera. Poolaw always
said he did not want to be remembered himself, he wanted his
people to remember themselves through his pictures.
Plates: 34b, 188, 198-204.

JOLENE RICKARD (TUSCARORA TURTLE CLAN)

Born in 1956 in Niagara Falls, New York, and currently living
within the territories of the Tuscarora Nation, Rickard is an
educator, writer, artist and curator. Her work focuses on the way in
which sovereignty is negotiated and represented in the 20th
century. Issues relating to the land and environment within the
territories of the Tuscorora Nation are expressed verbally and
visually through much of her work. Rickard is continually seeking
to identify and understand indigenous knowledge systems. Widely
exhibited and published, Rickard was recently chosen for the Heard
Museum Biennial in Phoenix. She also completed a residency at
Lightworks in Rochester and is currently on the advisory board of
the Center for Exploratory and Perceptual Art in Buffalo, New York
and is a Board member of the Otsego Institute of Native American
Art History, New York State Historical Association, Cooperstown,
New York. Rickard is an assistant professor in the art and art history
departments of the University of Buffalo, New York.

Selected exhibitions:

1998 – *Reservation X*, Canadian Museum of Civilisation, Hull,

Quebec

1996 – *Strong Hearts, Contemporary Native Visions and Voices*,
 Smithsonian Ripley International Gallery, Washington, DC, and
 currently travelling.
1995 – *Western New York Exhibition*, Albright Knox Art Gallery,
 Buffalo, New York
1994 – *Watchful Eyes: Native American Women Artists*, The Heard
 Museum, Phoenix, Arizona
1994 – *Cracked Shell*, Robert B Menschel Photography Gallery,
 Syracuse University, Syracuse, New York (solo).
1993 – *Defining our Realities: Native American Women Photographers*,
 Sacred Circle Gallery Seattle, Washington
Plates: 235-244.

ROSS COBB, JENNIE, (ANIYUNWIYA [CHEROKEE]) (1882-1958)

At twelve years old Jennie Ross Cobb was given a box camera by
her father and although she was to have no formal training she
developed a passionate interest in photography. By the late 1890s
Jennie was a skilled practitioner of the medium. Many people at
that time were actively interested in photography, but Jennie was
probably the only Aniyunwiya photographer and one of the
youngest women photographers.

Born in 1882, Jennie was educated at the Cherokee Female
Seminary in Tahlequah, Oklahoma from 1888 until 1900 from
where she graduated at the age of eighteen. The Seminary had its
own photographer who made formal recordings of school life, but
Jennie was able to capture more intimate images of her fellow
students, which were full of movement and narrative.

Following in the footsteps of her older sister, Jennie became a
teacher and practised at a school near Christy, Oklahoma from 1902
until her marriage in 1905. Her husband, Jessie Clifton Cobb, was a
Texan who came to Oklahoma to work as a surveyor in the wake of
the Dawes Act of 1887, which brought about the individual
allotment of reservation lands. Throughout the 1920s and 1930s he
was employed in the oil industry, which meant that the family had
to move from town to town. Soon after their marriage Jennie had a
daughter, Jenevieve Chiouke Cobb. The hardships the family
suffered were compounded by Jessie's gambling, forcing Jennie to
earn extra income as a travelling photographer, making and selling
postcards. By the late 1930s, Jessie was seriously ill, and the family
settled in Arlington where Jennie and her daughter opened a florist
shop. After her daughter died in 1945, Jennie boarded students to
enable her to raise her two grandchildren.

Robert B. Ross, Jennie's father, was a farmer, who was also
active in Aniyunwiya politics, an interest that could be linked to the
fact that the Ross family traced its descent from the Aniyunwiya
leader John Ross and his first wife, Quatie Brown Henley. In 1900
the Ross family lived in the George Murrell House, Park Hill which
is now a historic site run by the state, and it is was to here that
Jennie returned in 1952 to become its first curator.
See: Hulleah Tsinhahjinnie's essay, pp.41-55. Plates: 28, 29, 192-194.

PAMELA SHIELDS (BLACKFOOT/BLOOD BAND)

Born in 1956 in Salt Lake City, Shields was brought up and educated
in Calgary, Canada and now lives in San Francisco, California, where
she is co-founder of the Folsom Street Interchange Art Space. The
subject of her works focuses upon her culture, Blackfoot, family
histories and stories filtered through experience. Over the last ten
years, Shields has been working with alternative photographic
processes, including cyanotype, Van Dycke, and gum dichromate, as
well as liquid photo emulsion on various materials, such as
buckskin, silk and muslin. Most recently, Shields has been

manipulating digitised photographs. In this manner she strives to combine old and new technologies to articulate the connection between past and present.

Selected exhibitions:

1998 – *Unthinkable Tenderness: The Art of Human Rights*, Art Department, California State University, San Francisco

1997 – *Life Clusters*, Euphrat Museum of Art, DeAnza Community College, Cupertino, California

1997 – *We are Many, We are One*, University Art Gallery, University of Wisconsin, La Crosse

1997 – *Indian Casino:Slots and Sovereignty*, Carl Gorman Museum, University of California, Davis

1996 – *Strong Hearts, Contemporary Native Vision and Voices*, Smithsonian Ripley International Gallery, Washington, DC

1994 – *Watchful Eyes: Native American Women Artists*, The Heard Museum, Phoenix, Arizona

1994 – *Rooms for the Dead, Dia De Los Muertos*, Center for the Arts at Yerba Buena Gardens, San Francisco, California

Plates: 190a, 230-234.

RICHARD THROSSEL (MÉTIS / CREE / ADOPTED CROW / SCOTTISH / ENGLISH) 1882-1933

Born in 1882 in Marengo, Washington, where Throssel's Cree grandparents and extended families - all Hudson's Bay Company employees, had settles in 1841, he was an accomplished commercial photographer. At the age of twenty, and convalescing from a long and debilitating illness, Throssel moved to the Crow Reservation where he lived from 1902-1911. Shortly thereafter, he purchased his first camera, taught himself the fundamentals of photography, and set out to produce a photographic document of the Crows.

Of the 'stampede of photographers' that visited the Crow Reservation, the most influential was Edward S. Curtis, whose first visit was in 1905. Another influence was fellow Crow Agency clerk, Fred Miller who was related by marriage and also adopted into the Crow tribe at the same time as Throssel. By 1911 Throssel had compiled more than one thousand photographs, recording the day-to-day and cultural life of the Crows in casual snapshots, formal and informal portraits, documentary and dramatic pictorial images - in effect, a visual census. Though his early work targetted a non-Native audience, in later years he aimed more of his work toward Native audiences, incorporating Native symbolism into the content.

Throssel photographed Northern Tististas [Cheyenne] ceremonies which were prohibited by government regulation, and as an employee of the US Indian Service, he produced a series of images depicting disease among Montana's Crow people, for use in national education programmes aimed at improving Native health.

One of the most popular of his series, *Interior of the best Indian Kitchen on the Crow Reservation* promoted the benefits of living in conventional houses and eating formal meals at a table.

In 1924, Throssel was elected to the Montana State Legislature for two terms (1925 and 1927), where his activism followed a series of policy-based events that affected him personally as a North American Native and as a Crow. He died in 1933 at the age of 51 in Camp Cooney, Montana.

Plates: 31, 34, 187, 195-197.

HULLEAH TSINHNAHJINNIE (SEMINOLE/MUSKOGEE/DINE´)

Born in 1954 in Phoenix, Arizona and now living in Chinle, Arizona, Tsinhnahjinnie's formative years were influenced by some of the finest Native artists; Fred Beaver, Pablita Velarde, Adee Dodge, and her father. A strong indigenous artistic base fused with her mother's commitment to community and protocol created the catalyst for an artist of political conviction.

For the past six years Tsinhnahjinnie has been a visiting artist for the Bug-Ga-Na-Ge-Shig School in Cass Lake, Minnesota and recently a Rockefeller Fellow in residence at the University of California at Davis, Native American Studies Program. She has taught at; the Institute of American Indian Arts, Santa Fe, New Mexico; San Francisco State University and the California College of Arts and Crafts, Oakland. She has also served as a board member for the Inter-Tribal Friendship House in Oakland, California and the American Indian Contemporary Arts in San Francisco. Exhibited nationally and internationally, Tsinhnahjinnie claims photographs as her primary language. Creating fluent images of Native thought, her emphasis is art for indigenous communities.

Selected exhibitions:

1998 – *Hulleah J. Tsinhnahjinnie: New Works*, Carl Gorman Museum, University of California, Davis (solo)

1997 – *Native Women of Hope / Portraits of Indigenous Women*, 1199 Gallery, New York (solo)

1996 – *Shared Visions*, The Heard Museum, Phoenix, Arizona, travelling to Auckland, Christchurch and Hamilton, New Zealand

1994 – *Watchful Eyes, Native American Women Artists*, The Heard Museum, Phoenix, Arizona

1994 – *This Path We Follow*, Gustave Heye Center, National Museum of the American Indian, Smithsonian Insitution, New York

1994 – *Photographic Memoirs of an Aboriginal Savant*, Sacred Circle Gallery, Seattle, Washington and Carl Gorman Museum, University of California, Davis (solo)

Plates: 190, 220-224.

SELECTED READINGS

ALBERS, P AND JAMES, W (1984) 'The Dominance of Plains Indians Imagery on the Picture Postcard' Fifth Annual Plains Indian Seminar in Honour of Dr. John C Ewers, ed. George Horse Capture and Gene Ball, 73-97, Wyoming: Buffalo Bill Historical Centre, Cody.

ALBRIGHT, P (1997) Crow Indian Photographer The Work of Richard Throssel, Albuquerque: University of New Mexico Press.

APERTURE FOUNDATION INC (1995) Strong Hearts: Native American Visions and Voices Aperture (139), New York.

BANTA, M AND HINSLEY, C (1986) From Site to Sight Anthropology, Photography, and the Power of Imagery, Massachusetts: Peabody Museum Press, Cambridge. Distributed by Harvard University Press.

BUSH, A AND MITCHELL, L (1994) The Photograph of the American Indian, New Jersey: Princeton University Press.

CARDOZO, C (ed.) (1993) Native Nations First Americans as seen by Edward S Curtis, New York: Bulfinch Press Book, Little, Brown and Company.

CASTLEBERRY, M (ed.) (1996) Perpetual Mirage Photographic Narratives of the Desert West, New York: Whitney Museum of American Art.

CURTIS, E S (1997) The North American Indian The Complete Portfolios, London: Taschen.

EDWARDS, E (ed.) (1994) Anthropology and Photography 1860-1920, New Haven and London: Yale University Press in association with The Royal Anthropological Institute, London.

EWERS, J (1965) 'The Emergence of the Plains Indian as the Symbol of the North American Indian' Smithsonian Report for 1964, pub. 4636: 531-544, Washington DC: Smithsonian Institution.

FLEMING, P AND LUSKEY, J (1992) The North American Indians in early photographs, London: Phaidon Press Limited.

FLEMING, P AND LUSKEY, J (1993) The Shadow Catchers Images of the American Indian, London: Laurence King Publishing.

FORESTA, M (ed.) (1996) American Photographs The First Century From the Isaacs Collection in the National Museum of American Art, Washington and London: Smithsonian Institution Press.

GIDLEY, M (1979) With One Sky Above Us, London: Windward and New York: Putnam's.

GIDLEY, M (1987) The Vanishing Rac: Selections from Edward S Curtis' The North American Indian, Seattle: University of Washington Press and Vancouver/Toronto: Douglas & McIntyre.

GIDLEY, M (1998) Edward S Curtis and The North American Indian, Incorporated, New York and Cambridge: Cambridge University Press.

GOETZMANN, W (1991) The First Americans Photographs from The Library of Congress, Washington, DC: Starwood Publishing, Inc.

GREEN, R (1988) 'The Indian in Popular American Culture' History of Indian - White Relations Vol. 4 Handbook of North American Indians ed. Wilcomb E. Washburn Washington DC: Smithsonian Institution.

HARLAN, T AND RICKARD, J (1994) Watchful Eyes Native American Women Artists, Phoenix, Arizona: The Heard Museum.

HIESINGER, U (1994) Indian Lives A Photographic Record from the Civil War to Wounded Knee, Munich and New York: Prestel-Verlag.

LIPPARD, L (ed.) (1992) Partial Recall, New York: The New Press.

LYMAN, C (1982) The Vanishing Race and Other Illusions Photographs of Indians by Edward S Curtis, New York: Pantheon Books, in association with the Smithsonian Institution Press.

MASAYESVA, V AND YOUNGER, E (1984) Hopi Photographers / Hopi Images, Arizona: Sun Tracks and University of Arizona Press.

MILLER, L (ed.) (1995) from the HEART: Voices of the American Indian, London: Pimlico.

O'CONNOR, N (ed.) (1985) Fred E Miller Photographer of The Crows, Montana: University of Montana School of Fine Arts in Missoula, and California: Carmam VidFilm Inc. of Malibu.

POOLAW, L (1990) War Bonnets, Tin Lizzies, and Patent Leather Pumps: Kiowa Culture in Transition, 1925-1955 The Photographs of Horace Poolaw, California: Stanford University.

SCHERER, J (1974) Indians Contemporary photographs of North American Indian Life 1847-1929, London: A Ridge Press Book / Octopus Books.

SCHMITT, M AND BROWN, D (1948) Fighting Indians of the West, New York: Charles Scribner's Sons.

SONTAG, S (1979) On photography, London, Penguin.

TAFT, R (1964) Photography and the American Scene, New York: Dover Publications, Inc.

TAYLOR, C (1980) 'Ho, For the Great West!' The English Westerners' Society ed. Barry C Johnson, London.

TAYLOR, C (ed.) (1991) The Native Americans - The Indigenous People of North America, London: Salamander Books Limited.

VIZENOR, G (1998) Fugitive Poses Native American Indian Scenes of Absence and Presence, Lincoln and London: University of Nebraska Press.

WEYBRIGHT, V AND SELL, H B (1956) Buffalo Bill and the Wild West, London: Hamish Hamilton.

CONTRIBUTOR NOTES

JANE ALISON curates and organises exhibitions in her position as Exhibition Organiser at the Barbican Art Gallery. A fine artist by training, she has also contributed to and edited a number of publications, including: *Stanley Spencer: the Apotheosis of Love* (1991), *Border Crossings: Fourteen Scandinavian* Artists (1992) (co-edited and co-written with Carol Brown), *Jam:style+music+media* (1996).

ELIZABETH EDWARDS curates photography at the Pitt Rivers Museum, University of Oxford and teaches critical history and theory of still photography in anthropology and museology within the sub-faculty of anthropology. A historian by training, she has written extensively on the relationship between photography, anthropology and history, especially as related to the Pacific, and on the relationship between ethnographic photography and contemporary arts practice. Her many publications include her edited volume *Anthropology and Photography 1860-1920, Beyond the Boundary:a consideration of the expressive in photography and anthropology* in M. Barks and H. Morphy *Rethinking Visual Anthropology* and *Performing Science: Still Photography and the Torres Strait Expedition* in A. Herle and S. Rouse, eds., *Cambridge and the Torres Straits*. In 1996 she curated an exhibition of 19th century Native American photographs in Oxford. She is on the editorial boards of the *History of Photography* and *Visual Anthropology Review* and on the Photographic Committee of the Royal Anthropological Institute.

PAULA RICHARDSON FLEMING is an archivist, advisor, curator, lecturer, and author, and is currently Photographic Archivist for the National Anthropological Archives, Smithsonian Institution, where she has worked since 1970. Having undertaken extensive research into 19th century photographs of Native Americans, she has advised several institutions, identifying photographers, subjects, photographic techniques and authenticating and dating images at other major repositories such as The British Museum, the Southwest Museum, the National Museum of the American Indian, the Amon Carter Museum, the Royal Anthropological Institute of Britain and Ireland, and the Pitt Rivers Museum, University of Oxford. She has lectured internationally and published extensively, including: *Grand Endeavours: Masterworks of American Indian Photography* (published in the UK as *Shadow Catchers; Images of the North American Indian*), *The North American Indians in Early Photographs* and *The Indian Nations:The First Americans* and *American Experience*. She is on the Board of Directors of the National Stereoscopic Association.

MICK GIDLEY is Professor of American Literature at the University of Leeds. He has published widely in American Cultural History and is an authority on Edward S. Curtis. His books on Native American themes include: *With One Sky Above Us, Kopet; A Documentary Narrative of Chief Joseph's Last Years* and *Edward S. Curtis and The North American Indian, Incorporated*. He has also edited *Representing Others: White Views of Indigenous Peoples* and a Curtis anthology, *The Vanishing Race*.

BENEDETTA GUIDI CESTELLI is an art historian who has recently edited *Aby Warburg in America 1895-96: Photographs at the Frontier* for the Warburg Institute in London. She has also curated a touring exhibition of Warburg's photographs from the Southwest of America in Hamburg and touring. She has organised various exhibitions in Italy and has worked as a correspondent and journalist in arts and culture for the Italian daily newspaper, *Il Manifesto*. She lives in London and Rome.

THERESA HARLAN (Laguna/Santo Domingo/Jemez Pueblo) is a curator, lecturer and writer. She is Director of the Carl Gorman Museum in the Department of Native American Studies at the University of California at Davis and currently contribes to *Fresh Talk: Daring Gazes of Asian American Art* co-edited by Elain Kim and Margo Machida, as well as the revised edition of *Critical Image: Essays on Contemporary Photography* edited by Carol Squiers. She has written for photographic journals including: *Aperture, Exposure, San Francisco Camerawork, Views* and *Contact*. In 1994 Harlan guest curated an exhibition of Native American women artists, *Watchful Eyes*, and authored a catalogue of the same name for The Heard Museum in Phoenix, Arizona. She also curated a photographic travelling exhibition, *Message Carriers: Native Photographic Messages* for the Photographic Resource Center at Boston University in 1992. Harlan has a bachelors degree in Ethnic Studies from the University of California at Berkeley; she attended the Institute of American Indian Arts in Santa Fe, New Mexico.

GEORGE HORSE CAPTURE (A'ani) is a curator, author and advisor, currently the Deputy Assistant Director for Cultural Resources at the National Museum of the American Indian, New York. Previously he taught at the College of Great Falls and Montana State University, and was Curator for the Plains Indian Museum at Cody, Wyoming for several years. Horse Capture's studies in anthropology and history were motivated by his commitment to better the conditions of the Native American people and his belief that their future lies in a renewed understanding of the old ways. With several awards, publications, and films to his name, Horse Capture has also established scholarship funds for students at the Fort Belknap Reservation. He has also served on several committees which include, the National Indian Education Association, the American Indian Historical Society, and as a presidential appointee to the National Museum Services Board.

COLIN TAYLOR is a writer, lecturer and film consultant. He was formerly a Senior Lecturer at Hastings College of Arts and Technology, Hastings, East Sussex, and has studied Native American Plains history and culture for over forty years. For more than a decade he has presented a paper at the annual seminar held at the Plains Indian Museum which is part of the Buffalo Bill Historical Center in Cody, Wyoming. As well as being a contributor to the Smithsonian Institution's *Handbook of the North American Indians*, one of his most recent publications relates to a rare manuscript on Mandan ceremonies, The George Catlin O-kee-pa at the British Museum. Widely published, Taylor has authored several books including, *The Plains Indians, Native American Life, Native American Myths and Legends, Native American Arts and Crafts* and *The Native Americans*. More recently he has acted as an advisor for the forthcoming movie directed by Richard Attenborough telling the story of the Englishman Archie Belaney who was adopted by the Ojibwa Indians and became Grey Owl – a conservationist and champion of the North American Indian.

ACKNOWLEDGEMENTS

Janeen Antoine
Ken Arnold
James Ayres
Gayle Baker
David Brodie
David Burgevin
Dan Cameron
May Castleberry
Charlie Cleary
Chester Cowen
Daniel Davis
Pamela Dewey
Michael Donlevy
Sandra Douglas
James Faris
Irene Gilchrist
Rayna Green
Connie Hammon
Mark Haworth-Booth
Emil Her Many Horses
Graham Howe
Pete James
Joan Jensen
Brian Johnston
Denna Jones
Dr Charles Junkerman
Carol Kalafatic
Jonathan King
Wes Kramer
Phil McNally
Maggie Magnuson
Tony Marinella
Kathy Marmon
Victor Masayesva
Joan Morris
Christopher Morton
Toddy Munson

David Neel
Nancy Fields O'Connor
Stewart O'Connor
Lorie Olsen
Malcolm Osmond
Joanna Ostapkowicz
Susan Otto
Robert Parks
Sue Percival
Harry Persaud
Linda Poolaw
Jean Rees
Alissa Rosenberg
Stuart Ross
Janine Sarna-Jones
Aaron Schmidt
William Schupbach
Anthony Shelton
Sue Smallwood
Alexandra Smith
Michael Smith
Don Snoddy
Art Sutch
Betty Taylor
Ellen Thomasson
Timothy Troy
Stephen Vitiello
Chad Wall
Kim Walters
Kate White
Chris Wright
Chris Winter

LENDERS

Sir Benjamin Stone Collection, Birmingham Central Library

Liz Farrelly, London

The Fred E. Miller Collection: Nancy F. O'Connor

Guildhall Library, Corporation of London

The John Judkyn Memorial, Bath

The Graham Nash Collection, Los Angeles

National Anthropological Archives, Smithsonian Institution

Pitt Rivers Museum, University of Oxford

Royal Anthropological Institute Photographic Collection, London

Royal Engineers Library, Chatham

The Taylor North American Indian Archives, Hastings

The Trustees of the British Museum, London

The Warburg Institute, London

The Wellcome Institute Library, London

Union Pacific Museum, Omaha

Whitney Museum of American Art

CORPORATE MEMBERS

Barbican Art Gallery would like to thank its Corporate Members:

The Bethlem Maudsley NHS Trust
Brtish Petroleum Company plc
The Chase Manhattan Bank
Clifford Chance
Robert Fleming & Co. Ltd
Merrill Lynch
The Observer
Save & Prosper plc
Selfridges
Unilever plc
Warr's Harley-Davidson

COLLECTION INFORMATION

MUSEUMS, LIBRARIES, ARCHIVES AND PRIVATE COLLECTIONS

Negative numbers, where applicable, given in brackets

Alaska State Library: plate 88, (87-10), 250 (87-70), 251 (87-303)

Birmingham Central Library: plates 7, 89, 92, 105, 106, 107, 108, 137, 138

Trustees of the British Museum: plates 15 (mmo34562/26), 47 (mmo34563/28), 48 (mmo34563/30), 64 (mmo34564/23), 65 (mmo34564/1), 93 (mmo34563/7), 94 (mmo34562/25), 95 (neg: mmo34563/5), 96 (mmo34563/3), 97 (mmo34563/4), 98 (mmo34562/19), 99 (mmo34563/13), 100 (mmo34562/29), 101 (mmo34563/0), 102 (mmo34562/27), 104 (mmo34562/34), 156 (mmo34562/22), 158 (mmo34563/10)

Fred Miller Collection: Nancy F. O'Connor: plates 10, 11, 80, 81, 82, 83

Guildhall Library, Corporation of London: plates 13, 27, 115, 116, 117, 118, 120, 121, 122, 123, 124, 125, 135, 246,

John Anderson Collection, Nebraska State Historical Society: plates 16 (A547-228), 87 (A547-5P), 245 (A547-69P)

Library of Congress, Washington: plates 132 (LC-USZ62-19725), 133 (LC-USZ62-38149)

Liz Farrelly, London: plate 112

Mick Gidley: plate 127

Horace Poolaw Photography Collection, Stanford University, and the Poolaw Family: plates 34, 188, 198, 199, 200, 201, 202, 203, 204

Milwaukee Public Museum: plates 21 (43757), 247 (43753)

Museum of Northern Arizona Photo Archives: plates 12 (75.920), 67 (75.659), 68 (75.839)

National Anthropological Archives, Smithsonian Institute: plates 14 (1713), 17 (43003-B), 18 (55516), 19 (55517), 20, 22 (1008), 24 (55,298), 25 (55,018), 26 (2251-D-2), 30 (4117), 32A (52,542), 32B (52,543), 33, 34C (2041), 37 (2137-B), 46 (3686), 49 (2189), 50 (1733-B), 51 (3179-C), 62 (3413-B), 63 (3413-A), 66 (1668), 74 (1982-C), 75 (81-2705), 76 (43091), 77 (76-15144), 78 (26,537-t), 79 (34054-m), 85 (53,340-C), 86 (83-7744), 90 (1663-t), 91 (1536), 126 (83-7738), 128 (3678), 129 (2860-W), 130, 131 (2517-A), 134 (83-4199), 136, 139, 140, 141, 142, 143, 144, 147 (3383-A-2), 149 (3834-A-1), 150, 151 (2267-E), 159 (4484), 160 (42,977-A), 195 (4644), 248 (55,297)

Archives and Manuscripts Division of the Oklahoma Historical Society: plates 28 (2061.17), 29 (20661.13), 192 (20661.14), 193 (20661.6), 194 (20661.21)

Pitt Rivers Museum, University of Oxford: plates 41, 42, 43, 44, 52, 53, 54, 55, 56, 57, 58, 59, 60, 61, 69, 103, 109, 110, 111, 145, 146, 148, 152, 153, 154, 155, 157

Royal Anthropological Institute Photographic Collection, London: plates 8, 35, 38, 45

Royal Engineers Library, Chatham: plates 1, 39, 40

Taylor North American Indian Archives, Hastings: plates 161, 162, 163, 164, 165, 166, 167, 168, 169, 170, 171, 172, 173, 174, 176, 177, 178, 179, 180, 181, 182, 183, 184, 185

The Southwest Museum, Los Angeles: plates 186 (41393)

The Warburg Institute, London: plates 70 (91), 71 (70), 72, (41), 73 (42)

Union Pacific Museum Collection, Omaha: plate 36

University of Nevada, Reno Library: plate 187

University of Wyoming (American Heritage Center): plates 31, 196, 197

Wellcome Institute Library, London: plates 23 (V38484), 113, 114, 119 (V38481), 249

Whyte Museum of the Canadian Rockies: plate 84

PHOTOGRAPHIC ACKNOWLEDGEMENTS

Barbican Art Gallery would like to thank all the individuals and institutions, and their staff, who made negatives available for reproduction in this book, as listed above. We would also like to thank particular photographers who made copy prints for use in this book. They are:

Prudence Cumming Associates, London
Steve Hopkinson, John Whybrow Ltd, Birmingham
Victor Krantz

TRIBAL DESIGNATIONS

With the registration of over 500 federally recognised tribes in the United States alone, and in conjunction with the challenges of achieving tribal sovereignty, specific Nation, tribe, and band names have become a contentious issue. Historically, the majority of designations were documented by visiting officials and non-Natives who frequently misinterpreted band and personal names as a result of linguistic complexities. As sovereign Nations, the reclamation of identity has become paramount and so we have made every effort to use current preferences. Where it likely that the reader will be unfamiliar with the preferred tribal designation, we have given the more traditional name in square brackets. Correct preferred usage names are denoted by round brackets.

Perhaps the most complicated designations surround the Sioux nations, a catalyst for the meeting of 12 Sioux leaders brought together by Emil Her Many Horses at the National Museum of the American Indian, in June 1998 to specifically address this issue and arrive at the results published below. For other nations, we have consulted with George Horse Capture of the National Museum of the American Indian, Jonathan King of the British Museum, as well as several on-line resources, specific tribe and band web pages, and recent publications.

The editorial approach through the introduction, captions and end-matter of this book has been to give Native names first and translated common usage names in square brackets. Similarly, it has been our policy to use the term 'Native American' rather than 'Indian.' However, it is acknowledged that different authors, Native and non-Native alike, have different views on this; North American Indian is widely accepted for instance; and so there has been no attempt to standardise throughout.

Sioux tribal designations:

Lakota:	Nakota:	Dakota:
Teton	Yankton	Santee
Sicangu (Brulé)	Yankton	Mdewakanton
Oglala	Yanktonais	Wahpekute
Hunkpapa		Wahpeton
Minneconjou		Sisseton
Blackfeet		
Two Kettle		
Sans Arc		

NATIVE NATIONS

First published in Great Britain by Barbican Art Gallery in association with Booth-Clibborn Editions 12 Percy Street, London W1P 9FB.
www.booth-clibborn-editions.co.uk
e-mail: info@internos.co.uk

On the occasion of the exhibition:
Native Nations – journeys in American photography

10 September 1998 – 10 January 1999

Barbican Art Gallery, Barbican Centre,
London EC2Y 8DS

ISBN 1-86154-073-6
Distributed world-wide and by direct mail through Internos Books, 12 Percy Street, London W1P 9FB.

Barbican Art Gallery is owned, funded and managed by the Corporation of London.

Managing Director of Barbican Centre, John Tusa.

Curator, John Hoole.

Native Nations – journeys in American photography
©1998 Corporation of London
Texts ©1998 authors

Exhibition organised by:
Jane Alison, together with Conrad Bodman, Louise Vaughan and Philippa Alden.

Research assistance: Veronica Passalacqua

Editorial support: Martin Barr

Catalogue designed by Kate Stephens and et al
Printed in Italy